# OBJECT AND IMAGE

Wiesen
Weisen

THIRD EDITION

# OBJECT AND IMAGE

# An Introduction to Photography

**GEORGE M. CRAVEN**

De Anza College

PRENTICE HALL, Englewood Cliffs, New Jersey 07632

*Library of Congress Cataloging-in-Publication Data*

CRAVEN, GEORGE M (date)
  Object and image: an introduction to photography/George M.
Craven.—3rd ed.

    p.    cm.
  Includes bibliographical references.
  ISBN 0–13–629064–7
  1. Photography.   I. Title.
TR145.C89  1990
770—dc20                           89–36933
                                        CIP

Editorial/production supervision and
interior design: Hilda Tauber
Cover design: Ben Santora
Manufacturing buyer: Ray Keating
Page layout: Debra Toymil

*To The Memory of*

**CLARENCE H. WHITE, JR.,**

*mentor and friend,*
*whose teaching career*
*at Ohio University*
*from 1949 until 1972*
*touched many lives*

Printed in the United States of America

10 9 8 7 6 5 4 3 2 1

ISBN 0-13-629064-7

Prentice-Hall International (UK) Limited, *London*
Prentice-Hall of Australia Pty. Limited, *Sydney*
Prentice-Hall Canada Inc., *Toronto*
Prentice-Hall Hispanoamericana, S. A., *Mexico*
Prentice-Hall of India Private Limited, *New Delhi*
Prentice-Hall of Japan, Inc., *Tokyo*
Simon & Schuster Asia Pte. Ltd., *Singapore*
Editora Prentice-Hall do Brasil, Ltda., *Rio de Janeiro*

# CONTENTS IN BRIEF

# CONTENTS

# 4

## ALL ABOUT FILM     54

# 5

## USING FILTERS ON YOUR CAMERA     60

# 6

## PROCESSING BLACK-AND-WHITE FILM     66

# 7

## BASIC PRINTING AND ENLARGING     90

# 8

## ADVANCED PRINTING TECHNIQUES    108

# 9

## PHOTOGRAPHING IN COLOR    124

# 10

## PROCESSING COLOR FILMS    132

# 11

## MAKING COLOR PRINTS    138

# 12

## OUR PHOTOGRAPHIC HERITAGE   154

# 13

## THE CLASSIC APPROACH   186

# 14

## THE JOURNALISTIC APPROACH   198

# 15

## THE SYMBOLISTIC APPROACH    208

# 16

## AWAY FROM REALISM    216

# 17

## LARGE-FORMAT PHOTOGRAPHY:
## VIEW CAMERAS AND SHEET FILM    232

# 18

## FLOOD AND FLASH: PHOTOGRAPHY BY
## ARTIFICIAL LIGHT    250

# 19

## CAREERS AND EDUCATIONAL OPPORTUNITIES 266

# 20

## IMAGE AS OBJECT: LOOKING AT PHOTOGRAPHS 276

## APPENDIX A: INSTANT-PICTURE MATERIALS 286

## APPENDIX B: ARCHIVAL PROCESSING AND STORAGE 291

## GLOSSARY 293

## BIBLIOGRAPHY 306

## INDEX 319

# PREFACE

*Object and Image* is an introduction to the exciting world of photography. It has three main objectives: to help you make better photographs, to suggest different ways that photography can be a vehicle of communication and personal expression for you, and to explore how we can respond more fully and rewardingly to the photographs of others.

This third edition has been updated with the very latest developments in the field of photography. The presentation has been reorganized to group chapters concerned with basic skills at the beginning of the book. Chapter 1 provides a context for learning and introduces a basis for thinking photographically. Chapters 2 through 7 discuss basic tools and techniques. Each procedure is presented step-by-step with illustrations showing widely used equipment and products. Chapter 8 extends the basic technical discussion to fiber-base black-and-white printing, mounting, and matting. Chapters 9 through 11 are devoted to color photography. The chapter on color printing has been expanded to include several processing modes.

Chapter 12 presents the history of photography with 52 illustrations and descriptions of early methods. This chapter is followed by a discussion of four major styles of contemporary work, each of which is illustrated with numerous examples. Most of the contemporary photographs are new to this edition, and each is discussed in the text. This section, comprising Chapters 12 through 16, thus forms a broad overview of photographic styles and applications, past and present.

Chapters 17 through 19 cover additional topics often included in more advanced courses—in particular, large-format photography (with view cameras and sheet film) that is new to this edition. The final chapter, "Image as Object," addresses the way we look at photographs and respond to them, and offers some suggestions for viewing fine prints firsthand rather than through reproductions.

Three useful features are new to this edition: (1) A detailed table of contents outlines the material and any special features to be found in each chapter. (2) Technical procedures have been separated from the general text to make them easier to locate and follow. (A typographic distinction shows the reader at a glance the steps that are done in the darkroom with lights on and the steps that require total darkness or safelights.) (3) A summary at the end of each chapter lists the most important points discussed.

Each illustration by a credited photographer has been chosen because it clarifies a particular point in the text and because it is also a fine example of that photographer's work or an outstanding image from an important historical collection. Because most have been published elsewhere, they will also serve as a guide to other examples by these photographers in books and exhibitions. To help you locate such examples, the bibliography in this edition has been annotated, updated, and expanded to include a selection of nonprint materials. All technical terms are defined in the glossary, and the index has been extensively cross-referenced.

Modern photography is an assemblage of many tools and techniques, materials and processes. Rather than discussing them all, I have made careful choices based on many years of experience with photography and the learning process. For example, I strongly recommend the use of variable-contrast, resin-coated photographic paper for learning basic black-and-white contact printing and enlarging. It is economical for the student, and its quick-processing feature permits more learning within the limited class time available. Once basic procedures have been handled with confidence, the advantages of fiber-based and graded papers and of fine-print finishing can be usefully explored. These are fully discussed in a separate chapter.

I prefer international (metric) units where feasible to encourage their use, but I also recognize that total conversion is not likely to occur in this century. Therefore I have again used both the customary American and the international units as commonly practiced in the photographic industry.

## ACKNOWLEDGMENTS

For the third edition I again want to thank all who have shared with me their critical reactions to the earlier editions. Several features of the present volume are due to these constructive comments.

I also thank Dan Biferie, of the Southeast Center for Photo/Graphic Studies, and David F. Drake of Cypress Community College, who reviewed the manuscript of this edition. Their comments were encouraging and helpful.

I am most grateful to the photographers, collectors, museums, and manufacturers who have allowed me

to reproduce their photographs. I also thank Don George, Lisa Grumann, Mike Pendelton, Greg Serniuk, John and Gwen White, my son Clarence, and my wife Rachel for generously giving their time and energy to help me produce the hundreds of step-by-step and technical illustrations in this edition. Ewert's Photo, Santa Clara, CA, loaned equipment for some of these pictures. Additional technical photographs were provided by Wilfredo Castaño and Douglas Cheesman of De Anza College. The assistance of San Jose Camera and Video, Inc. in the production of the cover photograph is gratefully acknowledged.

At Prentice Hall I have again had the pleasure of working with a fine group of professionals. Bud Therien, Executive Editor for Art and Music, provided informed guidance with warm enthusiasm at many stages of the project, and shared my belief that a book on photography should appeal to the eye as well as to the mind. Hilda Tauber designed and edited this edition and supervised the countless details of production with intelligence and grace. Debra Toymil handled the difficult task of page layouts.

My final debt is to friends and family, especially my wife, whose patience with me and continual encouragement over the many months required to produce this book are deeply appreciated.

# OBJECT AND IMAGE

**1**

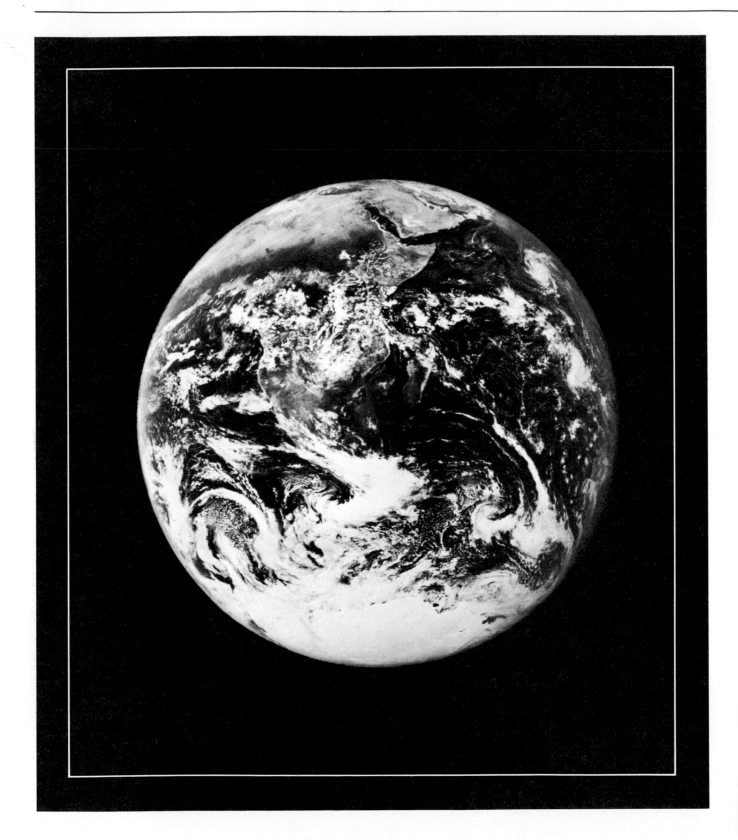

# OBJECT AND IMAGE
## What Photography Is

**1-1** *The Earth from Apollo 17, 1972. NASA.*

Among all the forms of picture making devised by humans on their long journey from the cave to the moon, photography is one of the youngest and most fascinating. Its immense popularity raises important questions: Why do people make pictures? And why have photographs so captured our imagination?

The answers to these questions are found in human nature rather than in photographs, for words and pictures have been fundamental to human existence since the beginning of recorded time. Words and pictures, of course, are symbols invented by humans to help us understand ourselves, our behavior, and the complex nature of the world in which we live. Woven into language, these verbal and visual symbols have formed the fabrics of many different cultures. For a long time they have been the basic tools that people have used to communicate and to learn.

When were the first pictures made? No one knows; their origin is prehistoric. But evidence suggests that centuries ago they evolved into a widely understood form of language, creating bridges of understanding between different cultures. Most languages, of course, were spoken and written, and the latter were stored in books. With the invention of printing in the fifteenth century, the number of books greatly increased and the need for pictures to illustrate them grew rapidly. The invention of photography in the nineteenth century turned this evolution of picture making into a revolution. Photography changed the way we see things, and it changed picture making forever.

What is photography? In its simplest dimensions, photography is a means of producing images or pictures by the action of *light* on a substance that is *sensitive* to that light. But such a simple definition does not begin to describe either the experience of making photographs or the tremendous impact that these pictures have had on nearly every aspect of modern life. First, remember that you and I were introduced to photographs (and to their televised counterparts) at a very early age; we have been looking at them all our lives. Second, what we know about the universe, and the way we have come to understand it, are due in large measure to the eye of the camera. Think about this a moment. We have seen history made before our eyes. The distant planets Mars and Jupiter, and even Saturn's rings, have all been vividly brought into our experience through photography. And photographs of our own planet earth, taken from outer space, have not only reaffirmed the legends of early explorers (who dared to think that the world was not flat) but they also have revealed to us an earth-bound environment that is beautiful, delicate, and precious (Fig. 1-1). On a different but no less remarkable scale, other photographs have revealed the mysterious beginnings of human life in a mother's womb.

Photography, of course, is more than a scientific tool; it is also an inseparable part of life's most important rituals and events (Fig. 1-2). Can you remember a wedding that did not include a photographer? And who has not seen a baby coaxed into a smile for a waiting camera? Photographs give us tangible reminders of people, places, and events in our lives. They function like mirrors held up to our past, letting us re-experience recorded events of our own lives, and turning history into convenient packages that we can possess,

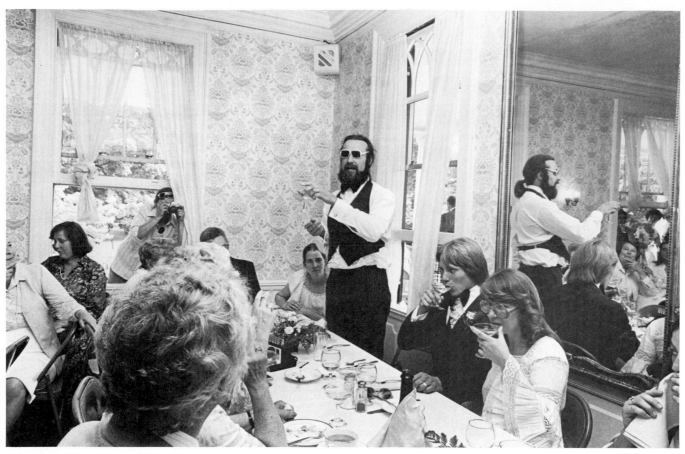

**1-2** *Abigail Heyman: Wedding Party, 1980. Archive Pictures.*

study, or discard. Photographs bring distant lands and people close at hand, and by lifting such experiences out of their original context, they can make familiar things seem unusual. Thus they can give the commonplace a new sense of importance; they can make people seem larger than life.

Small wonder, then, that these pictures have fascinated people for more than a century. Photographs have increased our sense of awareness and intensified our powers of observation. What gives photography these abilities? Such a powerful force in our lives deserves a closer look.

## HUMAN VISION AND CAMERA IMAGING

Almost anyone can pick up a camera, take a picture, and produce a recognizable image. In fact, making a photograph seems so easy that we are tempted to think of photographs as miniature versions of the real world where they were made, and that resemblance, of course, is what makes them so popular and useful. Closer study of photographs, however, reveals that they are really not mirrors of the actual world. Nor do they show things exactly as we see them.

Let's consider for a moment how we see things and how a camera image is formed. Although the human eye and the camera are both built on the same principle, they function differently. Our eyes produce a pattern of nervous stimulation in the brain, rather than a picture in our head. Our vision is binocular, which enables us to perceive things in three dimensions rather than two; most cameras, of course, have only one picture-forming lens and therefore make only flat, two-dimensional images.

Other differences are less obvious. We see things in what we perceive to be natural color; cameras record in fixed schemes of three colors or in monochrome. Photographs can closely approximate, but never duplicate, human color sensation.

Our eyes are continually in motion, which enables us to take in a wide field of view. But we see only part of this field at any given moment, and each part only for an instant. We use our total vision to establish the general arrangement of a scene, but we direct our central vision, which is clearer, to concentrate on smaller areas of greater importance to us. To see the entire field of view clearly we must move our eyes to bring each important part of that field briefly into our central vision.

In contrast, the camera image usually is an instantaneous one. Typically, all parts of it are produced simultaneously in a very short span of time. Indeed, the process has become symbolized by the

"click of a shutter." But unlike the human eye, the camera can accumulate weak light, if necessary, until it builds up a developable image; it can, in fact, take photographs in near darkness where the eye can see little or nothing.

The eye sees only in a changing continuum of real time, but the camera can retain a single image forever. It can also combine successive images one on top of another, superimposing them into a single impression. And by varying the time span and sequence of its exposures, the camera can not only stop time but also compress and expand it. Thus a visual world unknown to the eye can be discovered through controlled use of the camera.

The camera also is indiscriminate. Without human direction, it cannot decide what is important and what is not within its field of view. To the casual photographer or snapshooter, this usually isn't a problem. But for more serious picture making we must recognize that without deliberate direction, a camera renders important things and trivial things with equal accuracy and force. Selection, then, is the photographer's responsibility. It requires sight, which lets us *look*, and insight, which allows us to *see*.

*Looking* and *seeing* are not the same thing. Looking uses our basic visual sense; all of us do that. But *seeing* involves looking with an effort to *understand* what we see. It requires some degree of *empathy*, of feeling our way into whatever we experience, so that we recognize and comprehend it more effectively. Seeing, then, demands an *awareness* of what we view, and that, in turn, requires us to put aside preconceived notions of what we see and look at things with an open mind as well as an open eye.

This process, which we call *perception*, is largely a series of acts that require little conscious effort on our part, but that are conditioned by our entire system of human values—our beliefs, prejudices, opinions, and experiences. Because we are human, all these affect how we perceive what we see, and because these values differ for each of us, no two individuals perceive things exactly the same.

This suggests that although the camera is able to image everything within its field of view with equal emphasis and clarity, human vision is much more selective. We see largely what we want to see, what our mind allows us to see, and as we learn from life's experiences, that constantly changes. It is not surprising, then, that photographers like Bruce Gilden (Fig. 1-3) have discovered that the camera is a wonderful instrument for sharpening one's perception, for heightening one's awareness, and for opening the eye of the mind.

**1-3** *Bruce Gilden: New York City, 1983.*

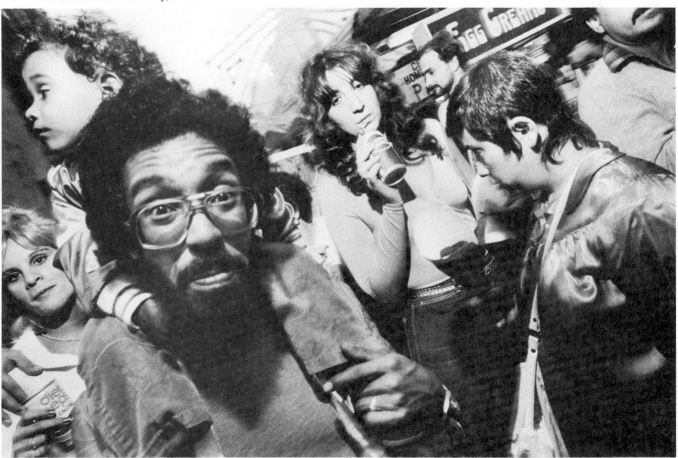

## WHAT A PHOTOGRAPH IS

Just as human vision and camera imaging differ, photographs are unlike every other form of picture and unlike the real world from which they are made. Photographs depend on *light*. The word *photography*, which was first used in 1839 by the English scientist Sir John Herschel, means, literally, *writing or marking with light*. In photography, light "writes" by changing certain characteristics of materials that are sensitive to it. Light is thus the physical force which produces and reproduces the image, and because light-sensitive materials are required, both govern important characteristics of the photographic image.

Perhaps the most important of these characteristics is *continuous tone*. Continuous tone describes the ability of photography to record changes from light to dark—from white to black—without noticeable steps: in other words, to produce an almost infinite number of *values* or *shades of gray*. Bruce Barnbaum's photograph made in Waterholes Canyon (Fig. 1-4) dramatically reveals this quality, which is due to the way most photographic materials respond to light. This continuous range of tones from light to dark is formed like the image itself, in an *instant*; no other means of making pictures except video can approach photography in this respect.

Camera images are usually formed with a lens, which gathers light rays and focuses them. Lenses are able to form pictures with great *detail*, and this characteristic of photographs has extended beyond the medium to contribute a term to our verbal language. When we speak of certain drawings or paintings as having a "photographic" appearance, or of someone having a "photographic" mind, we refer to an impression of unlimited detail. This feature of photographs, of course, makes them efficient and val-

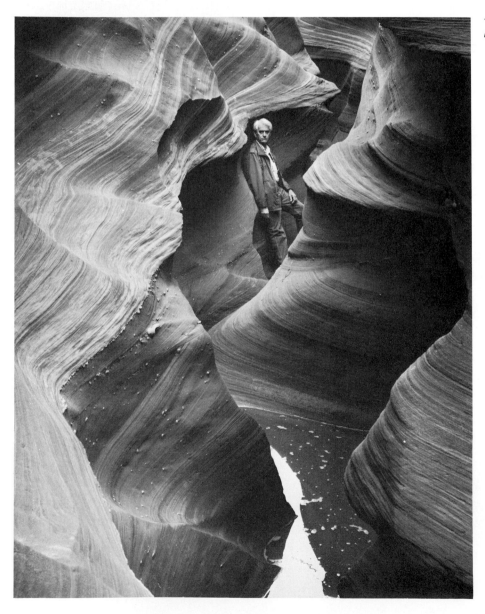

**1-4** © *Bruce Barnbaum: Marion Brown in Waterholes Canyon, 1987.*

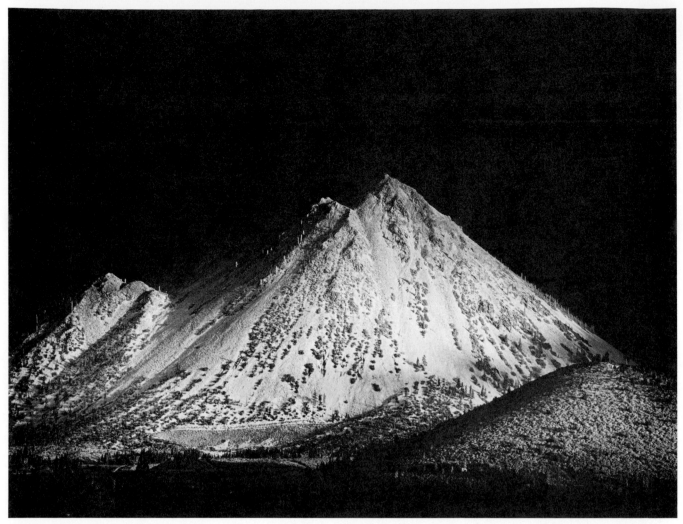

**1-5** © *Mathias Van Hesemans: Black Butte, Mt. Shasta, California, 1984.*

uable conveyors of visual information, as Mathias Van Hesemans's dramatic photograph of a volcanic cinder cone demonstrates (Fig. 1-5).

Another important characteristic of the photographic image that derives from the nature of the process is its capacity for *unlimited duplication.* Most forms of the photographic image are produced first as a *negative*, with tones reversed from their usual order, and then from that negative as an unlimited number of *positives*, with the light and dark tones in proper order once again. We may make one positive or any number of exact duplicates without diminishing or destroying the original image. We may also change the size: reproductions can be larger or smaller than the original. And even in those few processes which produce no negative (and are therefore called direct-positive processes), the image can be rephotographed and duplication continued. Office copy machines, available everywhere, are built around this principle. So, too, is the printing industry. The typesetting and printing plates for this book, for example, were produced by photographic means.

This capacity for duplication that is such an im-

portant feature of photography has not only revolutionized communication and education but has changed our entire culture. For instance, André Malraux, the late French scholar, has claimed that the study of art history is, in reality, the study of art that can be photographed. Few of us, he notes, have access to many original works of art; we usually learn about them, like so many other things, through photographic reproductions. Until recent improvements in color photography became available, however, the subtle hues and intensities of many medieval stained glass windows and Byzantine mosaics could not be adequately reproduced. Thus students who studied them only through written accounts or inadequate reproductions really did not know them at all.

Historian Daniel Boorstin has written lucidly on this substitution of *image* for *object*, which he sees as a "Graphic Revolution." In *The Image* (see bibliography under General Works), he suggests that photography has played a major role in encouraging the rapid spread of pseudo-events (the "media event," for example) to replace real ones, and copies of objects and experiences to replace originals. Even more

alarming is his observation that we often value the reproduction more than the original. This is evident in the mass-merchandising of goods and services and in the nationwide proliferation of franchised restaurants, each serving identical, undistinguished food. Rampant duplication, then, is not limited to printed matter; it has become characteristic of our culture.

To sum up, these are the most common characteristics of the photographic image:

1. It is produced by *light* on a *light-sensitive substance or surface*.
2. It has *two real dimensions*. Depth is simulated.
3. It is often distinguished by *continuous tone*.
4. Typically it has abundant *detail*.
5. Usually it is produced *instantly*, and all parts of a single image are produced simultaneously.
6. It can be *duplicated* without limit.

Taken together, these characteristics suggest that the photograph is a unique kind of picture. Indeed it is.

## PHOTOGRAPHY IS ROOTED IN REALITY

Looking at photographs soon convinces us that photography is rooted in reality. The earliest photographers recognized that fact and it became their working esthetic. For nearly half a century the degree of likeness between the object and its image was the chief guideline by which photographers measured their success as artists. This degree of likeness, of course, allows us to substitute the photograph for the object itself, and that is the principal reason why we make photographs today.

When pictures look like the real objects they portray, we call them *representational*. Portraits, catalog illustrations, photographs for sales and advertising in business and industry—even snapshots—are all important examples of representational images. Photographs are made for reference and for all kinds of records. In our society we have developed an essential need for such pictures, and it is hard to imagine modern life without them.

Because photographs capture reality so well, they help us remember things and events that change. Our memory, of course, is not static either. The way we observe events constantly changes like the events themselves. By isolating moments of time as well as fields of view, photographs can intensify history and reinforce our memory.

Cheryl Nuss's photograph of Pope John Paul II embracing a 4-year-old victim of AIDS provides a good example (Fig. 1-6). Ironically, powerful images like this one can sometimes acquire a new sense of reality all their own, and occasionally this makes these im-

**1-6** *Cheryl Nuss: Pope John Paul II Embracing Brendan O'Rourke, 4, an AIDS Victim, in San Francisco, 1987. From the* San Jose Mercury News.

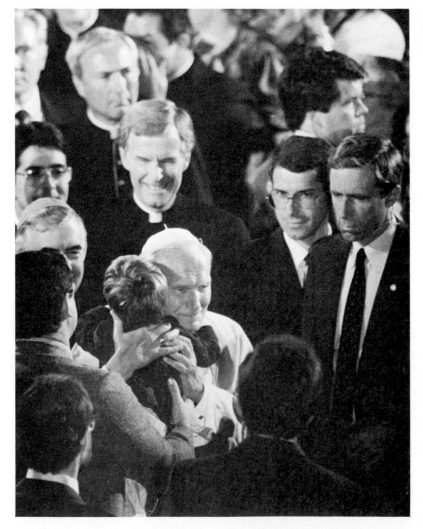

ages more meaningful to us than the events which produced them.

We use photographs in so many ways today that we often take them for granted and accept them as literal truth. Sometimes we even question reality when it doesn't measure up to its photographic representation. We can observe this, for example, at our favorite fast-food restaurant, where we judge the hamburger or taco served to us by how closely it matches a color photograph on the wall. In this case, reality becomes true to the extent that it resembles its photograph!

## CREATING THE ILLUSION

Our ability to occasionally switch reality (the object) with its photograph (the image) provides a clue to understanding what this act of photographing involves. Making a photograph is a way of creating an *illusion*, and because of the interchange of functions just described, it isn't hard for photographers to fill their pictures with illusory truth. For one thing, the camera can collapse a great span of time into an instant, summing up in a single picture what may have taken minutes or hours to transpire. Thus it can record more than the photographer can perceive. For another, the camera can expand a moment into a new

reality visible only in its image, as Richard Schmidt's photograph of a track meet demonstrates (Fig. 1-7). And if this were not enough to make photographs different from other kinds of pictures, they often have the advantages of continuous tone and great detail (discussed above) to help make them distinctive and powerful images.

This places a great responsibility on anyone who would make fact-filled images, for people find it easy to accept such pictures as truth. Responsibly used, photography can thus be a witness for fairness and truth. But used without such principles, it can also be a tool for propaganda. Photographers need to be aware of this power, and to use it with wisdom and care.

### Analysis and Synthesis

How, then, is photography different from other kinds of picture making? Painters who want to create an illusion of reality must draft the image in a chosen space and enrich it by adding sufficient color and detail. They must visualize their image as a changing series of fragments, and *synthesize* or build it, element by element, adding, revising, elaborating their theme toward its final state. Photographers, on the other hand, have a different problem: Their image is drawn, in effect, by the camera's position and its lens; choosing these defines the picture. Once these

**1-7** *Richard D. Schmidt: Women's Cross Country Meet, 1983. From* The Sacramento Bee.

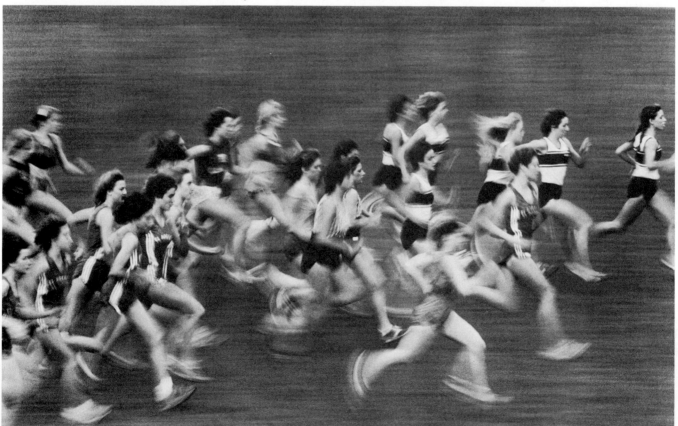

choices are made, the photographer's task is not how to include enough detail but rather how to eliminate all that isn't needed.

Photographers usually begin with the image whole. Like painters, they limit their view by imposing a *frame* on the real world, but then they *select* within that frame by using light and shadow to give objects the appearance of form and substance, and to eliminate less important elements so that only the desired visual idea remains. Marion Patterson's photograph (Fig. 1-8) demonstrates the result.

The photographer's way of working, then, is basically *analytic* rather than synthetic. It distills significance out of confusion and brings order and structure to the picture. This approach to image making is the opposite of the painter's, even when both have the same objective in mind. Indeed, we point out the difference when we remark that paintings are *made*, and photographs *taken*.

## AN EXPERIENCE IN ITSELF

Wynn Bullock was a sensitive photographer who realized that a photograph could be *made* as well as taken, and that it could be created from an inner reality of thought and feeling as well as from an external world of objects and events (Fig. 1-9). This idea is important to photographers because it can free them from any need to make the photograph a picture of

*something;* like other artists, they may make the image simply a *picture*. By recognizing that photographs are based on reality but do not reconstruct it, photographers can open the door to an enormous range of picture-making possibilities and enjoy virtually all the freedom of image formation that artists in other media traditionally have known. Thus a photograph does not always have to illustrate another idea, but may simply be presented as an experience in itself.

Sometimes such photographs bear little resemblance to what was in front of the camera, and are called *nonrepresentational* or *abstract*. Although it clearly portrays a scene in the real world, Bullock's image also suggests a degree of abstraction. The picture invites us to bring our own thoughts and feelings to it, to view it in the light of our own imagination. What each of us sees in this photograph, then, may reflect our own ideas as strongly as it reveals those of the photographer. Such a photograph can function more as a mirror than as a window; it can cause us to reexamine our thoughts and feelings, and it will often evoke varied responses from different viewers.

## SEEING PHOTOGRAPHICALLY

No matter how we want our picture to function, as photographers we must also think of our image in terms of what our tools and materials can do. Practically speaking, we must understand how photo-

**1-8** *Marion Patterson: California Poppies, 1988.*

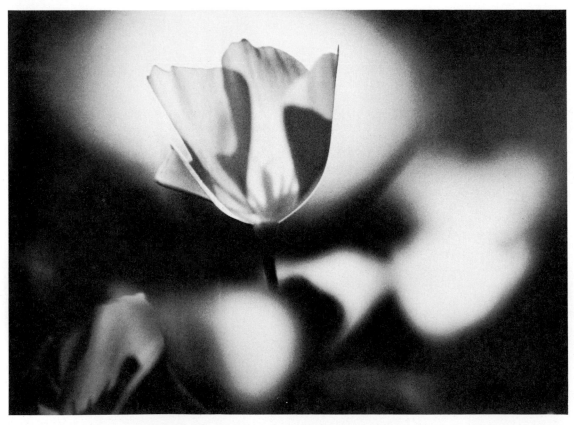

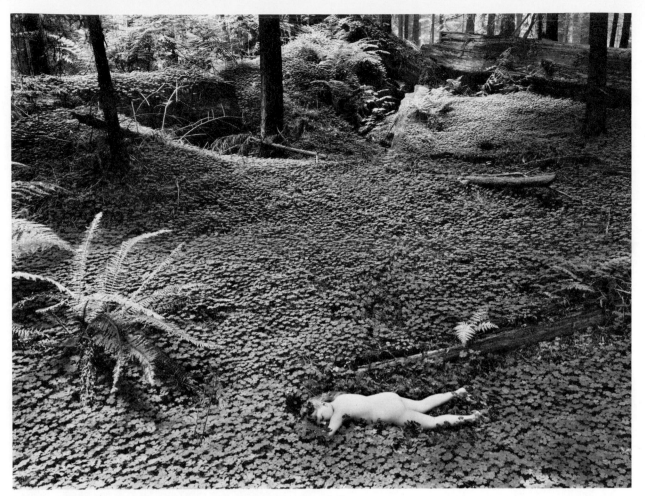

**1-9** *Wynn Bullock: Child in Forest, 1951. Wynn and Edna Bullock Trust.*

graphic materials and processes work in order to visualize our picture. To Edward Weston, the photographer, this was "seeing photographically," a process by which we concentrate on an object or observe an event, decide what kind of image we want to make from it, *and then see the image in our mind as a picture.* Although great photographs occasionally result from accident or chance, most are created by photographers seeing and visualizing the image beforehand.

The title of this chapter and this book, then, suggests the importance of a relationship that is central and vital to the photographic experience. Each of these realities, *object* and *image*, is given meaning in terms of the other through the eye of the photographer.

## SUMMARY

1. Photography is a means of producing pictures by the action of *light* on a surface that is *light-sensitive*, but the act of photographing is much more than that. Photographs have enriched our lives in many ways and increased our awareness of life itself.

2. The human eye and the eye of the camera see differently. The camera can produce a single image or superimpose one on top of another; it can compress, expand, or stop time, allowing us to discover a world through its lens that we can't see with our own eyes. But it needs human direction.

3. *Looking* and *seeing* are not the same; seeing involves *perception*, and this brings into play our entire system of human values. Because people's values differ, no two individuals see exactly the same.

4. Photographs are pictures with unique characteristics based, in part, on their relationship with light. Among these are *continuous tone*, unlimited *detail*, a capacity for *unlimited duplication*, and the ability to be *produced instantly*.

5. Photography is rooted in realism. Most photographs are *representational*, looking like the real object they portray. Other photographs bear little resemblance to the real world from which they were made; we call them *nonrepresentational* or *abstract*.

6. When we make a photograph we create an illusion. But unlike painters, who build their images by adding elements and details, photographers start with their images whole and create them by eliminating nonessentials. Where painters *synthesize*, photographers *analyze*.

7. Whether realistic or not, however, all photographs ultimately become experiences themselves; they exist on their own. A photograph does not have to be a picture of *something* but may be simply a *picture*.

8. Because most photographs are made by visualizing the image before it is recorded, photographers should learn to see photographically and to conceive their images according to what their materials and equipment can do.

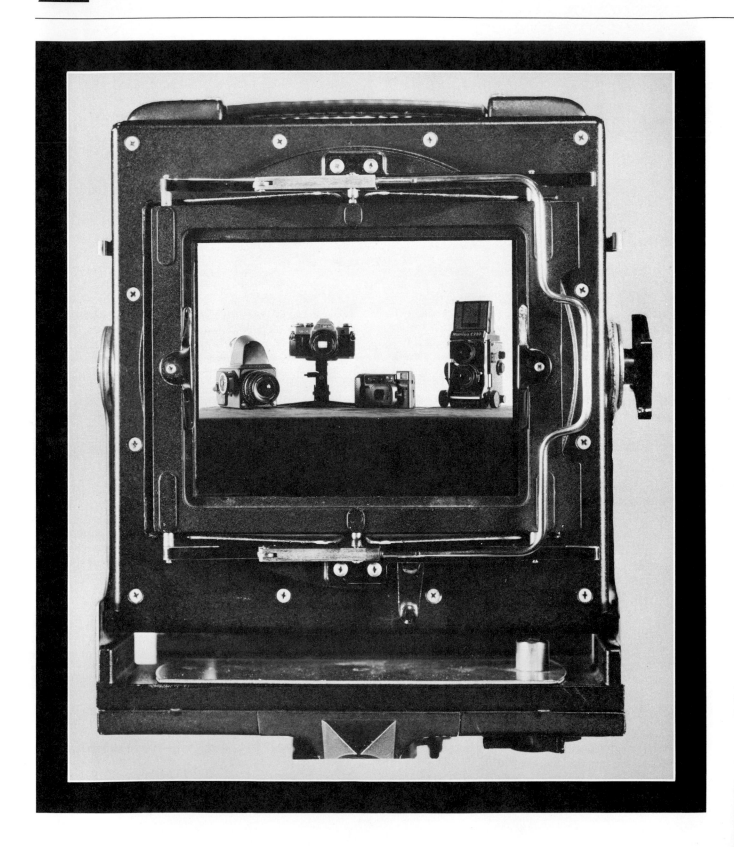

# THE CAMERA

**2-1** *Basic types of cameras. From left: 2¼ × 2¼ in. single-lens reflex, 35mm single-lens reflex, 35mm viewfinder, and 2¼ × 2¼ in. twin-lens reflex. All are shown within the imaging area of a 4 × 5 in. view camera.*

Every camera is essentially a light-proof box with a lens at one end and a light-sensitive film inside at the other. Its function is to make a picture, and it does this by gathering light rays reflected from a scene or subject and projecting them as an image onto the sensitive film.

To do this, a camera has these fundamental parts:

1. A **lens** to gather the light and form an image, much as the human eye does.
2. A **viewing system** or **viewfinder** that shows what the picture will include.
3. A **focusing mechanism** to adjust the position of the lens and make its image sharp.
4. A **shutter,** which determines when the exposure is made, and which times the passage of light to the film.
5. An **aperture,** located within the lens, to control the amount of light reaching the film.
6. To use the camera, a light-sensitive **film** must be placed inside to record the image.
7. Most cameras have a **film-advancing mechanism** to replace exposed film with fresh after each picture is taken.
8. A **lightproof chamber** or **box,** which protects the film from all light except that which enters through the lens during exposure.

## BASIC CAMERA TYPES

Although all cameras are similar, they also have important differences which are part of their basic design. There are four major types, usually identified by their viewing system or mechanism:

1. Viewfinder cameras.
2. Single-lens reflex cameras.
3. Twin-lens reflex cameras.
4. View cameras.

Recognizing these basic types is the key to understanding how they work.

### Viewfinder Cameras

In a viewfinder camera, you see your subject through a small but brilliant window that frames it as you hold the camera up to your eye (Fig. 2-2). By looking *through* this window, you can use the camera as an extension of your eye, continuously observing your subject and sometimes even interacting with it. Such viewing is direct and simple, and this design is therefore often used in snapshot cameras and others intended for casual picture making. But it is not limited to such cameras; fine professional cameras of this type are still made, and many skilled photojournalists prefer them.

The viewfinder, of course, is only a framing device; its image is always in focus. Better, older cameras of this design therefore usually have a *rangefinder* built into the viewfinder as a focusing aid. Typically, the rangefinder is a pair of small mirrors or prisms placed about three inches apart within the camera body (Fig. 2-3). One mirror is semi-transparent (you can see through it) and does not move. The other mirror or prism pivots as the camera's lens is adjusted, resulting in two images which overlap to form one when the lens is focused on the same distance. Without a rangefinder, manual focusing must be done by estimating the distance to the subject and then setting the lens accordingly. With a rangefinder, however, focusing is quick and accurate.

Newer cameras of this type, including many simple snapshot cameras, have automatic focusing built into them. Typically, such a

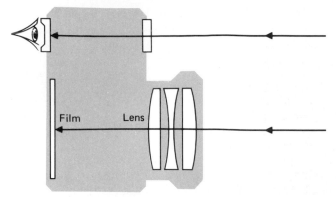

2-2  *Viewfinder camera design.*

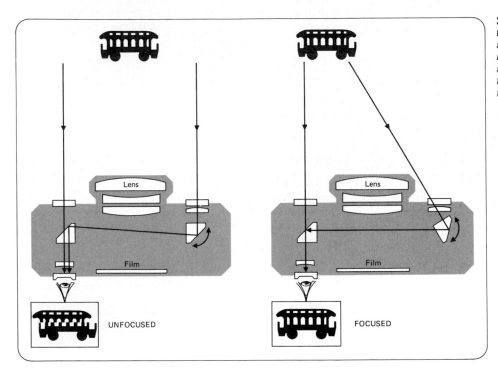

2-3  *How a rangefinder works. When the camera lens is not focused on the subject distance, the image seen in the rangefinder is split in two and offset as shown. When the lens is focused on the subject, however, the two halves of the image are aligned.*

UNFOCUSED

FOCUSED

camera will project an infrared beam onto the subject in front of it, and measure its reflection back to the camera with a sensitive electronic device. The camera will automatically focus the lens on that distance.

The viewfinder camera, however, has one serious flaw. Its viewfinder and taking lens are in different places, and therefore do not frame exactly the same area of a subject. This problem, known as *parallax error* (Fig. 2-4), is most serious at close working distances—within 1.5 meters (about 5 feet)—and it makes these cameras difficult to use for closeup photography. Another minor problem with such cameras is that although they invite you to observe your subject, they do not help you visualize it *as a picture*: what you see in the viewfinder, of course, is the *object* rather than its image.

Most viewfinder cameras, like the popular Canon Sure-Shot series (Fig. 2-5), are simple snapshot cameras. Millions of these are in use. But a few fine 35mm viewfinder cameras, such as the legendary Leica fam-

2-4  *Parallax error. At close range, the viewfinder and the camera lens frame different parts of the subject.*

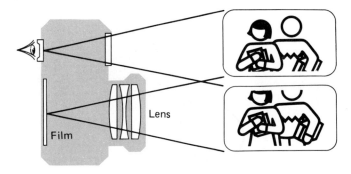

ily (Fig. 2-6), are also made for more serious work. All are compact, lightweight, and rapid working, and because they contain relatively few moving parts, they usually are quiet and reliable.

### Single-lens Reflex (SLR) Cameras

Single-lens reflex cameras let you frame and focus your subject directly through the camera's lens (Fig. 2-7), thereby eliminating the parallax problem of the viewfinder type. They also let you quickly adjust the focus and see how much of the framed area is sharp—another advantage over the viewfinder or rangefinder design.

To combine viewing and taking functions in a single system, however, the SLR camera requires a movable mirror behind its lens. In its lowered position (A), the mirror directs light upward to a ground glass viewing screen, and then into a prism that corrects the inverted image left to right and turns it right-side up before passing it on to your eye. In its raised position (B), the mirror lets the light pass directly back to the film, but it momentarily blocks out the viewing system.

A pair of small, reversed prisms or a microprism grid often is built into the viewing system to assist you in focusing. These devices work like a rangefinder, but they are more difficult to use in dim light. In adequate light, however, the combined viewing and focusing system of the SLR works well with any kind of lens. Most of these cameras therefore have *interchangeable lenses* (discussed in the next chapter) and other accessories (such as motorized film winders) which make them easy to use in a wide variety of picture-making situations. A single shutter located in the rear of the camera near the film plane serves all lenses.

Most SLRs also contain an *exposure metering system* that senses the light through the camera's lens and makes correct exposure simple or automatic.

What are the disadvantages of an SLR camera? As a rule, SLRs are bulkier and heavier than viewfinder-rangefinder cameras, and they contain more moving parts. This makes them more expensive and more likely to need repairs. The mirror's movement produces a loud "click" whenever a picture is taken, and it also makes these cameras difficult to hold still at very slow shutter settings.

But because they are so easy and convenient to

2-5  *Canon Sure Shot Multi-Tele camera. Courtesy Canon USA, Inc.*

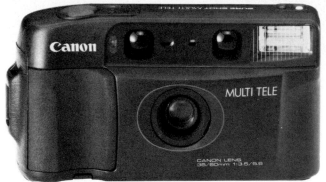

2-6  *Leica M6 camera. Courtesy Leica USA Inc.*

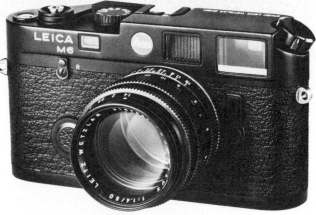

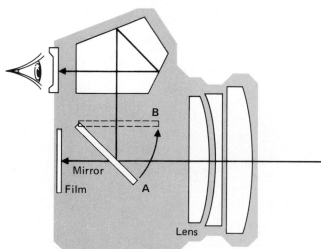

2-7  *Single-lens reflex (SLR) camera design. Mirror is normally in position **A** for viewing but pivots rapidly to position **B** for exposure.*

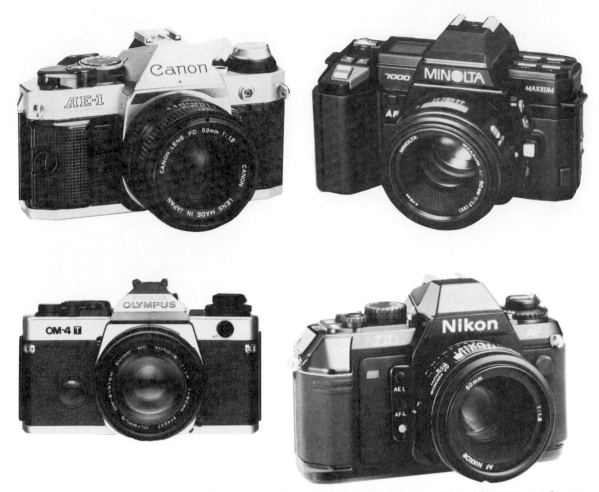

**2-8** *Popular SLR cameras: Canon AE-1 Program, Minolta Maxxum 7000 Autofocus, Nikon AF N2020, and Olympus OM-4T. Courtesy Canon USA, Inc., Minolta Corporation, Nikon, Inc., and Olympus Corporation.*

use, single-lens reflex cameras are the most popular type among serious photographers. Dozens of brands are available in the 35mm format, and these are ideal for making color slides as well as prints in color or black-and-white. Canon, Minolta, Nikon, Olympus, Pentax, and Ricoh are just a few of many popular brand names (Fig. 2-8).

***Recent SLR Design Improvements.*** Today's newest SLR cameras contain several outstanding features that were largely unknown a decade ago. The most obvious one is a design that incorporates a *hand-grip in the camera body*, making it easy and natural to hold. The most unusual model to include this feature is the Yashica Samurai (Fig. 2-9), a compact 35mm camera designed for one-hand holding. It makes pictures 17 × 24mm (smaller than the standard 24 × 36mm format), has a zoom lens and an integrated flash unit, and is completely automatic in operation.

Another feature of most new 35mm SLR cameras is *automatic focus*. The Canon EOS series (Fig. 2-10) is a leader here, using tiny motors in each lens to focus the elements and control the aperture. Optical

*2-9  Yashica Samurai camera. Courtesy Yashica Inc., a subsidiary of Kyocera International, Inc.*

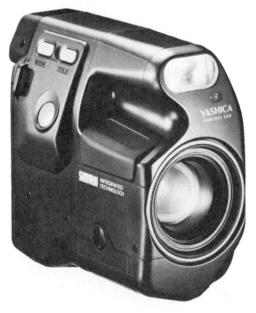

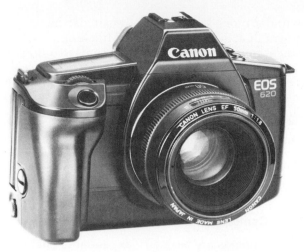

**2-10** *Canon EOS camera. Courtesy Canon USA, Inc.*

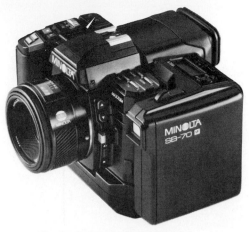

**2-11** *Minolta Still Video Back SB-70 (on Minolta Maxxum 7000 camera). Courtesy Minolta Corporation.*

and electronic sensors in the camera body guide the focusing mechanism, and the user has some control over what the camera focuses on.

The third new feature, just beginning to appear, allows a few SLR cameras to be used for either conventional photography with film or for *still video imaging*. The Minolta Maxxum series is available with a standard film back or with a video back that records the image on a 2 in. square device, much like a miniature computer disk (Fig. 2-11). Although image quality cannot yet compare with that obtainable on film, the recorded picture can be transmitted electronically, played back anytime after recording on a standard TV set, and needs no chemical processing. Thus the camera is truly a hybrid, capable of making pictures electronically or with film.

***Medium-format SLR Cameras.*** In addition to the popular 35mm format, SLR cameras are available for 120-size, medium-format rollfilm too (Fig. 2-12). This format offers the advantage of a larger film area than 35mm, with a corresponding increase in image quality. The Hasselblad and Rollei 66 make negatives $6 \times 6$ cm ($2\frac{1}{4} \times 2\frac{1}{4}$ in.). the Bronica ETRS and Mamiya M645 Super, which make pictures $4.5 \times 6$ cm ($1\frac{3}{4} \times 2\frac{1}{4}$ in.), are less costly. The Mamiya RB67 and Pentax $6 \times 7$ are larger cameras that make $6 \times 7$ cm ($2\frac{1}{4} \times 2\frac{3}{4}$ in.) pictures.

Each of these cameras is designed as part of a *modular system* featuring interchangeable lenses, viewing components, and other accessories. Most newer models also have interchangeable film magazines. This feature permits you to switch films in mid-roll (from black-and-white to color, for example) with a single camera body and lens. Medium-format cameras, of course, are heavier and more expensive than most of their 35mm counterparts, but they are superbly built photographic tools capable of making high quality images. They are widely used by professional photographers.

**2-12** *Medium-format cameras: Hasselblad 503 C/X and Mamiya M645 Super. Courtesy Victor Hasselblad, Inc. and Mamiya America Corporation.*

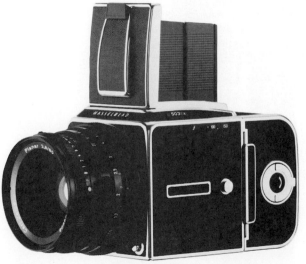

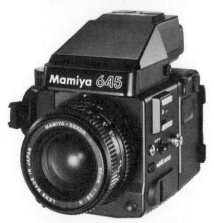

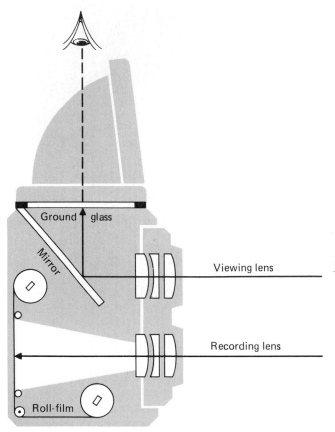

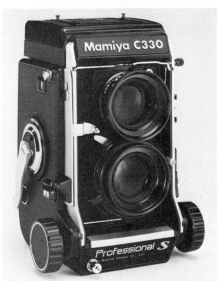

2-13 *Twin-lens reflex (TLR) camera design.*

## Twin-lens Reflex (TLR) Cameras

Twin-lens reflex cameras have separate lenses for viewing and recording, mounted one above the other so that they focus together (Fig. 2-13). The image formed by the upper lens is reflected off an angled mirror to the ground-glass viewing screen, where you can see it as a two-dimensional picture. Because this mirror does not pivot, as in the SLR, a second lens containing the shutter and aperture does the actual picture-taking below. Since these lenses are closely matched, what you see on the ground glass is more or less what you get on the film.

The differences between the two images, however, can sometimes be disturbing. The ground-glass image, although right-side up, is reversed from left to right. The twin-lens reflex, like the viewfinder camera, suffers from parallax error at close working distances, and on most TLR cameras you cannot interchange lenses as you can on a single-lens reflex.

Yet the advantages of a twin-lens reflex camera should not be overlooked. It makes an image 6 cm (2¼ in.) square on 120 rollfilm, large enough for thoughtful study before exposure and for easy printing later. These features make the TLR a good choice for portraits; it can also be used for general work at waist level or on the ground. In dim light, the hood surrounding the ground glass can be depressed to form an eye-level finder (converting the camera to the viewfinder type). In this mode it can also be used to photograph action by panning or tracking.

Since most twin-lens reflex cameras are uncomplicated, they usually are rugged and dependable. Moreover, their straightforward, boxy shape makes them easy for many physically limited people to hold. And all these features come at a reasonable price.

The Mamiyaflex (Fig. 2-14) has interchangeable lenses. The older (now classic) Rolleiflex and Rolleicord are similar in design but do not have interchangeable lenses. The Yashicamat, although no longer made, is still very popular.

## View Cameras

View cameras are basically expandable chambers or boxes; a lens and shutter on the front and a ground-glass viewing screen on the rear are connected by an accordion-like bellows (Fig. 2-15). In principle they are the simplest and oldest cameras of all, directly descended from the *camera obscura* of Renaissance times (see Chapter 12).

The modern view camera, however, is a precise photographic instrument. Larger and heavier than most other types, it is not designed to be hand-held, and requires a tripod or stand for steady support. Its standard picture sizes are 4 × 5 and 8 × 10 inches.

With the view camera you must compose your image on the *ground glass*. Although this image will be larger than that of reflex or viewfinder cameras, it will also be dimmer, reversed left to right, and upside down. To see the image you will usually need to place an opaque *focusing cloth* over the ground glass and your head. There are no built-in exposure meters, focusing aids, or other automatic features on this camera: you must work out these problems yourself each time you use it.

2-14 *Mamiya C330 camera.
Courtesy Mamiya America Corporation.*

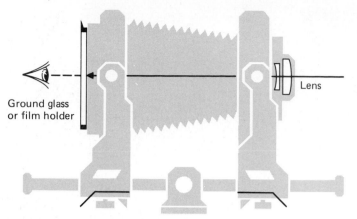

**2-15**  *View camera design.*

Ground glass
or film holder

Lens

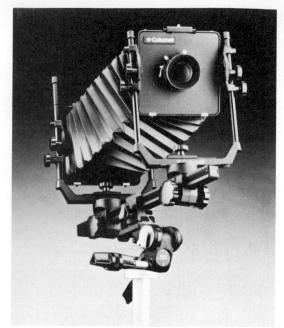

**2-16**  *Calumet 4 × 5 View camera.
Courtesy Calumet Photographic, Inc.*

Nonetheless, the view camera has several important advantages over other types. Foremost among these is *control of the image.* You can interchange lenses and freely adjust both the lens and film positions to eliminate distortion, to control perspective and focus, or to produce an image of a precise size. No other type of camera gives you such ability. This combination of precision and adaptability makes the view camera ideal for product photography, architectural work, or any other application where large, detailed images are required. These applications are discussed in Chapters 13, 17, and 19.

View cameras use film in large, flat sheets that can produce brilliant photographs in black-and-white or color. Each sheet of film can be independently processed, and because each film (in a special holder) replaces the ground glass just before exposure, you can record on the film precisely what you see.

Using a view camera is a slow, deliberate process, but if you are patient it can be rewarding. It is a superb tool for learning to see photographically. Being able to study the ground glass with both eyes helps make you aware of the image *as a picture.* The view camera thus encourages discovery, builds discipline, and effectively separates the image of a photograph from its object in the real world. Calumet (Fig. 2-16), Cambo, Horseman, and Sinar are among several brands available. View cameras and lenses are usually

sold separately; together they can represent a significant investment.

The operation of view cameras is different from that of other types. So is the handling of the sheet film they use. These topics are fully discussed in Chapter 17.

### Instant Picture Cameras

Instant picture cameras made by Polaroid use unique films in pack, roll, or sheet formats. These films contain their own processing chemicals, and the cameras include special rollers that squeeze the chemical pods open to begin processing as the exposed film is removed from the camera.

Polaroid Spectra System cameras and those that use SX-70 film units have mirrors in their optical systems to orient the images so the prints will not be laterally reversed (Fig. 2-17). SX-70 cameras also have

**2-17**  *CAD-CAM diagram of the Polaroid Spectra System camera.
Courtesy Polaroid Corporation.*

**2-18** *Polaroid Spectra System camera. Courtesy Polaroid Corporation.*

an unusual reflex viewing system which permits the camera to fold into a thin unit when not in use.

Some Polaroid cameras have fixed focus, some are focused manually, and others, such as the Polaroid Spectra system camera (Fig. 2-18), focus automatically using reflected sound waves. All Spectra System cameras and those that use SX-70 film have automatic exposure and processing systems powered by a battery built into each film pack. This battery also provides all electrical power needed by the camera, including power for a motor that ejects each print after exposure. Spectra System and SX-70 cameras make only color photographs, but other, older Polaroid cameras can use special color or black-and-white films.

Other unusual aspects of these remarkable cameras center on the film units and their processing cycles, and these are more fully explained in Appendix A.

### Other Specialized Cameras

Two other specialized types of cameras are used widely enough to warrant your awareness of them. The *Nikonos* is a 35mm camera designed to be used underwater. Its lenses are adapted to the refractive characteristics of water and it contains few moving parts so that if it should accidentally flood, cleaning is relatively simple. These features make it popular with skin divers.

Another specialized type of camera makes extreme wide-angle photographs. The Fuji *Panorama* and Panon *Widelux* are capable of sweeping, panoramic views.

### IMAGE FORMATS

In the preceding section we classified different types of cameras by their viewing systems, which point out the basic differences between various de-

signs. Cameras can also be classified by the *film formats* they use. Three formats, shown in Figure 2-19, are widely used for serious photography:

1. 35mm (the most popular format).
2. 120 rollfilm (also known as *medium format*). The two most popular image sizes in this format are 4.5 × 6 cm and 6 × 6 cm. Most cameras in this format use one size or the other.
3. 4 × 5 in. sheet film (also known as *large format*).

Generally, each type of camera is designed to use only one format of film, but special adapters are available to convert some professional cameras from one format to another. For example, some medium-format SLR cameras can be converted to use sheet films and instant film packs, and 120-rollfilm adapters are available for most view cameras. Some snapshot cameras may use other formats such as 110 or 126 cartridge films or disc films.

### THE CAMERA'S MAJOR CONTROLS

Most modern cameras have six major controls:

1. A *viewfinder*.
2. A *focusing knob* or *ring*.
3. An *aperture*, also known as the *f/ stop*.
4. A *shutter*.
5. An *exposure meter* or *system*.
6. A *film advancing mechanism*.

Exceptions are view cameras (discussed in Chapter 17), and simple snapshot cameras, which may not have a focusing or metering device.

### The Viewfinder

The viewfinder shows you what the picture will include, as we noted when describing each major type

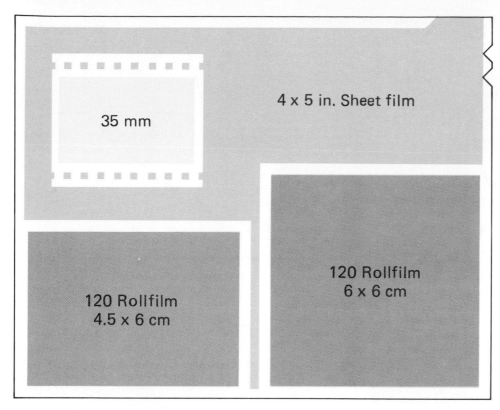

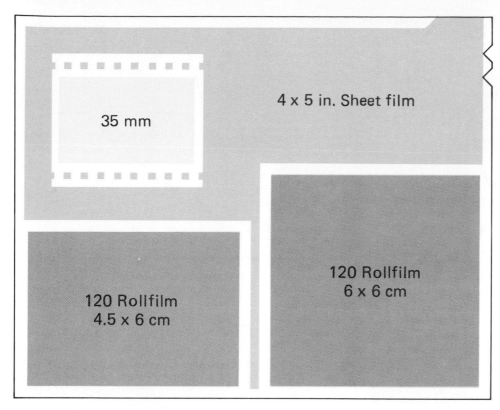

35 mm

4 x 5 in. Sheet film

120 Rollfilm
4.5 x 6 cm

120 Rollfilm
6 x 6 cm

**2-19** *Three popular film formats: 35mm, 120 rollfilm—both 4.5 × 6 cm and 6 × 6 cm (2¼ × 2¼ in.), and 4 × 5 in. sheet film.*

in the previous section. Although that is its primary function, the viewfinder usually must be used with the focusing controls described below, and it often contains a display of exposure information too.

### The Focusing Knob or Ring

This is a ring or grip area surrounding the lens mount on most 35mm cameras (Fig. 2-20). You rotate this ring as you look through the viewfinder to adjust the focus of the lens and make desired areas of the picture clear and sharp. On some cameras, particularly twin-lens reflexes, a knob must be used instead (Fig. 2-21).

Each focusing device is accompanied by a *focusing scale*, which shows the distance in feet and meters

**2-20** *Focusing ring and scale on a typical 35mm camera lens.*

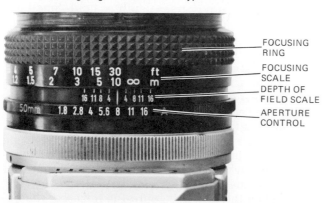

FOCUSING RING
FOCUSING SCALE
DEPTH OF FIELD SCALE
APERTURE CONTROL

on which the lens is focused. A *depth of field scale* often accompanies the focusing scale, and it can be used together with the aperture control (see below) to insure the general area of sharpness desired.

### The Aperture

The *aperture* (also known as the *f/stop*) is an opening in the lens formed by overlapping metal leaves that pivot to make the opening larger or smaller (Fig. 2-22). Thus they are a remarkable imitation of the iris diaphragm in the human eye. The camera aperture has the same purpose: by opening—becoming

**2-21** *Focusing knob on a TLR camera.*

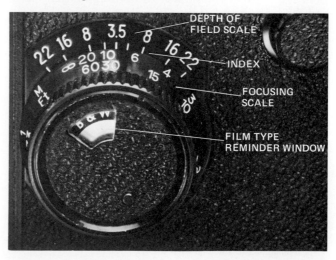

DEPTH OF FIELD SCALE
INDEX
FOCUSING SCALE
FILM TYPE REMINDER WINDOW

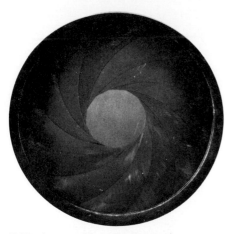

**2-22** *Lens aperture (partly open).*

larger—it admits more light to the camera. By closing—becoming smaller—it admits less.

In early cameras, apertures were made by inserting small metal plates called *stops* into the lens barrel. Each plate had a hole of a different size in it; changing plates thus changed the amount of light passing through. Waterhouse stops, as these plates were known (after their inventor), are no longer used, but lens apertures are still called "stops," and when photographers make an aperture smaller, they call this action "stopping down."

Aperture settings on modern lenses are designated by a series of *f/ numbers* that express *the diameter of the lens opening as a fraction of its focal length.* The f/ numbers usually found on modern lenses are: f/1.4, 2, 2.8, 4, 5.6, 8, 11, 16, 22, 32, and 45. Not all f/ numbers appear on all lenses; most contain only part of the sequence. The largest opening (f/1.4 in the series above) admits the most light; each successive number in the series designates an opening *half as large* (in area), *admitting half as much light.*

Note that *larger numbers designate smaller openings.* As you move the aperture control to each larger *number,* you cut the light passing through the lens *in half.* As you move the control to each smaller number in the series, you *double* the amount of light passing through (Fig. 2-23).

You may also set the aperture in between two numbered stops for an intermediate effect, but the important principle here is this: *Each f/ number in the series admits half or double the light of each one next to it,* and all aperture settings are similarly related.

The maximum aperture (smallest f/ number) of a lens depends on its design and is used to designate the "speed" of a lens; this and its focal length are usually marked on the lens mount. Thus a lens designated 1:2 f = 80mm is described as an 80 millimeter, f/2 lens. Occasionally the maximum aperture falls in between the familiar f/ numbers; the largest aperture on some lenses may be f/3.5, 4.5, or 6.3.

---

* Focal length is explained on page 46.

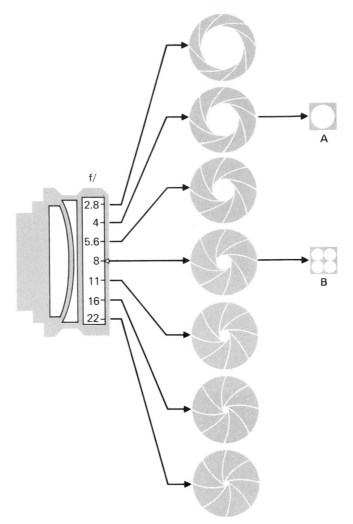

**2-23** *Relation between f/ numbers and aperture openings. Note that an f/4 setting **(A)** admits four times as much light to the camera as an f/8 setting **(B).***

### The Aperture and Sharpness: Depth of Field

Although the primary function of the aperture is to control light, it also is used to extend or limit the area of sharp focus in the picture. The range of object distances from which a sharply focused picture is formed is known as the *depth of field.* In Figure 2-24, all of the objects, from near to far, are in sharp focus because the lens was set at a small aperture, f/16. This picture has great depth of field. Small apertures tend to bring a deeper area into focus simultaneously. In Figure 2-25, however, the sharp area is noticeably reduced because a large aperture, f/2.8, was used. Large apertures tend to limit the depth of field, isolating some objects clearly while at the same time showing others out of focus.

You can see this effect in the viewfinder of most SLR cameras by using a *preview button* or *lever* located near the lens. Pressing this control permits the aperture to momentarily close down to a smaller preset opening where it will show you a dimmed but sharpened image with greater depth of field (Fig. 2-26). When the preview control is released, the ap-

erture returns to its normal, wide-open position where the depth of field is more limited but where the image is much brighter for easier framing and focusing (Fig. 2-27).

In viewfinder and twin-lens reflex cameras, the depth of field cannot be seen directly on the ground glass since their viewing lenses do not have adjustable apertures. On these cameras, depth of field must be judged on a *depth of field scale* next to the focusing knob or ring (see Figs. 2-20 and 2-21).

### Hyperfocal Focusing

Whenever *maximum* depth of field is desired, it can easily be obtained by *hyperfocal focusing*. When a lens is focused on infinity (a great distance desig-

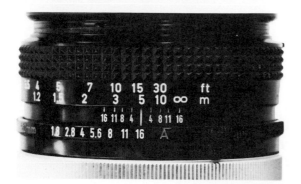

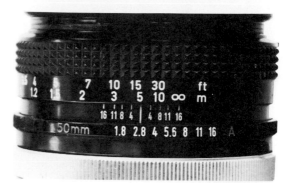

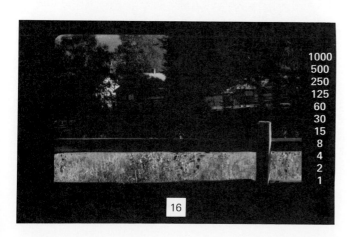

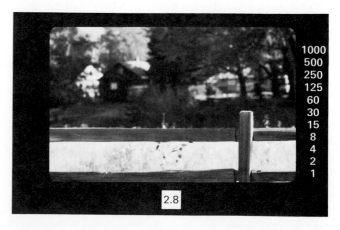

**2-28** *View focused on infinity (∞).*

**2-29** *View focused on the hyperfocal distance.*

nated by the symbol ∞ on the focusing scale), distant objects will be sharp but nearby ones will not (Fig. 2-28). The nearest plane that is included in the sharply focused area is known as the *hyperfocal* plane, and the distance from the camera to that plane is the *hyperfocal distance*. As we noted earlier, the depth of field increases as the lens is stopped down. The hyperfocal plane therefore moves closer to the camera as smaller apertures are used.

In Figure 2-29 the lens has been focused *on the hyperfocal distance*. Now nearby objects as well as those in the background are sharp. The depth of field now extends from half the hyperfocal distance all the way to infinity. Because smaller apertures provide more depth of field, *using the smallest aperture practical and focusing on the hyperfocal distance will produce the greatest depth of field in our view.* The technique is summarized in the box on the next page. For other photographs made with this technique, see Figures 13-3, 14-5, and 20-2.

### The Shutter

The shutter is a device that you adjust to determine the length of time that light will reach the film, and open and close to make the exposure. Early cameras did not have shutters. The photographer simply uncapped the lens and recapped it minutes or seconds later when he or she thought sufficient light had reached the plate. But as plates and films became more sensitive, the time required for exposure rapidly decreased. The hand-held lens cap wasn't quick enough, so a mechanical device—the shutter—replaced it.

Most shutters are located either within the camera's lens or in the camera's body just in front of the film.

*Leaf shutters* (Fig. 2-30) consist of a set of pivoting metal blades or leaves, arranged *inside the lens* like

the petals of a flower so that they overlap and prevent light from entering the camera. A large spring provides the power; it is set by the film-advancing mechanism or by a cocking lever. Pressing the release button then opens the shutter to start exposing the film. After a preset length of time (typically from 1 second to 1/500 second), the leaves quickly close, ending the exposure. Leaf shutters are relatively quiet and can be synchronized with flash units at any time setting (see Chapter 18). In larger cameras they tend to have fewer time settings than in smaller ones.

*Focal-plane shutters* (Fig. 2-31) consist of two opaque, flexible or segmented curtains *in the rear of the camera body* that overlap to keep light from reaching the film. These curtains are connected in such a

**2-30** *Leaf shutter (partly open).*

way that when you push the release, the first curtain moves aside and uncovers the film, permitting light to reach it. After a preset time elapses, the second curtain follows the first, covering the film again to end the exposure.

At 1/30 second or longer, all of the picture is exposed at once. At shorter times, however, the second curtain follows the first one more closely, and this creates a narrow slit between them that exposes only part of the film at any given moment as it crosses in front of it. The sequence is illustrated in Figure 2-32.

A focal-plane shutter typically has more time settings (1/1000 to 1 or more seconds) than a leaf shutter does. Its location just in front of the film does away with the need for separate shutters in each interchangeable lens. Most SLR cameras therefore have this type. Focal-plane shutters, however, have a limitation when used with flash. Because only part of the film might be exposed at a given instant, electronic flash can be synchronized with these shutters only at longer time settings which expose the entire picture frame simultaneously. But focal-plane shutters have fewer moving parts than leaf shutters and are therefore generally more reliable. Most move as described above, from side to side, but a few move from top to bottom of the frame, and newer cameras may have electronically operated shutters with time settings as brief as 1/8000 second.

***The Shutter Dial.*** The shutter dial controls the length of time the shutter stays open and thereby determines *how long* light will reach the film. The settings on the dial represent *fractions of one second*, but to save space they are written as whole numbers (Fig. 2-33). Thus 500 is 1/500 second, 250 is 1/250 second, 4 is ¼ second, 2 is ½ second; all other times of 1 second or less are similar. Numbers for times longer than one second are usually marked in a different color for clarity.

A typical shutter dial has these settings: 1, 2, 4, 8, 15, 30, 60, 125, 250, 500, 1000. *Each setting therefore provides half or double the exposure time of the setting next to it.* Stated another way, if you move the dial from 125 to 250 you cut the time in half. On the other hand, if you change the setting from 125 to 60, you double the exposure, and changing from 60 to 15 increases the exposure four times.

On cameras with mechanical shutters, the dial should always be set squarely on the desired time and it will usually be notched slightly to make this easy. Setting it between two numbers will not give an intermediate time.

The shutter dial may also include B and T settings. When set at B, the shutter will remain open as long as the release button is held down.* Thus the B setting is useful for exposures lasting longer than one second. The T setting (*time*) is similar, but it requires two actions of the shutter release—one to open the shutter and another to close it.

**2-31** *Focal-plane shutter.*

* The B stands for *bulb* and is a throwback to the days when nearly all camera shutters were operated by squeezing a rubber bulb at the end of a long air tube. The name survives to designate a similar action on modern cameras.

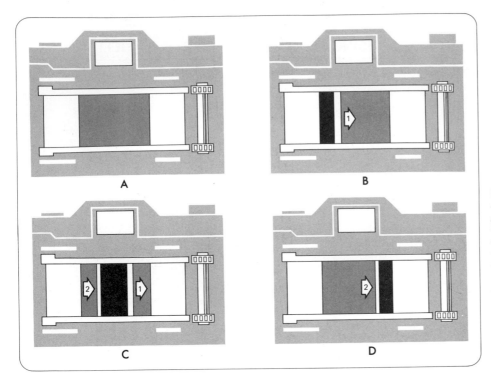

**2-32** *How a focal-plane shutter works. A pair of flexible, opaque curtains is positioned inside the camera just in front of the film. One of these curtains normally covers the entire film opening (**A**). Exposure begins when the first curtain opens, uncovering part of the film (**B**). As the first curtain exposes more of the film area, the second curtain is released to begin covering the opening (**C**). Exposure time is adjusted by changing the gap between the two curtains. Exposure ends when all of the film area is recovered by the second curtain (**D**).*

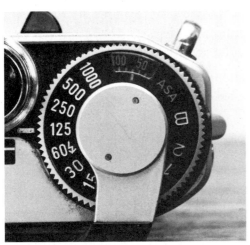

**2-33** *Shutter dial.*

Some 35mm SLR cameras have *electronic shutters* in place of manually set ones. When you press the release button of such a shutter, the blades open, allowing light to reach an internal sensing device exactly long enough for proper exposure. Then the blades automatically close. Because they can measure a great range of times and are not limited to the usual mechanical settings, electronic shutters control time more precisely than manually set ones can.

### The Shutter and Movement

Whenever an object moves in front of your camera, its image formed on the film inside will also move. The shutter can be used to control the way this motion is photographed, letting you choose between "freez-

ing" the action, showing it as a blur, or showing it clearly against a blurred surrounding. The photographs in Figure 2-34 show these choices.

If you use a short shutter time (fast shutter speed) such as 1/1000 or 1/500, the movement will be stopped or "frozen" (A). At longer shutter times (slower shutter speeds) such as 1/60, some blurring occurs but the moving object is still identifiable (B). At very long shutter times (very slow speeds) such as 1/8, the object is blurred beyond recognition when the camera is held still (C). But when the camera is moved, or *panned*, to follow the moving object, long shutter times produce a relatively clear object against a blurred background (D). Such pictures capture the *feel* of motion without losing the object's identity. The technique is often used in sports photography to capture both the feeling and the fact of an event (see Fig. 1-7, p. 7).

The shutter time, however, is not the only factor that will affect how motion photographs. The *distance* of the moving object from the camera will also have a bearing on the result. The farther away the moving object is, the more clearly it will photograph at any shutter time. Hence automobiles moving at a distance appear sharper than those moving at the same speed closer to the camera (Fig. 2-35).

Moreover, the *angle* at which an object moves (in relation to the camera) also affects how motion is photographed. When the object moves parallel to the film plane (*side to side*), its movement will blur on the film unless very short shutter times (such as 1/500) are used (Fig. 2-36A). If the movement is *directly toward* the camera, however, the image moves little on the film and a clearer photograph results (C). *Diagonal movement* (B) produces an intermediate effect.

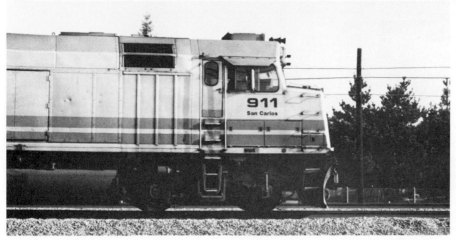

A

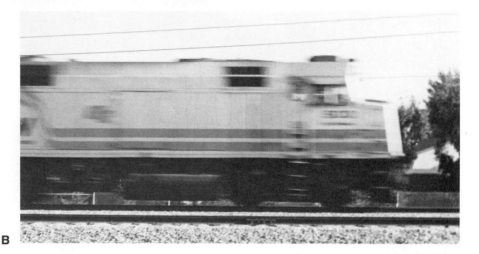

**2-34** *Objects photographed in motion.* **A:** *1/1000 sec.* **B:** *1/60 sec.* **C:** *1/8 sec.* **D:** *Camera panned at 1/30 sec.*

B

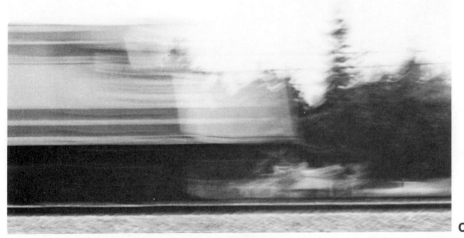

C

D

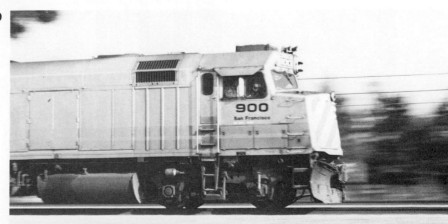

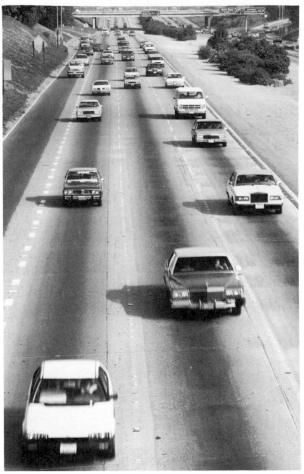

**2-35** *Movement at a distance and close to the camera. The photograph was taken at 1/60 sec.*

**2-36** *Movement side-to-side* **(A)**, *diagonally in front of the camera* **(B)**, *and directly toward the camera* **(C)**. *All photographs were made at 1/60 sec.*

**A**

**B**

**C**

## How the Shutter and Aperture Work Together

The shutter setting and the aperture work together to control the amount of light reaching the film. Consider for a moment how you fill a glass with water from a faucet: If you open the faucet fully, the glass fills quickly. Close the faucet so that the water only trickles out, and the glass takes longer to fill. The shutter and aperture work together in the same way.

Typically, a large amount of light (large aperture) needs only a short exposure time (shutter setting). Lesser amounts of light (smaller apertures) require longer exposure times to produce the same effect. Thus, f/4 at 1/500 sec., f/5.6 at 1/250 sec., f/8 at 1/125 sec., and f/11 at 1/60 sec. all deliver the same amount of light to the film, and are *equivalent exposures*. In these examples, as the aperture *decreases in size*, the shutter setting *increases in time* by the same factor. Shutter and aperture settings, then, are your basic exposure controls. In the next section we will see how modern cameras help you determine correct shutter and aperture settings.

## Exposure Meters in Cameras

Every photographic exposure involves four variable elements:

1. The **intensity** of light falling on the subject, or the **luminance** of that subject's reflection to the camera.*
2. The **sensitivity of the film** to this light.
3. The **length of time** that you expose the film. This is controlled by the camera's **shutter.**
4. The **amount of light** you admit. This is controlled by the aperture.

Most cameras have *exposure meters* built into them to help you select (or in some cases, select for you) the correct shutter and aperture settings to expose your picture. In a typical meter, a small light-sensing device (usually a gallium or silicon photodiode) controls the flow of current in an electronic circuit; a battery (typically a dime-sized mercury cell) in the camera provides the power to operate the system.†

---

* **Intensity** is a measure of light coming from a source (such as the sun) and *falling on* an object. **Brightness** describes a similar quality of light *reflected by* an object and *perceived by the eye*; it is thus subjective. **Luminance** describes this same aspect of light reflected by an object to the camera. Exposure meters measure luminance.

† Some older hand-held meters (such as the Weston Master Series) have selenium cells that generate their own electricity when light falls on them. They have no batteries.

*Meters built into cameras measure reflected light*—luminance reflected by the subject to the camera—and are directly connected to the shutter and aperture controls. Through-the-lens (TTL) meters, which are found in most modern cameras, do the best job. They measure the light that actually forms the picture and exposes the film, and if you change lenses or add a filter to the camera, they take that into account. In some older viewfinder and TLR cameras, however, the meter's sensor is located elsewhere in the camera body with its own window; there it can measure light reflected to the camera but cannot accomodate the lens or filter changes mentioned above.

Most meters measure light from the entire area shown in the viewfinder but with greater sensitivity or emphasis in the lower center of the frame (Fig. 2-37A). This is known as a *center-weighted* system, and is so designed because the more important elements of photographs are usually located in that part of the picture. Other meters are designed to measure only a small spot in the center of the viewing field, ignoring everything else beyond it (B). This *spot meter* design can provide more accurate information, but only if the photographer takes the time to make multiple readings before repositioning the camera to frame the view desired (some newer cameras automatically take an array of spot readings across the viewing field). Your camera's instruction manual should indicate which reading pattern it uses.

***Automatic Metering Modes.*** Cameras now offer several ways of indicating or automatically selecting the best shutter and aperture settings. Each of these modes is explained below. Figure 2-38 shows typical displays of their exposure information in the viewfinder. Many cameras offer two modes of operation, but the best SLRs allow you to choose between several of them.

The *shutter-priority mode* requires *you* to select a shutter time; the camera then indicates the best aperture for correct exposure and sets it automatically. This semi-automatic exposure mode is useful when you want to photograph action, such as sports events, or when you wish to deliberately blur the motion in your picture (see Figures 1-7 and 14-8). You retain control of the shutter time to get the desired effect, and the meter sets the aperture (f/ stop) correctly.

The *aperture-priority mode*, on the other hand, requires you to choose the aperture first; the camera then selects and sets the proper shutter time for correct exposure. This mode is useful when you want

**2-37** *Sensing areas of typical meters in cameras.* **A:** *Center-weighted meter reads entire area but is more sensitive to the lower central zone.* **B:** *Spot meter reads only a small spot in the center of the picture.*

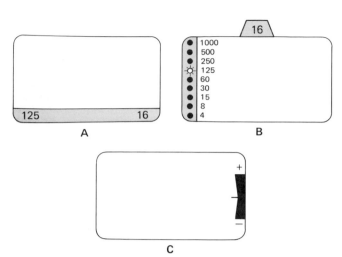

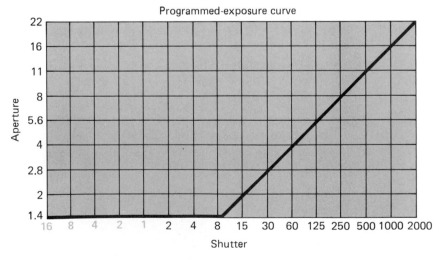

**2-38** *Typical viewfinder displays of meters in cameras.* **A:** *shutter and aperture settings shown at bottom of window.* **B:** *Selected aperture shown at top; automatically determined shutter time illuminated by LEDs at left.* **C:** *Manual or match-needle; + and − indicate zones of over- and underexposure respectively.*

great depth of field in your picture, as in landscape views, or when you want the focus to be selective—when you don't want everything sharp (see Figures 1-8 and 14-4). In this mode *you* control the aperture (and thus the depth of field), while the camera selects and sets the shutter time. If the camera has an electronic shutter, the aperture-priority mode provides the most accurate and consistent exposures. Remember, however, that in shutter-priority or aperture-priority modes, *the "priority" refers to what you, the photographer, must choose.*

Many newer cameras offer a fully automatic *programmed mode* in which the camera selects *both* the shutter time and the aperture from a list of the most useful combinations stored in its memory. Some programs also take into account the focal length of the lens, providing shorter shutter times (higher shutter speeds) with longer or telephoto lenses which must be free from camera movement for sharp imaging. Figure 2-39 shows typical combinations available for a given amount of light and type of film.

In addition to one or more of the automatic modes described above, many cameras also provide a *manual mode* (on simpler cameras it may be the only one

available). This is sometimes called a *match-needle* mode, and it requires *you* to set *both* the shutter and the aperture by centering a needle between two limits, or by aligning one needle with a reference mark (hence the name). When the needle is centered, or when the two indicators align, correct exposure is set. Since both the shutter and aperture are set manually, neither has priority over the other.

***Overriding the Meter.*** Meters built into cameras average everything they read to a *medium gray tone.* They are unable to distinguish an object that is largely light in value or white from one that is mostly dark in value or black. Moreover, they cannot tell which objects in a view are more important and which are less so. All meters can do is to *average* all the luminance values they read, and thus they convert everything in the viewfinder, light or dark, to a *medium gray value.*

Although this is sufficiently accurate for most situations, occasionally you will encounter conditions where the meter's inflexibility will create a serious error.

When most of the scene in the viewfinder is much

**2-39** *Chart of programmed shutter and aperture settings for a typical 35mm camera.*

**A**

**B**

**2-40** *Overriding the meter for a lighter-than-average scene. Photographed with the meter in control **(A)**, and overridden **(B)**.*

lighter than average, as in Figure 2-40, the exposure must be *increased* to correctly record the scene. The *override control* (Fig. 2-41), found on many 35mm SLR cameras near the rewind crank, permits you to change the exposure to compensate without resetting the shutter or aperture controls each time such a situation is encountered. Moving the control to +1, for example, will give one stop additional exposure (doubling it).

Similarly, if most of the scene is darker than average, as in Figure 2-42, moving the override control to −1 will cut the exposure in half (one stop less), preserving the darker tones correctly on the film (instead of lightening them to medium gray).

Backlighted subjects (see Fig. 13–9), or scenes that have extremely light and dark values with few midrange ones, as in Figure 2-43, present special problems that can be improved by overriding the meter to favor either the light *or* dark areas. Increase the exposure (+1 or +2) to record more detail in the darker areas; decrease it (−1 or −2) to similarly favor the lighter ones. Some experience using this feature will make the proper compensation easier to judge.

***Equivalent Exposures.*** Within the range of exposures typically used for most pictures, the length of time and the amount of light are balanced against each other. For example, if you double the time used and cut the amount of light in half, the exposure of the film remains the same. Thus, 1/125 at f/16, 1/250 at f/11, and 1/500 at f/8 are all *equivalent exposures*. Moreover, programmed cameras are designed around this common reciprocal effect.

**2-41** *Override control on a typical camera.*

A

B

**2-42** *Overriding the meter for a darker-than-average scene. Photographed with the meter in control (A), and overridden (B).*

**2-43** *Overriding the meter for a contrasty scene. Photographed with the meter in control (A), and overriden (B).*

A

B

***Reciprocity Failure.*** There are some conditions, however, where these changes, if equally made, will not produce corresponding results. With most films, *exposure times longer than one second* will result in underexposures if the meter indication is used, and black-and-white negatives given such long exposures will show a slight increase in contrast unless the development time is adjusted. As the exposure time increases beyond one second, the disparity becomes greater; a meter-indicated exposure of 10 seconds, for example, may in actuality require five times that much exposure to produce the expected effect on the film.

Extremely short exposure times have a similar effect. Times shorter than 1/1000 second, unless compensated, also produce underexposures and a decrease in negative contrast. These conditions are often encountered when using modern thyristor flash units. In these units the flash is automatically terminated when sufficient light has entered the lens, and when such units are used at close range, flash duration times can be extremely short.

This tendency of films to respond in an unequal way to the changes described above, over the ranges of extremely long and extremely short exposures, is commonly known as *reciprocity failure*. The condition is inherent in the nature of film emulsions, and can be corrected by using the override control of the meter or by increasing the exposure manually.

The amount of correction varies with the exposure time and with the type of film. Table 2-1 shows typical corrections needed for black-and-white films. Color films exhibit similar tendencies, but such changes in exposure also produce changes in color balance, and these may require filtering for correction. Information on these corrections is packed with color films that are used mainly by professional photographers.

### Hand-held Meters

View cameras, some medium-format SLR cameras, and many older cameras of all types do not have exposure meters built into them. Separate, *hand-held meters* can be used with these cameras to obtain correct shutter and aperture information, which must then be set on the cameras manually.

**TABLE 2-1** RECIPROCITY CORRECTIONS FOR TYPICAL BLACK-AND-WHITE FILMS

| If the Indicated Exposure Time Is | Use This Exposure Time | and | Use This Development Adjustment |
|---|---|---|---|
| 1/1000 sec. | 1/1000 sec. | | 10% more |
| 1/100 sec. | 1/100 sec. | | None |
| 1/10 sec. | 1/10 sec. | | None |
| 1 sec. | 2 sec. | | 10% less |
| 10 sec. | 50 sec. | | 20% less |
| 50 sec. | 6½ min. | | 25% less |
| 100 sec. | 20 min. | | 30% less |

**2-44** *Gossen N-100 hand-hold exposure meter. Courtesy Bogen Photo Corp.*

Hand-held meters (Fig. 2-44) make it easy to take separate readings of important light and dark areas of a subject, a technique that can give you more accurate exposure data while allowing you to favor areas of your choice. A single hand-held meter, obviously, can be used with more than one camera, and if the meter needs repairs, it doesn't take the camera out of service with it. But hand-held meters have drawbacks too. These meters are fragile, easily damaged by rough handling, and they take additional space in the camera case or bag. Good ones, especially those with digital displays (that are less likely to be misread), are costly.

Most hand-held meters are *reflected light meters* that read an area similar to what a normal camera lens includes in its view. Within that area, the meter *averages* what it "sees" to a medium gray tone. These meters must therefore be held near the camera and pointed at the subject, as shown in Figure 2-45, for best results.

***Spot Meters.*** Some meters measure only a very small part (typically a 1° angle) of the scene before them, and these are called *spot meters*. A spot meter often has an eyepiece like a camera viewfinder (Fig. 2-46). The sensing area or spot is outlined in this viewing frame; you aim the meter at your subject and read the exposure data in the window or on the body of the instrument. Spot meters are useful to measure large objects from a distance (across a river, for example), or very small objects at close range. You can also use them when a small part of your picture is extremely important (you can take your reading from that part alone), or when important things in your picture are surrounded by contrasting light values (as in Fig. 2-43), which you can similarly exclude.

***Incident Light Meters.*** Although almost all hand-held meters measure reflected light, most can be con-

**2-45** *Reflected light meters are held at the camera and aimed toward the subject so they "see" more or less what the camera lens does. See text for cautions.*

**2-46** *Hand-held spot meters. Courtesy Sekonic RTS Inc., and Pentax Corporation.*

## HOW TO USE EXPOSURE METERS

### CAMERAS WITH AUTOMATIC AND PRIORITY EXPOSURE MODES

1 / Set the ISO (ASA) rating of your film on the camera. If **both** the camera and film cartridge are equipped with DX coding, this will occur automatically.

2 / Select and set the priority feature (shutter or aperture) you wish to use.

3 / Focus the lens and read the appropriate areas of your subject.

4 / Make the exposure when ready.

### CAMERAS WITH MANUAL EXPOSURE SYSTEMS

1 / Set the ISO (ASA) rating of your film on your camera.*

2 / Select the shutter time (or aperture) you prefer to use.

3 / Focus the lens and read the appropriate areas of your subject.

4 / Adjust the aperture (or shutter) until the correct exposure indication appears in the viewfinder.

5 / Make the exposure when ready.

### HAND-HELD REFLECTED LIGHT METERS

1 / Set the calculator dial for the ISO (ASA) rating of your film.†
If the meter has a small white dome or igloo, move it aside.

2 / Aim the light-sensing cell toward the subject and press the pointer release to get a reading on the luminance scale.

4 / The correct shutter and aperture settings will now be adjacent to each other on the dial. Set the camera's controls accordingly.

5 / Make the exposure when ready.

### HAND-HELD INCIDENT LIGHT METERS

1 / Set the calculator dial for the ISO (ASA) rating of your film.†

2 / Stand at the subject position and aim the meter's igloo toward the camera.

3 / Set the calculator index to this luminance reading.

4 / The correct shutter and aperture settings will now be adjacent to each other on the dial. Set the camera's controls accordingly.

5 / Make the exposure when ready.

---

* On Instamatic cameras, inserting the film cartridge automatically sets the ISO (ASA) rating.

† Before using a hand-held meter, check the zero setting. When no light strikes the cell, the meter **must** read zero. Adjust this if necessary (see the meter's instruction manual), and repeat this check periodically thereafter.

---

verted to read *incident light*—light falling on the subject—as well. Incident light meters are identified by a small white dome or "igloo" over the light sensor (Fig. 2-47). They are popular with motion-picture and TV photographers, and with still photographers who work in studios where the ratio of highlight-to-

**2-47** *Incident light meters. Courtesy Sekonic RTS, Inc., and Minolta Corporation.*

shadow brightnesses from multiple light sources can be controlled. Since incident light meters measure the intensity of light falling on a subject rather than its reflection to the camera, these meters must be held at the subject position and aimed toward the camera, as in Figure 2-48, exactly the opposite of how reflected meters are held.

Meters built into cameras cannot measure incident light, but usually this is not a problem. Most still photographers tend to work with light as they find it; reflected light meters are therefore more useful to them.

### Setting the Film Speed

Regardless of whether they are built into cameras or hand held, almost all meters require you to preset them for the speed (sensitivity) of the film you are using. Film speed is shown as a number on a scale adopted by the International Standards Organization (ISO). Therefore, *film speed is expressed as an ISO rating.* * Usually it is shown prominently on the film

---

* Until recently, film manufacturers used ratings based on a similar standard published by the American Standards Association (ASA). Until the change-over is complete, you will still find the ASA designation on many cameras. ASA and ISO numbers are the same.

In Europe, films were rated for many years on a German scale, Deutsche Industrie Normen (DIN). On this logarithmic scale, a 3° increase indicated a doubling of the film speed.

**2-48** *Incident light meters (note the "igloo") are held at the subject and aimed toward the light source. They measure light falling on the subject rather than the light it reflects to the camera.*

box or in the product's name. *The higher the ISO number, the more sensitive to light the film is.* Thus a film rated ISO 400 is four times more sensitive to light than one rated 100.

On most manually adjustable cameras the setting for film speed is still marked ASA (see note on p. 33), and is usually located near the shutter dial or rewind crank (Fig. 2-49). If your camera is designed for DX-coded film, as many newer cameras are, it will set itself automatically when you insert the coded film cartridge. Of course, if the camera does not contain a meter, there will be no ASA adjustment to set.

**2-49** *ISO (ASA) adjustment on a typical 35mm camera.*

## WHICH CAMERA FOR YOU?

There is no such thing as a universal camera, so the choice of one for your own use becomes a personal one. Which camera is best for you?

As we have explained in this chapter, each basic type of camera has advantages and drawbacks. The most popular cameras, of course, are the simplest to use: the snapshot cameras of the "load and shoot" variety that take film in quick-loading cartridges. Most of these cameras require few decisions from the user other than framing, snapping, and advancing the film. If you expect to take pictures casually and infrequently, such a camera may be all you need.

But as you become more interested in photography, you will probably find such simple cameras too limiting. Other types of cameras generally are much more adaptable to individual needs and interests. Three types—the 35mm SLR, the 6cm (120) SLR, and the 4 × 5 view camera—are widely used by serious photographers.

Deciding which type of camera is best for you involves thoughtful consideration of several questions. The first has to do with performance. *What do you expect the camera to do for you?* If color slides are your main concern, for example, a 35mm SLR would clearly be the best choice. If you expect to photograph landscapes and travel views more often than news or sports events, you should consider a 35mm SLR with an aperture-priority mode. If sports and people will be your most important subjects, a shutter-priority SLR would be a better choice. If precision, sharpness, and maximum image quality are more important to you, the medium format SLRs should be examined, and if thoughtful preplanning of each picture or complete control of the image appeal to you, and you don't mind carrying heavier equipment, a view camera might be your best choice.

If you expect to begin a career in photography, or are interested in doing several different kinds of photographic work most efficiently, the advantages of a *system camera* should be carefully considered. System cameras can be assembled from modular components designed to work together (Fig. 2-50). They have interchangeable lenses, many accessories to make routine work more efficient, and the basic camera can be expanded as the work demands. Some even have interchangeable film magazines.

In any case, a few important questions need to be answered by actual trial. *How does the camera feel* in your hands? *If you wear glasses,* can you see the entire viewfinder through them, and can you read the camera's controls without removing them? Once a basic camera is chosen, decide which features you need and which you can do without.

Then the final question: *How much money* can you afford to invest in your choice? The answer to this question may determine whether you should look for a new camera or a used one. Cameras and lenses depreciate in value much like cars, and a used camera

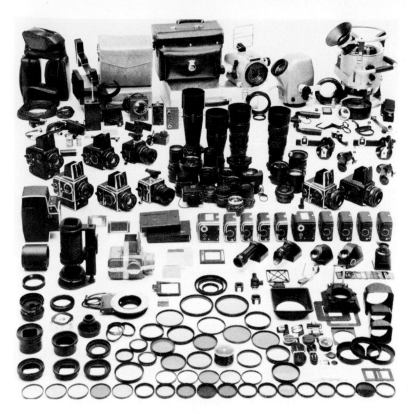

2-50 *Hasselblad camera system showing all of its components. Courtesy Victor Hasselblad, Inc.*

purchased from a friend or reputable dealer can often be an outstanding value for a beginning photographer. Check the camera thoroughly for damage and wear, and be sure you have the option to return the camera if it doesn't satisfy you.

## GETTING THE MOST OUT OF YOUR CAMERA

Taking proper care of your camera will do much to prolong its working life and help you get the best performance from it, and good camera care is mostly common sense. Cameras are delicate instruments and should be handled with care. They should not be stored in hot places such as glove compartments and window ledges of automobiles. Keep them in places that are clean, cool, dark, and dry.

### Cleaning Your Camera and Lens

Dirt or dust on the outside of your camera can easily be wiped away with a soft, dry cloth. Before loading your camera with film, however, check it for dust *inside* the chamber or bellows. Dust that settles on the film in your camera will produce tiny black specks in your prints or slides. You can remove this dust before loading with a little dry, compressed air (convenient, pressurized cans are available at photo shops) or with an inexpensive squeeze-blower brush (Fig. 2-51).

Clear pictures require a clean lens, and cleaning must be done with care to avoid scratching the sur-

faces. First, remove any dust by lightly whisking the lens with a sable brush or wad of lens-cleaning tissue. Fingerprints or grease on the lens should next be removed with a sheet of lens-cleaning tissue moistened with a drop or two of lens cleaning solution (inexpensive materials available at any photo shop). Wipe the lens with a gentle, circular motion, and let the fluid dissolve the grease as it slowly evaporates. Clean *only* the front and rear lens surfaces. Don't try to take the lens apart; that's a job for a trained technician with proper tools.

If you use your camera in very cold weather, remember that the camera, like eyeglasses, also "steams

2-51 *Camera cleaning supplies: blower-brush, lens-cleaning paper, lens-cleaning fluid.*

up" when taken from the cold into a warm room. *This condensation also forms inside the camera and on the film surface.* You must allow time for it to evaporate before you use the camera or advance the film again.

### Checking the Batteries

As we noted earlier, most cameras contain one or more batteries to power the electronic circuits of the camera's controls. These batteries should be checked from time to time to make sure they are clean and at full strength.

Locate the battery compartment in your camera (usually it's in the bottom, or check the camera's instruction manual), and notice how the batteries are positioned. Then carefully remove and inspect them. If you notice a white, powdery substance on the batteries, discard them. Be sure the contacts inside the compartment are shiny and clean. If they are not, use a soft cloth to polish them. And try not to touch the battery terminals with your fingers; oils in your skin can interfere with good electrical contact.

Wipe the battery terminals with a clean, dry cloth, and carefully insert them, making sure the positive (+) end of each battery is next to the + mark in its compartment. Now replace the compartment cover. To test the batteries, consult your camera's instruction manual.

If you haven't used your camera for several months, always check your batteries (as explained above) before you proceed.

### Loading Your Camera with Film

Always load your camera with film in *subdued light*, never in direct sunlight. Correct movement of

**2-52** *Loading a 35mm camera.*

film in the camera requires proper loading, and care taken at this step will avoid damaging problems or lost pictures later.

All 35mm cameras use film in cartridges that load quickly and easily, but require careful threading of the film tongue into a takeup spool (Fig. 2-52). After the roll of film is exposed, it must be *rewound into the original cartridge* before the camera can be opened and the cartridge removed.

Rollfilm cameras require a different procedure. An empty film spool must first be moved from the loading to the takeup position. Then the new roll of film is inserted and the film's backing paper threaded up the back and into the takeup spool (Fig. 2-53A). Most rollfilm cameras provide automatic spacing of the pictures on the roll, and to insure this you must *align an arrow* on the backing paper with a *starting mark* in the camera (Fig. 2-53B) before you close the back.

**2-53** *Loading a rollfilm camera. Film positioned inside the back (A), and bottom view showing arrow at the start mark (B).*

A

B
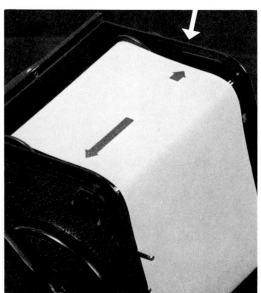

## HOW TO LOAD A 35MM CAMERA

1 / Place your camera, lens down, on a clean, firm surface, and locate the rear cover lock. On most 35mm cameras it is built into the rewind knob; pulling this knob **straight up** should spring the back open.*

2 / Insert the film cartridge on the left side of the chamber, pulling the tongue of the film across the camera back and over the sprocket wheel toward the takeup spool (see Fig. 2-52). Insert the tongue into a slot of the takeup spool.

3 / Now advance the film by alternately stroking the film advance lever and pressing the shutter release button. Repeat this procedure until both the upper and lower perforations of the film engage the sprocket wheel. **Be sure that the film actually advances as you stroke the lever.** Sometimes the tongue will slip out of the takeup spool as soon as it rotates, and if this happens, you will get no pictures.

4 / Next close the camera back and continue advancing the film until the exposure counter reads **1.** As you advance the film, **watch the rewind knob; it should turn with each stroke,** indicating that the film is advancing inside. If it does not turn, open the camera back and rethread the tongue into the takeup spool.

5 / If your camera has a flat frame about 1½ inches square on its back panel outside, tear off the end of the film carton and insert it in this frame as a reminder of the kind of film you have just loaded.

6 / Finally, check the ISO (ASA) setting of the meter and adjust it if necessary. Now you are ready to photograph.

\* Some cameras must be opened by pulling a small lever at one end of the back or by turning a wheel on the bottom.

## HOW TO LOAD A ROLLFILM CAMERA

1 / Locate the rear cover lock on your camera and open the back. In the bottom of the camera there should be an empty film spool. Above it, on the other side of the open chamber behind the lens, is the space for the takeup spool.

2 / Pull the pin holding the empty spool, remove it, and insert the spool in the takeup position (see Fig. 2-53A). Turn the crank or the film-advancing lever (or knob) a stroke or two to make sure the spool turns freely.

3 / Insert the roll of film in the lower chamber from which you earlier removed the empty spool. The printed paper should face **outwards** as you break the seal and unroll it. If it doesn't, turn the roll end-for-end before proceeding.

4 / Find the **film start mark** in the bottom or back of the camera.

5 / Unfold the paper tongue, revealing the squared-off end, and insert this end in the slot in the center of the film spool. Now turn the film-advancing crank, knob, or lever to start the paper winding onto the takeup spool. Continue until the large **arrow** points directly to the film start mark inside the camera (see Fig. 2-53B).

6 / Close the back of the camera, making sure the back is securely locked so that it cannot spring open.

7 / Now advance the film until the mechanism **locks** and the number **1** shows in the exposure counter.

8 / Finally, **check the ISO (ASA) setting** of the meter and adjust it if necessary. You are now ready to photograph.

---

After the roll is exposed, you simply continue winding the backing paper onto the takeup spool; no rewinding is involved.

Snapshot cameras are the easiest to load; you simply insert the cartridge or disc and close the camera back. View cameras, on the other hand, require a more elaborate loading procedure using film holders, and this is discussed in Chapter 17.

Detailed procedures for loading 35mm and rollfilm cameras are given in the boxes above.

### Holding Your Camera Still

As we saw earlier, different shutter settings govern how the camera records subject movement and how you can interpret this movement in your pictures. Shutter settings can also minimize or amplify any undesired movement of the camera during exposure. At 1/1000 or 1/500 sec., for example, a slight shaking or movement of the camera will probably go unno-

ticed. But if your shutter is set for longer exposure times such as 1/60 or 1/30 sec., any movement of your camera will show as blurring in your picture.

Careful camera holding will minimize most of these problems. The illustrations in Figure 2-54 suggest several ways that you can use your body to help steady your camera. And bracing your body against any convenient tree, doorway, fence, or railing will also help.

The best way to prevent unwanted movement of your camera is to secure it on a steady *tripod* (Fig. 2-55). A tripod limits your camera's mobility, but this small sacrifice usually is worth the dividend it pays in sharper, clearer pictures. Most tripods have an adjustable center column that will permit you to raise or lower the camera, and a pan head that will allow you to pivot the camera from side to side or up and down. The center post can often be removed and replaced upside down, so that you can secure the camera close to the ground. Whichever way you use

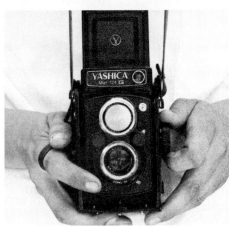

**2-54** *Using your body to steady your camera.*

**2-55** *Camera on tripod.*

the center column, try not to extend it too far from its junction with the tripod legs. The entire rig will be more steady that way.

A *cable release* is inexpensive and useful to absorb the small shock or bump that can occur when you release the shutter. Most cable releases screw into the shutter release button itself, but a few older cameras require an adapter that covers the button instead.

### Other Ways to Use Light Meters

The easiest way to use a reflected light meter, such as those built into cameras, is to take a single reading from the chosen point of view, that is, from where you will take the picture. The meter then *averages* all the reflected luminances within its field of view to a medium gray value, and if the camera has a programmed or automatic exposure system, it sets the appropriate controls. This works fine for subjects that are average themselves, that is, subjects that are not dominated by extremely light or dark values.

If your camera has a *manual exposure mode* or if you are using a *hand-held exposure meter*, other methods are practical and useful. Moving closer to your subject to measure only the important areas will help; the camera can then be moved back to frame

the desired picture after the shutter and aperture are set. If you are photographing a landscape, momentarily tip the camera down slightly so that the meter favors the land rather than the brighter sky, and then set the controls accordingly.

**The Luminance Range Method.** Although a single, overall reading usually works well, a pair of close-up readings measuring the lightest and darkest important objects or areas—the *luminance range*—works even better. First read the darkest important object in the scene that you wish to photograph with texture or detail. Then similarly read the lightest important, detailed object.

If you are making negatives, select an exposure halfway between the two readings, or favor the darker object a bit to be sure you expose it adequately. Detail in the brighter areas (highlights) can be strengthened in printing, but shadows without detail will always print as empty voids.

For color slides, use the median exposure as suggested above, or slightly favor the lighter object to avoid washing out its color. Any *manual* reflected light meter can be used in this manner, but a *spot meter* is ideal for it. Meters built into cameras may require a bit of patience to take and integrate the readings involved.

**Substitute Readings.** If your subject is not easily accessible for close readings, more convenient objects with similar reflecting characteristics may be substituted. Nearby trees, for example, can be metered in place of more distant ones. A white handkerchief will substitute for anything you expect to appear white in your print. A black dress similarly can be substituted for deep shadow areas. Be sure you place the substituted item in the same light and at the same angle as the original one.

**Gray Card Readings.** Some photographers prefer to use an *18% gray card* as a substitute for average subjects. This card, supplied by Kodak and others, and included in some Kodak Dataguides, has a convenient, photometric "middle gray" tone on one side and a 90% white surface on the other. It is called an 18% gray card because although it appears medium gray in brightness (halfway between white and black), it actually reflects only 18 percent of the light striking it, absorbing the rest. Its white side similarly reflects 90% of the incident light.

The gray card must be held parallel to the subject or surface being photographed, and must receive the same illumination as the subject (Fig. 2-56). Outdoors, avoid tilting the card back where it might pick up too much blue light from the sky overhead.

**Skin-tone Readings.** If you use a hand-held meter, readings may also be taken from the palm of your other hand. Typical Caucasian skin reflects about twice the light of an 18% gray card, so if you take a close-up reading from such skin, expose one f/ stop larger than the meter indicates. Some older meters,

**2-56** *To meter an 18% gray card, hold the meter close enough so it "sees" only the gray card, but be careful it does not cast a shadow onto the card. Hold the card parallel to the surface being photographed.*

such as the Weston Master series, make this correction automatically if the "C" position on their dials is used instead of the normal red index mark (Fig. 2-57). For meters in cameras, set the override control at +1.

## Bracketing Exposures

Another useful technique to determine correct exposure in uncertain or unusual situations is called *bracketing*. This requires three or more exposures of

**2-57** *Skin tone is metered much like a gray card. The meter must not cast a shadow onto the skin. To meter Caucasian skin, use one f/ stop larger than the meter indicates. See text.*

## TABLE 2-2 GUIDE FOR EXPOSURES IN DAYLIGHT WITHOUT A METER

*Set the shutter time equal to 1/ISO rating (example: for ISO (ASA) 125 film, set the shutter at $\frac{1}{125}$ second). Then use the following apertures for the light conditions described:*

| | |
|---|---|
| **Bright or somewhat hazy sun: strong shadows** | **f/16** |
| **Hazy sunshine: weak, poorly defined shadows** | **f/11** |
| **Overcast but bright: no shadows visible** | **f/8** |
| **Overcast but dark: high fog, light rain, gray sky** | **f/5.6** |
| **Heavy overcast: thick fog, heavy rain, dark sky** | **f/4** |
| **Open shade on sunny day (subject entirely in shade under open sky)** | **f/5.6** |

*Use this guide for average subjects from about an hour after sunrise until about an hour before sunset. Adjust the exposure for subjects that are darker or lighter than average, for backlighted subjects (where light comes directly toward the camera from behind the subject), and for extreme North and South latitudes. For example:*

**For average subjects in light sand or snow, use one f/ stop smaller.**

**For light-colored subjects, use one f/ stop smaller.**

**For darker-than-average subjects, use one f/ stop larger.**

**For backlighted subjects, use two f/ stops larger.**

**For extreme North and South latitudes, use one f/ stop larger.**

the subject on separate frames of film. Give the first frame the exposure indicated by the camera or meter, and other frames half and double the first (in manual mode, adjust the aperture *or* shutter *but not both*; in automatic modes, use the override control). Additional frames can be exposed for one-fourth and four times the exposure of the first frame, if desired. For example, if an exposure of 1/125 sec. at f/8 is indicated, expose one frame for those settings, a second frame for 1/125 sec. at f/11, and a third frame for 1/125 sec. at f/5.6. Alternatively, you may keep the aperture constant and vary the shutter setting instead.

Choose the resulting negative or slide that has the best range of tones or colors. Avoid using negatives that have clear, empty shadows (caused by too little exposure) or dense, gray highlights (caused by too much). Similarly, discard color slides that have deep black shadows (too little exposure) or weak, washed out highlights (too much).

### Exposures Without a Meter

Although a properly working luminance meter is your best guide to correct exposure, *daylight exposures for typical subjects outdoors* can be determined from Table 2-2 if a meter is malfunctioning or is unavailable. Daylight varies in intensity according to a number of factors, but many of these factors are common enough to be easily quantified. On a typical sunny day, for example, the intensity of daylight will not vary much from place to place, nor will it change much from one such day to the next. Thus it is possible to estimate this intensity with sufficient accuracy to be useful, yet casually enough to be simple.

Table 2-2 relates the four variables of exposure over a range of daylight conditions that is fairly predictable. Once you choose a shutter setting and f/ stop from the table, *any equivalent combination may be*

*substituted.* For example, average subjects in bright sunlight can be photographed on Plus-X Pan film with an exposure of 1/125 sec. at f/16. But 1/500 sec. at f/8 and 1/60 sec. at f/22 are equivalent; these combinations may also be used. Within the limits indicated, this daylight table will give you good advice for average situations, and it is simple enough that its main features can be memorized.

### Unloading Your Camera

Unloading a 35mm camera is easier than loading it. On the bottom of the camera, locate a small button (Fig. 2-58) and press it to disengage the sprocket wheel inside from the advancing mechanism. Next, slowly turn the rewind crank or knob until the film pulls loose from the takeup spool (you can feel it do this). Then give the rewind crank a couple of additional turns to wind the film entirely into the cartridge (by doing this you won't mistakenly reload the exposed roll, thinking it is new film). Now open the camera back and remove the cartridge. Keep it in its original

**2-58** *Reversing button on a typical 35mm camera. It must be pressed to rewind the film into the cartridge. On some older cameras, you must move a small lever to the **R** (rewind) position instead.*

plastic container (if you saved it) until you can get it processed.

To unload rollfilm cameras you simply wind the remaining backing paper onto the roll (typically about six more turns of the winding crank or knob). Then open the camera back, remove the exposed roll (notice its paper now says "EXPOSED"), and seal it with the gummed sticker provided. No rewinding is necessary.

Simple, cartridge-loading cameras that use size 110 or 126 films are the easiest of all. You simply stroke the film advance lever a couple of times, open the back of the camera, and pop the cartridge out.

## SUMMARY

1. Every camera has these essential parts: a *lens*, a *viewfinder*, a *focusing mechanism*, a *shutter*, an *aperture*, a *film-advancing mechanism*, and a *lightproof box* that contains everything else. A *film* must be inserted into the camera to use it.

2. There are *four basic types of cameras*: viewfinder, single-lens reflex (SLR), twin-lens reflex (TLR), and view cameras.

3. Most *viewfinder* cameras are simple snapshot cameras used for casual photography. Better ones include a *rangefinder* to help you focus the lens, but all suffer from *parallax error* which affects framing at close range.

4. *Single-lens reflex cameras* have a pivoting mirror inside so that the lens can be used for both viewing and recording. They are free from parallax error, quick focusing, and very popular. Most SLR cameras have *interchangeable lenses*. The latest designs are easy to hold, have automatic focusing, and a few are adaptable to still video work as well as photography.

5. *Twin-lens reflex (TLR) cameras* have separate lenses for viewing and taking. They make larger images than 35mm cameras do, but cause parallax error at close range.

6. *View cameras* are larger and heavier than most other types and are designed to be used on a tripod. They use film in flat sheets, and have many movable parts that make them precise and adaptable instruments.

7. *Instant-picture cameras* (usually viewfinder or SLR type) begin processing their films as soon as these leave the camera.

8. Three film formats, 35mm, 120 rollfilm (medium format), and 4 × 5 in. sheet film (large format), are widely used.

9. Cameras have several major controls: a *viewfinder* to frame the subject, a *focusing knob* to adjust the lens and make the image sharp, an *aperture* (f/ stop) to control the amount of light reaching the film, a *shutter* to time the exposure, and an *exposure meter or system* to indicate or automatically adjust shutter and aperture settings.

10. The *aperture*, or *f/ stop*, is designated by a number that indicates the diameter of its opening as a fraction of the lens focal length. Each number in the series designates an opening that allows *half* or *double* the amount of light

to pass through the lens. The aperture also controls *depth of field*, or near-to-far sharpness. Smaller apertures (f/16, f/22) give more depth of field, larger ones (f/2, f/2.8) give less. *Maximum depth of field* can quickly be obtained by using the smallest practical aperture and *hyperfocal focusing*.

11. *Leaf shutters* (located within the lens) or focal-plane shutters (located just ahead of the film) time the exposure of the film. Their controls are marked in *fractions of a second*, with each setting indicating half or double the adjacent ones. The shutter also controls how the camera photographs *movement*. Shorter times tend to stop or freeze action; longer ones allow the movement to blur. If the camera is *panned* to follow the action during a long exposure, the moving object will be relatively clear but the background will blur behind it.

12. The shutter and aperture work together to control exposure of the film; because either can be increased if the other is decreased by the same amount, *equivalent exposure combinations* are available.

13. *Exposure meters* measure the intensity or luminance of light, relate it to the sensitivity of the film, and then indicate or automatically set the shutter and aperture. *Shutter-priority mode* works well for photographing action because it gives you control of the shutter time; *aperture-priority mode* is better when sharpness or depth of field are more important. For routine or casual photography, a *programmed mode* is convenient since both shutter and aperture are set automatically. *Manual settings* are also available on better cameras if you want to control these factors yourself.

14. Before any meter is used, it must be set for the film sensitivity or speed. This is expressed as an ISO (ASA) number; the higher the number, the more sensitive to light the film is.

15. Meters *average* everything they measure to a *medium gray tone*, and if a subject is not average, the meter must be *overridden* for properly exposed pictures. Many cameras have an adjustment for this purpose.

16. Choosing the best kind of camera for you is a personal decision that should be made only after you have determined what you expect to do with it. For serious photography, or for a career in photographic work, a *system camera* with interchangeable lenses and other components should be considered.

17. Proper *camera care* will help you get the most use out of any camera you choose. Store the camera where it will be cool, dry, and dark. Clean it carefully before loading it with film, and always load the camera in subdued light. Check any batteries periodically. Cameras brought in from the cold "steam up," so give this moisture time to evaporate completely before using the camera again.

18. Daylight exposures without a meter are simple to figure out from memory, but a meter should be used in all other cases. If the situation is unusual or uncertain, *bracketing* exposures will usually solve the problem.

19. A tripod and cable release are useful to minimize or eliminate unwanted camera movement. Finally, be sure to follow correct loading and unloading procedures for your type of camera.

# 3

# LIGHT AND LENSES

Photography, as we noted earlier, depends on light. The word is derived from two Greek terms meaning "to write with light." For the first photographers, working with simple lenses and primitive plates, this took all day long in bright sunlight. But as plates (and later, films) were made more sensitive, and as more efficient lenses were designed, the time required to expose a photograph was reduced from hours and minutes to fractions of a second. Imogen Cunningham, whose photographic career spanned more than seventy years, experienced some of this improvement and appreciated the change. "Wherever there is light," she loved to say, "one can photograph." Technology has made photography easier, but *light* is still the energy that makes it possible.

## THE NATURE OF LIGHT

Like heat, sound, and electricity, *light is a form of energy*. It moves outward from its source, much like ripples or waves on a pond, but in three dimensions—that is, in all directions rather than in a single plane. In this respect, light behaves much like television and radio signals, X-rays, and other forms of radiant energy that are part of the *electromagnetic spectrum* (Fig. 3-2).

Our concept of this spectrum, first described by the Scottish physicist James Clerk Maxwell, is based on our ability to detect these waves and distinguish one kind of wave from another. Radios and TV sets are two familiar kinds of detectors. Our eyes, of course, are another, and the radiant energy that they can detect is what we call *light*.

If we represent a light wave as an oscillating line, the distance from one crest to the next is called its *wavelength* (Fig. 3-3), and by this measure we can sense how vast the electromagnetic spectrum appears to be. At one extreme are certain radio waves whose crests are several miles apart. Toward the other end are X-rays that vibrate a billion times in a single millimeter.*

Light waves occupy a very small part of the spectrum—between about 400 and 700 nanometers in wavelength. Beyond this section in the direction of longer wavelengths lie infrared or heat rays, microwaves, TV and radio signals. Radiation with wavelengths shorter than light includes ultraviolet rays (that cause sunburn), X-rays, and radiation associated with nuclear reactions.

Our eyes see different wavelengths within the narrow band of light as different *colors*. The shortest wavelengths we call violet, the longest ones red; all other colors of light lie between these two on the spectrum (see Fig. 3-2).

When all wavelengths of light are mixed together in sufficient intensity, we see the result as *white light*. At lesser intensities the same mixture appears *gray*. When the intensity is too low for the eye to detect, or when most of the light falling on a surface is absorbed and almost none reflected, the result appears *black* to us. In the absence of light, we see nothing.

### Physical Properties of Light

Photography as commonly practiced makes use of five basic

---

* To measure such short wavelengths, *nanometers* are more convenient units. A nanometer (nm) is one millionth of a millimeter (.000001 mm), or $10^{-9}$ meters.

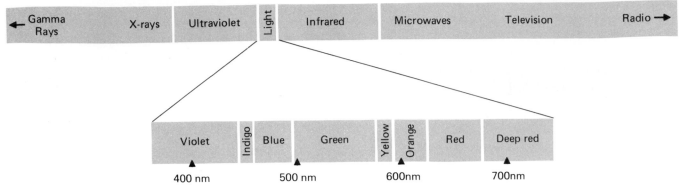

| Gamma Rays | X-rays | Ultraviolet | Light | Infrared | Microwaves | Television | Radio |

| Violet | Indigo | Blue | Green | Yellow | Orange | Red | Deep red |

400 nm     500 nm     600nm     700nm

**3-2** *The electromagnetic spectrum.*

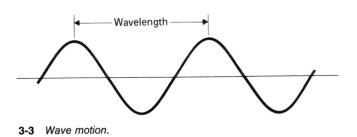

**3-3** *Wave motion.*

physical properties of light (Fig. 3-4):

1. Light *radiates* from a luminous point-source in straight lines, spreading outward in all directions (A).
2. Light can be *reflected*. A matte (dull) white surface reflects most wavelengths striking it, but scatters those reflections in many directions (B). A mirror reflects light in the same way but does not scatter it.
3. Light falling on a black surface will be *absorbed*. Because almost none is reflected to our eye, that surface appears black (C).
4. When light passes from one material, such as air, to another such as a triangular piece of glass (a prism), its waves are bent (D). This bending is called *refraction*, and is the basic principle on which lenses work.
5. Light can be *filtered*. In any mixture of two or more wavelengths, such as white light, certain waves can be absorbed by a substance while others are allowed to pass freely through it (E). This will be further explained in Chapter 5.

The wave theory can explain these actions of light and can demonstrate most of its properties. Other actions of light, however, cannot be readily explained this way. For example, when a ray of light, traveling as a wave, strikes the film in our camera, it causes a change in the light-sensitive coating that cannot be satisfactorily explained as a wave effect.

However, if we think of light as a stream of particles rather than a wave, its action in film is easier to understand. Our basis for this idea comes from two German physicists: Max Planck, who proposed a *quantum*, or particle *theory* to explain the movement of

energy, and Albert Einstein, who adapted that theory to the behavior of light. Light particles, or *photons*, as Einstein called them, seem to act more like matter than like waves of energy. When a photon of light (an extremely small amount) strikes sensitive molecules in photographic film, it begins a complex chain of events that only recently has been observed through the electron microscope, and which is not yet fully understood. This quick succession of events results in microscopic physical and chemical changes that form a latent or invisible image.

**3-4** *Physical properties of light.*

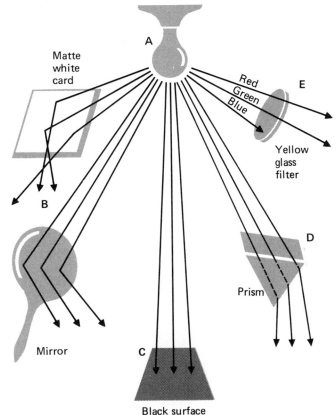

## HOW WE SEE LIGHT

Light occurs in two general forms, natural and artificial, and in a spectrum of wavelengths that we see as colors. We can also describe it in various degrees of intensity, clarity, and direction.

*Natural light* comes from the sun. Daylight, which is a combination of direct sunlight and its reflection from the atmosphere, is its most common form. We perceive daylight as coming from above; indeed, our sense of it "falling" on objects is so firmly fixed in our minds that we may find it difficult to think of light coming from other directions as natural. Moreover, when we create light artificially, we usually try to copy the natural kind. Natural light, then, is fundamental to our perception of reality.

Natural light also has certain characteristic colors. Direct sunlight is rich in red and yellow; we tend to think of it as "warm." Light reflected from a clear, overhead sky is much stronger in blue and violet than red or yellow; thus we regard it as "cool." Daylight contains different mixtures of sunlight and skylight at different times of day, and its dominant hue can therefore vary from warm to cool.

Our eyes, however, respond to all kinds of daylight in much the same way. We tend to think of sunlight and skylight, whatever the mixture, as *white* light, when in fact it is quite bluish if overcast or yellowish if the direct rays of the sun are dominant. Our eyes adapt themselves quickly and automatically to these differences, but our films do not, and therein lies a problem of color photography: correctly matching the light's color to the film's response. This will be further discussed in Chapter 9.

### Brightness and Luminance Ranges

As we can see in Thomas McCartney's photograph (Fig. 3-1), light varies tremendously in *intensity*, and objects differ in the degree to which they reflect and absorb light. Taken together, these two facts account for a great range of *brightnesses* in the light that subjects reflect to our eyes, and in a similar range of *luminances* that they reflect to the camera.*

A simple demonstration will illustrate these points. Take two pieces of construction paper or similar material, one white and the other matte black. Place them both in direct sunlight. One should reflect about twenty times more light than the other. If measured under skylight only, without direct sunlight, the range will be about the same, but the actual levels of reflected illumination will be much lower than they were in the sun.

Now place the white paper in deep shade and the black piece in the sunlight; the white one will reflect

---

* For an explanation of intensity, brightness, and luminance, see footnote on page 27.

only about twice the light of the other. Next, switch the papers so that the white one is sunlit and the black one is in shadow; the *difference* between the illumination levels they reflect might now be as great as 1:200.

This difference between the reflections from the highlights and shadows of a scene or subject is called its *brightness range* as *we* perceive it, and its *luminance range* as it appears to the *camera*. Because it varies so much, this range needs to be carefully measured if the film is to be properly exposed. *Exposure meters*, built into our camera or hand-held externally, perform this important function.

## CAMERA LENSES

The lens is the camera's eye. It gathers light rays and forms an image by projecting these rays onto the viewing system or film. Perhaps more than any other factor, the quality of a camera's lens determines the quality of the images it can produce. Because computers are used to design them, lenses of excellent quality are now found on relatively inexpensive snapshot cameras as well as those designed for professional work.

Better cameras often have *interchangeable lenses*, a feature that makes them more useful and adaptable. Being able to remove one lens and substitute another that will form a different image, is one feature that makes *system cameras* so appealing to serious photographers. But in order to choose and use such lenses wisely, photographers need to understand how a lens works.

### How a Lens Forms an Image

A camera lens forms an image by bending rays of light that pass through it, a process called *refraction*. Earlier we noted that when light passes from one material to another of different density, its waves are bent. For example, when a ray passes from air into a denser material such as glass, the ray is bent *toward* a line perpendicular to the surface of that material. When light leaves a dense material and enters a less dense one, the opposite occurs. Thus a ray passing from glass into air is bent *away from* the perpendicular to the surface as it passes through.

Figure 3-5 shows the example just described. If the two glass surfaces are parallel, as in a rectangular block, the entering and emerging rays will be parallel too. But if these surfaces are *not* parallel, as in a *prism*, the rays will be *bent*, in this case toward the base of the prism (Fig. 3-6).

Now visualize two identical prisms base to base. Rays of light passing through them are all bent or refracted toward the baseline and ultimately cross one another (Fig. 3-7).

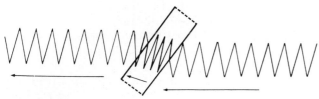

**3-5** *Light wave passing through air and glass.*

**3-8** *A simple lens.*

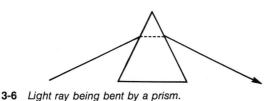

**3-6** *Light ray being bent by a prism.*

Positive     Negative

**3-9** *Positive and negative lens elements.*

**3-7** *Light rays being bent by two prisms, base to base.*

If we add more surfaces to these prisms at the correct angles, all the emerging rays will converge and cross at the same point. An infinite number of such surfaces—a spherical surface on the prisms—would cause all light rays emanating from one point and passing through the prisms to converge at another point beyond them. Now we would have a simple lens (Fig. 3-8).

### Positive and Negative Lenses

Lenses cause light rays to come together or spread apart. Lens elements that cause light rays to come together, or converge, are called *positive* lenses; they are thicker in the center than at their edges. Lens elements that make light rays diverge, or spread apart, are *negative* lenses; they are always thicker at their edges than at their centers, and they cannot form an image by themselves as positive lenses can do. Both types are diagrammed in Figure 3-9.

In all but the simplest lenses, positive and negative elements are combined. This helps to disperse the image evenly over the film plane, and to improve its sharpness and overall quality. Regardless of how various elements are combined, however, the aim is to produce a lens that will form a clear, flat, sharp image

the size of the film to be used with it, and to do that over a range of lens-to-subject distances for which the camera is intended.

### Focal Length

The most important characteristic of any lens is its *focal length*. Generally speaking, *this is the distance from the center of the lens to the film plane, when the lens is focused at infinity* (Fig. 3-10).* With any lens, the longer the focal length, the larger the image size of an object at a given distance. Focal length and image size are therefore directly proportional. If you replace a lens of 50mm (2 in.) focal length with one of 100mm (4 in.) focal length, the latter image will be exactly twice the size of the former.

The focal length of a lens is usually marked on its mount or rim, as is the ratio of its *maximum aperture*, another important identifying feature. Thus a typical lens may be marked as follows: Canon Lens FD 50mm 1:1.8. In this example, *Canon* is the manufacturer, *FD* is the lens type or series, its focal length is 50mm (2 in.), and its maximum aperture is f/1.8.

With interchangeable lenses, we may vary the size of our image on the film, but not all of that image may be usable. That depends on another important characteristic of a lens—its *angle of coverage*.

### Lens Coverage

Light passing through a lens forms a circular image, but practically all cameras are designed to make rec-

---

* This is an adequate but inexact explanation. The measurement is properly made from a point within the lens system called the *emerging nodal point*. All rays that travel through the optical center of the lens appear to leave the lens from that node.

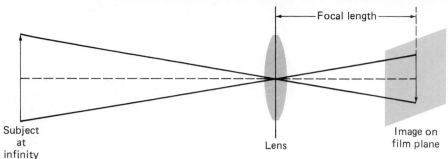

Focal length

Subject at infinity

Lens

Image on film plane

**3-10** *Focal length of a lens.*

tangular pictures within that circle. Each lens is designed to cover a particular size field, a requirement usually dictated by the format and construction of the camera for which it is intended. Lenses designed for 35mm cameras, for example, will produce images only about 75mm (3 in.) in diameter. A lens to be used on a 4 × 5 in. view camera, however, must form a circular image at least 150mm (6 in.) wide. This is why different lenses of the same focal length cannot be interchanged among all types of cameras. Although a 135mm lens for a 35mm camera and one of the same focal length for a 4 × 5 in. camera will form images of the same *magnification*, the two lenses are not interchangeable since the one designed for the 35mm camera will not cover the larger film area of the other. Thus *focal length*, which governs the image size, and *angle of coverage*, which determines the film size for which the lens is designed, are key factors in understanding what a particular lens can do.

Lens coverage is usually not marked on the lens mount like focal length is, but as a rule, the mount will fit only the type of camera for which it is designed.

## TYPES OF LENSES

Four types of lenses are widely used in general photography, and they form the basis of most interchangeable lens systems:

1. **Normal lenses,** of medium focal length. This is the type commonly found on most cameras; it is suitable for general use.
2. **Wide-angle lenses,** which have shorter-than-normal focal length. These enable the camera to record a larger

area while being confined to a close distance, as in a small room, and they have other useful applications.
3. **Long-focus lenses,** which have longer-than-normal focal length. These lenses produce larger images than normal ones do and are therefore useful over greater distances. A *telephoto* lens is a special kind of long lens.
4. **Zoom lenses,** whose focal length can be *varied* over a certain range. Some zoom lenses also incorporate a macro function (discussed below) in the same unit.

Special-purpose lenses are used for enlarging and for closeup photography. These are discussed later in this chapter.

### Normal Lenses

A lens is considered *normal* when its focal length is *slightly greater* than the diagonal of the film size being covered. A 50mm (2 in.) lens, for example, is a normal or medium focal length for the 35mm format, which has a 44mm diagonal.* Table 3-1 gives the focal lengths of normal lenses for most popular film formats.

The focal length and coverage of a normal lens (Fig. 3-11) are similar in proportion to the average focal length and visual field of the human eye.† Thus the

---

* The 35mm designation for format and focal length may be confusing. The *35mm format* uses a strip of film 35mm wide. Allowing for the two rows of sprocket holes, its typical image frame is a 24 × 36mm rectangle, which has a 44mm diagonal. A 50mm focal length is therefore normal for this format, and a lens of *35mm focal length* would be a wide-angle lens on such a camera.
† The *visual field* of the eye is the area it can see from an immobile position. Because the eye moves, however, we usually refer to its *field of view*, a greater area describing the limits of its visual field in all orbital positions.

**TABLE 3-1** NORMAL LENS FOCAL LENGTHS FOR POPULAR FILM FORMATS

| Format Name | Film Size Designation | Image Size | Diagonal | Normal Lens Focal Length |
|---|---|---|---|---|
| Pocket instamatic | 110 | 13 × 17 mm | 21 mm | 25 mm |
| Instamatic | 126 | 28 × 28 mm | 40 mm | 45–50 mm |
| 35mm | 135 | 24 × 36 mm | 44 mm | 50 mm |
| 645 | 120 | 45 × 60 mm | 74 mm | 80 mm |
| 6 × 6 cm (2¼ × 2¼ in.) | 120 | 60 × 60 mm | 76 mm | 80 mm |
| 6 × 7 cm | 120 | 60 × 70 mm | 92 mm | 105 mm |
| 4 × 5 in. | 4 × 5 | 95 × 120 mm | 152 mm | 150 mm |

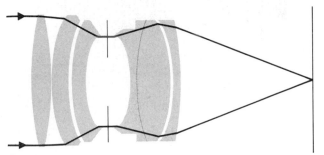

**3-11** *A normal lens.*

**3-13** *View photographed with a wide-angle lens. Compare with Figure 3-12.*

image produced by a normal lens has a perspective within it that we find familiar (Fig. 3-12). Normal lenses are suitable for general photographic work, and should be used unless you have a good reason for choosing another kind.

### Wide-angle Lenses

A lens is called a *wide-angle lens* when its focal length is much *shorter* than the diagonal of the film size it covers. Examples include lenses of 35mm focal length or less for a 35mm format (see footnote on page 47), and lenses of 40 to 65mm focal length for the $6 \times 6$ cm ($2\frac{1}{4} \times 2\frac{1}{4}$ in.) format. Wide-angle lenses are similar in construction to normal lenses, but some of their elements are thicker in the center. Typically they have an angle of coverage twice that of a normal lens. They are useful to photograph room interiors and similar confined spaces where a normal lens would frame too small an area; their wide angle of coverage permits a larger area to be included (Fig. 3-13).

Their greater depth of field (compared to a normal lens) also makes wide-angle lenses useful in jour-

**3-12** *View photographed with a normal lens.*

nalistic photography. Nick Lammers of the Fremont, California *Argus* used a full-frame *fisheye lens* to make an unusual self-portrait from the top of the San Francisco–Oakland Bay Bridge on the occasion of the bridge's 50th anniversary (Fig. 3-14). Fisheye lenses are extreme wide-angle lenses; some produce unusual circular images.

Due to their short focal length, wide angle lenses must be placed closer than normal to the camera's film plane. In some reflex cameras, where a mirror must move up and down in that same space, such a lens would interfere with this movement and make the mirror unworkable. A neat solution to this problem is the *retrofocus lens*, in which the optical path is lengthened by placing a negative group of elements ahead of the positive group (Fig. 3-15). This produces an *effective* focal length shorter than the actual distance required between the lens and film plane to focus its image, thus leaving space for the reflex mirror to function.

### Long-focus Lenses

A lens is considered to be a *long-focus lens* when its focal length is *much greater* than the diagonal of the film size being covered. Long-focus lenses produce larger images at a given subject distance than normal ones do on the same film size. In general photography they are useful for framing a smaller area or a more distant subject than a normal lens can do; although they "see" less area, they enlarge it more (Fig. 3-16). Compare this photograph with Figure 3-11.

Long-focus lenses are useful to compress distant space to form a more compact view, as Figure 3-16

**3-14** *Nick Lammers: Self-portrait atop the San Francisco-Oakland Bay Bridge, 1987. Photographed with a full-frame fisheye lens.*

shows. They can also reduce distortion of the third dimension that comes from too close a viewpoint. For example, when making head-and-shoulders portraits, a long lens allows the camera to be farther away from the subject, yet still fill the frame; a normal lens requires a closer camera position, from which the subject's nose may appear too large and ears appear too small.

Long lenses have their problems, though, and one of them is that image movement from a shaky or unsteady camera is magnified along with the picture. A

**3-16** *View photographed with a long-focus lens. Compare with Figure 3-12.*

**3-15** *A retrofocus lens.*

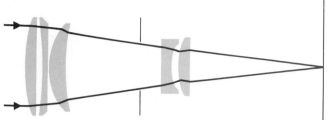

**3-17** *Diagram of a typical telephoto lens.*

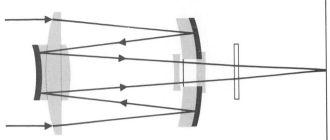

**3-18** *A mirror lens.*

tripod may be needed to control this. Another problem is the increased distance necessary between the lens and the film. This requires a longer bellows or lens mount on the camera, and there are practical limits of space and weight to such apparatus.

**Telephoto Lenses.** A solution to this latter problem is the *telephoto lens*, constructed with two groups of elements separated by an air space (Fig. 3-17). The front group is positive, or converging; the rear group negative. This arrangement permits the lens to focus its image at a much shorter lens-to-film distance than a normal lens of equal focal length would require. For example, a 300mm telephoto lens mounted on a 35mm camera may require only 145mm of space between its rear element and the film plane. This saves considerable space and makes the camera and lens easier to hold and balance.

Incidentally, all telephoto lenses are long-focus lenses, but the converse is not true. A telephoto lens must focus at a lens-to-film distance *shorter* than its actual focal length. If it doesn't, it's merely a long-focus type.

**Mirror Lenses.** When extremely long focal lengths are needed for small-camera lenses, a *catadioptric lens system* may be employed. This type of lens combines reflecting mirrors with refracting elements, enabling the light rays to be reflected back and forth within the lens system before being passed on to the film (Fig. 3-18).

Such a lens can save considerable space and weight in focal lengths beyond 400mm (for a 35mm camera), but it has two troublesome features. If the view being photographed has a highly reflective background, such as the sunlit surface of a lake, the lens will produce circular, out-of-focus highlights in the image from uncontrolled reflections in its mirrors (Fig. 3-19). A more serious problem with mirror optics is that *they have no adjustable aperture* because it would obstruct the passage of light through the mirror system. Exposure must therefore be controlled entirely with shutter settings or filters, and depth of field cannot be varied. In spite of these drawbacks, however, mirror lenses represent a compact alternative to telephoto lenses that would otherwise be too long and difficult to handle.

**3-19** *Photograph made with a mirror lens.*

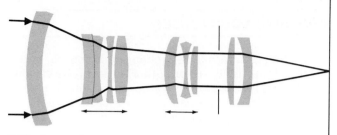

**3-20** *A zoom lens.*

## Zoom Lenses

Zoom lenses are *variable-focal-length* lenses. In a zoom lens, focal length, and thereby image size, is varied by moving certain groups of elements within the lens in relation to others, which remain in a fixed position (Fig. 3-20).

We've all seen the effect of zoom lenses used on TV cameras where they permit smooth and continuous changes in image size from a fixed camera position. This "zooming in" or out adds a bit of motion to a scene that might otherwise be static and less interesting. In still photography, where this feature is less important, zoom lenses have other advantages. Media and sports photographers find them convenient because these photographers can quickly change focal lengths, as the assignment demands, without the delay of removing and replacing lenses of fixed focal length. Moreover, a zoom lens takes less space in the camera bag than several fixed lenses would.

Zoom lenses are also useful for making color slides, which cannot easily be cropped for projection after they are made as negatives can. With a zoom lens, precise framing can be done in the camera. Some zoom lenses also have a *macro*, or closeup function built into them, increasing their usefulness for that kind of photography, and most zoom lenses can produce a special visual effect if you change the focal length during a long exposure (Fig. 3-21).

Zoom lenses are more complicated and often more expensive than lenses of fixed focal length, and most cannot produce image definition and sharpness equal to that of a high-quality, single-focal-length lens. Nevertheless, they are becoming increasingly popular on automatic snapshot cameras.

## SPECIAL PURPOSE LENSES

Most ordinary camera lenses are designed to focus sharply over a range of distances, typically from about 1 meter (3 feet) to infinity. When the circumstances under which a lens will be used are quite different from these conditions, the lens can be designed to form its highest quality images within the special conditions of its use. Four such types, widely used by photographers, are explained here.

### Enlarging Lenses

Camera subjects are generally three-dimensional and are located at a moderate distance. An enlarger's "subject," on the other hand, is flat and close—a negative located only inches from the lens. Enlarging lenses therefore are designed to form an image from a nearby flat plane (a negative) on another flat plane (the printing paper) only a couple of feet away. In an enlarger (see Chapter 7) the lens always functions under these conditions, and need not be designed for any others. Enlarging lenses are therefore not well suited for general camera use.

Some enlarging lenses are specially designed wide-angle lenses. These produce greater magnification without increasing the lens-to-paper distance, thus allowing larger prints to be made where low ceilings prohibit the use of tall enlarger frames that would otherwise be needed.

### Macro and Micro Lenses

These lenses are specially designed for closeup work, where photographs are made at very short dis-

**3-21** *Special effect possible with a zoom lens by changing its focal length during exposure.*

tances (often less than two feet) from the subject, and where the image produced in the camera will often be the same size or larger than the object in front of it. Although macro lenses produce their best image quality at short distances, many of them are also suitable for general work over a longer range. Most have features to make routine closeup work more efficient.

Technical photographers will find a *macro lens* unsurpassed for making same-size photographs of small, three-dimensional objects and specimens. *Micro lenses*, on the other hand, are designed to reproduce flat fields—two-dimensional subjects. These lenses usually have the prefix *micro* in their names, and are widely used for copying artwork, in slide reproduction cameras, and in office copy machines.

### Process Lenses

Process lenses are specially designed to make *extremely sharp images of flat fields*. They are similar to enlarging lenses in this respect, but they attain their image quality by sacrificing speed and depth of field. Process lenses typically have small maximum apertures and focus best over a range of about 3 to 30 feet. Most are designed to focus all colors or wavelengths in precisely the same plane. These lenses are used on reproduction cameras for the printing industry and in special cameras used by the electronics industry to make masks for printed circuit layouts and microelectronic "chips."

### Closeup Attachments and Tele-extenders

These are not complete lenses in themselves but typically are single lens elements that can be added to existing lenses to change their focal length. By placing a suitable closeup attachment in front of a regular camera lens, it is often possible to produce reasonably sharp images as close as 30 cm (12 in.) from the subject. The camera may then be used to photograph small objects such as ceramic pots, drawings, paintings, or other flat objects that a close viewpoint will not distort. Closeup attachments represent an economical way to shorten the focal length of a normal lens for the uses described above.

Closeup attachments for certain twin-lens reflex cameras, such as the Yashicamats, come in pairs: a thin element goes on the lower (taking) lens, and a thicker one, containing a prism, attaches to the viewing lens above. *A reference mark or dot on the upper lens must be on top when this lens is in place* (Fig. 3-22). Then the prism will aim the viewing system at the closer lens-to-subject distance involved, conveniently eliminating most parallax error.

Tele-extenders work similarly, except that they increase the effective focal length of the normal camera lens and are an economical way to make larger-size images of more distant objects.

## CHOOSING YOUR LENSES

If your camera has interchangeable lenses, you'll soon be tempted to try out other lenses in its system. Additional lenses are among the more useful but more expensive items you can add to a basic camera, so any choices need to be made with care. Here are some suggestions:

1. *Start with a normal lens.* This is usually the one that comes with the camera, and is likely to be the most useful to you. Discover all the things it can do for you before you switch to others.

2. *Define your needs carefully for any additional lenses.* If you travel a lot and wish to make color slides of your trips, consider a zoom lens. You'll appreciate its convenience and its ability to frame your slides well. If you expect to travel in Europe or the Orient, where streets tend to be narrow and full of interesting details, a wide-to-long range zoom lens (35 to 85mm) might be your most useful choice. On the other hand, a longer telephoto lens will be useful to photograph outdoor sports, and will be essential to photograph wildlife.

3. *Avoid high-speed lenses* (with maximum apertures larger than f/1.7) unless you absolutely need them. They are rarely necessary with modern, high-speed films, and are usually very expensive.

4. *Buy the best lens for your camera that you can afford.* Name-brand lenses designed for your camera system will usually give the best performance, but other, universally

**3-22** *Closeup lens attachments on Yashica 124G camera. The* **dot** *on the thicker lens must be on* **top** *to correctly orient the prism in it.*

adaptable brands may give adequate performance at a lower price. If the lens you want is too expensive new, consider a second-hand one.

5. *A lens shade* will improve the performance of almost any lens (including a normal one) by reducing stray light that causes *flare*. It will be one of your most valuable and inexpensive accessories. A sturdy *tripod* will minimize or eliminate unwanted camera movement, and that will allow you to get the best image quality from every lens you use.

## SUMMARY

1. *Light* is a form of radiant energy occupying part of the electromagnetic spectrum between approximately 400 and 700 nanometers in wavelength. Humans see different wavelengths of light as different *colors*. When all wavelengths of light are mixed together, we see the result as white, gray, or black depending on its intensity. Without light, we see nothing.

2. Photography uses five basic physical properties of light: *radiation*, *reflection*, *absorption*, *refraction* (the principle on which lenses work), and *filtration*. These properties are easily explained by the *wave theory*, but other aspects of light's behavior, such as its effect on film, are more readily understood by the *quantum theory*, which describes light as a stream of particles rather than a wave of energy.

3. The most common kind of light is *natural daylight*, which comes from the sun. It has different characteristic colors at different times of the day. Because humans adapt to these changes, we "see" daylight as white light, but films cannot adapt to such differences and this is sometimes troublesome in color photography.

4. Light can vary tremendously in intensity. The difference in the amount of light reflected to a camera from the highlights and shadows of a subject is called its *luminance range*, and this is best measured by an exposure meter.

5. Lenses form images by *bending* rays of light passing through them. *Positive* lens elements cause light rays to come together; these can form an image. *Negative* lens elements cause light rays to spread apart, and these cannot form an image alone. Most lenses therefore combine positive and negative elements to make images of greater clarity and sharpness.

6. The most important characteristic of any lens is its *focal length*, which is roughly the distance from the center of the lens to the plane of its sharpest image when the lens is focused on infinity. Image size is directly proportional to focal length. The focal length and *maximum aperture* are usually marked on the lens rim or mount. The *angle of coverage*, another important characteristic, determines the size of film and camera with which a lens may be used.

7. Four types of lenses are in common use on cameras: *normal*, *wide-angle*, *long-focus*, and *zoom* lenses. Zoom lenses have variable focal length and can be used like several of the preceding types. *Telephoto* and *mirror* lenses are special long lenses that save weight and space by their design.

8. Special-purpose lenses are made for enlarging, for precise reproduction work, for large images of small objects at close distances, and for converting normal lenses to make them work better at very close or very great distances.

9. Choose interchangeable lenses with care. First, decide what you are trying to do. Normal lenses are fine for most work; select additional ones according to your most important needs. A lens shade and tripod will help you get the best performance out of any lens you use.

**4**

# ALL ABOUT FILM

**4-1** *Photographed by existing light on Kodak T-Max P3200 film exposed at ISO 6400 and developed in D-76. Exposure 1/500 sec. f/2.*

"You press the button, we do the rest." With that famous advertising slogan, George Eastman introduced the rollfilm camera to the world a century ago. The *Kodak* camera was easy to use, but what made it an instant success was that Eastman also provided a service to develop and print the film. To be sure, it wasn't the one-hour photo service available almost everywhere today, but from 1888 on, amateur photographers could leave the darkroom and its chemicals behind, and simply enjoy the fun of taking pictures.

Today most photographers are still content to follow Eastman's advice and leave the processing of their films to others. Color photography, with its universal appeal, has replaced black-and-white for nearly all uses except art and publication, and modern technology has made the processing of color films fast, inexpensive, and available everywhere.

Similar processing services for black-and white films, however, are no longer widely available, so most photographers working with these materials do their own. This, of course, allows them to maintain control of their image-making at every step of the process, a creative advantage for photo-artists and a convenience for those who need their pictures quickly. But because most of the technical properties of modern films are invisible, and because their processing must begin in total darkness, a bit of mystery still surrounds these remarkable materials.

## MAJOR CHARACTERISTICS

Photographic film and the reaction that light produces within it are both simple and complex.

Taken out of the camera, film looks simple enough—a strip of shiny, plastic material, dark on one side, light gray or pale orange on the other, and ready to roll up as soon as we let go of it. Even a microscopic cross-section (Fig. 4-2) gives us few clues to its remarkable nature. Most of the thickness we feel as we handle it is film base— a flexible support for the thin, light-sensitive emulsion where the image is formed. Film base must be optically transparent and tough, yet be unaffected by water and the chemicals used in processing. Two materials meet these requirements well: cellulose triacetate and polyethylene terephthalate. The former is made from wood pulp, the latter from ethylene glycol and other petroleum-based chemicals. Both are used worldwide in film manufacturing.

### The Sensitive Emulsion

Certain compounds of silver are *photosensitive*. They tend to break down or decompose under the influence of light, and virtually all photographic processes depend on this effect. The most useful of these compounds are the *silver halides*, combinations of silver with chlorine, iodine, or bromine. The last mentioned, *silver bromide*, is the most important. Silver bromide crystals are extremely small— about 500 to 4000 nanometers (.0005 to .004 mm) wide. For photographic use they are held in a suspension of gelatin, which keeps them separated from one another and disperses them evenly across the film surface.

*Gelatin*, in fact, plays an important role in the manufacture of modern photographic materials. Made from the hides, hooves, and bones of calves and pigs, gelatin is a remarkable material. Liquid

**4-2** *Cross-section of black-and-white photographic film.*

when hot, it cools and dries to a hard, smooth layer that freely permits light to pass through it. Gelatin helps to control the size and dispersion of silver bromide crystals when the emulsion is made, and it holds these crystals and the image formed in them firmly in place. In cold water gelatin swells but does not dissolve, thereby permitting other dissolved chemicals, such as developers, to pass through it and get to deeply situated crystals as well as those near the surface. Since 1878 gelatin has been a universal emulsion material.

Gelatin is also used for the thin, topcoat layer that protects the emulsion from mechanical damage (such as scratching) in the camera, and for a thin, colored, anti-halation layer on the back of the film base (see Fig. 4-2). When a bright source of light is included in the picture area, rays from that source striking the film at an angle (as they will everywhere except in the center of the frame) might travel through the base and reflect off its far side, reexposing the emulsion in a wider area than a perpendicular or central ray would. This effect is called *halation*; it produces fuzzy highlights in a picture and reduces image sharpness. The dyed gelatin coating on the back of the film absorbs such light and prevents it from reflecting back to cause halation. This anti-halation dye is later removed from the film during processing.

### Sensitivity to Light

Films differ from one another in several ways. Some are for color prints, others produce color slides. Still others produce negatives for prints in black-and-white. Within each of these three basic types there are other differences, and the most important of these is *sensitivity to light*. To describe this sensitivity, photographers generally use the term *film speed*, expressed as a number on an international standard scale (ASA, ISO, etc. See footnote on p. 33). The film speed is therefore known as an *ISO rating*, and it is often prominently featured in the name of the product (see, for example, Tables 4-1 and 9-1).

Speed, or sensitivity, is governed largely by the size of silver bromide crystals in the emulsion and by the presence and concentration of certain other chemicals. Fewer but larger crystals give a higher (faster) film speed with relatively lower contrast. A dispersion of many small crystals, on the other hand, yields a less sensitive (slower) emulsion with greater contrast.

### Graininess

As sensitivity increases, so does graininess. *Graininess* results from a grouping or clumping of the larger silver bromide crystals in faster emulsions, and it is most often noticed when a negative is greatly enlarged. High-speed films contain larger crystals because when these crystals are developed, they produce more silver metal than smaller crystals do, and thus they can form a usable negative with a minimum of exposure. Graininess is increased if a film is overexposed or overdeveloped. On the other hand, in slower films the grain structure is finer and less noticeable.

### Acutance and Resolving Power

Slow films also have greater *acutance*, or ability to record the edges of adjacent tone areas cleanly, and higher *resolving power*, a measure of their ability to record fine detail. Both characteristics stem from the smaller crystals in their emulsions, but these smaller crystals also make the films less sensitive to light.

Some fine-grain films have extra-thin emulsions that reduce internal light scattering to improve image sharpness. To further enhance acutance, the anti-halation dye layer is sometimes coated on top of the film base, directly under the emulsion, rather than on the back.

Acutance and resolving power are compromised if the film is overexposed or underexposed, or if it is overdeveloped.

***T-Grain Emulsions.*** For many years film manufacturers have tried to reduce graininess without sacrificing sensitivity. Recently, a new family of films with T-grain emulsions has made a remarkable improvement in this respect. T-grain emulsions use silver bromide crystals in tabular form (rather than the traditional pebble shape), and these are arranged in the emulsion in such a way that their flatter surfaces absorb more light. Thus in T-grain emulsions, more sensitivity is obtained from smaller crystals, producing two very desirable features—higher speed with finer grain.

### Color Sensitivity

Silver halides, by their chemical nature, are sensitive only to ultraviolet, violet, and blue light; they are not sensitive to green or red. Nineteenth-century photographers like T. H. O'Sullivan had to contend with this when working outdoors. Their plates would record brown and green landscape hues only with long exposures, during which blue skies became relatively overexposed and printed out uniformly white. Today such blue-sensitive emulsions are used only for black-and-white printing papers and a few special-purpose professional films.

By adding certain dyes to the emulsion when it is made, its spectral sensitivity can be extended to other colors of light. *Orthochromatic* emulsions are sensitive to violet, blue, *and green* light. They are not sensitive to red, however, and thus can be handled and developed under red safelights. These emulsions, called simply *ortho*, are also found on photographic papers and on special films used primarily in the printing trade.

**4-3** **A:** *Santa Clara Valley from Mt. Hamilton, CA., 1968, photographed on infrared film.*

**B:** *The same view made on panchromatic film.*

If an emulsion is sensitized to *red* as well as green light, it is designated *panchromatic*, or simply *pan*. Added to its inherent blue sensitivity, this gives such films a balanced response to all colors of light. *Most black-and-white films are panchromatic* and therefore reproduce all colors as gray tones of corresponding value. But because panchromatic films are sensitive to all colors of light, they must be handled and developed in total darkness. Color films, of course, are also sensitive to the entire visible spectrum; these, too, must be handled and developed in absolute darkness.

The dye-sensitizing process noted above can also extend the spectral response of film beyond light wavelengths into the *infrared* region of the spectrum, to about 1350 nanometers. This makes photography by invisible infrared radiation possible. Infrared rays can penetrate hazy atmospheric conditions where light rays cannot, and photographs made by them have many applications in scientific, aerial, and landscape work (Fig. 4-3). Infrared film can also give some daylight landscape photographs an aura of fantasy by recording familiar objects in unfamiliar tone values. This film, however, requires special filters and focusing techniques, and these are discussed in Chapter 5.

### X-Ray Sensitivity

All films are sensitive to X-rays, and security measures used at airports have made this sensitivity a major concern for photographers. X-ray doses that are safely tolerated by humans will ruin photographic film; *screening units used for people and luggage should not be considered safe for undeveloped films.* Fogging (nonimage exposure) from X-rays is most noticeable on color films and high-speed black-and-white materials, but any undeveloped film can be ruined if the unit is powerful enough, and this can be a serious problem at airports outside the continental United States. To make matters worse, multiple screenings increase the hazard as each dose adds its effect to the previous ones.

The best way to minimize this risk is to *carry your film with you when boarding an aircraft.* Always request a *hand search* of your camera and film cases (and arrive at the airport early enough to allow time for it). Don't ship film in baggage that will be checked, and if your trip will require repeated X-ray inspections, place your film in protective, lead-shielded bags available from photo dealers.

### Contrast

Every photographic image has a range of tones or values that extend from light to dark. This range of values is known as *contrast*, and in black-and-white films it is related to speed and graininess. Higher-speed films tend to produce less contrasty images; lower-speed films more. Most fine-grain films (which are slow) produce negatives of moderate contrast when processed as recommended. But there are other kinds of films that are specially designed to produce high contrast images—those in which black and white tones are more evident than shades of gray. These films tend to have relatively low speeds, and many of them are used primarily for microfilming, reprographic work, and other technical applications in the printing industry. A few, such as Kodalith Ortho Type 3, are also used in photographic design work, and some of these applications are discussed in Chapter 16.

Except for a few special-purpose kinds made for laboratory work, films are not designed to produce low-contrast images.

### Chromogenic Black-and-White Films

Chromogenic black-and-white films are special multilayer films that produce *neutral-colored* (*gray*) *dyes* in the emulsion instead of silver images. They are made and processed like color-negative films (see Chapter 9), but because their images are neutral gray, they can be printed like black-and-white. Thus they can be processed by any one-hour color photo service to yield black-and-white prints.

Their multilayered image structure makes it pos-

**4-4** *Subject photographed on three different films. Left to right: ISO 32, ISO 400, ISO 6400. Compare the sharpness and tone reproduction of these images.*

sible to expose these films over a wide range of ISO (ASA) values. Nominally, they are rated at ISO 400, but they can be exposed at speeds from 100 to 800 to yield printable negatives. Agfa Vario-XL Professional film and Ilford XP1 400 are products of this type.

In other respects, these films behave much like fast black-and-white films. Their primary advantage, however, is that they can be processed along with any other color print films, and this service is available everywhere.

### Instant-picture Films

Instant-picture films made by Polaroid Corporation can give processed, permanent images in seconds

**TABLE 4-1** GENERAL PURPOSE BLACK-AND-WHITE ROLL AND 35MM FILMS AND THEIR ISO (ASA) RATINGS

| FAST FILMS | KODAK T-Max P3200 | 3200/36° |
|---|---|---|
| | FUJI Neopan 1600 | 1600/33° |
| | AGFA Agfapan 400 | 400/27° |
| | ILFORD HP5 | 400/27° |
| | KODAK T-Max 400 | 400/27° |
| | KODAK Tri-X Pan | 400/27° |
| MEDIUM SPEED FILMS | ILFORD FP4 | 125/22° |
| | KODAK Plus-X Pan | 125/22° |
| | KODAK Verichrome Pan | 125/22° |
| | AGFA Agfapan APX 100 | 100/21° |
| | KODAK T-Max 100 | 100/21° |
| SLOW FILMS | ILFORD Pan F | 50/18° |
| | AGFA Agfapan APX 25 | 25/15° |

*Color films are listed in Table 9-1; instant-picture films in Appendix A.*

(black-and-white) or minutes (color) after they are exposed. Although most of these films can be used only in special cameras designed for them, some Polaroid films can be used in conventional 120 roll-film and 4 × 5 in. sheet film cameras with special film holders or adapters. Because instant-picture materials are all basically different from other films and papers, they are discussed in Appendix A.

### CHOOSING YOUR FILMS

From a practical standpoint, photographers generally divide general-purpose films into three groups: fast, medium-speed, and slow. Fast films are those with ISO (ASA) ratings of 400 or more (see Table 4-1). Although they are less able to show fine detail than other groups are, fast black-and-white films are more tolerant of variations in exposure and development and can be "pushed" (exposed at higher-than-normal ISO ratings) with the help of high-energy developers. These films are widely used by newspaper and other media photographers who often must work in difficult lighting conditions. As a rule, high-speed films should be used only when their extra light-sensitivity is needed.

Slow films are those with ISO ratings of 80 or less. They require more exposure than other groups, but their longer tonal scales, finer grain, and moderately high contrast make them ideal for use when highly detailed images or rich tone quality in the print are desired, or when extreme enlargement will be needed. Slow color films are the best choices when rich, saturated colors are wanted.

Medium-speed films range from ISO 100 to 320,

**4-5** *Electron photomicrograph of an exposed silver bromide crystal at the beginning of chemical development. Reproduced by permission of the Eastman Kodak Company and the American Society of Photogrammetry.* © 1966, 1981.

and these are good choices for general photographic work. They are less contrasty than slow films and less grainy than fast ones. Medium-speed films usually are excellent choices for a beginning photographer.

The division of films into three speed groups is somewhat arbitrary and mainly serves as a convenient way to compare them. Figure 4-4 shows this comparison for typical black-and-white films in each of these groups, and color films show similar differences. Seeing these differences should make it easier to choose a film that will best serve your needs. ISO ratings, of course, are the most useful way to identify one film from another, especially in black-and-white. When you choose color films, however, other considerations become equally important, and these are discussed in Chapter 9.

Whichever type of film you choose, take time to discover what it will do for you before switching to others.

## THE LATENT IMAGE

What actually happens when light strikes the film in our camera? Until a couple of decades ago this was known only in theory because the actual event could not be seen until the introduction of the electron microscope. From a microscopic viewpoint, the emulsion is a deep layer of gelatin in which are scattered millions of silver bromide crystals. Each of these crystals, if greatly magnified, would appear to be a three-dimensional arrangement of alternating silver and bromine particles called *ions*—electrically charged atoms—and the entire crystal structure would look something like a triangular pebble or cough drop (Fig. 4-5).

We noted earlier that when light strikes a photographic film, it behaves more like a stream of particles than a wave. When a particle (photon) of light strikes one of these crystals, it sets off a sequence of events that results in the formation of tiny particles of silver metal. Energy from the photon of light releases electrons from the bromine ions, and these negatively charged, free electrons move about the crystal until they are caught and held at certain points in the crystal structure called *sensitivity specks*. There they attract positively charged silver ions, which join the electrons at the specks to form atoms of silver metal. As more light is absorbed by the crystal, more electrons and silver ions are attracted to these growing sensitivity specks, and more silver metal is formed.

This formation of tiny silver particles on exposed silver bromide crystals is called the *latent image*. *Latent* means lying hidden and undeveloped, which perfectly describes this silver pattern. Development, the next step in the photographic process, will begin in this same pattern, amplifying the effect of light a billion times, and that will make the latent image visible.

## SUMMARY

1. Photographic *film* consists of a *light-sensitive gelatin emulsion* coated on a flexible, waterproof plastic *base*.

2. *Silver bromide* crystals make the emulsion sensitive to light; the gelatin helps to control the dispersion of these crystals and allows processing solutions to reach them.

3. Most films also contain an *anti-halation dye layer* to absorb stray light that could otherwise be reflected from the rear surface of the film base. This dye is removed during processing.

4. Three major types of films are *color-negative films* for color prints, *color slide* or *transparency films*, and *black-and-white negative films* for black-and-white prints.

5. Within each type above, films differ mainly in their *speed*, or sensitivity to light, expressed as an *ISO or ASA rating*. Other differences occur in graininess, contrast, and color sensitivity.

6. As speed increases, so does *graininess*, although other factors such as exposure and development also affect it. Films with thin or T-grain emulsions are designed to minimize graininess.

7. Most black-and-white films are sensitive to all colors of light and are called *panchromatic*; they must be handled and processed in total darkness. Some are sensitive only to blue and green light but not red; these are called *orthochromatic*, or *ortho*, and can be handled under a red safelight. A few are sensitive only to blue and ultraviolet; all are sensitive to X-rays. Some special-purpose films are sensitive to invisible infrared radiation.

8. *Chromogenic black-and-white films* are actually color-negative films that produce neutral (gray) dye images. Thus they can be processed anywhere like other color-negative films but printed as black-and-white. They also offer some flexibility in their ISO ratings.

9. Some special films are made to process automatically as they leave the camera, providing pictures instantly. See Appendix A.

10. *Fast films* can be "pushed" when processed to increase their sensitivity; they are more tolerant of exposure and development variations but also more grainy. *Slow films* produce better image tone and can record greater detail, but are less sensitive to light. *Medium speed films* have some of the characteristics of each of the above types, and are a good choice for general work.

**5**

# USING FILTERS ON YOUR CAMERA

Filters are thin pieces of transparent gelatin, plastic, or glass which contain a substance, such as a dye, that absorbs certain colors or wavelengths of light. Six general types of filters are useful on camera lenses:

1. Contrast filters for black-and-white photography.
2. Polarizing filters.
3. Infrared filters.
4. Neutral-density filters.
5. Conversion filters for color photography.
6. Color-compensating (CC) filters for color photography.

As we explained in Chapter 4, films and papers respond to light in different ways. We call their overall sensitivity to light their *speed*, using ISO (ASA) ratings for films and similar data for most papers. But we also noted that films and papers respond differently to various colors or wavelengths of light. We use labels such as *orthochromatic* and *panchromatic* to designate this kind of response. If a film or paper responds to more than one color of light, we can change that response by using filters.

All filters work the same way: *they block or absorb some colors (wavelengths) of light, while they allow other colors to pass through them.* Thus they function as selective valves, controlling the color and the quantity of light that passes through.

ple, yellow or orange contrast filters are commonly used in black-and-white photography to darken blue sky and thereby make clouds more prominent, as in Tom Gore's photograph of an English garden (Fig. 5-2). These filters pass yellow light but absorb its complement, blue. Similarly, a red filter will pass red light but absorb blue and green rays, and a green filter will pass green ones but absorb red and blue.

Filters, of course, do not screen out subjects; they only respond to colors of light. Perhaps their use can be understood more easily by studying the photographic color circle (Plate 5). The basic principle is that *any filter passes or transmits its own color of light and absorbs its complement*—the color that is opposite it on the circle.

As a filter darkens its complementary or opposite color, it makes its own color look lighter by comparison. From this behavior, we can derive a basic rule for using filters on the camera lens: *Any filter will lighten the rendering of its own color in the subject and darken the rendering of its complement.* Thus a red filter will render a red barn or a red apple lighter than the green grass or tree around it (by darkening the green areas). Similarly, a green filter on the camera will lighten a green leaf but darken a purple flower next to it. The illustrations in Figure 5-3 show these effects.

## CONTRAST FILTERS FOR BLACK-AND-WHITE PHOTOGRAPHY

These are strongly colored filters that let you make the tone (value) of certain colors lighter or darker in your picture. For exam-

### Filter Factors

Because they absorb or block some wavelengths of light, most filters *reduce the total amount of light* passing through them to the lens and film. Unless this reduction is slight, *an increase in exposure will be required* when

**61**

**5-2** *Tom Gore: At Blenheim Palace, Woodstock, England, 1985.*

**TABLE 5-1** EXPOSURE FACTORS FOR FILTERS USED IN BLACK-AND-WHITE PHOTOGRAPHY WITH PANCHROMATIC FILM

| Filter Color | No. | Exposure Factor in | |
| --- | --- | --- | --- |
| | | Daylight | Tungsten |
| Medium Yellow | 8 | 1.5 | 1.5 |
| Orange | 15 | 2 | 2 |
| Green | 11 | 4 | 3 |
| Red | 25 | 6 | 4 |
| Deep Blue | 47 | 10 | 16 |
| Polarizing Filter (for full effect) | — | 3 | 3 |

*If more than one filter must be used, multiply the factors.*

using them. This can be accomplished by increasing the exposure time, or by opening the aperture to allow more of the filtered light through.

Modern cameras with automatic exposure systems built into them will make this adjustment automatically. So will cameras with built-in meters that measure the light coming through the lens (as most do). But if you are using an external or hand-held meter to determine your exposure, you must increase the exposure by applying the appropriate filter factor.

A *filter factor* designates the amount of increase necessary. You simply multiply the exposure time by the factor. Alternatively, you can open the aperture an equivalent amount. For example, if the factor is 2, you must double the time *or* open the aperture one stop.

Factors differ for each filter, for daylight and tungsten light, and for the type of film with which it is used. Table 5-1 lists the exposure factors for the most popular filters used in black-and-white photography with panchromatic film.*

## POLARIZING FILTERS

Polarizing filters are useful to reduce or eliminate reflections from water, glass, or other smooth, nonmetallic surfaces. Light waves ordinarily vibrate in all directions perpendicular to the path they travel, but light reflected from water, glass, or other smooth, nonmetallic surfaces vibrates in only one perpendicular plane. We call such light *polarized*. The effect is strongest when the light is reflected at about a 35° angle from the surface, and disappears entirely at the perpendicular.

Polarized light also occurs directly in nature as the deep blue skylight seen at an angle of 90° to the sun. At other angles it is less noticeable, and it disappears entirely when the sun is directly behind the viewer.

A polarizing filter contains a material that works like a louver, blocking polarized light while it lets other rays pass through. Since both polarized and

---

* Ortho films require different factors; see the information sheet packed with the film.

*A:* No filter

*B:* Yellow filter

*C:* Green filter

*D:* Red filter

*E:* Blue filter

**5-3** *Effect of colored filters used to photograph various colored objects.*

unpolarized light look the same to the eye, only the blocking effect is noticed (Fig. 5-4).

To use a polarizing filter, *hold it in front of your eye and rotate it until the desired effect is seen through it.* Then place it over the camera lens *in the same position.* Most polarizers are neutral in color, so they can be used with color film as well as black-and-white. They require about 3 times the normal exposure if set for the full polarizing effect.

Small reflective objects such as glass-covered pictures may be photographed by this method. Tungsten light can be used, but it is necessary to polarize the light before it reaches the shiny surface. Polarizing material similar to the filter must be placed over the lights, and this can be an expensive procedure. Such material will polarize the light falling on the reflective surface; a polarizing filter at the lens will then block the reflection that reaches the camera. Using the camera filter alone, unfortunately, will not work, since the light reaching it will not be polarized and therefore cannot be filtered out.

## INFRARED FILTERS

These filters *absorb or block all visible light* and pass only the longer infrared wavelengths. They must be *used with infrared film* to obtain an infrared effect. Otherwise the film, which is also sensitive to blue light, would record the blue wavelengths much more strongly, and the infrared effect would be obscured.

When properly exposed, infrared film can produce strange, dream-like images of landscapes (Fig. 5-1) and startlingly clear, haze-free views of longer vistas (see Fig. 4-3A). The film is available from Eastman Kodak Company in 35mm and 4 × 5 in. sizes. *The containers must be opened and cameras loaded only in total darkness.*

The No. 87 filter blocks all visible light, exposing the film only by infrared rays. Similar but somewhat less dramatic effects can be obtained with the No. 25 or No. 29 red filters; these pass the red portion of the visible spectrum but screen out the blue rays.

### Exposure

Most in-camera exposure systems do not respond to infrared as they do to visible light, so exposures must be set manually using guidelines packed with the film. Because the amount of infrared radiation can vary so much, even in daylight, *exposures should always be bracketed* (see p. 39) over several frames or films. Since infrared rays are longer than red ones, *the focus of the camera lens must be extended slightly* to render them sharply, especially when the No. 87

**5-4** *Effect of a polarizing filter used on the camera.*

**A:** *Without filter*

**B:** *With filter*

**5-5** *Infrared focusing index on a lens.*

filter is used. Some lenses have a special red index mark on their focusing scale (Fig. 5-5) to use for this purpose.

### Processing

Infrared film can be developed like other black-and-white films (see next chapter), but steel tanks *with steel lids and caps* should be used since some black plastic lids will pass infrared rays. Once the negatives are processed, they may be handled and printed like any others.

## NEUTRAL-DENSITY FILTERS

These are *neutral gray* filters that are occasionally used to reduce the amount of light entering the lens without changing color values. They are designated by their density; .3 reduces the light by one stop, .6 by two stops, and .9 by three stops. Because they are neutral, they can be used with color film as well as black-and-white. They have no effect on tone or color rendering; they only reduce the amount of light. These filters make it possible, for example, to use very large apertures (for selective focus) or very long exposure times (for deliberate blurring) in bright light. They are also useful to control exposure with cata-dioptric (mirror) lenses, which have no adjustable apertures.

## CONVERSION FILTERS FOR COLOR PHOTOGRAPHY

These filters are used to change the color balance of light from daylight to tungsten or vice versa, as further explained in Chapter 9. They allow daylight color film, for example, to be used in tungsten light, or tungsten color film to be used outdoors in daylight. Since the film's color balance cannot be changed, the filter converts the light balance to match it. The two most useful conversion filters are the No. 80A, a deep blue filter that converts tungsten studio light to the color balance of daylight, and the No. 85B, a salmon-colored filter that converts daylight to the color of tungsten studio light. Conversion filters are sometimes called light-balancing filters.

## COLOR-COMPENSATING FILTERS

These filters are made in the six primary and secondary colors (see the color circle, Plate 5), and in density values from .025 to .50. They are designated by density and color, with a prefix of CC (a CC10Y filter is a yellow filter with a density of .10; others are similarly identified). The cyan, magenta, and yellow sets are used for color printing (Chapter 11); these and the other colors can also be used to adjust the colors of transparencies or slide film images.

## FORMS OF FILTERS

Filters for use on camera lenses are made in two forms. *Gelatin filters* are thin squares of dyed gelatin, lacquered on both sides. They are available in many colors for general and technical work. Because they are very thin, they seldom interfere with image sharpness, but they are easily soiled. They must be handled with great care, and only near their edges. Clean gelatin filters only by whisking them lightly with a lens brush or air syringe; never rub them with anything. A scratched or soiled gelatin filter should be discarded and replaced.

*Glass filters* are circular and are mounted for easy attachment to the lens. They are more convenient to use than gelatin ones, but are more expensive. Because they are thicker, glass filters may soften the sharpness of an image when used on lenses of extremely long or short focal length. If kept clean and properly positioned in front of the camera lens, however, glass filters can be useful camera accessories.

Filters for color printing and for contrast control in black-and-white printing are made as dyed sheets of acetate or polyester than can be cut to fit enlarger lamphouses. These should not be used on camera lenses since they are intended only for coloring raw light and may reduce the sharpness of camera images.

## SUMMARY

1. A filter *blocks* or *absorbs certain colors of light* while passing others.
2. Any filter *lightens* the rendering of its *own* color and *darkens* the rendering of its *complement*.
3. *Contrast filters* for black-and-white photography let you lighten or darken some tones in the print while leaving others unchanged. Blue sky, for example, can be darkened to make clouds more visible or dramatic.
4. Filters require an *increase in exposure* to allow for the light they absorb. Cameras with through-the-lens (TTL) meters or automatic exposure systems take care of this automatically, but with other cameras or hand-held exposure meters, the exposure must be increased by the appropriate *filter factor*.
5. Polarizing filters, which block polarized light, are useful to *reduce or eliminate reflections* from water, glass, or other smooth, nonmetallic surfaces.
6. *Infrared filters* can be used with *infrared film* to make strangely beautiful landscape photographs or clear, haze-free images of distant views. Special handling, exposure, and focusing techniques are required with these films.
7. *Neutral-density filters* are used to reduce the amount of light entering the lens without changing color values or making the aperture smaller.
8. In color photography, *conversion filters* are used to convert daylight to tungsten color balance, and tungsten studio light to daylight balance. *Color-compensating (CC) filters* are used for color printing and for making minor adjustments to the color of transparencies or slides.
9. *Gelatin filters* are best for use on the camera lens but are fragile and easily soiled. *Glass filters* are more durable and more expensive, but they can reduce image sharpness in some uses.

# 6

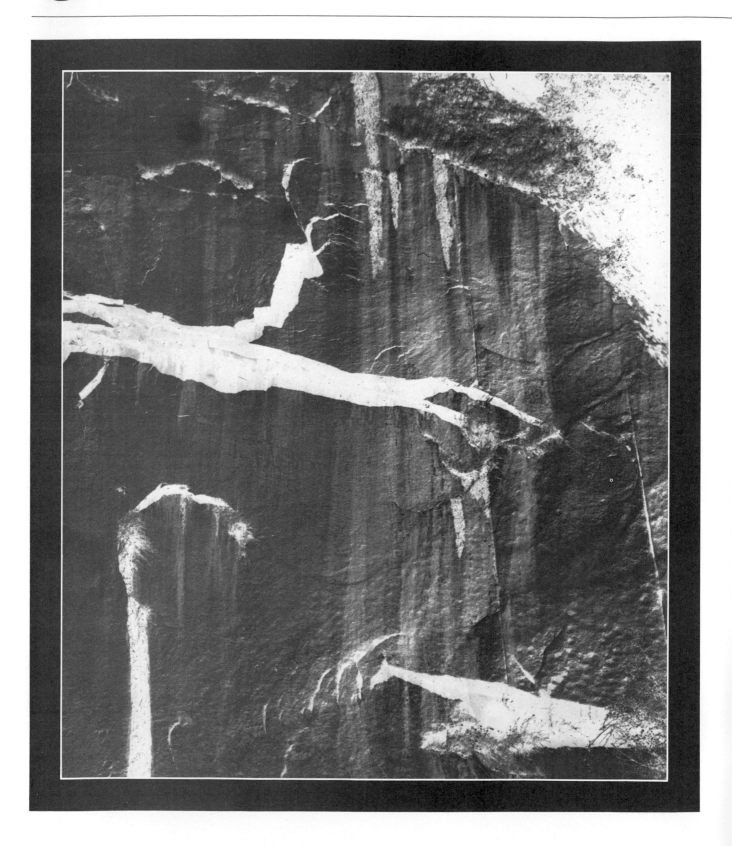

# PROCESSING BLACK-AND-WHITE FILM

**6-1** *Feather River canyon near Belden, CA, 1988 (negative state). Compare with Figure 7-1.*

Processing the film makes its latent images visible, brings them to full intensity, and makes them permanent. The sequence for black-and-white materials is relatively simple and is described in this chapter. Color film processing involves additional steps and is outlined in Chapter 10.

## THE PROCESSING STEPS

There are five major steps in black-and-white processing:

1. **Developing,** which makes the latent images visible.
2. **Rinsing,** which stops the development.
3. **Fixing,** which removes the light sensitivity from the emulsion and hardens it.
4. **Washing,** which removes all dissolved chemicals from the film or print to preserve it.
5. **Drying,** which completes the process.

Let's take a closer look at each step.

### Developing

The developer reduces *exposed* silver bromide crystals to tiny particles of silver metal. Concentrated in the emulsion, these particles absorb light and appear dark, producing the familiar, gray-toned image we call a *negative.* To be useful, the developer must discriminate between exposed and unexposed silver bromide crystals, for if it did not, all of these crystals would be reduced to silver and that would produce a completely black film on which we could see no pictures.

Developers come as powders to be dissolved in water or as concentrated liquids that only need to be diluted to use. Most black-and-white film developers are one of three basic types: general purpose, fine grain, or high energy. The most popular of each type are listed in Table 6-1.

*General-purpose developers* produce negatives of excellent printing quality with most films. They are best for all-around use and are particularly good choices for beginners. Some, such as D-76, are economical in large quantities, and are provided by many school and college photography labs.

*Fine-grain developers,* as their name suggests, produce negatives with a finer grain structure than most general-purpose developers do. This makes them useful for small negatives that will be greatly enlarged when printed. With some fine-grain films, these developers can produce crisp, brilliant negatives that contain fine tone quality and detail, but only if the films are correctly exposed; over- or underexposures nullify this advantage.

*High-energy developers* can be used to process film exposed in very dim light. With these developers it is often possible to triple the effective film speed (ISO), but under these conditions you should not be surprised if your pictures look grainy and lack some detail.

***One-shot or Replenished Use?*** Most black-and-white film developers should be prepared as *stock solutions,* which are concentrated and have good keeping and storage properties. The best way to use developers is to dilute the stock solution to a *working solution,* use it once, and then discard it. This procedure, called *one-shot use,* gives you a fresh solution of known strength for each use, and with 35mm and rollfilms, the small volume of developer needed is not expensive. For consistent, reliable results, one-shot use is the best way to go.

If larger quantities of developer (2 liters or more) must be used, however, one-shot methods can be expensive and wasteful. In such cases, some developers can be prepared directly as a working solution, and used over and over if you add a *replenisher* solution to the developer tank or jug after each use (p. 87). The amount of film processed, the volume of developer used, and the amount of replenisher added must all be accurately measured, but if you do this with care, you can develop large quantities of film economically.

**TABLE 6-1** COMMONLY USED BLACK-AND-WHITE FILM DEVELOPERS

| General-purpose Developers | Fine-grain Developers | High-energy Developers |
|---|---|---|
| Edwal FG-7 | Acufine ACU-1 | Acufine |
| Ilford ID-11 Plus | Ethol UFG | Kodak T-Max |
| Kodak D-76 | Ilford Microphen | |
| Kodak HC-110 | Kodak Microdol-X | |

***Time, Temperature, and Agitation.*** Like most chemical reactions, development occurs more rapidly as the temperature rises. For each temperature there is an optimum time, and this should be carefully observed. Other factors also affect the result, but the *time-temperature relationship* is fundamental. Figure 6-2 shows this relationship for a typical black-and-white film and developer.

The *temperature* of the developer and all other solutions used, including the rinse and wash water, *must not exceed recommended limits*. All solutions should be within 5°F of each other at all times, and *it is especcially important not to let the wash water fluctuate in temperature* (this can easily happen if you are not paying attention, especially where many users share a common water supply). Film subjected to sudden changes in temperature can pick up a stress pattern of random, textured ripples, cracks, or circles called *reticulation*. Such an effect is unpredictable and irreversible, and unless sought for its graphic qualities, it becomes a permanent, undesirable addition to the pictures (Fig. 6-3).

The *frequency and consistency of agitation* also affect the development rate; the more frequent or vigorous the agitation, the greater the development. As the developer reduces the silver bromide crystals in the emulsion to silver metal, the bromide ions diffuse out of the emulsion and tend to collect on the film surface. Periodic agitation clears away this buildup, which would otherwise slow down development. The bromide ions are held in solution and eventually discarded with it.

### Rinsing

After most developers, a simple water rinse will stop the developer's action. However, an *acetic acid stop bath* is more efficient since it quickly neutralizes the alkaline developer. A stop bath should always be used following a high-energy developer. Some stop baths contain an indicator dye which changes color from yellow to purple when the solution is exhausted, but an equally effective stop bath can be prepared by adding 25 ml of 28% acetic acid to 1 liter of water (1 oz of the acid to 32 oz water).*

The exposed areas of the film will now have a visible silver image. Unexposed areas, however, will still be full of light-sensitive silver bromide, and any light striking the film at this point will ruin it.

---

* To prepare a 28% solution of acetic acid, first dilute 3 parts of glacial (99.5%) acetic acid with 8 parts water. **DANGER:** Glacial acetic acid is toxic and irritating, and can cause severe burns. Handle the acid only in a well-ventilated area. Protect your eyes and skin from splashes, and observe all precautions on the label. Because the reaction gives off heat, **always pour the acid into the water,** never the opposite.

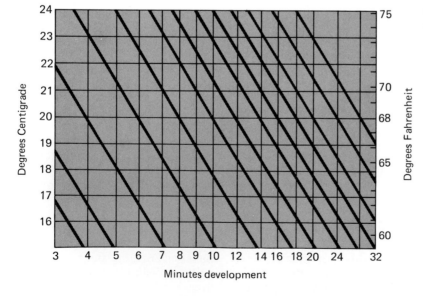

6-2 *Time-temperature relationship for typical black-and-white films.*

**6-3** *Effect of reticulation.*

### Fixing

Removing this unused light sensitivity after development is called *fixing*. Fixing dissolves the silver bromide, leaving the silver metal image in an otherwise transparent emulsion. With its sensitivity gone, the film can no longer be changed by further exposure to light.

Fixers are supplied in both powder and liquid forms. Some liquid fixers are fast-working and are ideal for processing film. Powdered formulas (which need to be carefully dissolved in warm water) work more slowly, but are a bit more economical. All fixers are prepared as *working solutions* that can be used and reused until they are exhausted (a simple chemical test can determine this). If used in large quantities, as often occurs in school and college labs, exhausted fixers should have the dissolved silver ions removed before the solution is discarded (p. 88).

Throughout the preceding steps, water and chemicals have penetrated the gelatin emulsion, swelling and softening it. If we touched the emulsion now, we could damage it and the pictures it contains. Most fixers therefore contain a *hardener* to toughen the gelatin so that when dry, the film can safely be handled with reasonable care.

### Washing and Drying

Washing removes fixer and dissolved silver compounds from the film, leaving only the pure silver image in clean gelatin. Removal of these soluble compounds is necessary to make the image permanent; if they remained in the emulsion they would cause the silver image to ultimately break down into other silver compounds, discolor, and fade.

The rate at which effective washing takes place depends to some extent on the temperature, but it is largely governed by the molecular structure of the gelatin emulsion itself. As long as clean water is supplied to the film surface at a steady rate, washing will proceed until the concentration of fixer and dissolved silver salts in the emulsion is virtually nil. Increasing the flow of clean water faster than the gelatin can absorb it will not improve the washing or reduce the time required for it.

Chemical *washing aids*, such as Heico Perma Wash or Kodak Hypo Clearing Agent, may be used to *help* remove the soluble compounds from the emulsion. They also save large amounts of water by greatly reducing the required washing time (Fig. 6-4). With some of these products, the total washing time can be reduced from 30 to about 3 minutes. However, washing aids, by themselves, remove no chemicals from the film; only the *subsequent* washing step does that.

After washing, the film is briefly bathed in a *wetting agent* such as diluted Kodak Photo-Flo Solution. Using a wetting agent reduces the surface tension of

**6-4** *Effect of using a washing aid when processing film.*

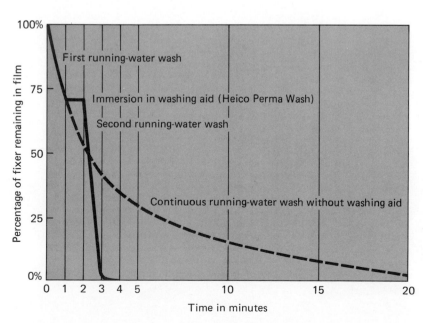

water remaining on the film, and helps it drain quickly off without leaving spots. It also permits faster drying. It is best to prepare the solution in deionized or distilled water, and never make it stronger than the manufacturer recommends.

The treated film should then be hung to dry, *undisturbed, in a clean, dust-free place.*

As soon as it is dry, the film should be cut into strips and placed immediately in protective, transparent *negative preservers.* Polyethylene preservers are the best, and are available to hold an entire roll of 35mm or 120 film as a single sheet that makes contact printing (explained step-by-step in the next chapter) quick and easy.

### Processing Tanks

Stainless-steel, spiral reel processing tanks are preferred by most serious photographers for processing roll and 35mm film. These tanks fill, empty, and transfer heat quickly; they also clean easily and dry quickly, and because they can be inverted, they permit smooth, even development. This kind of tank has only one serious shortcoming: its spiral reels are difficult for beginners to load.

The Paterson plastic tank has most of the advantages of the steel type. It, too, can be inverted for smooth, even development, and its plastic reel is easier than the steel type for most people to load. Although it does not transfer heat as easily as the steel type, its easier-loading reel makes it popular.

Both types of tanks are designed as modular systems so you can stack several rolls of the same kind of film in one tank for simultaneous processing.

*The processing tank must be loaded in total darkness.* A small, dust-free, windowless room or closet will usually meet this requirement, particularly at night, but it must be *totally dark.* A small table in this room will be helpful. Once the tank is loaded and closed, as shown in the illustrated procedures following this section, the rest of the process may be done in normal room light. At home, a kitchen sink or bathroom basin will be convenient and adequate.

### What You Need to Process Roll and 35mm Film

Figure 6-5 shows what you need to process roll and 35mm film. Once the process begins it goes rather quickly, so assemble everything you will need before you start.

Specific procedures will vary somewhat according to the kind of film, tank, and chemicals you use. Most of this information is supplied with the products themselves; follow it with care. Instructions for loading the three most popular tanks and a typical sequence for processing the film are shown in the step-by-step illustrations on pages 72–79.

**6-5** *What you need to process roll and 35mm film:*

1. Timer
2. Bottle opener (for 35mm cartridges)
3. Exposed film
4. Bottles of developer, stop bath (if used), fixer, and washing aid
5. Processing reel and tank
6. Scissors
7. Thermometer
8. Concentrated wetting agent (Photo-Flo)
9. Measuring cylinder (same capacity as your tank)
10. Two wood, spring-type clothespins
11. 8 × 10 tray or plastic dishpan if needed for temperature control
12. Plastic funnel

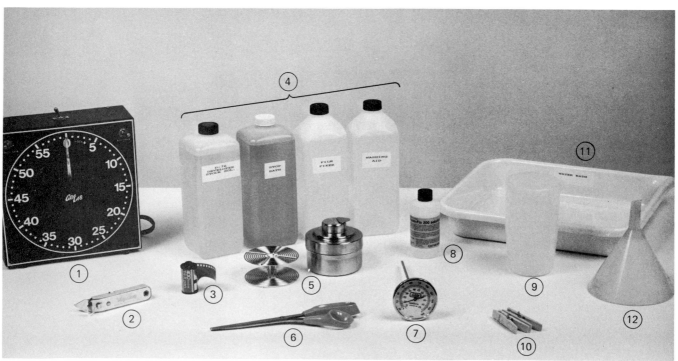

**TABLE 6-2**  DEVELOPING TIMES FOR POPULAR BLACK-AND-WHITE FILMS

### KODAK D-76 OR ILFORD ID-11 PLUS DEVELOPERS

Dilute 1 part developer stock with 1 part water, use the diluted solution once, and then discard it. Agitate tank continuously for first 30 seconds, then for 5 seconds each half-minute thereafter.

| | AGFA Agfapan APX 25 / Agfapan APX 100 / KODAK Plus-X Pan | ILFORD FP4 / Pan F / KODAK Verichrome Pan | AGFA Agfapan 400 / KODAK T-Max 100 / T-Max 400 / Tri-X Pan | ILFORD HP5 | KODAK T-Max P3200* | |
|---|---|---|---|---|---|---|
| 18°C | 8 minutes | 10½ minutes | 12½ minutes | 14½ minutes | 13½ minutes | 65°F |
| 20°C | 7 minutes | 9 minutes | 11 minutes | 12½ minutes | 11½ minutes | 68°F |
| 21°C | 6½ minutes | 8½ minutes | 10 minutes | 11 minutes | 10½ minutes | 70°F |
| 22°C | 6 minutes | 7½ minutes | 9 minutes | 10½ minutes | 10 minutes | 72°F |
| 24°C | 5 minutes | 6½ minutes | 8 minutes | 9 minutes | 8½ minutes | 75°F |
| 25°C | Not Recommended | 6 minutes | 7 minutes | 8 minutes | 7½ minutes | 78°F |

*The above times will produce medium contrast negatives suitable for printing in condenser enlargers. Increase times for more contrast, decrease them for less.*
*\* Develop this film in undiluted D-76 stock solution. Times given are for film exposed at ISO 3200 and printed in a condenser enlarger. For other speeds and conditions, see information packed with film.*

### KODAK MICRODOL-X DEVELOPER

Dilute 1 part developer stock with 3 parts water, use the solution once, and then discard it. Agitate tank continuously for first 30 seconds, then for 5 seconds each half-minute thereafter.

| | AGFA Agfapan APX 25 / KODAK Plus-X Pan | KODAK Verichrome Pan | AGFA Agfapan APX 100 | AGFA Agfapan 400 / ILFORD FP4 / Pan F / KODAK Tri-X Pan | ILFORD HP5 / KODAK T-Max 100 / T-Max 400 | |
|---|---|---|---|---|---|---|
| 18°C | 13½ minutes | 16 minutes | 17 minutes | 19½ minutes | Not recommended | 65°F |
| 20°C | 11½ minutes | 14 minutes | 15 minutes | 16½ minutes | 21 minutes | 68°F |
| 21°C | 11 minutes | 13 minutes | 14 minutes | 15½ minutes | 20 minutes | 70°F |
| 22°C | 10 minutes | 12 minutes | 13 minutes | 14½ minutes | 18½ minutes | 72°F |
| 24°C | 8½ minutes | 10 minutes | 11 minutes | 12½ minutes | 16 minutes | 75°F |
| 25°C | 7½ minutes | 9½ minutes | 10 minutes | 11½ minutes | 14 minutes | 78°F |

*The above times will produce medium contrast negatives suitable for printing in condenser enlargers. Increase times for more contrast, decrease them for less.*

**TABLE 6-3**  SUMMARY OF BLACK-AND-WHITE FILM PROCESSING

The best temperature for steps 1 through 7 is 20°C (68°F).

| Step | Solution | How Prepared | Time | Agitation |
|---|---|---|---|---|
| 1. | Developer | See Table 6-2 or instructions on package | See Table 6-2 | See steps 5, 7 (pp. 77, 78) |
| 2. | Stop Bath | 28% Acetic Acid diluted 1:20, or plain water may be used | 1 minute | Constant |
| 3. | Fixer* | As directed on label for films | 5 minutes | Intermittent* |
| 4. | First Wash | Running water in open tank | 1 minute | (Waterflow) |
| 5. | Washing Aid | As directed on label for films | 1–2 minutes | Constant |
| 6. | Final Wash | Running water in open tank | 1–5 minutes | (Waterflow) |
| 7. | Wetting Agent | Photo-Flo as directed on label | ½ minute | Constant |
| 8. | Drying | Air dry, not over 38°C (100°F) | Until flat | None |

*\* For Kodak T-Max films, use only fresh fixer with vigorous agitation.*

# HOW TO LOAD 35MM STEEL-REEL TANKS

### 1 / get everything ready

Have all tank parts, scissors, the film, and a bottle or cartridge opener within reach. **Total darkness is required from here on.**

### 2 / open the cartridge

Hold the cartridge at the protruding end and pry off the **other** end cap with a bottle opener or cartridge opener. Remove the spool of film.*

### 3 / cut off the narrow leader

With scissors, trim the end square about an inch or two beyond the tongue. Cut **between** the holes, not through them. Hold film only by the edges.

### 4 / position the reel for loading

Hold the reel in one hand and press down the small spring clip at its center (if reel has no clip, locate the open channel with your index finger).

### 5 / start loading the reel

Unwind about three inches of film and bow it slightly. Insert this end into the clip, centering it with your thumb and finger as shown (if reel has no clip, sharply bend about $1/4$ inch of film around a crossbar in the core of the reel).

### 6 / continue loading the reel

Place both the reel and the roll of film you are holding on a clean table. Turn the reel slowly as you bow the film slightly, letting the reel pull it **loosely** through your fingers into the spiral.

* Instamatic cartridges (size 126) can be opened **in the dark** by holding their two ends, one in each hand, with your thumbs over the cartridge label. Then **bend** the cartridge **back over your thumbs** until it breaks, remove the roll of film from one end, and separate it from its paper backing. Proceed as above for 35mm film.

Cut off the spool and finish loading the reel by rotating it until the end of the film snaps into the spiral grooves.

Hold the reel in one hand and tap the flat side with your finger. A slight rattle indicates the film is correctly loaded. If you can hear no rattle, the film is too tightly wound and may be touching itself in the reel. This will cause undeveloped spots. To avoid this, unwind the film and reload the reel.

Place the reel into the tank and press the cover firmly on. Room lights may now be turned on.

# HOW TO LOAD 120 STEEL-REEL TANKS

**1 / get everything ready**

Have all tank parts, the reel, and the film close at hand where you can find them in the dark. **Total darkness is required from here on.**

**2 / in darkness, unroll the film**

Break the seal and unroll the backing paper. The film will remain in a tight roll as you continue pulling the paper.

**3 / separate the film from the paper**

Fold back the paper where the end of the film is attached to it. **Slowly** tear the paper from the film. Discard the paper and spool.

**4 / start loading the reel**

Secure the taped end of the film under the clip. Center the film with thumb and forefinger. From here on, try to handle the film only by its edges.

**5 / finish loading the reel**

Hold the film flat and the reel on edge on a clean table, as shown. Slowly rotate the reel and let it pull the film loosely through your fingers and into the spiral as it turns.

**6 / check the loaded reel**

Tap a side of the reel with your finger to check for proper loading. If the film rattles, it's OK.

**7 / place the loaded reel into the tank**

Place the reel into the tank and press the cover firmly on. Room lights may now be turned on.

# HOW TO LOAD THE PATERSON SUPER SYSTEM 4 TANK

### 1 / get everything ready

Have all tank and reel parts, scissors, the film cartridge, and a bottle or cartridge opener within reach. **Total darkness is required for steps 3 through 10.**

### 2 / adjust the reel for your film size

Turn the two halves of the reel firmly clockwise against each other until they click. Then adjust them to the required film width. Now turn them firmly counter-clockwise until the locking mechanism clicks back into place. If the halves separate completely, be sure the notches on the center cores coincide when reassembling.

### 3 / prepare films for loading

In darkness, trim the end of 35mm film square with scissors about an inch or two beyond the tongue (upper photo). Cut **between** the holes, not through them. With 120 film, break the seal and unroll it until you can feel the loose end. Hold film only by the edges.

### 4 / position the reel for loading

Hold the reel in one hand with the entry points **on top** and **facing you.**

### 5 / insert the film

With care, push the film into the reel under the entry points, advancing it as far as it will freely go.

### 6 / wiggle the sides of the reel

Move the two sides back and forth against each other with a rotary motion, and let the reel pull the rest of the film into itself.

/continued

Cut off the spool before it reaches the reel, and continue wiggling the reel until all of the film is loaded. With 120 film, slowly tear off the backing paper.

Slip the loaded reel on the center column, pushing it all the way down to the flange. In the Universal tank, a second Paterson reel adjusted for 35mm may be loaded and stacked above the first one.

Lower the column and reel into the tank. It should seat easily in the center.

Seat the funnel in the column and turn it clockwise until it clicks. **Room lights may now be turned on.**

See the bottom of the tank for the volume needed for each roll. Proceed with the process on page 77, steps 1 through 3, but **do not tip** the tank while filling.

Insert the stick into the funnel and twist it sharply back and forth several times (left). Then tap the tank on the sink or table to release air bubbles and place the soft plastic cap over the funnel (right). Be sure it seals all around. Now proceed as shown in step 5, page 77. A water bath is not needed with this tank.

# PROCESSING BLACK-AND-WHITE FILM

### 1 / prepare the developer

Prepare enough solution to fill your tank.* Dilute the film developer stock solution as directed (D-76 is diluted with an equal volume of water) and check the temperature of the diluted solution.

If the room temperature is below 20°C (68°F) or above 24°C (75°F), fill a pan with enough water at the same temperature as the developer to immerse the lower part of the tank (but not the lid). Place the tank in this bath after each agitation cycle to stabilize the temperature in the tank.

### 2 / set the timer

Select the proper development time from Table 6-2 on page 71. For other developers, see instructions packed with them.

### 3 / start the timer and fill the tank

Start the timer and pour the developer slowly into the tank **without stopping.** Tilt steel tanks slightly for easier filling. Continue pouring until the tank is full.

An alternate procedure is to **turn off all lights,** open the tank and remove the reel of film. Now, in the dark, pour the prepared developer into the empty tank, start the timer, and immediately drop the loaded reel into the tank of developer. Replace the lid on the tank, turn on the lights again, and continue with the next step.

### 4 / release air bubbles

Tap the tank sharply on a sink or countertop to release air bubbles which can form on the film surface. This will allow the developer to reach all parts of the film.

### 5 / agitate the tank

Cap the tank and hold it with your thumb on the cap. Then gently turn it over and back **continuously** for 30 seconds.

### 6 / maintain the temperature

After the initial agitation cycle, set the tank down or return it to the water bath if you are using one.

---

* For 35mm steel-reel tanks use 250 ml (8 oz) for each reel, for 120 steel-reel tanks use 500 ml (16 oz) for each reel, and for Paterson tanks see the tank bottom.

## 7 / agitate regularly

Every half minute, pick up the tank and agitate it for **two cycles.** This should take about five seconds.

## 8 / maintain the temperature

After each agitation cycle, return the tank to the sink or water bath.

## 9 / pour out the developer

Just before the development time is up, remove the cap from the pouring opening **but do not remove the tank cover.** When time is up, empty the tank, discarding the used developer.

## 10 / pour in the stop bath

Fill the tank with water or stop bath. Be careful not to remove the cover.

## 11 / agitate for one minute

Tap the tank as before to release air bubbles, then agitate **continuously** for one minute by inverting as before.

## 12 / discard the used stop bath

Although this solution may be reused, it is inexpensive and easier to store as a fresh concentrate. Don't remove the tank cover yet.

## 13 / fill the tank with fixer

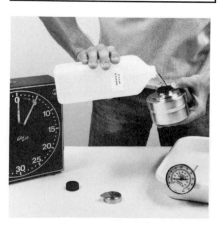

Reset the timer for 5 minutes (10 minutes for some types of fixers), pour in the fixer, and start the timer. Agitate occasionally as you did with the developer in step 7.

## 14 / pour out the fixer

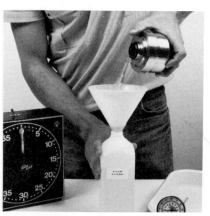

Return the fixer to its bottle or jug. It can be reused and later de-silvered.

## 15 / wash the film

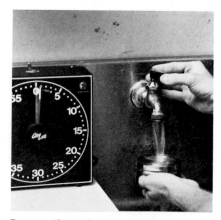

**Remove the tank cover** and direct a stream of water at 20°C (68°F) into the core of the reel. Let the tank overflow for one minute, then empty it.

## 16 / fill the tank with washing aid

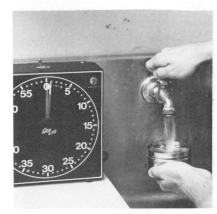

Immerse the film in Perma Wash solution for one minute (two minutes for Kodak Hypo Clearing Agent).

## 17 / pour out the washing aid

Return the washing aid to its storage bottle. It can be reused until it becomes cloudy.

## 18 / wash the film again

Let the open tank fill with water as before and overflow for one minute (5 minutes if Kodak Hypo Clearing Agent was used in the preceding steps). While the film is washing, prepare a tankful of wetting agent as directed on its label.

## 19 / add the wetting agent

Empty the wash water and fill the tank with Photo-Flo solution. Turn the reel gently to stir the solution for about 30 seconds.

## 20 / hang up the film to dry

Quickly unwind the film with care, lifting one end as you go. Attach a clip or clothespin to this end and hang the film in a dust-free location. At home, a tub or shower enclosure is a good place.

## 21 / weight the bottom end

Attach another clothespin to the bottom of the film and let it hang **undisturbed until dry.** As the film dries it will curl, but it will flatten out again when completely dry.

## 22 / cut negatives into strips

Cut the dry negatives into strips to fit negative preservers. **Do this on a clean, dry table, and handle the film only by its edges.**

## 23 / protect the processed negatives

Insert the strips into clear, polyethylene negative preservers. You can later make a contact sheet of the negatives without removing and handling them. Be sure the emulsion (dull) side of each strip is down.

## 24 / clean up

Wash all tank parts, reels, thermometer, measuring cylinder, and funnel, and rinse off the outside of your chemical bottles. **Dry the reel thoroughly before loading it again.**

## EVALUATING YOUR NEGATIVES

Two good negatives are shown in Figure 6-6. **A** was made in bright sunlight; its strong, dark highlights and clear shadow areas are easy to see. **B** was made in overcast daylight, which made the highlights and shadows softer or less apparent.

Shadows, highlights, and many gray tones are visibly separated from each other in each of these negatives. Detail is present in all areas; no important part of the image is completely transparent or opaque. Technically good negatives, then, have these identifiable characteristics: a variety of gray tones with no single shade of gray dominant, and detail in all important areas, from highlights to shadows.

How do your negatives look? Film processing is a sequence of events rather than a single step, so each visible effect can have several causes, including those related to exposure in the camera. Most can easily be identified by reviewing your procedures and by comparing your negatives with the examples shown on the following pages.

**6-6 Two good negatives:** *A was made in bright sunlight, B in overcast daylight.*

A

B

# NEGATIVE FAULTS CAUSED BY CAMERA WORK

### 1. Overexposure

Dark, gray or black tones everywhere in the image, with little variation or detail visible. **To correct**: reshoot with smaller aperture, shorter exposure time, or higher ISO (ASA) setting on meter.

### 2. Underexposure

Highlights (skies) may have adequate tone but shadows are clear without detail. **To correct**: reshoot with larger aperture, longer exposure time, or lower ISO (ASA) setting on meter.

### 3. Camera movement

Detail appears streaked or blurred in one direction. **To avoid**: Use a tripod and cable release whenever possible, or shutter settings faster (shorter) than 1/250 sec.

### 4. Image out of focus

No sharp detail visible anywhere in important parts of the image. **To correct**: reshoot with camera refocused on the most important part of your subject.

### 5. Light leaks

Vertical (35mm) or horizontal (120 formats) black streaks across film caused by light leaking into camera back or film cartridge. **To avoid**: Load cameras only in subdued light, and make sure the back closes firmly and completely.

### 6. Clear film with edge printing

Camera was improperly loaded so film did not advance, or shutter did not operate and film was not exposed. **To avoid**: Check these mechanical aspects of the camera before loading, and **before** you close the back of the camera, be sure film actually moves when you operate the advance lever.

# NEGATIVE FAULTS CAUSED BY PROCESSING

### 1. Irregular opaque or clear areas

These indicate improper loading of the tank or reel. Parts of the film touched, resulting in undeveloped (clear) or completely unprocessed (opaque) areas. This is a common problem with steel spiral reels. **To avoid:** Be sure reel is clean and dry, and practice loading it with an unexposed roll of film that you can later discard.

### 2. Cinch marks or "moons"

Small, dark, curved marks on negatives. Another common problem with steel spiral reels, caused by squeezing or pinching the film when loading. Creasing or bending the film leaves these pressure marks when it is developed; they appear as light "moons" in the print. **To avoid:** Handle the film only by its edges when you are loading the reel.

### 3. Insufficient developer

Frames only partially developed. **To avoid:** Check tank capacity and measure enough developer to fill it completely.

### 4. Trapped air bubbles

Small, round, clear spots randomly scattered. These are caused by air bubbles that were not dislodged from the film when development started. **To avoid:** Tap the tank more vigorously.

### 5. Uneven development

Streaks in sky near sprocket holes, or dark, uneven tones along film edges. Uneven development resulting from too little or too much agitation. **To correct:** Take it easy when you agitate your tank and try to use a consistent rhythm.

### 6. Overdevelopment

Highlights too dark but shadows still clear. Film developed too long, temperature of developer too high, or tank was agitated far too much. **To correct:** Check these factors again.

### 7. Underdevelopment

Entire negative, including edge numbers, looks weak and gray. Film not developed long enough, developer too cold, or insufficient agitation was used. Can also be caused by exhausted, oxidized, or contaminated developer. **To correct:** Check above factors and time-temperatures (Table 6-2). If your developer is tea-colored, replace it with fresh solution.

### 8. Clear film without edge printing

Usually caused by contaminated or exhausted developer, or by using fixer **before** the developer instead of after it. **To correct:** Use fresh developer at the beginning of the process.

### 9. Insufficient fixing

Image is visible but ligher areas and borders have a milky-gray appearance. This signals incomplete fixing, perhaps from exhausted fixer. **To correct:** If you notice this condition immediately after processing, you can usually refix the film in fresh fixer and rewash it without damage. If allowed to remain unfixed, however, the negatives will soon discolor and fade.

### 10. Dust and fingerprints

Small, black, hair-like marks, most visible in clear areas such as skies, indicate dust sticking to film. Fingerprints are more obvious. **To avoid:** Hang wet film to dry in a clean, dust-free place, and don't handle it while it is drying. As soon as film is dry, cut negatives into strips and place them in polyethylene preservers.

# HOW EXPOSURE AND DEVELOPMENT RELATE

Negatives 2, 5, and 8 were all normally exposed. Negatives 1, 4, and 7 were given 1½ stops less exposure; negatives 3, 6, and 9 were given 1½ stops more than normal. Negatives 4, 5, and 6 were normally developed. Negatives 1, 2, and 3 were developed twice the normal time; negatives 7, 8, and 9 only half of the normal time. Compare the center negative, number 5 (which is normally exposed and developed), to the other eight around it. The differences are further discussed in the text.

1 / *underexposed, overdeveloped*

2 / *normally exposed, overdeveloped*

3 / *overexposed, overdeveloped*

4 / *underexposed, normally developed*

5 / *normally exposed, normally developed*

6 / *overexposed, normally developed*

7 / *underexposed, underdeveloped*

8 / *normally exposed, underdeveloped*

9 / *overexposed, underdeveloped*

## HOW EXPOSURE AND DEVELOPMENT RELATE

Good negatives, of course, make good prints. Poor negatives (like the examples on pp. 81-83), which contain errors in exposure or processing, will produce prints that also show those errors rather than overcoming them. Changing the exposure and developing times of a film, however, can sometimes improve a negative's tonal scale, and this, in turn, can make better prints possible.

What happens when exposure and development times are increased or decreased? The group of nine negatives on page 84 shows the result typical of each change. Compare the center negative (5) to each of the eight negatives around it. Notice how *highlights* (darkest areas of each negative) tend to darken more as development lengthens (2), but lighten as development is shortened (8). Shadows (lightest areas of the negative) change similarly, but to a much less degree.

Exposure changes, on the other hand, affect *shadows* more directly; decreasing exposure (4) weakens them, whereas increasing exposure (6) makes them darker. Highlights are affected less by exposure changes than by development changes.

Notice, too, how these factors interact. *Decreasing both* exposure and development (7) produces negatives with little detail and poor tone separation. *Increasing both* (3) creates an excess of silver everywhere; printing times will be longer (see next chapter), and tone separation does not improve.

However, these same factors can be played off against each other with useful results. For example, when film is *overexposed and underdeveloped* (9), shadows and highlights both retain detail and tone separation. This procedure is helpful when the subject is high in contrast (as shown in Fig. 6-7 **A** and **B**).

When the exposing light is flat, as on an overcast day, or when subject values are similar throughout the picture, *underexposing and overdeveloping*

**6-7**  *Effect of changing exposure and development.*
*Top: Subject with moderately high contrast. **A**: Print from normally exposed, normally developed negative. **B**: Print from overexposed, underdeveloped negative. Bottom: Subject in open shade, where contrast is low. **C**: Print from normally exposed, normally developed negative. **D**: Print from underexposed, overdeveloped negative.*

A

B

C

D

the film (1) extends the tonal range of the negative, and a richer, more lively print will result (Fig. 6-7 **C** and **D**).

These procedures work well with most black-and-white films and general-purpose developers. They will also work with color slide (transparency) films, but not with color negative (print) materials. Changing the developing time of most color negative films causes undesirable color changes that make good prints difficult or impossible to obtain from them.

## HANDLING PHOTOGRAPHIC CHEMICALS SAFELY

Most photographic chemicals are safe to handle if you heed the warnings on their labels and use common sense. All of them, without exception, should be kept away from children and from anyone who cannot read their labels. The major health hazards come from breathing their vapors or dust, from skin contact with certain powders and solutions, and from accidentally swallowing them.

Powdered chemicals, acids, and most chemicals for color processes should be mixed and used only in well-ventilated areas so that their dust and vapors do not hang in the air or concentrate in one place. Proper ventilation of darkrooms is especially important. Masks with appropriate filters are helpful when handling powders and strong acids.

When you are handling liquid chemicals, use care to avoid splashing them in your eyes. Safety goggles are helpful, particularly when handling strong acids (such as *glacial* acetic acid). Whenever you prepare liquid chemicals, it is a good idea to have a small stream of water running from a nearby faucet so that you can quickly rinse any spills off your skin. *If you get any chemical into an eye, even in a tiny amount, flush the eye with clean water for at least 10 minutes, and get medical advice at once.* Because so many photographic chemicals look like water, it is best to wipe up or rinse away spills as soon as they occur. **Do not eat or smoke in the work area.**

A few individuals are unusually sensitive to certain photographic chemicals, especially developing agents known as Metol or Elon, and paraphenylenediamine. Contact with these chemicals can cause itching, a rash, or (rarely) open skin sores in these people. Known as *contact dermatitis*, this problem can be avoided by using rubber gloves or by using developers made with metol-substitutes such as Phenidone.* Consult a physician if the reaction is severe.

## Preparation of Chemicals

Developers for black-and-white processes are often prepared as concentrated *stock solutions*. For use, these stock solutions are diluted with water to make *working solutions*, which typically are used only once and discarded. Stock solutions keep better than diluted ones, and use less storage space. Most other photographic chemicals are prepared as working solutions, ready to use.

Always dissolve or mix the ingredients of a solution in the order given in the instructions or formula. Ordinary tap water is adequate for most photographic solutions;† be sure it is the proper temperature for mixing. Developer powders, for example, usually require warm water for mixing; don't forget to let these solutions cool to approximately room temperature (20°C or 68°F) before using them. As you mix, stir the solution long enough to thoroughly dissolve all powdered ingredients, but avoid stirring excessive air into the solution as that will help it to oxidize and spoil.

## Storing Photographic Chemicals

Photographic solutions should be stored in plastic bottles with tight-fitting caps. Empty bottles originally used for milk or drinking water are usually satisfactory, but bottles that originally contained laundry bleach, herbicides, insecticides, or other poisons should *not* be used. Always label and date each bottle so you will know the identity and freshness of each solution.

Developers should be stored in full containers because they readily oxidize. As you use small amounts of them, transfer the remainder to smaller bottles. Developers kept in partially filled bottles with large amounts of air inside quickly go bad.

Properly bottled, most black-and-white developers can be stored for several weeks (see product labels or literature for specific data), while most stop baths, fixers, and washing aids can be stored several months without difficulty. Chemicals for color processes, however, often have shorter storage lives, and for best quality results, these should not be extended.

## Keeping Your Darkroom Clean

Vacuum your darkroom frequently to remove dust, and keep all tanks, trays, measuring cylinders, chemical containers, and darkroom table surfaces spotlessly clean. Once the residue of a chemical dries on a container or utensil, it may be difficult or impossible to remove. The simple habit of washing every utensil

---

* Metol, Elon, and Phenidone are trademarks.

† Wetting agents, such as Photo-Flo, and stabilizers for color processes should be mixed in purified or distilled water.

after each use will go a long way toward making your darkroom a clean and healthy workplace.

## THE CHEMISTRY OF BLACK-AND-WHITE PROCESSING

### Development

As we noted earlier in this chapter, the first step of processing is to make the latent image visible, and this is known as *development*. A typical developer contains several chemicals dissolved in water. Its most important ingredients are called *developing agents*, and their task is to reduce the exposed silver bromide crystals to silver metal by causing these exposed crystals to break down into their two components. To do this, the developing agents give up some of their chemical energy to the silver ions in those crystals, producing silver metal. In the process, the developing agents themselves are oxidized to a less active state.

Development begins at the sensitivity specks in each exposed crystal (p. 59). Like most chemical reactions, it goes faster as the temperature is raised. The longer the developer works on the film or paper, the more it breaks down the exposed crystals of the latent image to produce silver metal.

The most common developing agents in today's black-and-white processes are hydroquinone, Metol (Elon), and Phenidone. Hydroquinone produces intense black tones in a negative or print. Metol and Phenidone work more softly, producing many shades of gray. Most modern developers therefore combine Metol or Phenidone with hydroquinone; this combination works better than any of the developing agents used alone, and it produces an ideal range of densities and contrast in most films and papers. Phenidone, as we noted earlier, has the added advantage of not causing contact dermatitis with people who are sensitive to Metol.

Almost all developing agents work best in an alkaline environment, usually provided by the addition of sodium carbonate, sodium hydroxide, or borax to the solution. In such alkaline solutions, developing agents have a tendency to oxidize, or combine with oxygen from the air, and this weakens their ability to reduce silver bromide. Sodium sulfite is commonly used to retard this oxidation. When present in large quantity, as it is in D-76 developer, sodium sulfite also tends to reduce the size of silver grains in the emulsion and thus contributes to a fine grain effect, but it is primarily a preservative.

Most developers also contain a small amount of potassium bromide, which restrains the developing agents from acting on unexposed silver bromide crystals and thus prevents indiscriminate silver formation unrelated to the latent image. Such non-image silver is called *fog*; the potassium bromide thus functions as an antifoggant.

Typical black-and-white developing solutions, then, contain developing agents, an alkali, a preservative, and a restrainer.

***Replenishment.*** The developing procedures for rollfilm recommended earlier in this chapter called for the developer to be used once and then discarded. Such one-shot use insures that fresh solution is used each time, and because processing one or two rolls does not use much solution, it is a good way to work.

Sometimes, however, large quantities of film must be developed simultaneously, or large sizes of film (requiring greater volumes of solutions) must be processed. In these cases, one-shot use could be wasteful and expensive, so an alternate method using *replenishment* is often employed.

If a developer is used and reused, the strength of its developing agents and alkali diminishes, while the amount of bromide (which is released from the developing emulsion) increases. Adding a *replenisher* solution to the used developer corrects this imbalance and restores the developer to its original activity level. Replenishers therefore contain somewhat higher concentrations of developing agents and alkalis than developers do; potassium bromide, on the other hand, is usually omitted from replenishers since the used developer contains enough of it already. By carefully adding a replenisher solution in proportion to the amount of film developed, you can greatly extend the capacity and useful life of many developers, especially where large quantities of solutions are involved.

### Fixing

Fixers must dissolve silver bromide in the emulsion without affecting the silver metal forming the image. Sodium thiosulfate has been used for this purpose since the earliest days of photography, but ammonium thiosulfate works faster and washes out more easily.* Either compound converts the silver bromide to silver thiosulfate, which is highly soluble and easily washed out of the gelatin if the concentration of silver is not excessive, that is, if the fixing solution is not overworked.

Overworking the fixer leaves unfixed silver bromide in the emulsion, usually visible as a milky, pink cast in processed film. Whenever this condition is observed after fixing for the maximum recommended time, the fixer is exhausted and should be replaced. Refixing an affected film immediately in fresh solution will usually save it.

---

* Sodium thiosulfate was used by Sir John Herschel to dissolve silver salts as early as 1819, when it was known as hyposulphite of soda. Today many photographers still refer to it as "hypo." Correctly speaking, "hypo" is sodium thiosulfate, but the term is loosely applied to any fixing solution.

A good way to avoid overworking print fixers is to use two fixing baths in succession, dividing the total fixing time between them. In a two-bath process, most fixing occurs in the first bath while the second acts as "insurance" to fully dissolve any remaining undeveloped silver salts. The first bath thus does the "heavy" work and exhausts more rapidly. When its capacity has been reached (as determined by a simple chemical test available from several manufacturers) it is replaced by the fresher second bath, and a new second bath (with full capacity) is prepared. With this arrangement, about twice the usual number of prints can be treated. For large volumes of work, then, the two-bath fixing method is both more efficient and less expensive. But even if only a few prints are involved, the method helps to produce more thoroughly fixed (and therefore more permanent) images.

Most fixers also contain aluminum to harden the gelatin emulsion, typically in the form of potassium aluminum sulfate (potassium alum). Since alum hardens best in an acid solution, acetic, boric, or sulfuric acid also is added, and sodium sulfite is included to prevent the precipitation of collodial sulfur.

Fixing baths, then, typically contain four ingredients: a thiosulfate to dissolve the silver salts, alum to harden the gelatin, an acid to make the hardener efficient, and a preservative to keep the solution clean-working.

### Recycling the Silver

As fixing baths are used over and over, they accumulate increasing quantities of silver thiosulfate and other dissolved silver compounds. This concentration of silver is an economic resource, and it is also a potential water pollutant.

For ages, silver has been a valuable element, and its continued availability for photographic use at reasonable prices depends in part on recycling this costly metal. Since used fixing solutions are a convenient source of it, reprocessing these solutions to remove and recover the silver is a useful conservation measure.

Like other heavy metals, silver in high concentrations is harmful to bacteria used in water pollution control (sewage treatment) systems. By removing it from fixing solutions before discarding them, we also help to reduce its polluting effect. Many local communities with water treatment systems now require such removal of dissolved metals from effluents before they are released to the sewer system.

Silver is removed from used fixing baths by electrolysis. Recovery systems, most of which pass an electric current through the solution and collect the silver on large electrodes or terminals, are available from several manufacturers. Although not practical for small volumes of fixer, such as an individual home darkroom would typically produce, these systems are used by most commercial studios and processing laboratories, and by many school and college departments where local sanitary codes require them,

or where the volume of fixer used is sufficient to warrant recovery. If your school or college recycles its fixing baths, be sure to return them to their storage bottles or other designated containers. *Remember: the silver can be recovered only if the used fixer is saved.*

### Washing

Washing insures survival of the silver image by displacing the thiosulfates and other dissolved compounds from the film or paper. A steady flow of fresh water eventually will diffuse most of the thiosulfates from a gelatin emulsion, but paper fibers tend to release thiosulfates much more slowly. Raising the temperature speeds up this process, but introducing sodium sulfite, sodium chloride, or other salts to the unwashed material dramatically increases the displacement rate of the thiosulfates, particularly from paper fibers, and thus makes the subsequent washing much more efficient. In practice this saves time and water. Sea water, which contains such salts, may be used for washing black-and-white films and papers, but it must be followed by a fresh-water wash to remove the sea salts.

Commercial *washing aids* such as Heico Perma Wash, Kodak Hypo Clearing Agent, and other similar products are more convenient. Some of these products are called *hypo eliminators*, an attractive but erroneous label. Such products eliminate nothing, and in fact add their own dissolved chemicals to those already in the unwashed film or paper. Although they greatly shorten the washing process and improve its effectiveness, they are not substitutes for it. Washing is the only effective way to remove dissolved chemicals and thus make the silver image permanent.

The fixing and washing measures described above will insure a chemically stable photographic image, capable of surviving long enough for most applications. If negatives or prints are to be preserved for half a century or longer, however, *archival processing methods* must be used. These will insure prolonged life for films and papers provided that they are packaged and stored properly. Details of archival processing and storage procedures are given in Appendix B.

### SUMMARY

1. Processing a film makes its latent images *visible*, brings them to *full intensity*, and makes them *permanent*. It involves five major steps: *developing, rinsing, fixing, washing, and drying.*

2. Developing reduces exposed silver bromide crystals (the latent image) to silver metal. There are three types of black-and-white film developers: *general purpose, fine grain, and high energy.*

3. The best way to use most developers is to prepare them as *stock solutions*, dilute them to *working solutions* for processing, and discard the diluted solution after one use. This procedure is called *one-shot use*.

4. When large quantities of developer are needed (for large-batch processing or large film sizes), *replenishing* the tank or storage bottle after each run and reusing the same solution is more economical.

5. Development occurs more rapidly as the temperature of the solution rises; the best time therefore depends on the temperature. *Time-temperature graphs* show this relationship.

6. The temperature of all solutions in the process should be within a few degrees of that of the developer. Sudden changes in temperature can cause *reticulation* of the gelatin emulsion.

7. Consistent *agitation* during development disperses bromide ions from the emulsion and insures more even development.

8. An acetic acid *stop bath* or a water rinse should be used to stop development at the optimum time.

9. *Fixers remove the unused light-sensitivity* of a film or print by dissolving the silver bromide remaining in the emulsion. Most of them also *harden the gelatin.*

10. *Washing removes all dissolved chemicals* from the emulsion, insuring survival of the silver image. *Washing aids* are often used to save time, conserve water, and insure more complete removal of fixer. Treating the film in a *wetting agent* after washing helps it to dry cleaner and faster.

11. Stainless-steel, spiral reel processing tanks are popular for processing film, but other types are available. *All must be loaded in total darkness.* The actual processing can then be done in ordinary room light.

12. There is a useful relationship between exposure and development. Increasing *exposure* primarily adds more detail to *shadows*; increasing *development* strengthens *highlights* and increases *contrast.*

13. *Always keep photographic chemicals away from children* and from people who cannot read their labels. Avoid breathing their vapors or dust, avoid skin-contact with developer powders, and avoid ingesting them. If any are splashed in the eyes, flush the eyes with water and get medical advice at once. *Rinse away or wipe up chemical spills* at once, before they dry, and wash every darkroom utensil after each use. *Follow instructions carefully* when mixing or preparing chemicals, and store them in full plastic bottles, labeled and dated, with tight-fitting caps.

14. *Developers* include developing agents, an alkali, a preservative, and a restrainer. The most common developing agents are hydroquinone, Metol (Elon), and Phenidone. Metol or Phenidone are usually combined with hydroquinone to give proper development to both shadows and highlights of an image. *Replenishers* are chemically similar to developers, except that they contain more developing agents and alkali but no restrainer.

15. The most common *fixers* are sodium thiosulfate and ammonium thiosulfate. Most fixers also contain a hardener, a weak acid, and a preservative. Used fixing solutions are an excellent source of *silver metal*, which can be recovered from them by electrolysis and later reused in film manufacturing.

16. For long-term permanence (50 years or more), *archival* processing methods must be used. See Appendix B.

# 7

# BASIC PRINTING AND ENLARGING

The experience of making a fine photographic print is both a creative visual exploration and a disciplined scientific process. Nowhere in photography do these two aspects of the medium come together more directly, and nowhere else is their combination more rewarding. Like processing film, printing and enlarging involve an orderly chemical sequence, but they also offer us a chance to be selective and creative in much the same way that camera work does. All of our creative effort can be applied to make an individual print, and once made, that print can be easily duplicated. This ability to duplicate a photographic image has been fundamental to the medium since William Henry Fox Talbot produced the first negative more than a century and a half ago.

Today's photographers produce not only traditional photographs but also a rich variety of other pictures that blur the boundaries between photography and other, older print-making processes. Screen printing, lithography, etching, and engraving are now freely combined with photographic images and methods. In this and the following chapter we'll study a contemporary approach to traditional, black-and-white print making. Color printing will be discussed in Chapter 11, and other printmaking processes that are currently used by photographic artists will be considered in Chapter 16.

In photographic printing we customarily take a *negative*, whose light and dark values are reversed from their original order, and make *another negative* image by passing light through the first. A negative of a negative, of course, is a *positive*; both terms, in fact, were given us by Sir John Herschel in 1840, and we still use them today.

## THE DARKROOM

Printing and enlarging require a *darkroom, from which all light can be excluded*, with an electrical outlet and one or two tables. A well designed darkroom should be organized into a *dry area* and a *wet area* that are physically separate from each other.

The enlarger is the major item in the dry area (Fig. 7-2). The other times shown—a safelight, package of photographic paper, contact frame (or enlarging easel), timer, contrast-control filters, dusting brush, and, of course, the negatives to be printed—complete a workable setup.

The wet area contains trays of chemicals and related items used to process the prints (Fig. 7-3). Although a sink with running water makes this area more efficient, the primary requirement is a water-resistant table; washing and drying the prints can be done elsewhere in ordinary light. The wet area also needs *adequate ventilation*—at the very least, an exhaust fan designed so that it will not admit light.

The entire darkroom should be light-tight, or *capable of total darkness*. Once this is assured, white walls will provide maximum reflectance for safe illumination inside. Walls around the immediate area of the enlarger, however, should be dark to minimize undesirable reflections when photographic paper is exposed.

### Safelights

Most black-and-white photographic papers are sensitive pri-

**7-2** *Darkroom dry area setup.*
1. Enlarger
2. Safelight
3. Enlarging easel
4. Photographic paper
5. Contact frame
6. Timer
7. Camel's hair brush (for dusting)
8. Contrast-control filters
9. Negatives to be printed

**7-3** *Darkroom wet area setup.*
1. Safelight
2. Tray of developer
3. Tray of stop bath
4. Tray of fixer
5. Tray of water
6. Print tongs in each tray

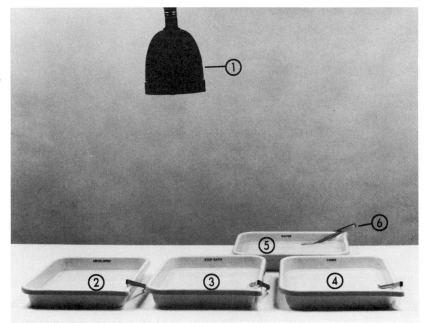

marily to blue light, and they can be handled in orange or yellow illumination provided by safelight lamps with proper filters.* There are two types of safelights in general use. One uses the intense but pure yellow light of a sodium-vapor lamp, and is more suitable for large darkrooms. The other type consists of a filter or colored glass in a lamphouse containing an ordinary light bulb of low wattage. For most black-and-white work, this type should be equipped with a 15-watt bulb and a Kodak OC Filter, and it should be positioned at least 1.2 meters (4 feet) above the trays or enlarger table.

It is important to note that *safelights*, as a rule, *are not absolutely safe*. Most will expose enlarging paper left under them too long or placed too close to the lamp.

## THE ENLARGER

The basic tool for virtually all contemporary photographic printing is the *enlarger*. A good one can be remarkably versatile, performing several other useful functions in addition to its basic printing role. A poor enlarger, on the other hand, will only limit your creativity and skills in the same way that any shoddy tool affects the work done with it. Furthermore, using an inadequate enlarger can weaken all the effort and craftsmanship you expended earlier to visualize your picture and obtain a good negative.

The enlarger works like a camera in reverse. Instead of reducing the larger dimensions of the real world to a few square inches of film as the camera does, the enlarger expands the image produced by the camera so that we can discover all that the picture contains, give it our personal interpretation, and print it large enough to be easily viewed. Because most cameras rely on small formats such as 35mm, the enlarger is a fundamental tool that we use to move from our original picture idea or impression of an object to the final expression of our image.

The enlarger, then, is a vertically oriented projector with the same essential parts that a camera or any other projector has: a lens to form and project the image, a frame to hold the negative in the correct position, and a bellows or cone to connect them and keep out extraneous light. It also has another important part: a source of light.

Any good enlarger has three essential characteristics:

1. It must *project a clear, sharp image* of all parts of the negative frame.
2. It must *distribute light evenly* over the entire projected area.
3. It must be *sturdy*, and its adjustable parts must not vibrate or slip.

---

* Exceptions are papers designed for making black-and-white prints from color negatives. These papers are panchromatic, and must be handled and developed in total darkness.

## Condenser Enlargers

Most enlargers contain a milky-white light bulb as the illumination source. This softens the light, which is then collected by a set of *condenser lenses* that spread it evenly across and direct it straight through the negative below (Fig. 7-4).

Some condenser enlargers, such as the Omega 4 × 5, require you to reposition a movable condenser lens in the enlarger's head if you change from one size negative to another (Fig. 7-5). Other enlargers,

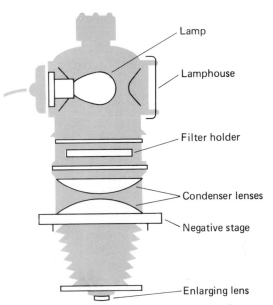

7-4  *Optical system of a typical condenser enlarger.*

7-5  *Variable condenser in enlarger head.*

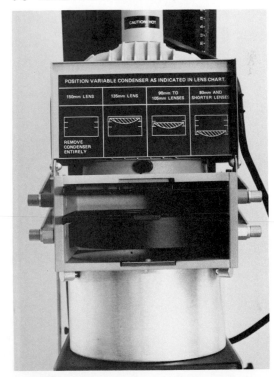

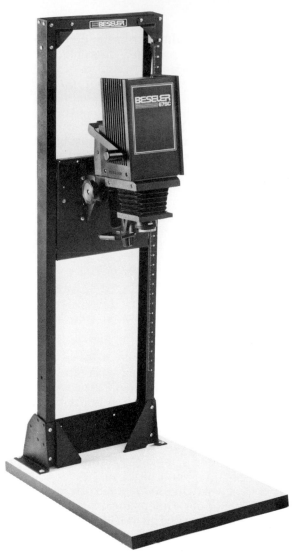

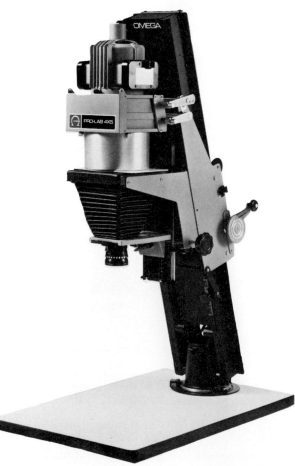

**7-6** *Typical enlargers: Durst M370 BW, Beseler 67SC, and Omega Pro-lab 4 × 5. Courtesy Nutek, Inc., Charles Beseler Company, and RT/Omega Industries.*

such as the Beseler 4 × 5 models, require you to move the negative stage closer to the condenser lenses for larger size negatives, or farther below it for smaller ones. With a fine quality enlarger lens added, these arrangements can project images that have excellent contrast and crisp definition.

Condenser enlargers are efficient and popular; those shown in Fig. 7-6 are a few of several excellent models available.

### Diffusion Enlargers

Some enlargers do not use a condenser system. Instead they pass the light through a sheet of opal or ground glass that scatters and further softens it before it reaches the negative (Fig. 7-7). *Diffusion enlargers,* as these are called, project less contrasty images than condenser types do, but diffusion systems can hide small scratches and similar imperfections in the image, and grain is less noticeable with them. This arrangement causes some loss of fine detail, but it usually produces elegant tone quality in the print. Diffused light source units are available to convert many condenser enlargers to the diffusion type.

### Printing Filters

Enlargers designed primarily for black-and-white photography have a *filter holder* in the lamp or condenser housing. To work with variable-contrast papers (explained below), you must place colored filters in this holder. This feature also permits the enlarger to be used for making color prints (Chapter 11).

Variable-contrast printing filters are supplied in two forms: as *thin, dyed, polyester sheets* (that must sometimes be cut to fit the enlarger's filter holder), or as thicker but smaller *framed plastic squares* designed to hang under the enlarger's lens. The thin filters are less expensive but are easily soiled; the

**7-8** *Contrast-control filters for variable-contrast, black-and-white printing.*

framed squares are more durable but more costly. Either kind is satisfactory for general work, but the thin sheets (Fig. 7-8) are better because they are used in the lamphouse where they color the raw white light before it reaches the negative. There they do not interrupt the projected image, and thus cannot soften or distort it. Either type, of course, must be kept clean.*

If an enlarger is designed primarily for *color printing,* it will have a set of three colored filters *built in.* These filters, adjustable in intensity, make color printing efficient, and they can also be set to do black-and-white work. This kind of enlarger is further explained in Chapter 11.

### The Enlarging Lens

The enlarging lens is a special type of lens with f/ stops just like those on the camera. The focal length of the enlarger lens must be properly matched to the size of the negative (see Table 7-1). With shorter focal lengths, the corners of the projected image may be unsharp or cut off entirely. Longer focal lengths, on the other hand, provide greater coverage and a straighter optical path for the projected image, and this helps to insure sharpness from corner to corner.

**7-7** *Optical system of a typical diffusion enlarger.*

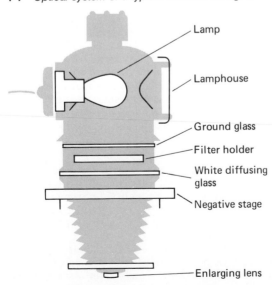

Lamp

Lamphouse

Ground glass

Filter holder

White diffusing glass

Negative stage

Enlarging lens

**TABLE 7-1**  FOCAL LENGTH OF ENLARGER LENSES

| Negative Size or Format | Focal Length of Enlarger Lens |
|---|---|
| 35mm | 50– 65 mm |
| 4.5 × 6 cm (645) | 75– 80 mm |
| 6 × 6 cm (2¼ × 2 ¼ in.) | 75– 80 mm |
| 6 × 7 cm (2¼ × 2 ¾ in.) | 90–100 mm |
| 4 × 5 in. | 135–150 mm |

* Clean filters with a dry camel's-hair brush, followed by a soft cotton pad moistened with rubbing (Isopropyl) alcohol. *Do not use water or alcohol on Ilford Multigrade II filters.*

If the focal length is too long, however, magnification will be limited, and you may not be able to get a large enough image, even with the enlarger head at its highest position. *As a general rule, for quality work, the focal length of the enlarger lens should be somewhat longer than the diagonal dimension of the negative.*

Used enlargers and enlarging lenses are often available from photo dealers. Like used cameras, they can be a good investment for a beginning photographer. Check them with care for the essential characteristics previously listed.

## PHOTOGRAPHIC PAPERS

Photographic papers are manufactured in great variety, and there are two major groups of them for black-and-white work.* As we might expect, papers are layered products similar in many ways to film (Fig. 7-9). The most prominent layer is the *paper base*, which serves as a support for the light-sensitive emulsion, and which also distinguishes one major group of photographic papers from the other.

One type of base is produced from wood pulp that has been processed to high standards of purity and quality. *Fiber-base paper*, as this is known, can withstand long immersion in water without disintegrating as ordinary paper would, but because this type of paper absorbs chemicals and water during processing, it requires careful washing and drying to remove these solutions.

The other type of base uses a similar fiber paper stock coated on both sides with polyethylene resin. These coatings make the base waterproof, effectively sealing it from chemical penetration. *Resin-coated (RC) paper*, as this type is called, has other advantages

7-9 *Cross-sections of photographic papers.*

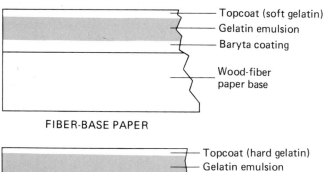

FIBER-BASE PAPER

Topcoat (soft gelatin)
Gelatin emulsion
Baryta coating
Wood-fiber paper base

RESIN-COATED (RC) PAPER

Topcoat (hard gelatin)
Gelatin emulsion
White polyethylene resin
Wood-fiber paper base
Clear polyethylene resin

* Papers for color photography are discussed in Chapter 11.

that reduce its processing time and make it popular for many kinds of photographic work.

Fiber-base papers have a layer of barium sulfate (baryta) applied to them to give them a smooth, white surface on which the emulsion is coated. Resin-coated papers achieve their white surface from titanium dioxide pigment in the upper resin layer.

Fiber-base and RC papers each have several other identifying characteristics, and because there are so many kinds, these features are listed below as an aid to understanding labels and selecting products. The best guide to how an image will look on a particular paper, of course, is a sample book of papers that many photo dealers carry.

### Photographic Paper Characteristics

1. **Weight:** the thickness of the paper base. Among fiber-based papers, *single weight* is commonly used for commercial work. *Double weight* is more expensive but more durable, permitting easier handling of large prints without damage. A few other weights are available for special purposes. Resin coated papers are made on a *medium weight* base.

2. **Tint:** the color of the paper base. White is standard, but a few fiber-base papers are made in others such as cream, ivory, and buff.

3. **Speed.** Just like films, some papers are more sensitive to light than others. A separate scale of ISO numbers similar to those used for films is applied to papers. This information usually is supplied with products.

   Paper emulsions contain crystals of silver bromide and silver chloride, or chloride crystals alone. Silver chloride emulsions are very slow and are used only for contact printing (where the negative and print are the same size) with bright light sources. Other papers contain both silver chloride and silver bromide, and are used for enlarging. If chloride crystals dominate the mixture, the paper is moderately slow and warmish in tone, but with bromide crystals dominant, the paper is cold-toned and fast. These fast papers are also used for contact printing under the enlarger.

4. **Tone:** the color of the developed image. This varies from a warm, brown-black through neutral to a cold, bluish-black. Slightly warm-to-neutral blacks are typical.

5. **Surface Texture.** This affects reflective characteristics of the paper and therefore its depth of tone and image contrast. *Glossy* finish is the most common and versatile. On fiber-based papers it can be dried to a high gloss or a lustrous, brilliant finish, and for this reason it is favored by many workers. Other surfaces such as *matte, semi-matte, luster,* and *pearl* are widely used, and special textures (silk, tweed, tapestry) are available on a few fiber-based papers used mainly for hand-colored portraits.

6. **Contrast:** the exposure scale or printing grade of the paper. *Graded papers* are made in several contrasts numbered from **0** (very soft) through **6** (extremely hard). Grade **2** is considered medium or normal contrast. To get a useful range you must buy separate packages of each contrast grade needed.

   *Variable-contrast papers* are adjustable from soft through hard with colored filters. Because only one package of paper is needed, variable contrast papers are

**TABLE 7-2** VARIABLE-CONTRAST, RESIN-COATED, BLACK-AND-WHITE PHOTOGRAPHIC PAPERS

| | Paper | Finishes |
|---|---|---|
| AGFA | Multicontrast High Speed | glossy (MC310), semi-matte (MC312) |
| ILFORD | Multigrade III RC Rapid | glossy (1M), matte (5M), pearl (44M) |
| ILFORD | Multigrade III RC Deluxe* | glossy (1M), pearl (44M) |
| KODAK | Polycontrast III RC | glossy (F), lustre (E), semi-matte (N) |
| KODAK | Polyprint RC* | glossy (F), lustre (E), semi-matte (N) |
| MITSUBISHI | MC Resin-coated Multi-contrast | glossy |

*These papers do not have developer-incorporated emulsions and are intended for manual (tray) processing only. The others can be processed in either trays or rapid-processing machines.*

more economical for general work. For more discussion of contrast, see pages 104 and 106.

7. **Processing Mode.** Most photographic papers are intended for processing by hand, using the methods outlined later in this chapter. Some resin-coated papers have *developing agents incorporated in their emulsions*, making it possible to also process them in high-speed, automatic machines. These papers, which produce permanent images in a minute or less, are widely used in commercial and news-media applications.

A few papers are designed for *stabilization processing*, which produces a damp-dry print in 10–15 seconds. Its image is *stabilized* rather than fixed; it will last long enough for some uses, such as making photomechanical printing plates, but it is not permanent.

For the basic procedures that follow, the primary choice is **variable-contrast, resin-coated photographic paper.** The ease of handling this material is helpful for a beginner, and the time saved by its quick processing can be put to productive use. In a typical class situation where time is limited, more printing, hence more learning, can be accomplished.

Variable-contrast printing filters, required to use these papers, are now available in economical sets; if your school or college does not provide them, you can buy your own. This features makes it possible to use a single package of paper for virtually any black-and-white negative. Table 7-2 shows black-and-white, variable-contrast, RC papers currently available.

Instructions for processing black-and-white fiber-base papers are given in Chapter 8. For color prints, see Chapter 11.

## PREPARING THE DARKROOM FOR PRINTING

To work efficiently, you will need the dry area setup shown in Figure 7-2 (p. 92), with a *contact frame* or *film proofer*. If the latter is not available, you can easily improvise one with 8 × 10 in. pieces of polyurethane foam and plate glass, both $\frac{1}{4}$ in. thick. Set up the enlarger and contact frame as shown in Figure 7-2. Be sure the glass of the contact frame is clean.

Exposed prints are processed in a way similar to film, and four trays will be needed for the wet area of the darkroom, as shown in Figure 7-3.

First comes *development*, to make the latent image visible. Kodak *Dektol* is a standard paper developer. Prepare it to make a *stock solution* (concentrated); then dilute the stock solution as needed to prepare a *working solution* for the first tray. Use 1 part Dektol stock solution to 2 parts water (1:2).* Fill the tray about an inch deep.

Because developers are alkaline, acetic acid is used as a *stop bath* to stop development when it has fully revealed the image. Dilute 50 ml of 28% acetic acid with 1 liter of water (1 part 28% acetic acid with 20 parts water).† An *indicator stop bath*, which contains a dye that changes color when the bath is exhausted (in addition to the acid), should be diluted as directed on the label instead. Pour this solution into the second tray.

Fill the third tray about half full of *fixer* solution. Any kind of fixer, prepared as the label directs for paper, may be used. The fourth tray should be filled with water. Use this tray to collect and hold fixed prints for washing and drying later.

The above procedure completes the preparation for making contact sheets. A *contact sheet* is a print made by placing the negatives so that their emulsions and the paper emulsion are in firm contact with each other, and then exposing the paper through these negatives. The images on the print will thus be the same size as the negatives. An entire roll of 35mm or 120 film can be printed this way on a single 8 × 10 in. sheet of photographic paper. Contact sheets are useful to select those negatives that will make the best enlargements. You'll save much time and material in later steps by first making contact sheets of your work and studying them.

For enlargements, you will need to replace the contact frame with an *enlarging easel*. No other changes in the setup are required. The illustrated sections that follow describe each procedure, step by step.

---

*If you use Ektaflo Developer Type 1, which is a highly concentrated liquid, dilute the concentrate 1:9 to make a working solution.

† To prepare a 28% solution of acetic acid, see note and warning on page 68.

# MAKING A CONTACT SHEET

### 1 / set up the enlarger

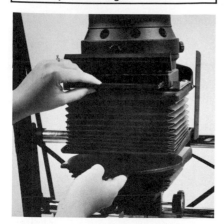

Place the empty negative carrier in the enlarger and a medium contrast filter (No. 2½) in its holder. Set the timer for a **10 second** exposure.

### 2 / illuminate the contact frame

Switch the timer to the **focus** mode to turn on the enlarger light. Sharply focus a rectangle of light about 10 × 12 in. on the baseboard and place a contact frame in the center of this area. Now turn off the enlarger light.

### 3 / set the lens aperture

If you have 35mm negatives, set the lens at f/5.6. Use f/11 for 120 film. **Now turn off the room light.**

### 4 / take out a sheet of paper

Under a Kodak OC safelight (light brown), remove a sheet of paper from its package. Reclose the package at once.

### 5 / place the paper in the frame

One side of the paper is shiny and usually curls inward; this is the **emulsion side** and it must always face toward the enlarger light. Place it **face up** under the glass on the contact frame pad.

### 6 / lay the negatives on the paper

Lay the page of negatives in their polyethylene preserver directly on the photographic paper with the **emulsion (dull) sides of the negatives down.** If glassine or paper preservers are used, remove the negatives before placing them on the photographic paper.

### 7 / expose the paper

Lower the glass over the negatives and give a trial exposure of **10 seconds.** Subsequent prints may require more or less time.

### 8 / remove the paper

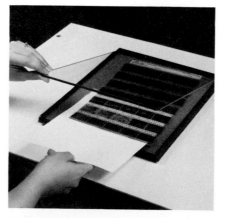

Carefully remove the exposed paper from under the page of negatives. Leave the negatives there so you can make another print if the first one is too light or too dark.

### 9 / develop the print

Slide the exposed print **face up** into the developer tray, making sure it is quickly and evenly wet.

Rock the tray slowly by repeatedly lifting one corner an inch or so to keep the developer in motion for **1 to 1½ minutes** (2 to 3 minutes for Ilford Multigrade III Deluxe and Kodak Polyprint RC papers).

When time is up, lift the print with tongs, drain it a few seconds, and transfer it to the stop bath tray.

Rock continuously in the stop bath for 15 seconds, then transfer the print to the fixer. Keep stop bath and fixer tongs out of the developer tray.

Treat the print in the fixer for two minutes, agitating periodically. Then transfer it as before to a tray of water.

Rinse the print briefly in the water tray. You may leave it there while you make others, and treat all of them together through remaining steps. Room lights may be turned on now **if your paper package is completely closed.**

In room light, compare the wet contact sheet to the exposure samples shown in Figure 7-10. If necessary, adjust and repeat the procedure to make a properly exposed contact sheet. Look for the frames that convey the strongest feeling you have about your subject; these will most likely produce good enlargements. An image with these qualities will usually be evident even in its small size on a contact sheet, although you may have to use a magnifier to see all details. Also, look for sharply focused frames with a good balance between highlight and shadow tones. At first, these will be the easiest frames to print successfully.

If you remove a print from the sink or wet area to look at it elsewhere, always carry it in a tray to avoid dripping chemicals on floors.

When you have made your choices, return the contact sheet to the water tray for continued processing with the enlargements later, or you may proceed to wash it (step 26, page 102).

# MAKING A TRIAL ENLARGEMENT

### 1 / place the easel on the baseboard

Replace the contact frame with the enlarging easel. Some easels make prints of one size only, such as 8 x 10. Others have sliding bands that can be adjusted for other shapes and sizes.

### 2 / insert the negative

Remove the negative carrier from the enlarger head and carefully center the selected negative in it **emulsion side down.**

### 3 / clean the negative

Lightly brush each side with a negative brush to remove dust particles. If not removed, they will enlarge too. Dry, compressed air is also useful to clean negatives.

### 4 / position the carrier in the enlarger

Open the gap (or lift the lamphouse) and center the negative carrier under the condenser lenses.

### 5 / open the lens aperture fully

Open the lens aperture to its largest setting to give the most light for focusing and framing. **Now turn off the room light** and switch on the enlarger light.

### 6 / adjust the enlarger head

Take a few minutes to discover how the enlarger works. Raise or lower the entire head (rear knob or motor switch) to make the image larger or smaller.

### 7 / check the focus

Focus the lens (front knob) and note how the enlarged image quickly becomes sharp, then unsharp again.

### 8 / adjust the easel

Move the easel around on the baseboard to frame the best part of your image rather than the whole picture area. Just as you did with the camera, fill the frame with important elements and crop out unimportant ones.

### 9 / recheck the focus

Look for fine details or lines in the image, and be sure they are sharp. A focusing aid or grain focuser, shown here, may be helpful; focus until the grain is sharp and clear.

## 10 / reduce the lens aperture

Stop down the lens to f/5.6 or f/8 for 35mm negatives (try f/11 or f/16 for 120 film). Then turn off the enlarger light.

## 11 / load the easel with paper

Insert a fresh sheet of enlarging paper in the easel **face up** and lower the bands. Reclose the paper package.

## 12 / set the timer

Set the timer for 2 seconds to make a series of exposures.

## 13 / make the first exposure

Cover most of the easel with a piece of cardboard, revealing about an inch of the paper at one end. Give a 2-second exposure.

## 14 / make the next exposure

Move the cardboard aside about an inch and give a two-second exposure again. Be careful not to touch the paper in the easel.

## 15 / repeat across the sheet

Continue uncovering the sheet in 1-inch steps, giving each step a 2-second exposure. Then push the timer switch two more times to add a 4-second exposure to the entire sheet.*

## 16 / remove the exposed sheet

The series of exposures on the sheet will begin at 6 seconds and increase in 2-second steps.

## 17 / develop the trial enlargement

Develop the print just as you did the contact sheet (p. 98, steps 9–10) for 1½ minutes with continuous agitation.† Watch the time carefully; you want accurate information now.

## 18 / stop development; then fix print

Rinse the print in the stop bath for 15 seconds, then transfer it to the fixer for 2 minutes with occasional agitation.

/continued

---

* Alternatively, in steps 12 through 15, 5-second exposures can be used, but a smaller lens aperture (f/11 or f/16) may be necessary.

† 2 minutes for Ilford Multigrade III Deluxe paper, 3 minutes for Kodak Polyprint paper.

## 19 / examine test print in room light

Rinse the print in water and evaluate it in white light. A good trial print will look too light at one end and too dark at the other.

## 20 / determine the best exposure

Count from the **lightest** step, which was 6 seconds. Darker steps represent longer times. If the entire print is too dark, make another with a smaller aperture (f/8 instead of f/5.6). If the print is too light everywhere, use a larger aperture.

## 21 / make a verification print

Reset the timer to the chosen time and **turn off the room light.** Insert a new sheet of paper in the easel and expose it. Some photographers call this a workprint.

## 22 / process this print

Develop the print exactly as you did the trial print earlier. Touch it as little as possible with the tongs as you gently agitate the tray.

## 23 / transfer the print as before

Lift the print with tongs, drain, and transfer to the stop bath and fixer as before, agitating gently in each tray. If print is too light, make a new one with more exposure; if too dark, with less. Don't change the developing time.

## 24 / fix the print

Immerse the print in the fixer and agitate the tray gently for 2 minutes. When fixing is completed, **room lights may be turned on if your paper package is tightly closed.**

## 25 / transfer the print to water tray

Rinse the print briefly to remove excess fixer, then transfer it to a larger tray for washing.

## 26 / wash the prints

Wash RC paper for 4 minutes in running water. The tray siphon shown here, which attaches to any tray and faucet, is efficient and inexpensive. **A continuous change of water in the washing tray is very important.**

## 27 / remove surface water and dry

Sponge or wipe excess water from the print, then hang it from a corner with a spring clothespin to dry in the air. A hair dryer may be used to speed drying. Do not use belt dryers or blotters with RC paper.

**TABLE 7-3**  SUMMARY OF BLACK-AND-WHITE PRINT PROCESSING WITH RESIN-COATED (RC) PAPER

The temperature of all solutions should be about 20°C (68°F).

| Step | Solution | How Prepared | Time | Agitation |
|------|----------|--------------|------|-----------|
| 1. | Developer | Dektol 1:2 or Ektaflo Type 1, 1:9 | 1–1½ minutes* | Constant |
| 2. | Stop Bath | 28% Acetic Acid 1:20 | 15 seconds | Constant |
| 3. | Fixer | As directed on label for prints | 2 minutes | Intermittent |
| 4. | Rinse | Still or running water | 1 minute | Intermittent |
| 5. | Wash | Running water (separate from above step) | 4 minutes | Constant |
| 6. | Remove excess water from print surfaces | Use squeegee or sponge | | |
| 7. | Dry | Air dry; do not use drum or belt dryers | | |

*\* 2–3 minutes for Ilford Multigrade III Deluxe and Kodak Polyprint RC paper.*

A   B   C   D   E

**7-10**  *Guide for judging exposure of a contact sheet.* **A:** −1 stop, **B:** −½ stop, **C:** correctly exposed, **D:** +½ stop, **E:** + 1 stop.

## IMPROVING YOUR WORKPRINTS

### Judging Print Density

Carefully examine the trial prints and workprints you have made. You can see that *as you increase the exposure, you make the image darker.* Shadows darken first, then middle tones, and finally the highlights. Because the *highlights* (brightest areas of the picture) darken last and least, they offer the best evidence of how exposure affects the density of the print. *To judge exposure, always examine the highlights of the print.* Look for a faintly-detailed white in the most important highlights.

Increasing the exposure then, increases the print's overall darkness or *density*; all tones get darker. Conversely, reducing the exposure reduces the overall density and makes all parts of the picture lighter.

Here's a tip for changing the exposure: if a small change is needed, change the exposure *time*; if a large change is indicated, change the *aperture.* Remember that one stop larger will double the exposure, while one stop smaller will cut it in half.

## Judging Print Contrast

Most photographic prints contain many tones or shades of gray, each caused by exposure of the paper through a correspondingly opposite tone of gray in the negative from which the print was made. The range of these exposures, from the lightest area to the darkest area of the print, is called its *exposure scale.* Photographers, however, usually refer to this exposure scale by its visual equivalent, *contrast.*

Judging print contrast is not difficult once you know what to look for. First, find the *lightest* area in the picture that is important to its subject or meaning. This area may be large or small, but it must be important; ignore insignificant background details or tiny patches of sky. Next locate the *darkest* area in the print that is similarly important, ignoring tiny dark shadows. *The difference in tone or density between these lightest and darkest important areas is the contrast of that print.*

If this difference is great, as from near white to deep black, we call the contrast *high* or *hard.* High contrast prints appear to be dominated by black and white tones (Fig. 7-11); gray tones are usually less noticeable.

If this range of tones in the print is not great, and there appear to be many shades of gray but few black

**7-11** *High-contrast print.*

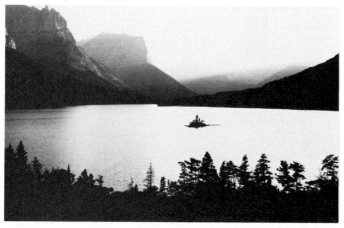

**7-12** *Low-contrast print.*

**7-13** *Medium-contrast print.*

or white tones, we say the contrast is *low* or *soft.* Low contrast prints are dominated by gray tones (Fig. 7-12); they often show lots of detail but generally look unexciting. And rarely do they have a clean white *and* deep black together with the gray tones.

We usually try to make prints that lie somewhere between these two extremes. A typical *medium* or *normal* contrast print will contain blacks, whites, and numerous gray tones (Fig. 7-13); the aim is to achieve a balance between them.

### Adjusting Print Contrast with Variable-contrast Paper

For the procedures detailed on these pages we have recommended *variable-contrast photographic paper.* Variable-contrast paper is made with an emulsion sensitive to several colors of light. If exposed by orange or yellow light, it produces low contrast images with many shades of gray. When exposed by blue or violet light, however, it produces high-contrast images with deep black tones but few shades of gray. Thus by changing the color of the exposing light we can change the contrast response of these papers.

We control the color of the enlarger light by using *variable-contrast filters.* Ilford Multigrade II filters and Kodak Polycontrast II filters are made in economical sets; eleven filters are numbered from 0 through 5 with half-steps in between. The mid-range filter, No. 2½, produces a print with medium contrast. Lower-numbered filters (0 through 2) produce lower-contrast prints; higher-numbered filters (3 through 5) produce higher-contrast prints. The illustrations in Figure 7-14 show these differences.

Earlier we recommended the No. 2½ filter for contact sheets and trial enlargements. We also advised you to time your exposure (or select a time segment from your trial print) that produced, after full development, a *faintly detailed white in the most important highlight.*

*Now examine the tone of the most important shadow area* in this same print. *If this shadow is too gray, increase the contrast by changing to a higher-*

*A:* #1 filter

*B:* #2 filter

*C:* #3 filter

*D:* #4 filter

*E:* #5 filter

**7-14** *The same negative printed with five different contrast-control filters.*

numbered filter. *If the shadow is too deeply black, reduce the contrast by changing to a lower-numbered filter.*

Filters numbered from 0 through $3\frac{1}{2}$ in each set require the *same exposure*; filters numbered 4, $4\frac{1}{2}$, and 5 require *one f/stop more exposure* (f/8 instead of f/11).

### Adjusting Print Contrast with Graded Paper

*Graded papers* are printed without filters in the enlarger, that is, with *white light*. Their exposure scale or contrast is determined when they are manufactured; they are made in several contrast grades numbered from 0 (extremely low or soft) through 6 (extremely high or hard).

Low-numbered grades have long exposure scales. They require much longer exposures to produce a black tone than to yield a very light gray, and are best-suited to high-contrast negatives that have intense black *and* clear or transparent areas in them.

High-numbered grades, on the other hand, have short exposure scales. These grades produce their black tones with relatively smaller increases in exposure than other grades do, and are best suited to low-contrast negatives that appear more uniformly gray.

Intermediate grades, of course, are for negatives of medium or average contrast. These negatives usually contain a few weak shadow tones, a few dense highlights, and various shades of gray in between.

Graded RC papers require no filters and work equally well in condenser or diffusion enlargers. These are their major advantages. A single package, however, contains only one grade, so several packages (each of a different grade) must be kept on hand to print varied negatives. Table 7-4 shows graded RC papers currently available.

On the other hand, with variable contrast paper, a single package of paper can be used (with filters) for negatives that are low, medium, or high in contrast, and this is a more economical method. This feature is also an advantage in commercial production work, where it allows a single continuous roll of paper to be used in automatic machinery to print varied negatives. This roll can then be efficiently processed in other machines as a continuous strip of prints, to be cut apart later when dry.

---

## SUMMARY

1. A *darkroom*, divided into wet and dry areas, is required for printing and enlarging. The dry area must contain an *enlarger*; the wet area needs a water-resistant table and must be *adequately ventilated*.

2. Kodak OC *safelights* can provide useful illumination inside a darkroom used only for black-and-white printing and enlarging.

3. The enlarger must *project a clear, sharp image* of the negative frame; it must *distribute light evenly* over this entire projected area; and it must be *free from vibration or slippage*.

4. *Condenser* enlargers produce crisp, sharp images; *diffusion* enlargers hide imperfections in a negative but can produce elegant print tone. Either type usually contains a *filter holder*.

5. *Variable-contrast printing filters* come as sets of thin sheets or framed plastic squares. The thin sheets are used above the negative, the framed squares below the lens.

6. The focal length of the *enlarger lens* should be slightly longer than the diagonal of the negative.

7. There are two major types of photographic papers:

---

**TABLE 7-4**  GRADED, RESIN-COATED, BLACK-AND-WHITE PHOTOGRAPHIC PAPERS

| | Paper Name | Grades Available | Finishes |
|---|---|---|---|
| AGFA | Brovira-Speed PE | 1 through 5 | glossy (310) |
| | | | semi-matte (312) |
| | | | lustre (319) |
| AGFA | Portriga-Speed PE | 2 and 3 | glossy (310) |
| | | | semi-matte (318) |
| ILFORD | Ilfospeed | 0 through 5 | glossy (1M) |
| | | | semi-matte (24M) |
| | | | pearl (44M) |
| KODAK | Kodabrome II RC | 1 through 5 | glossy (F) |
| | | 2 and 3 | lustre (E) |
| | | 1 through 5 | matte (N) |
| MITSUBISHI | SP Resin-coated Graded | 2 through 4 | glossy |
| | | | matte |
| ORIENTAL | New Seagull RP | 2 through 4 | glossy (RP-F) |
| | | | matte (RP-R) |
| UNICOLOR | B&W Resin Coated Paper | 1, 2, 3, and 6 | glossy |
| | | | matte |

resin-coated (*RC*) and *fiber-base*. Each type of paper has seven other major characteristics: weight, tint, speed, tone, surface texture, contrast, and processing mode.

8. Four trays of solutions are needed for processing prints: *developer, stop bath, fixer,* and *water*. A *contact frame* is needed for making contact sheets in an enlarger; the frame is replaced by an *easel* for making enlargements.

9. Illustrated step-by-step procedures are given for making a contact sheet, a trial print, and a verification print.

10. Always judge print *exposure times* in the *highlights* of the print. For small changes in exposure, adjust the *time;* for large changes, adjust the *aperture*.

11. Judge print *contrast* in the *shadow tones*. If shadows are too gray (when highlights are good), increase the contrast; if shadows are too black, reduce the contrast.

12. *Variable-contrast papers* are exposed with light colored by *filters*. Lower-numbered filters reduce the contrast; higher-numbered filters increase it. Exposures with the various filters are equal except when Nos. 4, $4\frac{1}{2}$, or 5 are used; these require one f/ stop larger.

13. *Graded papers* are printed with *white light* (without filters). Grade numbers correspond to filter numbers; the higher the number, the greater will be the contrast of the print.

---

## TIPS FOR EASIER PRINTING

### CONTACT SHEETS

1 / When you set up the enlarger, raise the head high enough to sharply project the empty negative carrier opening about 2 inches larger than the printing frame. Make a note of this **magnification** or setting so you can easily repeat it.

2 / Use an easily repeatable time such as **10 seconds,** and a medium aperture setting (**f/8** or **f/11**) for the first contact sheet. Don't forget the No. $2\frac{1}{2}$ filter.

3 / Adjust the time or the aperture until most frames on the sheet print with sufficient detail. If the entire sheet is **extremely light or dark, change the aperture.** If the sheet is only **slightly light or dark, change the time.**

4 / Make a note of the best exposure time and aperture for each film size you print.

### VERIFICATION PRINTS (WORKPRINTS)

1 / Look at the **shadows** in the verification print. If they are **too weak and gray, switch to a higher number filter.** If they are **too black, switch to a lower number filter.** It is best to make this judgment in white light.

2 / Reprint. Remember that filters No. 4, $4\frac{1}{2}$, and 5 require one stop larger than the others.

3 / Fix prints the **minimum** recommended time in **fresh** fixer. Then transfer them to a tray of water to prevent overfixing.

4 / Be sure there is good circulation of water through the wash tray or vessel. Separate prints frequently to insure thorough washing.

### TRIAL ENLARGEMENTS AND TEST STRIPS

1 / Always set the enlarger **lens aperture wide open for framing and focusing.** Then stop down to a moderate aperture for exposures.

2 / If you use a narrow strip for your test, be sure to position it in the **highlight** areas (darkest important areas of the projected negative image).

3 / Develop the trial print or strip for the **maximum recommended time** to insure maximum shadow tone. Don't overwork your developer. If the solution is tea-colored or cloudy, discard it and prepare a fresh tray.

4 / To interpret the test, **count up from the lightest section.** Darker sections have more exposure. Be sure to look at **highlights** (lightest areas of the print), not shadows. Verify your choice of the best highlight tone.

# 8

# ADVANCED PRINTING TECHNIQUES

**8-1** *Swiftcurrent Lake, Glacier National Park, Montana, 1988.*

The basic printing techniques explained in Chapter 7 are easy and economical to learn, and sufficient for most routine work. Once they are mastered, however, you will also want to consider other, more advanced procedures that will reward you with fine prints of your best work. These techniques include printing on fiber-base papers for more elegant and permanent images, burning and dodging for better control of image tones, spotting prints to remove dust and similar imperfections, and mounting and matting your best work for better display and safer storage. Each of these techniques will be explained in this chapter.

## PRINTING ON FIBER-BASE PAPERS

Many photographers who use resin-coated paper for routine and commercial work prefer *fiber-base papers* for making *fine prints*. These papers are made in a variety of surfaces, tones, and contrast grades, and in several weights and colors (page 96). For many years they have been standard photographic print materials. Table 8-1 lists the most popular fiber-base papers currently available.

Because of their varied characteristics, fiber-base papers can produce prints of great beauty, subtlety, elegance, and permanence. Most of these papers have emulsions of *soft* gelatin, without developing agents incorporated. This requires them to be developed more slowly than most RC papers, and at temperatures which allow some manipulation of the developing process. Many fiber-base papers respond well to various chemical toning processes, giving photographers additional choices of image color and tone.

Fiber-base papers are exposed the same way resin-coated papers are, but from that point on their handling differs.

### Developing Fiber-base Papers

Standard paper developers such as Dektol give prints with neutral black tones on most fiber-base papers. Dilute the stock solution 1:2 and develop these papers for 3 minutes with constant agitation; this will allow shadows in your picture to reach maximum black.

Many fiber-base papers, however, may be developed in other developers such as Selectol, Selectol-soft, or Ektaflo Type 2. These solutions give warmer tones. Dilute them as recommended on their packages or on the information slip packed with the paper, and for best results, use the *maximum* recommended developing time.

### Stopping Development

As with RC papers, an acid stop bath should be used with fiber-base papers. A solution of 28% acetic acid diluted at 1:20, or an indicator stop bath, is recommended.*

### Fixing Fiber-base Papers

Because fiber-base papers have soft gelatin emulsions, a *hardening fixer* must be used (most prepared fixers are the hardening type). A fresh, rapid-acting bath (usually sold as a liquid concentrate) will fix prints in about five minutes; slower fixers (prepared from powder) takes up to ten minutes. With

---

* To prepare a 28% solution of acetic acid, see note on page 68.

**TABLE 8-1**  SELECTED BLACK-AND-WHITE FIBER-BASE PHOTOGRAPHIC PAPERS

| Paper Name | | Grades Available | Finishes |
|---|---|---|---|
| AGFA | Brovira | 1 through 5 | glossy (1, 111); lustre (119) |
| | Insignia Fine Art*† | 1 through 4 | glossy (111) |
| | Portriga Rapid† | 1 through 3 | glossy (1, 111); semi-matte (118) |
| ILFORD | Ilfobrom | 1 through 5 | glossy (1P, 1K); matte (5K) semi-matte (24P, 24K) |
| | Ilfobrom Galerie* | 1 through 4 | glossy (1K); matte (5K) |
| | Multigrade FB | Variable | glossy (1P, 1K); matte (5K) |
| KODAK | Elite Fine Art* | 1 through 4 | high lustre (S) |
| | Polyfiber | Variable | glossy (F) |
| MITSUBISHI | FD Fiber-based Graded | 2 through 4 | glossy |
| ORIENTAL | Center† | 2 and 3 | glossy (F) |
| | New Seagull* | 1 through 4 | glossy (F, G) |
| | New Seagull Select VC | Variable | glossy (G) |
| UNICOLOR | B&W Exhibition* | 2 through 4 | glossy |
| ZONE VI | Brilliant* | 1 through 4 | glossy |

\* Premium quality exhibition papers.
† Warm-tone papers.

either type, overfixing should be avoided as this makes subsequent washing less effective.

**Two-bath Fixing.**  If space permits, *two fixing baths used in succession* are better than a single solution for processing fiber-base paper. Prepare the fixer according to label directions and then divide it into two trays. Fix prints half the total time in the first tray and half in the second. When the first tray has been used to its capacity (see product label), discard this solution (or set it aside for silver recovery later) and replace it with the solution from the second tray. Then mix a new batch of fixer for the second tray. For large quantities of work, this procedure is more efficient and more economical than single-tray fixing.

### Clearing Fiber-base Papers

Fiber-base paper, which has no resin coatings to make it waterproof, absorbs large quantities of fixer. In addition, the baryta layer tends to retain thiosulfate ions from the fixer, further complicating their removal. Washing fiber-base papers, then, is more difficult than washing RC papers, and it requires additional processing steps. The first of these is a clearing bath or *washing aid*.

Washing aids usually contain a mixture of potassium and sodium salts. These salts convert the thiosulfate ions remaining in the paper to more soluble forms, but they do not remove them. *Removal of these compounds occurs during the wash that follows this step*; the washing aid simply makes that wash more efficient.

Typical products include Beseler Ultraclear HCA, Edwal Hypo Eliminator, Heico Perma Wash, Ilford Archival Wash Aid, and Kodak Hypo Clearing Agent. Directions for using these products usually call for the prints to be washed in running water to remove the excess fixer, then treated in the washing aid for

a few minutes, and finally washed in running water again to remove the converted fixer and the washing aid.

As we noted above, these so-called eliminators, clearing baths, or washing aids remove nothing from the paper. They simply make the retained fixer more soluble, thereby permitting its faster removal by the wash water in the next step. In practice, a 3-minute immersion in a clearing bath can reduce the washing time for fiber-base paper by 60–80%, saving time and water. The step-by-step procedure on page 112 shows a typical sequence using Heico Perma Wash.

### Washing Fiber-base Papers

Washing, of course, removes all remaining soluble salts from the emulsion and paper base. Converted by the clearing agent, these salts now dissolve out rapidly, as does the clearing agent itself. *A continuous change of water in the washing vessel is necessary*, and this can be achieved by a tray siphon (Fig. 8-2) which attaches to any tray and faucet, does an excellent job, and is inexpensive. Washers that rock or rotate (Fig. 8-3) are usually more efficient for large quantities of prints. Whatever the setup, it is desirable to remove some of the contaminated water from the bottom of the tray or tank, because fixer removed from the paper tends to sink if the flow of water through the container is not sufficient to remove it. Most washers therefore have small drain holes at the bottom in addition to the overflow provision at the top.

The *weight* (thickness) of fiber-base-paper *determines the washing time*, as shown in Table 8-2. If single and double weight papers are washed together, the entire batch must be treated as if it were all double weight.

Temperature is important, too. Release of fixer is impeded by cold water below 18°C (65°F), and at such temperatures additional time must be allowed. Tem-

**8-2** *Kodak tray siphon.*

**8-3** *Arkay 2024-PW rocking print washer.*

**TABLE 8-2** RECOMMENDED WASHING TIMES FOR FIBER-BASE PHOTOGRAPHIC PAPERS

All times in minutes

| First Wash or Rinse | Clearing Bath and Time | Single Wt. paper | Double Wt. paper | Mixed SW and DW paper |
|---|---|---|---|---|
| 1 | Beseler Ultraclear HCA   2 | 10 | 20 | 20 |
| 1 | Edwal Hypo Eliminator   3 | 10 | 20 | 20 |
| 3 | Heico Perma Wash   3 | 3 | 5 | 5 |
| 5 | Ilford Universal Washing Aid   10 | 5 | 5 | 5 |
| 1 | Kodak Hypo Clearing Agent   3 | 10 | 20 | 20 |
| — | None | 30 | 60 | 60 |

peratures above 25°C (77°F), on the other hand, permit efficient washing of paper but they may soften the gelatin emulsion. The 18°–25°C range is best.

*Once a batch of prints has begun to wash, no unwashed prints may be added to it* without recycling the entire batch for the full washing time.

### Drying Fiber-base Papers

Fiber-base prints are usually dried by first removing the surface moisture from both sides with a roller or squeegee, and then placing the prints face down on *nylon window screens* stretched over wood frames, arranged in such a manner that air can circulate between them. The prints may also be dried by placing them on clean, lint-free *photographic blotting paper.* When glossy fiber-base paper is dried in this manner, it takes on a lustrous finish instead of a high gloss, and this treatment is preferred by many artists.

When large quantities of prints are regularly processed, as in commercial and college laboratories, heated, rotary dryers are often used to dry prints continuously (Fig. 8-4). Manufacturers of these dryers

**8-4** *Arkay Model 150 Dual-dri Dryer for fiber-base paper.*

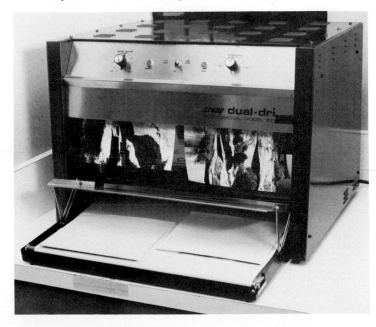

# PROCESSING FIBER-BASE PAPERS

**1 /** *Develop the print in Dektol 1:2, with constant agitation (as in step 9, page 98) for* **exactly 3 minutes.** *For other developers follow the instructions packed with the products or with the paper you are using.*

**2 /** *Stop development by agitating the print for 15 seconds in a diluted acetic acid stop bath (step 12, page 99).*

**3 /** *Fix fiber-base paper in a fresh bath of hardening fixer for* **5 to 10 minutes** *(use the* **minimum** *recommended time). Then proceed as follows to complete the process.*

**4 / rinse the prints**

*After the prints have been fixed, transfer them to a tray of water and briefly rinse them to remove excess fixer from their surfaces.*

**5 / first wash**

*Wash the prints in running water or with a tray siphon for at least 3 minutes. Be sure they separate from one another.*

**6 / immerse in washing aid**

*Immerse the prints one at a time, face up, in a tray of Perma Wash solution (or other washing aid) for 3 to 5 minutes. Agitate or interleave them continuously during this treatment.*

**7 / final wash**

*Return the prints to the washing tray for 3 to 20 minutes (see Table 8-2), again making sure they do not stick together.*

**8 / wipe off excess water**

*Place the print face down against a hard, smooth surface (such as a clean, inverted print tray), and remove the excess moisture from the back with a rubber squeegee or roller. Hold one edge as you draw the blade or pull the roller across the back of the print.*

**9 / dry the prints**

*If a rotary dryer is available, lay the prints* **face up** *on the belt and smear a few drops of water or conditioner on their surfaces. This will help produce a smooth, high gloss on glossy paper. For* **matte finish** *paper, lay the prints* **face down** *on the belt.*

**10 / drying with screens or blotters**

*Any fiber-base paper may be dried to a dull or semigloss finish by laying the squeegeed prints face down on plastic screens or between sheets of clean, white photographic blotting paper.*

**TABLE 8-3**  SUMMARY OF BLACK-AND-WHITE PRINT PROCESSING WITH FIBER-BASE PAPER

The temperature of all solutions should be about 20°C (68°F).

| Step | Solution | How Prepared | Time | Agitation |
|------|----------|--------------|------|-----------|
| 1. | Developer | Dektol 1:2 or Ektaflo Type 1, 1:9 | 3 minutes | Constant |
| 2. | Stop Bath | 28% Acetic Acid 1:20 | 15 seconds | Constant |
| 3. | Fixer | Hardening fixer prepared as instructed on label for prints | Minimum recommended | Intermittent |
| 4. | Rinse | Water | 30 seconds | Constant |
| 5. | First Wash | Running water | 1–5 minutes | Intermittent |
| 6. | Clearing Bath | As directed on label | 2–5 minutes | Constant |
| 7. | Final Wash | Running water | 3–20 minutes | Intermittent |
| 8. | Wipe Off | Use rubber squeegee | | |
| 9. | Dry | Use rotary dryer, screens, or blotters as explained in text | | |

often recommend that the prints be treated in a *conditioning solution* of diluted glycerin before they are placed on the dryer belt. This pretreatment prevents the prints from becoming brittle as they bake dry. The conditioner may be reused for many prints, but if it becomes dirty or contaminated by unwashed prints, it must be replaced at once.

A typical procedure for processing fiber-base paper is illustrated here step by step and summarized in Table 8-3.

## LOCAL IMAGE CONTROL: DODGING AND BURNING

The methods outlined in the previous sections should enable you to produce generally satisfactory prints from most negatives. Nearly all prints, however, can profit from some additional work to fine-tune them. Prints, after all, are what speak for us. They should convey our visual message with strength and conviction.

Quite often a print that is generally satisfactory will contain small areas where the tone is too dark or too light, where detail washes out or gets lost in shadows. A reflection of the sky in water, for example, may print too light, or the shaded face of a person may seem too dark. When the problem is local, such as a small area of an otherwise well-exposed print, its solution is local too.

### Dodging

Small areas that are too dark in an otherwise satisfactory print can be lightened by *dodging*. This is easily done with a *dodging wand*—a small piece of opaque paper or plastic attached to the end of a thin wire. You move or vibrate this wand over the projected image *during part of the exposure*, usually just a few seconds, so that it interrupts the light to the part of the image you wish to make lighter (Fig. 8-5). If the area to be lightened is along an edge of the

**8-5**  *Dodging.*

picture, your hand can often be used instead of a wand to interrupt the light. Move it quickly through the beam of light for a few seconds. Figure 8-6 shows the effect of using this technique. The first print is a "straight" exposure; the second has been dodged to lighten some of the shadows.

### Burning

If your print contains small areas that are too light, such as a sky area at the top of the picture or a reflection of sunlight in a pond, these parts of the image can be darkened by *burning*. This involves giving selected areas of the image *additional exposure time*. A *burning mask* can easily be made from a piece of cardboard by cutting a small hole of appropriate shape in it near the center. To darken a small area of your print, first give the normal exposure to the entire print; then hold this mask under the enlarger so that *only the area you wish to darken* shows through (Fig. 8-7). *Give this area extra time*, moving or vibrating the mask during this extra exposure.

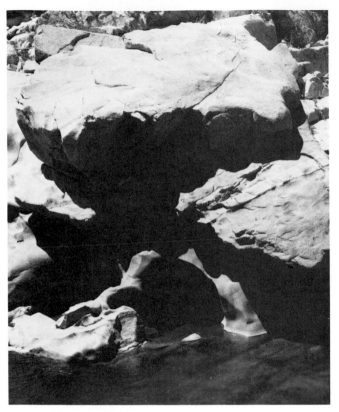

**8-6** *A: "Straight" print.*

*B: Print dodged to lighten shadow.*

**8-7** *Burning.*

**8-8** *A: "Straight" print.*

*B: Print burned to darken tone in corners.*

Landscape photographs can often be improved by this technique. Darkening the sky and corners of the print helps keep the viewer's eye on more central parts of the image. Here again, your hand can often be used to shield most of the image from the extra exposure, allowing only the desired area to darken. Figure 8-8, A and B, shows the result of burning parts of the picture.

*Variable-contrast papers* offer a special advantage if much dodging or burning are required. *You may change filters as you mask,* printing one part with a medium-contrast filter and another with a high- or low-contrast one. *Use the lower number filter first,* and be careful not to move or disturb the enlarger as you change filters. A rigid enlarger is required.

When dodging or burning, remember these points:

1. *Keep the wand, mask, or hand vibrating at all times* to prevent an outline of the mask or wand from forming in the print.
2. *Keep the procedure simple.* These techniques are not cure-alls. They can make a good print better, but cannot correct serious faults in a negative. Only a new negative can do that.
3. *These techniques take practice to do well,* so don't be discouraged if your first attempts are not successful. Keep trying until you are satisfied with the result.

## PRINT FINISHING

Prints intended for exhibition, reproduction, or publication must be *spotted* to remove dust and similar imperfections from their images. Those intended for exhibition or serious study should be *matted* or *mounted* on illustration board to isolate them from their surroundings and keep them flat. Finally, the fragile surfaces of many photographic papers must be protected from abrasion if the prints are to be stacked or frequently handled.

### Spotting

No matter how careful we are in the darkroom, a little dust usually manages to stick to our negatives, and this shows up as tiny white specks on our prints. These imperfections can be removed by *spotting* the print with dyes or pigments. *Spotone retouching dyes* come in a set of three colors: a brown-black, a blue-black, and a neutral black. By mixing them, the tone of any black-and-white photographic paper can be matched. You will also need a fine, tapered-tip, sable watercolor brush, size 00 or 000, and a small piece of watercolor or blotting paper.

Like other manual techniques, spotting takes pa-

**8-9** *Spotting a print.*

tience and practice, easily done on discarded prints. The easiest way to use these dyes is to shake the bottle and work with the residue left in the cap, as shown in Figure 8-9. If colors must be blended to match the tone of your paper, you can do this in a saucer with a drop or two of water. Be sure to set the open bottle well aside so it won't spill on your print.

Moisten the tip of your brush with water, pick up a bit of dye, and roll the tip of the brush on the blotting paper to thin out the dye and remove the excess. Slowly fill the white spot on the print with dye from the brush, using a stipple motion or a series of very short strokes. Use the dye *very sparingly* and build up the tone *slowly* with repeated applications rather than all at once. Avoid excessive wetting of the print.

Any kind of photographic paper may be spotted in this manner, although fiber-base papers may be somewhat easier to do than RC ones. Using this technique, the dye goes *into* the emulsion of the print rather than onto it, and if the brush is not excessively wet, the glossy finish of the paper will not be affected. The dye itself, of course, should not be noticeable.

Matte-finish, fiber-base papers can also be spotted with Kodak or Victor *spotting colors* (pigments). These also come in sets, the colors of which can be blended to match any paper tone. The pigments are applied the same way that dyes are, but because these colors remain on the print surface, they tend to be visible if used to hide large spots. It may be necessary to overspray the print surface with a dulling spray to hide them.

### Mounting Prints

Prints for exhibition or serious study should be mounted on illustration board to improve their appearance and durability, to keep them flat, and to make them easier to frame or display. The mount can also separate an image from its surroundings, making it appear more handsome and important.

White, cold-press illustration board of medium thickness, obtainable at art supply stores, is recommended for mounting most photographs. Other materials such as museum board, plastic foam-core board, and tempered masonite may also be used, but poster boards and ordinary cardboard, which contain impurities and are less durable, should be avoided.

Most photographers prefer to use a mount board that is larger than the print by about 5 to 10 cm (2 to 4 in.) in each direction, sometimes with an extra inch or so of space at the bottom. Other photographers prefer to bleed-mount their prints so that the print and mount board are the same size. Using mount boards of a standard size (such as 11 × 14 in. or 16 × 20 in.) makes framing easier later.

There are two ways to mount your photographs. *Cold mounting* uses pressure-sensitive or cold adhesive materials to bond the photograph to a stronger support. *Dry mounting* uses thermoplastic materials and heat to do the same thing. Cold mounting can be done with simple equipment; dry mounting requires a heated press and a tacking iron for best results. Other types of adhesives, such as white glue and rubber cement, should not be used because the water or solvents they contain can wrinkle or damage photographic prints.

Whichever method you use, remember that *the photograph and its mount together form a single statement.* A careless or sloppy mounting job will weaken the strongest photographic image. Don't let all of your earlier effort be undermined in these final steps!

***Cold Mounting.*** Cold mounting uses sheets or rolls of adhesive material and pressure to make the seal. No heat is needed. This method is excellent for prints on resin-coated (RC) paper.

Coda cold mount, Scotch brand Positionable Mounting Adhesive (PMA), and Seal PrintMount materials can be moved around to reposition the print on the mount before pressure is applied. Falcon Perma/Mount 2 material, Ilford Mounting Panels, and Seal ProBond products contain contact adhesives; these materials cannot be repositioned. The only special tools needed are a paper trimmer (or hobby knife), a metal straightedge, and a roller or squeegee.

The work must be done on a dry, hard surface that is *absolutely clean.* Because pressure is used, any speck of dirt or grit will leave a permanent imprint in the photograph. The illustrations that begin on page 118 show the procedure, step by step.

***Dry Mounting.*** Dry mounting uses *heat* rather than pressure to seal materials together. A sheet of thermoplastic material called *dry mounting tissue* is sandwiched between the print and the mount board. Heat melts the adhesive in the tissue, binding the materials together. Moderate pressure applied with the heat keeps the materials flat. The process works well for any paper materials that can withstand mod-

erate heat, and is the best way to permanently mount fiber-base photographic prints.

Most materials are available in standard sheet sizes or in rolls 50 and 100 cm (20 and 40 in.) wide. For resin-coated (RC) papers, use Seal ColorMount Tissue or Boards, Scotch brand Promount Tissue #572, or Kodak Dry Mounting Tissue Type 2. These all work at moderate temperatures (see Table 8-4). For black-and-white fiber-base papers, the Scotch and Kodak products work well, and Seal MT-5 plus, a higher-temperature material, can also be used.

Scotch Promount Tissue and Seal ColorMount Board make a reversible bond: the picture can be repositioned if necessary by reheating it. *The other products all produce a permanent seal*: once mounted, the print cannot be separated from the mount board without damaging both.

**TABLE 8-4**  MOUNTING PRESS TEMPERATURES FOR HEAT-SEALING MATERIALS

| | | |
|---|---|---|
| "Scotch" Brand Promount #572 | 82°C | 180°F |
| Seal ColorMount Tissue | 97°C | 205°F |
| Kodak Dry Mounting Tissue Type 2 | 99°C | 210°F |
| Seal MT-5 plus Dry Mount Tissue | 107°C | 225°F |

A dry mounting press and tacking iron, both thermostatically controlled, are needed for the process. *Correct temperature settings arc very important.* Remember that heat, not pressure, makes the seal. If the press is too hot, the adhesive material may soak too far into fiber-base papers and not seal properly. RC prints can melt, and color prints can similarly be ruined. If the press is too cool, the materials will not stick properly, or they may pop apart later. Allow the press and tacking iron about 10 minutes to reach the proper temperature (see Table 8-4). Other materials

needed are shown in the step-by-step illustrations that begin on page 119.

### Matting Your Best Prints

Prints that are examples of your very best work are worth the extra time and trouble to *mat* rather than mount. A mat is a piece of mount board containing an opening slightly smaller than the print. When placed over the picture, it forms a raised border around the print that sets it off and enhances its appeal (Fig. 8-10).

A mat has practical advantages too. Because it is raised, it protects the delicate print surface from other prints or mounts that might rub the surface if stacked on it. A mat also prevents the print surface from touching the glass when it is framed. Because the mat hides the edges and corners of a print, it is possible to use corner mounts instead of cold or dry mounting to fasten the print to its backing board. Only the corner mounts are permanently fastened to the board; no adhesive, heat, or pressure is used on the print itself. A damaged or soiled mat, of course, can easily be replaced without risk to the print it holds. For these reasons, an overmat (or window mat, as it is sometimes called) is preferred by many print collectors and museum curators as the best way to preserve and display fine photographs.

Window mats can be cut from any illustration board, but for fine prints and other valuable works of art, acid-free board should be used. A second board, the same size as the outer dimensions of the mat, is used as a base on which to mount the photograph. A hinge made of acid-free, linen tape (obtainable from framing shops and art supply stores) holds the two boards together along their top edge. Mounting corners can be made from acid-free paper, or corners made of paper or clear polyester material can be purchased ready to use.

Cutting a mat is almost an art in itself. Like spotting,

**8-10**  *Placing a print in a mat.*

# COLD MOUNTING A PHOTOGRAPH

## 1 / assemble the materials needed

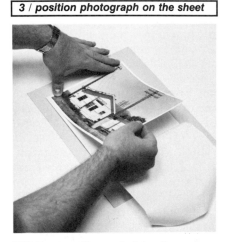

1. Metal ruler or straightedge.
2. Roller or squeegee.
3. Cold mounting material (see text).
4. Photograph to be mounted.
5. Mount board.
6. Paper trimmer or hobby knife.

## 2 / prepare the mounting material

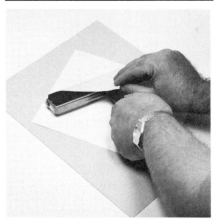

Place the adhesive sheet on a clean, flat surface, **printed side up.** * Then peel the printed backing away from the material.

## 3 / position photograph on the sheet

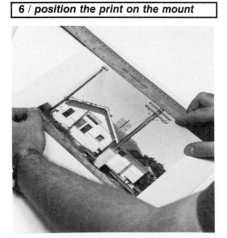

With the **mounting material** on the work surface, **uncovered adhesive side up,** gently press the photograph down onto the adhesive. Start at one side and work smoothly toward the other.

## 4 / trim off any excess

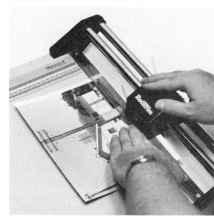

Use a paper trimmer (or a ruler and hobby knife) to remove any overhanging mounting material.

## 5 / peel off the carrier sheet

Place the print face down on the table again and peel away the protective sheet from the other side of the adhesive material. A roller will help you do this smoothly.

## 6 / position the print on the mount

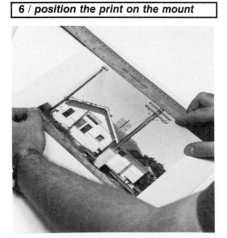

If you are using positionable material, the print can be moved around until you apply pressure. If the material is **not repositionable, position the print with great care.**

## 7 / apply pressure to make the seal

Place a clean cover sheet or the release paper (printed side up) over the print, and press down firmly with the roller or squeegee over the entire print surface. Be sure that all parts of the print stick to the mount board.

## 8 / for large prints, use a roller press

This will exert even pressure and insure a better seal. A press can be used for multiples of smaller prints too.

* If the material has no printed side, place either side up.

# DRY MOUNTING A PHOTOGRAPH

## 1 / assemble the materials needed

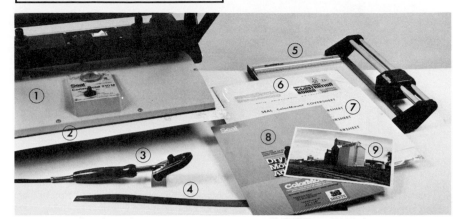

1. Dry mounting press.
2. Smooth, white drawing paper.
3. Tacking iron.
4. Metal ruler or straightedge.
5. Paper trimmer.
6. Illustration board.
7. Teflon-coated release sheet (for RC papers).
8. Dry mounting tissue.
9. Photographs to be mounted.

## 2 / preheat the materials

Begin by preheating the drawing paper, mount board, and the photograph to drive out moisture (do not preheat RC paper—it doesn't need it). Place the materials in the preheated press for 30 seconds under light pressure.

## 3 / lay the print face down

Be sure all materials are **absolutely clean** and free from dust or grit. Lay the print to be mounted **face down** on a clean, dry, hard surface, and place a sheet of dry mounting tissue over it.

## 4 / tack the tissue to the print

Fasten the mounting tissue to the back of the print with the hot tacking iron **in the center only,** sticking a spot about the size of a half dollar.

## 5 / trim excess tissue from the edges

Trim the photograph and tissue together, face up, so that the tissue does not extend beyond the edges of the print. Lay a straightedge or guide over the print close and parallel to the edge you are trimming, and **press firmly on it as you cut.** Any print borders may be trimmed off in this step.

/continued

## 6 / position the print on the mount

Now place the trimmed photograph and tissue face up on the mount, position it securely, and raise one corner in a **broad curl** so you won't crack the print surface.

## 7 / tack the print to the mount

Tack the tissue to the mount with the iron, working **outward toward a corner with a single stroke.** Leave the extreme corner free—don't tack it. Without shifting the position of the photograph, tack the other three corners the same way.

## 8 / insert the work in the press

Place the sheet of drawing paper (release sheet for RC paper) over the photograph and mount, and insert the entire sandwich into the press, **face up.** Close the press completely for **about 30 seconds,** then open it. For RC paper, close the press lightly for a moment to warm the print, then completely for 30 seconds to seal it.

## 9 / remove print and check the seal

Remove the mounted print and place it under a heavy weight (such as a large book) as it cools. When cool, **gently,** lightly, flex it; this will verify the seal. If your work comes unstuck, return it to the press for more time. That will usually correct the trouble.

## 10 / bleed mounting

If you want to bleed-mount your print (without a larger mat) trim only the excess tissue in step 5. Then proceed as before. After you remove your work from the press and cool it, complete the trimming of the photograph and the mount together. If the mount is a heavy board, make these cuts with the print **face down** on the cutter table. Position it with care.

## 11 / mounting with a household iron

If a dry mounting press is not available, small prints up to about 5 × 7 in. usually can be mounted with an electric household iron, using its tip for tacking. Be sure the iron is clean, dry, and **not set for steam.** Set the heat for permanent-press fabrics. Prepare the work and tack it in the usual manner, but make the final seal by starting the iron in the center of the print, moving slowly outward in a spiral pattern. Seal the corners last.

it takes skill and patience, and is best done with a *mat cutter* (Fig. 8-11). This is a heavy metal device that is gripped by your right hand and holds a knife blade. In some mat cutters the blade-holder rotates so that either bevel-edged or straight-edged mats can be cut with it. Of course, many frame shops and art supply dealers, for a nominal charge, will be happy to cut your mats for you. If you wish to do your own, however, the illustrations that follow will guide you through the steps.

**8-11** *Mat cutter.*

# MATTING A PRINT

## 1 / assemble the materials needed

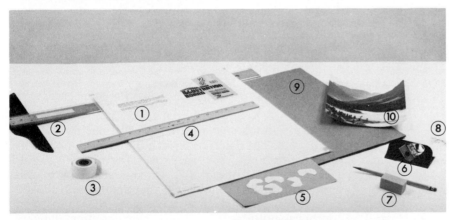

1. Two mat boards.
2. T-square.
3. Linen tape (for hinge).
4. Ruler or straightedge.
5. Mounting corners.
6. Mat cutter.
7. Soft pencil and artgum eraser.
8. Four push pins.
9. Expendable, corrugated cardboard as large as the mat boards.
10. Photograph to be matted.

## 2 / measure the picture

Decide how the picture will be cropped by the mat. If the picture will not be cropped, or if it has a border you do not want to show, **measure ¼ in. inside the print border all around.**

/continued

*A 2 in. border on the top and sides, with a 3 in. border on the bottom, is typical. Add these figures to the dimensions of the opening, **figuring the height and width separately.** The totals will be the outside dimensions of your mat. Cut **two** boards this size; one for the mat, the other for the backboard.*

*Place the mat board **face down** on the corrugated cardboard and mark the **back** of the mat board to indicate the opening to be cut. Fasten the mat board to the cardboard with push pins **inside the area to be cut out.***

*Set the blade of the mat cutter for the desired angle and depth (just through the mat board). Position the cutter at one end of a line, and set the T-square firmly against it to guide the cutter along. Firmly guide the cutter to **just beyond** the other end of the line.*

*Make the other cuts the same way, extending each cut just beyond the marked lines. When you have cut all sides, remove the push pins and gently press out the cut area. Use the artgum eraser to remove the guide lines if you wish.*

*Place the cut out mat **face down** on a clean, hard surface. Position the **top edge** of the backboard **face up** next to it. Cut a strip of linen tape almost as long as the **top** of the mat, moisten the gummed side, and apply it to both boards to make a hinge. Let it dry before moving the boards.*

*Close the mount and position the print under the window. Place a small weight on the print while you reopen the hinged mat. Slip a mounting corner under each corner of the print and secure each corner to the backboard. Reclose the mat and check to see if the print is properly framed. Reposition the corners if necessary to center the print.*

## Protecting Finished Prints

Photographic prints are fragile. They must be adequately protected from anything that might damage their delicate surfaces and edges, or cause them to deteriorate. There are three primary risks: chemical damage, which mainly affects the print emulsion and base, physical damage, which affects the print and its mount, and simple neglect, the most difficult problem to deal with.

The first step in protecting a print from chemical damage to the emulsion is to give it careful and appropriate processing. *Proper fixing and sufficient washing are most important;* even the most careful

storage cannot save a print that still has fixer chemicals in its emulsion or base. If the print must last for 20 years or more, *archival processing methods* should be used; see Appendix B. Once a print is properly processed, careful storage in chemically neutral packages made from acid-free materials will protect it from airborne pollutants and most other chemical dangers.

Physical damage to prints and their mounts can be controlled by proper storage and intelligent handling. Unmounted prints (such as workprints) and those intended only for reproduction or commercial use can be conveniently stored in empty photographic paper boxes. Don't mix print sizes, however, for this allows prints to slide against each other when

**8-12** *Portfolio boxes. Courtesy Light Impressions Corp.*

the box is placed on edge. Never fasten photographs to other things with paper clips (they leave their own impression in the picture), and never stack prints face to face without a clean paper separator sheet between them.

When you store mounted prints together, place a cover sheet of soft, white tissue over each print to protect its delicate surface. Gift-wrapping tissue will suffice for temporary storage, but for long-term keeping, acid-free tissue should be used. One excellent way to store mounted or matted prints is in *portfolio boxes* such as those made by Light Impressions Corp. (Fig. 8-12). These portfolio boxes are made from acid-free materials and are designed to last a long time.

The third major risk, *neglect*, is more difficult to deal with. When no one cares about a photograph, no one is responsible for its survival, and a print that is carelessly passed around from one person to another, or loosely mixed together with other papers, will soon lose its identity, its value, and its life. If you care about the photographs you make or handle, and share your concerns with others who view your prints, the risk from neglect will be minimal.

## SUMMARY

1. Fiber-base papers have emulsions of *soft gelatin*. They require longer development than most RC papers but they can produce elegant prints that are more permanent. Some manipulation of the process is possible.

2. Fiber-base papers are exposed just like RC papers but are processed differently. Various developers can be used to produce different print tones. The *maximum* recommended time for any developer will produce the richest print tones.

3. An *acid stop bath* should be used for fiber-base papers. For best results, fix fiber-base papers in *two successive baths of hardening fixer*.

4. A *washing aid* is recommended to help remove fixer from fiber-base papers. The bath itself does not remove anything but makes the retained fixer more soluble and thus easier to remove by subsequent washing.

5. *Thorough washing of these papers is very important.* The *weight* (thickness) of a paper determines its washing time; thicker papers require longer washing. The best washing temperatures lie between 18° and 25°C (65°–77°F). Once

a batch of prints starts washing, *do not add unwashed prints to it.*

6. Fiber-base prints can be *dried* on screens, on blotters, or in heated dryers. Surface water should be wiped off first.

7. *Dodging* and *burning* can be used to correct small areas of a print that would otherwise be too light or too dark. Dodging makes an area lighter, burning makes it darker. Anything used for this purpose (such as a dodging wand or opaque card) must be kept in motion during its use.

8. Prints for exhibition or publication must be *spotted* to remove dust and similar imperfections from the image. Retouching dyes produce the best results, but spotting colors can be used on matte-finish papers if the spots are small.

9. Prints for exhibition or serious study should be *mounted* or *matted* to improve their appearance and durability, and to make them easier to display or frame. White, cold-press illustration board is popular for this purpose. A mount with a *border* about 10 cm (4 in.) larger than the print's dimensions sets the picture off from its surroundings. *Flush mounting* backs the print with heavier material but provides no borders.

10. *Cold mounting* uses pressure-sensitive or contact-adhesive materials to bond the photograph to its mount. It needs only simple tools and works well for RC papers.

11. *Dry mounting* uses thermoplastic adhesive tissues and *heat* to make the seal. It requires a heated press and tacking iron, but is the best method for fiber-base prints.

12. Some cold-mounting materials let you *reposition* the photograph on the mount until pressure is applied. Contact-adhesive materials and almost all dry-mounting materials make only *permanent* bonds. Other adhesives such as white glue and rubber cement should not be used on photographs.

13. Remember that *the photograph and its mount together form a single statement*. Work in a clean area, and mount with care to support your earlier printing effort.

14. Consider *matting* your best prints. Overmats (window mats) give prints more protection than simple mounts do, they make framing easier, and they can be easily replaced if they get soiled or damaged without risk to the prints in them. Use *corner mounts* to hold the print in position on the backboard under the mat; the backboard and its overmat are hinged together at the top. Use a *mat cutter* to make a neat window mat.

15. Protect fragile print surfaces and edges from physical damage. Prints that must be stored for a long time should be protected from chemical damage as well. *Portfolio boxes*, made especially for this purpose, are convenient and safe for storing prints.

**9**

# PHOTOGRAPHING IN COLOR

Most of us see things in color, not in black-and-white. Nearly all of our daily visual diet—television, magazines, billboards, packaging—is in color, and even our daily newspapers frequently contain it. But color photography is a different medium from black and white, as you can quickly see by comparing Figure 9-1 with Plate 8. Color adds vitality, depth, and a heightened sense of drama to this picture and its visual message. In black and white it is much less exciting.

Today we expect the camera to record the colors of nature exactly as we see them. But as remarkable as photography is, it cannot always reproduce what we see in nature as accurately as we wish. There are two aspects to the problem. The first is related to what color is and how we perceive it. *Color is a sensation*, not a substance, and it engages our senses in a very special way. It intensifies realistic representation, which has always been one of photography's most important tasks. But color is also an emotional language that can easily dominate a picture's other attributes, including its content or message. In the hands of an artist, for example, it can give new meaning to ordinary things, or reveal a different way of seeing.

Because of this visual power, color photographs can be exciting and attractive, commanding our attention and effectively communicating their messages. But they can also be seductive, inviting us to substitute *their* colors for those of things in the real world that they represent.

Another problem lies in the way that photographic materials respond to color, the way they record it. Color films and papers have a fixed or unvarying response manufactured into them; they cannot match the changeability or adaptation of human vision. Subtle changes in the color of light, for example, that often go unnoticed by humans because of this adaptation, create more obvious and sometimes undesirable changes in the color of photographs.

Most people who make color photographs casually are not concerned with these problems. For them, a reasonable likeness is sufficient, and the heightened sense of reality that color provides is reason enough to choose it instead of black-and-white. For the serious photographer, however, certain aspects of light, human vision, image organization, and photographic materials combine to make photographing in color a different experience from working in black-and-white. This chapter will consider these differences; the next two chapters will explain how color materials are handled and processed.

## WHAT COLOR IS

All color originates in *light*, as Sir Isaac Newton discovered in 1666 when he used a colorless glass prism to split a beam of light into a spectrum of colors, and another such prism to recombine the spectrum into a single beam. Before Newton's experiment, color was thought to exist in objects themselves—a reasonable premise since nearly all objects contain *pigments* or *dyes*, and these are selective reflectors of light. A green leaf, for example, contains chlorophyll, a pigment that reflects green light and absorbs other colors. Paints, which contain pigments, are used to color many things. A red plastic toy contains a pigment or dye that reflects red.

Color can also be produced in other ways. Some objects appear

**125**

to be colored because their thin surfaces reflect light unevenly. Soap bubbles, for example, or gasoline spilled onto a wet pavement will both appear iridescent or multicolored. Each of these substances forms a very thin layer on the surface of the water, and light waves reflecting at an angle from the top and bottom of this layer are slightly misaligned, strengthening some waves and weakening others. The result is a spectrum of colors instead of a colorless liquid.

Color can sometimes be formed by scattering light waves. This is why the sky appears blue: the air contains gases that scatter shorter wavelengths of light. If there were no atmosphere to scatter the light, the sky would appear black, as it does in photographs made on or near the surface of the moon. We can see another example of this scattering on earth, however, almost every day. When we look at the sun just after sunrise, or just before sunset, it appears red or orange. The low angle from which the sunlight reaches us at these times requires it to travel farther through the earth's atmosphere. Most light waves are scattered by the atmosphere, and only the longest wavelengths—the red and orange ones—get through unimpeded. Daylight, then, changes in color with the time of day; it is similarly affected by the clarity or pollution of the air.

## HOW WE SEE COLOR

The retina of the eye contains millions of light-sensitive cells or receptors connected through optic nerves to the brain. There are two kinds of retinal cells: *rods* and *cones*. Rods are more sensitive and more numerous, but by themselves they cannot distinguish one color from another. Cones, which do respond to color, are concentrated near the center of the retina. Our color perception, then, is best when we look directly at objects, using our central vision, in adequate light; it is less reliable near the outer edge of our visual field or when the light is dim. Cones appear to be selectively sensitive to red, green, or blue rays, and all color photography is based on this three-color theory of visual perception.*

Human color vision is far from uniform, and although totally color-blind people are rare, mild deficiencies in color perception occur in about eight percent of men and fewer than one percent of women. Caused by abnormalities in the retina and its nerves, these defects cannot be cured, and since they are inherited, many people who have them are unaware of their problem because they have never seen things any other way. An optometrist, however, can identify

any deficiency, and the individual can then learn to compensate for it.

As we noted in Chapter 3, our eyes are marvelously adaptive, and if you have a black-and-white TV set you can perform a simple experiment to demonstrate this point. Place the set in a darkened room with no other sources of light. Watch the picture for a few minutes under this condition, and then step into another room illuminated by ordinary tungsten-filament light bulbs. At first, these lights will have a distinct reddish glow, but this glow will slowly disappear as your eyes adjust to them and you perceive these lights, as you did the TV picture, to be "white." Our eyes, then, are preconditioned by our brain to perceive certain colors as we expect them to appear. Couple this phenomenon with the variable color of daylight and with the variety of actual colors available from artificial light sources such as tungsten and fluorescent lamps, all of which we see as white light, and you have some idea of how adaptable our eyes can be.

Films, however, are different. They cannot adapt themselves, as our eyes can, to changing light conditions or sources. Instead, color films are manufactured to record a specific mixture of colors as "white." This response, called *color balance* (discussed later in the chapter), must be properly matched to the light being used if faithful color rendering is desired.

## HOW COLOR PHOTOGRAPHY EVOLVED

The desire to photograph in color is as old as photography itself. A direct color image eluded most of the pioneer inventors, including Niepce and Daguerre (Chapter 12), but many daguerreotypists hand-tinted their plates with pigments to complete a realistic illusion. W. H. F. Talbot, inventor of the first negative, also sought to reproduce colors in his photogenic drawings, but he had to be satisfied with white lines on a colored ground.

James Clerk Maxwell, who first described the electromagnetic spectrum, was more successful. In 1861 he used three collodion plates to demonstrate that all colors could be created by combining light from three major bands of the spectrum—red, green, and blue. Maxwell's experiment produced, by projection, a crude but recognizable color photograph (Plate 1), the world's first, and the principle he demonstrated, *additive synthesis*, became the basis of several early color processes.

Additive processes begin with darkness and produce their color by combining red, green, or blue light sources to produce all colors of the spectrum. *In an additive process, the three primaries together produce white light.* The most practical of these early additive schemes was the Autochrome process, introduced in France by the Lumière brothers in 1907. Autochrome plates used a mixture of red, green, and blue starch grains coated on the glass plate to filter the light before it reached the sensitive panchromatic

---

* Investigations by Dr. Edwin H. Land, reported in 1959, produced evidence that only two channels of color information are required for the human eye to perceive all colors in objects. The two channels, however, must be properly spaced apart on the electromagnetic spectrum, one on either side of 588 nanometers. Nevertheless, all current systems of color photography are tricolor in nature.

emulsion. After exposure, the plate was processed to a positive image with the starch grains intact, and then was viewed as a transparency (Plate 2). Although the color was satisfactory, Autochrome plates were very slow; long exposures were required.

Meanwhile, other means of making color photographs had been discovered. In 1869, Louis Ducos du Hauron and Charles Cros, working independently in France, almost simultaneously proposed a different path to full-color reproduction. Pigments, they suggested, appeared colored by *absorbing* certain components from white light, while reflecting only their own color to the observer. Each color could thus be made by combining primaries to absorb or *subtract* all others, but the additive primaries that Maxwell had used—red, green, and blue—would not work: their complements or opposites—cyan, magenta, and yellow—were required instead.

By 1877 Du Hauron had perfected a *subtractive* carbon printing process to demonstrate his theory. Three negatives, taken through primary filters, were printed on thin, sensitized tissues containing bluish-green (cyan), reddish-blue (magenta), and yellow carbon pigments. When the tissues were superimposed on a white base, a full-color image was created (Plate 3).

Unlike the additive systems for producing color, which proceeded from darkness to light, subtractive systems begin with white light. *In a subtractive scheme, each of the three colors absorbs a primary, thereby subtracting or removing it from white light.* Cyan, for example, subtracts red, magenta absorbs green, and yellow removes blue. If all three subtractive colors overlap, all light is absorbed, and the result appears gray or black.

Little more was done with the subtractive principle until 1905, when Karl Schinzel in Germany proposed coating three emulsion layers, each sensitized to a different additive primary but dyed the absorbent subtractive color, on a single base. Thus the idea of an integrated tripack, or *monopack*, which later became the basic structure of all color films, was formed. Although Schinzel's idea was conceptually sound, the dyes available to him at that time would not survive the required processing, and he was not able to produce a workable material.

In 1912, however, Rudolph Fischer of Germany discovered that as certain developing agents (such as paraphenylenediamine) reduced exposed silver bromide, they would simultaneously react with other chemicals to form stable, insoluble dyes. This discovery, known as *dye coupling*, pointed a way to form the proper subtractive colors in the layers of Schinzel's monopack. But one major problem remained: the sensitizing dyes tended to move from one layer to another, invalidating the selective color response essential for monopacks to work properly.

After more than twenty years of research, the Interessen Gemeinschaft (Agfa) company in Germany finally discovered a way to prevent the dyes from migrating by anchoring them to long-chain molecules. Their first successful monopack films, Agfacolor and Anscocolor, were introduced in 1936.

Meanwhile, two researchers at Eastman Kodak Company, Leopold Mannes and Leo Godowsky, Jr., solved the problem a different way by placing the dye-couplers in the developing solutions instead of the emulsion layers. This method also produced a practical subtractive monopack film, introduced in 1935 as Kodachrome. A year later, Kodak insured the success of the new film by placing the processed 35mm transparencies in two-inch square cardboard mounts or slides, making them easy to project.

By 1942, Kodak had successfully applied its dye-coupler technology to negative film and print materials, producing *complementary* colors in each by a single development. Kodacolor film, as it was called, could be used in ordinary snapshot cameras; color prints on paper were then made from the negatives. With these important achievements, modern color photography was born.

---

## COLOR FILMS

There are two basic types of color films. One kind produces color slides or transparencies that can be seen in a hand-held viewer or projected onto a screen in a darkened room, for simultaneous viewing by many people. The other type of film produces color negatives from which prints on paper are made. Table 9-1 lists both types of color films available.

### Color Slide Films

Color slide films produce their images directly: the same piece of film you load in your camera is returned to you containing the positive images. Slide films therefore let you see your results quickly and the cost per picture is low. Slides, or *transparencies* as they are also called, are convenient to store and easy to retrieve, transport, and sequence for showing. And because slides must be projected or viewed by transmitted light, richer, more intense colors can be obtained with them. This greater color intensity possible in slides helps to compensate for their small size, and for the inconvenience of having to set up a projector or light box to view them properly.

Color slide films, also known as *reversal films*, are now universally designated by names ending in -*chrome* (see Table 9-1). You can process most of them yourself (as described in the next chapter) or have a commercial lab do them for you.

### Color Negative Films

Color negative films, of course, must be handled twice after exposure: once to produce the negatives (as with black-and-white) and again to make prints from them. This takes longer than processing slides does and costs more, but the two-step procedure per-

**TABLE 9-1**  POPULAR COLOR FILMS

| | Color Slide Films | Color Negative Films for Prints |
|---|---|---|
| AGFA | Agfachrome 1000 RS | Agfacolor XRS 1000 |
| | Agfachrome 200 RS | Agfacolor XRS 400 |
| | Agfachrome CT 200 | Agfacolor XRS 200 |
| | Agfachrome 100 RS | Agfacolor XRG 200 |
| | Agfachrome CT 100 | Agfacolor XRG 100 |
| | Agfachrome 50 RS | Agfacolor XRS 100 |
| FUJI | Fujichrome 400 | Fujicolor Super HRII 1600 |
| | Fujichrome 100 | Fujicolor Super HG 400 |
| | Fujichrome 50 | Fujicolor Super HG 200 |
| | | Fujicolor Super HRII 100 |
| | | Fujicolor Reala (100) |
| KODAK | Ektachrome P800/1600 | Ektapress Gold 1600 |
| | Ektachrome 400 | Kodacolor Gold 1600 |
| | Kodachrome 200 | Ektar 1000 |
| | Ektachrome 200 | Ektapress Gold 400 |
| | Ektachrome 160* | Kodacolor Gold 400 |
| | Ektachrome 100 Plus | Vericolor 400 |
| | Ektachrome 100 | Kodacolor Gold 200 |
| | Ektachrome 64 | Ektar 125 |
| | Kodachrome 64 | Ektapress Gold 100 |
| | Ektachrome 50* | Kodacolor Gold 100 |
| | Kodachrome 40* | Vericolor III Type S (160) |
| | Kodachrome 25 | Vericolor HC (100) |
| | | Vericolor II Type L* |
| | | Ektar 25 |
| KONICA | Chrome 100 | SR-G 3200 |
| | | SR-G 400 |
| | | SR-G 200 |
| | | SR-G 100 |
| 3M | Scotch Chrome 640* | POLAROID OneFilm (200) |
| | Scotch Chrome 400 | |
| | Scotch Chrome 100 | |

Instant color films are listed in Appendix A.
* Tungsten color balance; all others are daylight.

mits some manipulation and control of the color that is not practical with slides. Color prints, of course, are easy to view; no special projector or other equipment is needed.

Most negative films have names ending in the suffix *-color* (see Table 9-1). Today they account for more than 15 billion color photographs made each year, or about 85 percent of all photographs made worldwide. Like reversal films, they can also be processed in your own darkroom or sent to a commercial lab. The process contains a few more steps than black-and-white films need, but not as many as color slides require.

If you enjoy darkroom work, you can also make your own color prints from your negatives. These can be enlarged, of course, and individually crafted just as black-and-white prints can. Instructions for processing color negatives and for making color prints from them are given in the next two chapters.

Although each type of film—slide or print—can be used to produce the other type of picture, results generally will be better (more predictable if others process the films, more controllable if you do your own) when you use a film intended primarily for the type of picture that you want.

## COLOR BALANCE

White light, as we have already noted, is a mixture of red, green, and blue wavelengths, but this mixture will vary from one kind of light source to another. The different sources that we perceive as "white" light can be compared by their *color temperature*, which is a way of designating the relative amounts of red, green, and blue in the mixture. Color temperatures are expressed as degrees on a Kelvin scale (Plate 4).* At lower temperatures, reddish light dominates the mixture; at higher ones the light is bluish.

Most color films are balanced for exposure by *daylight*. A few, however, are balanced for exposure by a type of tungsten-filament lamp widely used in photographic studios, and these are designated *tungsten*.

Daylight films record the color spectrum most accurately in average daylight (a mixture of sunlight and skylight), or by the light of electronic flash lamps which closely resemble daylight in color (see Chapter 18). Tungsten films, on the other hand, give the best color rendering when the subject is illuminated entirely by 3200K photographic lamps.

### Filters for Color Photography

If other light sources, such as ordinary household lamps, are used, or if the light source and film are not correctly matched, a filter must be used over the camera lens to balance the light for proper color rendering. Table 9-2 lists the light and film combinations requiring filters for best results. Note that if the camera does not have an internal exposure meter, the exposure must be increased when such a filter is used.

Filters will also be useful when you must make color photographs in fluorescent light. Fluorescent tubes emit a discontinuous or uneven spectrum, with much less red than is apparent to the eye. A fluorescent light filter (see Table 9-2) will prevent the blue-green cast which such photographs otherwise would have. Compare the colors of objects in Plate 6A, made without a filter, to those in Plate 6B, made with an FL-D filter on the camera lens.

In certain outdoor situations you will find other filters useful. When snow scenes, seascapes, views of mountains, or landscapes made at high elevations are photographed in sunlight, nearby shadows and very distant objects will often come out quite blue, due to the presence of a large amount of ultraviolet

---

* The Kelvin scale designates the temperature to which a theoretical "black body" must be heated to give off light of this color.

**TABLE 9-2** LIGHT SOURCE AND COLOR FILM COMBINATIONS REQUIRING FILTERS FOR CORRECT COLOR RENDERING

| Light Source | Film Type | Filter | Exposure Increase* |
|---|---|---|---|
| Blue skylight | Daylight | 81C | ⅓ stop |
| Sunlight | Daylight | None | None |
| | Tungsten | 85B | ⅔ stop |
| Fluorescent cool white | Daylight | FL-D | 1 stop |
| | Tungsten | FL-B | 1 stop |
| Photofloods 3400K | Daylight | 80B | 1⅔ stops |
| | Tungsten | 81A | ⅓ stop |
| Studio tungsten lamps 3200K | Daylight | 80A | 2 stops |
| | Tungsten | None | None |
| Household tungsten lamps 2850K | Tungsten | 82C | ⅔ stop |

\* For hand-held meters. Most meters built into cameras will compensate for this automatically.

light. Our eyes do not detect ultraviolet, but color films do and record it as blue. A *skylight filter* or *UV filter* will absorb these ultraviolet rays and prevent them from reaching the film.

Balancing the light to the film with filters is most important when you are making color slides, for the film you expose in the camera is the same one you will later project for viewing. *When making slides, all color correction must be done when you expose the film.* With negative film for prints, however, light balancing is less critical, since some correction can be done at the printing stage. Nevertheless, a properly balanced negative, made with a filter (if needed) on the camera lens, will be easier to print satisfactorily.

## STRUCTURE OF COLOR FILMS

All color films have a basic structure of three black-and-white, light-sensitive emulsion layers (Fig. 9-2). The top layer is sensitive only to blue light, the middle layer to green, and the bottom layer to red. A yellow filter layer under the top layer prevents the blue light from reaching the other two layers below (which, like all silver bromide emulsions, are also sensitive to blue light). The rest of the basic structure is similar to black-and-white films. Some films have multiple layers for each of the three colors to gain sensitivity without increasing graininess; others have additional filter layers built into the structure to screen out ultraviolet rays and improve color purity.

Almost all color films have color-forming ingredients called *couplers* in the three sensitive layers.* When the film is developed, these couplers react with other processing chemicals to form *colored dyes* in the light-sensitive emulsion layers. The dyes, of course, are those which absorb the primary sensitivity

\* Kodachrome film is an exception; its couplers are in the processing solutions instead of the emulsion layers. This requires a complex developing process provided only by a few large commercial laboratories. It is not suitable for processing by the user.

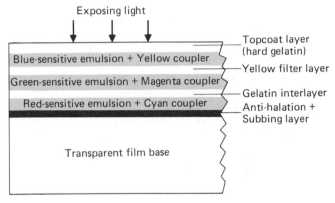

**9-2** *Basic structure of color films.*

of each layer: yellow dye is produced in the blue-sensitive top layer, magenta dye in the green-sensitive middle layer, and cyan dye in the red-sensitive one at the bottom. The yellow filter is removed by the processing chemicals.

## THE LANGUAGE OF COLOR

It is not surprising that something as complex as color has a language all its own, and since color is a function of light, the nature of light should give us some clues. In Chapter 3 we noted that different colors of light occur as different wavelengths on the electromagnetic spectrum, with red at one end and blue-violet rays at the other. If we bend a diagram of this spectrum so that its ends touch to form a circle, the three primary colors of light—*red, green,* and *blue*—will be equally spaced around it (Plate 5). These three colors are called the *additive primaries.*

You will also notice three other colors on the circle: *cyan* (blue-green), *magenta* (reddish-blue), and *yellow.* These are called *subtractive primaries.* They lie in between the additive ones, and virtually all color in photographs is produced by them. As their positions on the circle suggest, combining any two of these

subtractive colors produces the intermediate additive one: red, green, or blue.

## Color Notation

The eye, however, can distinguish many more colors than the six named above, so a means of accurately describing colors is useful. The widely used Munsell System, for example, describes a color in terms of three characteristics to which names, numbers, or other identifying symbols may be attached:*

1. **Hue** is the name of a color. Red, green, yellow, and magenta, for example, are all different hues. More than a hundred hues can be distinguished by the human eye.
2. **Lightness,** or **value,** is the degree of luminance a color possesses, and thereby a measure of how much light it reflects. Most yellows, for example, are high in lightness; navy blue is low (dark).
3. **Saturation,** or **chroma,** is the vividness or purity of a color. This is a measure of the dilution of a color with white light. Pink, for example, is a diluted version of red; a red traffic signal is not diluted.

## Color Relationships

Now study Plate 5 again. Notice how the six additive and subtractive primary colors are positioned around the circle. *The way these six colors relate to each other is fundamental to all color photography.*

*Complementary colors* are *opposite* each other on the circle; together they form neutrals: white, gray, or black. Thus red and cyan are complementary hues, magenta and green are complementary hues, and so are blue and yellow.

As we have already seen, all colors of light can be produced by mixing the primary hues: red, green, and blue. Several early color processes were based on this principle, and today theatrical or stage lighting and color television use it. But almost all color photography is based on the subtractive primaries of cyan, magenta, and yellow. These three dyes alter white light to give us the impression of all other colors in prints and slides. When none of these dyes is present we get the sensation of *white.* When all of them are present in full saturation, we see the result as *black.* Because of the three separate image layers that make up color films and prints, no other image colors are needed, and no other colors are present.

Colors next to each other on the color circle are often described in nonvisual terms. For example, we tend to identify the blue-cyan-green section of the circle as *cool,* and the yellow-red-magenta area as *warm.* Warm, saturated colors, for instance, can intensify our level of emotional response, while cool or desaturated colors can have the opposite effect.

Adjacent hues on the circle tend to harmonize, that is, to work together smoothly and maintain a sense of unity in a picture. On the other hand, complementary hues—ones that lie across the circle from each other—appear bold and decisive when framed together, especially when they occur next to each other, as in the author's image of a railway snowplow (Plate 8). Used in this manner, two colors can create a contrasting and dramatic effect. But if several complementary hues are present in the same picture, they can clash with each other and rob a picture of much of its visual power and unity.

A useful guideline, then, is to *use complementary colors sparingly.* One pair of them can add to a picture's strength. Another pair, in effect, introduces a second theme, which may compete with the first pair and weaken its visual effect. Three pairs of complementary colors in the same picture invite visual chaos.

Bernard Freemesser's photograph (Plate 9) works with a limited palette of blue, black, and white. Joel Sternfeld used the largely neutral colors of houses in his view as a relieving counterpoint to the mass of darker, richer earth tones surrounding them (Plate 10). In each case these photographers have resisted the temptation to include many hues in their images. Instead, their photographs achieve a striking effect from careful, limited use of color.

## COLOR AS FORM

What we see working in the preceding examples is *color as form and substance* rather than as surface quality alone. Earlier in this chapter we noted that color tends to dominate. In effective color photographs, *hue* and *saturation* usually are the dominant color characteristics, whereas gradations of *value* (from light to dark) vary or adjust the impact of these other characteristics. Photographs such as Freeman Patterson's dramatic view of an African desert (Plate 11) function by treating the color itself as a major element of the picture, just as lines, shapes, and contrasting tones are considered. And because the sensation of color can easily eclipse other picture factors, anyone using it seriously in photography must consider *color as form,* as an important element of the picture itself, and not simply as another aspect of the detail that photographs use to convey most of their content. Color adds to this informational function, of course, but when it is used effectively it accomplishes more than that. As Alfred Yaghobzadeh's dramatic image from Beirut confirms (Plate 12), color attracts our attention, compels our emotional involvement with the picture, and conditions our response to it.

## IS COLOR THE ULTIMATE REALISM?

A curious consequence of making color photographs is that the more closely we try to represent reality with them, the more critical we become of

* The Munsell System uses a set of sample color patches numerically labeled to indicate these characteristics. A three-dimensional model in which the patches are arranged around a vertical axis (like leaves and branches on a tree) also is available.

their failure to do so. Think about this a moment. A photograph that makes no attempt to echo the real world makes no special demands on us for credibility. We take it as it comes, accepting the way it looks to us, or inventing our own justification for what we see in the image. But if a color photograph closely resembles the real world, we make impossible demands of it. We expect the photograph to show us exactly what we see, although in actuality the world we see and the world our film can record are never quite the same.

Color films have their chromatic scale bred into them, a marvel of chemistry rather than a restatement of reality. Moreover, different brands of color films will show characteristic differences when recording the same situation or scene. One type may favor reds, for example, and another accentuate blue or greens. And differences in processing (as from one lab to another) can emphasize or minimize these effects. Together these forces conspire to make color photographs questionable facsimiles at best. In spite of generations of technological improvements aimed at making them accurate reproducers of the real world, color photographs have always fallen somewhat short of the mark.

This ultimate failure of color photographs to faithfully reproduce the real world is both a blessing and a paradox. We have grown so accustomed to seeing the real world through color TV and photographs that our perception of what is real often stems not from actual observation but from reproduced images instead (remember the menu photographs in any fast-food restaurant).

Such varied visual experiences, of course, make us more tolerant of how things look both as objects and as images, and sometimes this allows us to let color work for us in interesting ways. In Plates 8 through 11, for example, we can enjoy the visual excitement of color without being concerned about whether the things photographed were really that brilliant. When we ask color photographs to bear *symbolic* or *emotional truths* (as they do, for example, in greeting cards and calendars), they generally do these jobs rather well. But when we expect them to be conveyors of *objective truth*, or of indisputable facts (as we frequently do in advertising and commerce), color photographs may be among the most cunningly deceptive pictures in our entire visual world.

## SUMMARY

1. *Color is a sensation*, not a substance. *It originates in light* and is changed by pigments or dyes in objects reflecting that light to our eye or camera. Color can also be produced by scattering light, as the atmosphere does.

2. *We see color* using the cones in the center of the retinas in our eyes. Cones appear to be sensitive to red, green, and blue light, and *all color photography is based on this three-color theory of perception.*

3. *Our eyes adapt themselves* to slight changes in color, permitting us, for example, to see varied colors of light as "white." *Films cannot adapt their response* in this way. Instead, they record a specific mixture of colors as "white." This fixed response is called *color balance.*

4. James Clerk-Maxwell produced the first color photograph by *additive* projection in 1861, combining red, green, and blue light sources to produce the entire spectrum. The most practical additive process was the Lumière Autochrome process, introduced in France in 1907.

5. Louis Ducos du Hauron, however, had perfected a *subtractive* color process using cyan, magenta, and yellow pigments by 1877. Each of these colors absorbed or subtracted a primary color from white light.

6. Two other discoveries were needed to make color photography practical. *Dye coupling* made it possible to form color in the film during processing. *Anchoring the color-forming chemicals* prevented them from moving between layers. The first color slide films to solve this problem were Kodachrome (1935), and Agfacolor and Anscocolor (1936). Kodacolor, a negative film from which paper prints could be made, was introduced in 1942.

7. There are *two basic types of color films*. One produces positive transparencies or slides. The other produces negatives from which paper prints are made. Today all color slide films have names ending in *-chrome*; most color print films have names ending in *-color.*

8. *Color temperature*, expressed in degrees Kelvin, is a way of designating the *relative amounts of red, green, and blue light in a mixture.* Color films respond accurately only to certain color temperatures of light. The most common are *daylight* (5500K) and *tungsten* (3200K). Other kinds of light must be filtered at the camera for proper color rendition.

9. The *structure* of color films is similar to that of black-and-white, except that there are three light-sensitive layers, one for each of the primary colors of light. Almost all films have color-forming *couplers* in these three emulsion layers. When the films are developed, the couplers react with other processing chemicals to form cyan, magenta, and yellow *dyes* in the appropriate layers.

10. Red, green, and blue are *additive* primaries. Cyan, magenta, and yellow are *subtractive* ones. These six colors can be related to each other by placing them on a color circle. *This relationship is fundamental to all color photography.*

11. Any color can be described by three characteristics: *hue, value,* and *chroma*. Hue is a color's name. Value, or lightness, designates a color's luminance, and thereby how much light it reflects. Chroma, or saturation, measures a color's vividness or purity.

12. Colors opposite each other on the circle are called *complements*. Certain adjacent colors are often described in nonvisual terms, such as *warm* or *cool.*

13. In effective color photographs, hue and saturation often dominate the picture, allowing the color to function as *form* rather than as surface quality. Color often tends to convey symbolic or emotional ideas better than objective or factual ones.

# 10

# PROCESSING COLOR FILMS

**10-1** *Moorhead Junction, Minnesota, 1976. See also Plate 7.*

Processing color films is basically similar to black-and-white processing, but with some important differences. Color processes require different chemicals, have more steps, and take more time. Color materials and chemicals must be compatible, and they cannot be freely interchanged. Temperatures are higher and more critical for color processing, and timing must be precise. Because of these differences, *close attention to details and consistent working habits are very important.* They will do more than anything else to insure good results for you, time after time.

When color film is exposed in a camera, a latent image is formed in each layer wherever that layer's primary color is reflected by the subject. Processing the film converts these latent images into visible ones, producing silver metal (as in black-and-white) and forming appropriately colored dyes along with it. Then the silver and all soluble compounds are removed, leaving only the dyes in the gelatin emulsion. Color negative films, color slide films, and color prints each require somewhat different processing, although there are many similarities.

## PROCESSING COLOR NEGATIVE FILMS

Today color negative films are processed wherever films are developed; every shopping center uses its own quick-service lab. If you choose to process your own color negative films, however, you will need many of the same things used for black-and-white. A stainless-steel, spiral-reel tank is recommended because it transfers heat efficiently and fills and empties quickly. *Your thermometer must be accurate to within half of one degree at 38°C (100°F).* You'll also need four storage bottles with air-tight caps for the chemicals, and a plastic container or dishpan in which to immerse the tank and bottles to keep them warm.

The chemicals for **Process C-41** come in convenient, one-use kits available from Beseler, Kodak, Unicolor, and other suppliers. Kodak also supplies these chemicals in sizes to make 1 gallon or larger quantities of each solution, useful if more than a few rolls must be processed together. A totally dark place, of course, is needed to load the tank, but you may do all the processing in normal room light.

The process begins with a *color developer*, which forms silver from the latent image, and complementary-colored dyes (cyan, magenta, or yellow) in each of the three emulsion layers wherever the silver is produced. Next comes *bleaching*, which stops the development and changes the silver to a soluble compound but leaves the dyes alone. After a *wash*, the film is *fixed* to remove the soluble compounds formed in the earlier step, along with all unexposed silver halides, just as with black-and-white negatives. *Washing* again removes all soluble chemicals from the emulsion, leaving only the dyes. A brief bath in a *dye stabilizer* completes the process. The C-41 process, which has a total "wet time" of about 25 minutes, is summarized in Table 10-1.*

Color negatives have an orange-brown cast, even in unexposed areas that we would expect to find clear and colorless. This is because the magenta and cyan dyes used in negatives and color paper emul-

---

* Chemicals and procedures may change from time to time as improvements are introduced. Always follow the instructions packed with the chemicals if they differ from those given here.

**TABLE 10-1** PROCESS C-41 FOR COLOR NEGATIVE FILMS

| Step | Temperature °C | Temperature °F | Time in Minutes |
|---|---|---|---|
| 1. Developer | 38 ± ¼ | 100 ± ¼ | 3¼* |
| 2. Bleach | 24–41 | 75–105 | 6½ |
| *Tank may be left open for remaining steps* | | | |
| 3. Wash (running water) | 24–41 | 75–105 | 3¼ |
| 4. Fixer | 24–41 | 75–105 | 6½ |
| 5. Wash (running water) | 24–41 | 75–105 | 3¼ |
| 6. Stabilizer | 24–41 | 75–105 | 1½ |
| 7. Dry (remove film from reel) | 24–43 | 75–110 | |

*\* For the first roll of film in fresh solutions. As additional rolls are processed in the same solution, this time must be increased. See instructions packed with the chemicals.*

sions are not perfect; they actually transmit small amounts of wavelengths that they should absorb. To counteract this tendency, the middle (green-sensitive) layer of the film is colored pale yellow, and the bottom (red-sensitive) layer is colored pale red during manufacture. These colors remain in the film throughout the process wherever dye images are *not* produced, and function as color-correcting masks in the developed negatives. Together the two colored layers appear orange-brown, giving color negatives their characteristic appearance. This color does not appear, however, in prints made from the negatives, since the color-sensitivity of printing papers is balanced to ignore it.

## Processing Tips

1. Prepare the chemicals according to the instructions packed with them. Usually this requires diluting them in a specific volume of warm water. Label and date each bottle.

2. Preheat the chemicals to 38°C (100°F) by immersing their bottles in hot water. *The temperature of the C-41 Developer is very critical*; it should not vary more than $\frac{1}{4}$ degree. The other solutions and washes can be used at any temperature between 24° and 41°C (75° to 105°F).

3. It is extremely important to *keep the tank immersed almost to the rim in 38°C water throughout the development step*. Lift it out of the water bath *only* to invert it for agitation, and reimmerse it immediately after each inversion cycle.

4. Use a simple, repeatable agitation pattern, and allow the last 10 seconds of each step for emptying the tank.

5. Note how many rolls you process. The capacity and storage life of the solutions is given in the instructions packed with the chemicals. Do not exceed these limits.

## Changing the Speed of Color Negative Films

Most color negative films do not respond very well to speed changes produced by push-processing; they become difficult to print satisfactorily. However, there are several films designed for such treatment, and they are listed in Table 10-2.

**TABLE 10-2** COLOR NEGATIVE FILMS FOR PUSH-PROCESSING

| KODAK Film | To push to ISO | Increase time in C-41 Developer to |
|---|---|---|
| Kodacolor Gold 400 | 800 | 4 minutes |
| Kodacolor Gold 400 | 1600 | 5½ minutes |
| Ektapress Gold 400 | 800 | 3¾ minutes |
| Ektapress Gold 400 | 1600 | 4 minutes |
| Ektapress Gold 1600 | 3200 | 3¾ minutes |
| Ektapress Gold 1600 | 6400 | 4 minutes |

*Times in all other solutions remain unchanged.*

When an increase in film speed is desired, the normal time in the C-41 Developer (3¼ min.) must also be increased as shown in the table. Times in all other steps remain unchanged.

News photographers and others working for the media sometimes use this feature to make color photographs in less than ideal lighting conditions. Some

change in image quality should be expected, but results have been remarkably good.

## PROCESSING COLOR SLIDE FILMS

The setup for processing color slide films is similar to that for negatives. You need a steel tank, hot water, an accurate thermometer, seven storage bottles with air-tight caps, and a plastic dishpan or container large enough to hold the tank and bottles.

All color slide films except Kodachrome and Polachrome require chemicals for **Process E-6.*** There are two versions of the process available. One is a short, four-step process packaged for one-time use. Available from Beseler, Kodak, Unicolor, and other sources, these kits make processing quick and simple, but they can process only one or two rolls of film.

A longer version of the process is available as a one-gallon kit from Kodak; individual components of this kit are also available in one-gallon and larger sizes. The full process should be used whenever consistent, repeatable results are important, or whenever maximum image stability is desired.

The E-6 process begins with a *first developer*, which forms black-and-white negatives in the three

emulsion layers corresponding to the latent image of the camera exposure. Then the film is washed and treated in a *reversal solution*, which fogs all remaining light-sensitive silver halides throughout the film in much the same way that exposure to light would.

Next comes a *color developer*, which changes the fogged areas to silver and simultaneously forms complementary-colored dyes in each of them. These fogged areas include all of the film that was *not* affected by the camera exposure. Since the camera exposure produced a negative image, the fogged areas of the film are, in effect, a negative of a negative, which, of course, is a positive. While each of the two developers in this process produces silver, only the second (color) developer produces colored dyes at the same time. Thus the colored dyes are produced only in those areas corresponding to the second (positive) image. This second development is followed by a *conditioner*, which buffers the film emulsion, reducing its alkalinity to prepare it for the next step.

Now the film is treated in a *bleach*, which changes all of the silver to a soluble compound without affecting the dyes. Next comes a *fixer*, which dissolves the silver compounds, and a *wash* in running water to remove these and all other soluble compounds from the emulsion. At this point, only the colored dyes remain in the gelatin emulsion, which appears translucent or hazy. A *stabilizer* for the dyes, which improves their stability and which also contains a wetting agent to help the film dry cleanly and quickly, completes the process. Then the film is hung up to dry, clarifying as it dries. The entire E-6 process takes about 37 minutes plus drying time, somewhat longer than negative films require. It is summarized in Table 10-3.

---

* Kodachrome requires a much more complex process available only from a few large laboratories. If processed in E-6 chemicals, Kodachrome film will be ruined. Polachrome is discussed in Appendix A.

**TABLE 10-3**  PROCESS E-6 FOR COLOR SLIDE FILMS

| Step | Temperature °C | °F | Time in Minutes |
|---|---|---|---|
| 1. First Developer | 38 ± ½ | 100 ± ½ | 7* |
| 2. Wash (running water) | 33–39 | 92–102 | 2 |
| 3. Reversal Bath | 33–39 | 92–102 | 2 |
| *Tank may be left open for remaining steps* | | | |
| 4. Color Developer | 38 ± 1 | 100 ± 1 | 6 |
| 5. Conditioner | 33–39 | 92–102 | 2 |
| 6. Bleach | 33–39 | 92–102 | 7 |
| 7. Fixer | 33–39 | 92–102 | 4 |
| 8. Wash (running water) | 33–39 | 92–102 | 6 |
| 9. Stabilizer | 33–39 | 92–102 | 1 |
| 10. Dry (remove film from reel) | to 49 | to 120 | |

*\* For the first roll of film in fresh solutions. As additional rolls are processed in the same solution, this time must be increased. See instructions packed with the chemicals.*

## Processing Tips

1. Begin by preparing the chemicals according to the instructions packed with them, labeling and dating the bottles. Heat the bottled solutions to 38°C (100°F).

2. *The temperature of the first developer is the most critical; it must not vary more than one-half of one degree ($\pm\frac{1}{2}°$). The color developer is almost as critical ($\pm 2°$).* Other solutions can be used at temperatures from 33° to 39°C (90° to 102°F).

3. As with negative film, it is important to keep the tank immersed in 38°C water at all times, lifting it out only to agitate or empty it.

4. Use a simple, repeatable agitation pattern (as for black-and-white films) in all solutions, and always allow the last 10 seconds of each step for emptying the tank.

5. Note how may rolls of film you process in each batch of solutions, and the date you use them. The life and capacity of a processing line is limited (see information packed with the chemicals). For good results, do not exceed these limits.

## Changing the Speed of Slide Films

Some change of film speed (ISO) is possible with most slide films by *changing the time in the first developer*. For example, the nominal speed of a typical E-6 film can be *doubled* if the time in the first developer is increased by 2 minutes. When this is done, the time in all other solutions and steps remains unchanged. This will result in an increase in contrast and a change in the color balance, usually warmer. On the other hand, the effective ISO of the film can be *cut in half* by decreasing the first developer time by $1\frac{1}{2}$ minutes for less contrast and a slightly cooler color balance. Again, the times in all other solutions remain unchanged. Some inadvertent exposure errors that extend throughout a roll of film can thus be corrected during processing.

## Mounting Your Slides

When you process your own slides, you must also mount them in frames for projection—an easy and inexpensive task. Plastic or cardboard 2 × 2 in. slide mounts may be purchased from many photo dealers. Some mounts snap together; others are folded and sealed with their own adhesive or with the tip of a household iron.

Finally, orient and mark your slides for proper projection. Hold your slide exactly as you wish it to appear on the screen. Then place a spot or similar mark (a pencil eraser used as a rubber stamp works well) in the *lower left corner* of the mount (Fig. 10-2). If the slides are loaded in the projector or tray with this index mark at the upper right, facing the rear of the machine, the image will be correctly projected.

**10-2** *Indexing slides.*

# SUMMARY

1. *Color negative films* require chemicals for *Process C-41*, available in convenient kits, but this processing service is available commercially almost everywhere. The process is summarized in Table 10-1.

2. Color negatives have a characteristic orange-brown appearance caused by *colored couplers* placed in the film to correct dye-absorption characteristics. This color cast, however, does not appear in prints made from the negatives.

3. *All color slide films except Kodachrome and Polachrome* require chemicals for *Process E-6*. Short and full-length versions of this process are available. Two developers are used. The first produces black-and-white negative images, the second color positive ones. Removing the silver then leaves only the positive color images in the film. Table 10-3 summarizes Process E-6.

4. The *speed* of most color slide films and some color print films can be *altered* by changing the first development time. Changes in contrast and color balance may also occur.

5. *All 35mm slides must be mounted* for projection.

# 11

# MAKING COLOR PRINTS

**11-1** *Color printing can be fascinating and fun.*

Color printing requires a light-tight darkroom—one that can be made completely dark. Although some color print materials can be handled under a Kodak No. 13 safelight filter (dark amber), this safelight provides little useful illumination, and it is just as easy to work in the dark. Making color prints is a bit more complicated than making black-and-white ones, but if you have consistent work habits and keep careful notes of your procedures, color printing can be fascinating and fun.

There are three phases to color printing: (1) exposure, (2) processing, and (3) evaluation. The basic method is similar to black-and-white, but color materials must be completely processed and dried before you can accurately evaluate your results; you can't judge wet prints under a safelight as you can black-and-white. Color prints can be made from either color negatives or from slides, but procedures differ for each.

## PRINTING COLOR NEGATIVES

To make color prints, you will need the same basic darkroom setup that black-and-white work requires (p. 92), plus a few additional items:

1. A set of color printing filters. Beseler, Ilford, and Unicolor have convenient sets (Fig. 11-2); Kodak sells filters individually.
2. Color printing paper. Table 11-1 lists products currently available in convenient packages of standard sizes.
3. Chemistry to match the paper. Beseler 2-Step, Kodak Ektaprint 2, and Unicolor AR kits are all compatible with these papers. Kodak also supplies the individual chemicals in larger units.
4. Here, as for color film processing, an accurate thermometer and an adequate hot water supply are absolutely essential. You will also need a dishpan or deep tray to prewarm the bottles of prepared chemicals and keep them ready for use.

**11-2** *Color printing filter set. Courtesy Charles Beseler Company.*

**TABLE 11-1** COLOR PAPERS FOR PRINTING COLOR NEGATIVES

|  | Paper | Contrast |
|---|---|---|
| FUJI | Fujicolor Type 02-P | Normal |
|  | Fujicolor HR Printing Material* | Normal |
|  | Fujicolor Type 03 | High |
| KODAK | Ektacolor Professional | Normal |
|  | Ektacolor Plus | High |
| MITSUBISHI | KER 7000 PRO | Normal |
|  | KER 6000 Super | High |
| ORIENTAL | Color Paper RP-III | Normal |
| UNICOLOR | RB | Normal |

*Polyester base; all others are resin-coated (RC) paper.*

5. A *drum* or *tube* (Fig. 11-3) provides an efficient way to process the color print. Trays can be used, but drum processing offers several advantages over the tray method. First, after the drum has been loaded in the dark, the entire process can be done in white light. Second, drums require less of each chemical than trays do, and thus are more economical. Drums quickly pay for themselves this way. Third, drums can be uniformly agitated with a motorized base. Fourth, the drum method requires less hot water than the tray method does.

## Exposure

Any black-and-white enlarger that accepts filters in the lamphouse can be used for color printing. It should be equipped with a heat-absorbing glass between the lamp and the filter holder. If your electricity voltage varies considerably or frequently, a voltage regulator or constant-voltage transformer (with a capacity as great as the enlarger bulb's wattage) will also be helpful. If your electricity source is stable, however, you won't need it.

Start with the trial filter pack recommended by the paper manufacturer. This will include magenta and yellow filters (to control the color of the print), and an ultraviolet-absorbing filter (UV or 2B) which is *always used with the others*. Filter values of the same color can be added together (20Y + 05Y = 25Y), but *use as few filters as possible* in the pack.

Each color negative requires at least two trial prints: one for exposure, the second for color balance.

*11-3* Color print processing drums. *Courtesy Charles Beseler Company.*

*Always make the exposure test first.* As in black-and-white, if you increase the exposure (time or aperture), you will make the print darker. Your first trial print should be exposed in strips or sections (5, 10, 15, 20, 25, 30 seconds) using the recommended trial filter pack. Also make a note of the magnification used.*

Process this print (as described in either of the next two sections) and choose the trial exposure time that looks best. Use this time as a starting point for future trial prints.

### Processing: Drum or Tube Method

The *drum* or *tube method* of processing color prints is easiest for the beginner, and it uses the chemicals most efficiently. The illustrated sequence shown on pages 141–142 uses Kodak Ektaprint 2 chemicals; the steps are summarized in Table 11-2. Other brands of chemicals may require changes in the sequence, times, or temperature. Always follow the instructions packed with the chemicals if they differ from those given here.

*\* If the enlarger does not have a magnification scale on its column, insert a thin, transparent plastic ruler in the empty negative carrier and measure its enlarged image on the easel below.*

**TABLE 11-2** PROCESSING COLOR NEGATIVE PAPERS IN A TUBE OR DRUM WITH KODAK EKTAPRINT CHEMICALS

NOTE: Sequence or times may vary with other brands of chemicals. A No. 13 safelight or total darkness is required for loading the drum. Thereafter all steps may be done in white light. Chemicals in steps 2, 3, and 4 are used once and discarded.

| Step | Temperature °C | °F | Time in Minutes |
|---|---|---|---|
| 1. Prewet with 500 ml (17 fl oz) water | 36 | 96 | ½ |
| 2. Kodak Ektaprint 2 Developer (prepared for drum use) | 33 ± ½ | 91 ± ½ | 3½ |
| 3. Kodak Ektaprint 2 Stop Bath* | 30–34 | 86–93 | ½ |
| 4. Kodak Ektaprint 2 Bleach-Fix | 30–34 | 86–93 | 1 |
| 5. Wash in running water | 27–33 | 80–91 | 3½ |
| 6. Dry—air dry | to 99 | to 210 | |

*\* 1 part 28% acetic acid and 20 parts water may be substituted.*

# PROCESSING COLOR PRINTS: DRUM OR TUBE METHOD

### 1 / load the drum or tube

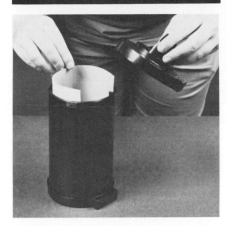

**Be sure the drum is clean and dry. In darkness,** load the exposed sheet of paper with its emulsion side facing **inward,** away from the tube wall. Then secure the end cap. (This operation can be practiced beforehand, in the light, with a discarded print.) When the drum is closed and light-tight, the room light can be turned on.

### 2 / prepare the chemicals

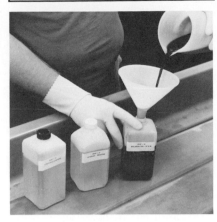

Follow mixing instructions for drum use and **wear rubber gloves** if you have sensitive skin. Label and date the containers. The chemicals should be about 36°C (96°F).

### 3 / prewet the print

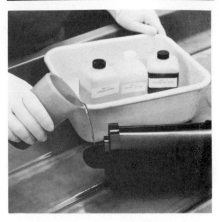

Fill the drum with 500 ml (17 fl oz) of 36°C (96°F) **water** to warm the drum and prewet the print.* Start timing **after** you fill the drum. After **30 seconds,** pout out the water (but don't open the drum).

### 4 / start development

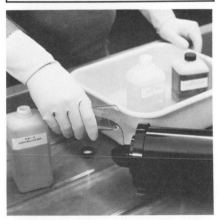

Measure 70 ml (2½ fl oz) of **developer** (use the same volume of other chemicals). Now pour it into the drum.

### 5 / agitate the drum

Roll it back and forth across a **level surface,** or place it on a motorized agitator for better control. Start timing when you start agitating; **develop the print for 3½ minutes.**

### 6 / discard the used developer

Ten seconds before the end of the step, stop the agitation and pour out the used developer. Do not reuse it.

### 7 / stop development

Pour in 70 ml (2½ fl oz) of **stop bath** and **agitate the drum for 30 seconds.** Then discard this solution.

### 8 / pour in the bleach-fix

Start the timer and **agitate for one minute.** Then discard the used solution.

### 9 / open the drum

Carefully open the drum and remove the print. Be careful not to scratch or rub its surface.

/continued

* The quantity given is for an 8 × 10 print in a typical drum. For an 11 × 14 print, double the quantity of water and each chemical.

| 10 / wash the print | 11 / wipe off excess water | 12 / dry the print |
|---|---|---|

Set up a tray siphon in a tray slightly larger than the print. **Wash the print in running water for 3½ minutes at 27°–33°C (80°–91°F).**

Place the print on a smooth surface (like a clean, upside-down print tray) and wipe both sides of the print carefully with a squeegee. This will help to avoid water marks.

A hair dryer may be used to speed the drying, but do not exceed 99°C (210°F). Wash all parts of the drum **thoroughly,** and dry it carefully before using it again.

## Processing: Tray Method

Tray processing of color prints requires more hot water than drum processing, and because no prewet step is involved, it also requires different preparation of the developer. Ektaprint 2 developer prepared for tray use *must be more dilute* than for drum or tube processing. *Separate instructions for preparing the developer are provided for each method, and must be carefully followed.* The stop bath and bleach-fix are prepared the same way for either method. If you have sensitive skin, wear rubber gloves.

No drum or tube is needed for tray processing, but *most of the process must be done in total darkness.* Follow the illustrated sequence below. The tray method of processing color prints, using Kodak Ektaprint 2 or similar chemicals, is summarized in Table 11-3 on page 144. Other brands of chemicals may require different times or changes in the sequence. See instructions packed with the chemicals.

## PROCESSING COLOR PRINTS: TRAY METHOD

| 1 / prepare the chemicals | 2 / prepare the trays | 3 / verify the temperature |
|---|---|---|

Measure and prewarm all required chemicals. For one 8 × 10 print in an 8 × 10 tray, you'll need 200 ml (7 fl oz) of each chemical. The developer should be used only once and discarded. Other chemicals can be used for three 8 × 10 prints if they are returned each time to their warming containers.

Arrange an 8 × 10 tray in a larger tray as shown here. A tray siphon is convenient to keep warm water circulating in the larger tray without overflowing its rim. The larger tray can be used for washing during the process. Fill **both** trays with water at about 35°C (93°F) to preheat them.

Check the temperature of the water bath and developer, and when they are 33°C or 91°F ± ½°, turn off the lights. If you have sensitive skin, wear rubber gloves.

## 4 / start the development

Empty the water from the small tray, pour in the **developer,** and immediately immerse the print **face down.** Then turn the print over and begin rocking the tray gently from corner to corner so the developer flows back and forth over the print.

## 5 / agitate the tray constantly

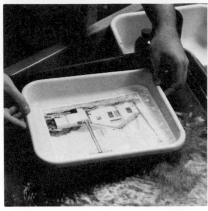

Rock the small tray lengthwise, then crosswise, alternating in a regular sequence. Keep it in constant motion for 3½ minutes.* Use the last 20 seconds of the developing time to pour the used developer out of the tray into a discard pail or drain, but leave the print in the tray.

## 6 / stop development

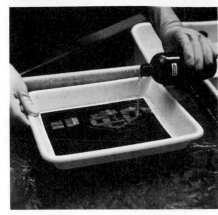

Immediately pour the premeasured **stop bath** over the print, rocking the tray as before for **1 minute.** Then drain the solution off, returning it to its warming container.

## 7 / rinse the print

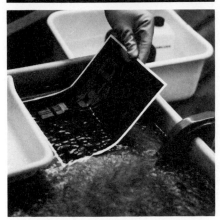

Now move the print to the larger tray and rinse it for 1 minute in running water. While the print is rinsing, rinse out the small tray under the siphon.

## 8 / bleach and fix the print

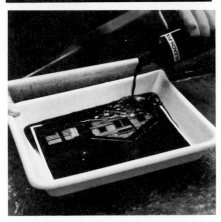

Pour the **bleach-fix** into the small tray and return the print to it for 1½ minutes. Rock the tray as before. White light may be turned on at the end of this step.

## 9 / wash the print

Return the print to the larger siphon tray and wash it for 3½ minutes. Pour the used bleach-fix back into its warming container for reuse, and thoroughly wash out the small tray.

## 10 / dry the print

Wipe excess water from both sides of the print with a squeegee and hang it up to dry. A hair dryer may be used to speed the drying. Do not exceed 99°C (210°F).

* This agitation pattern is important for even development. It can be practiced beforehand in white light by using 200 ml of water and a discarded black-and-white RC print. Be sure all parts of the print are covered by the solution.

NOTE: Sequence or times may vary with other brands of chemicals. A No. 13 safelight or total darkness is required for the first four steps. The developer in step 1 is used once and discarded. Other chemicals may be used three times if rewarmed after each use.

| Step | Temperature °C | Temperature °F | Time in Minutes |
|---|---|---|---|
| 1. Kodak Ektaprint 2 Developer (prepared for tray use) | 33 ± ½ | 91 ± ½ | 3½ |
| 2. Kodak Ektaprint 2 Stop Bath* | 30–34 | 86–93 | 1 |
| 3. Rinse in running water | 30–34 | 86–93 | 1 |
| 4. Kodak Ektaprint 2 Bleach-Fix | 30–34 | 86–93 | 1½ |
| 5. Wash in running water | 27–33 | 80–91 | 3½ |
| 6. Dry—air dry | to 99 | to 210 | |

\* 1 part 28% acetic acid and 20 parts water may be substituted.

## EVALUATION OF TRIAL PRINTS

Chances are that your first color prints will not look right, so some corrections and reprinting will probably be needed. This is typical, a normal part of the printing process. If you know exactly how the first print was made (even if it was a bad print), you can easily correct it. This requires *keeping a record of exposure, filtration, magnification, and how it was processed.* If you do this the same way each and every time, evaluation and correction will be easy.

Two judgments must be made of each print. The first is for exposure, the second for color. For both, the print should be dry.

### Judging Exposure

Exposure is judged the same as in black-and-white. If the print is too light, increase the exposure; if too dark, decrease it. Using the initial trial print as a guide, adjust the time for small changes, the aperture for large ones.

### Judging Color

Color is a bit more difficult to judge, but it can be learned with a little practice. Evaluation should be made in the same illumination (tungsten or fluorescent) in which the print will later be displayed or viewed. The procedure involves two questions: (1) Which color in the print is excessive? (2) How excessive is it?

It is easier to detect too much of a color than too little, so look at the print and *decide which of the six colors (red, yellow, green, cyan, blue, or magenta) dominates the others.* This judgment is best made in the highlights or lighter values of a picture, those areas between white and the middle tones.

The next question, *how much,* is more difficult. The guides supplied by paper manufacturers are helpful, but a better way is to look at the print through color-print viewing filters (Fig. 11-4). Choose a filter of a *complementary color* to the excessive one (see the color circle, Plate 5), and find the filter value that *neutralizes the excess* (makes it gray) in the highlight areas noted above.

**11-4** *Using color-print viewing filters.*

**PLATE 1**  *James Clerk Maxwell: Tartan ribbon, 1861 (additive projection). Trustees of the Science Museum, London.*

**PLATE 2**  *[Photographer unknown]: Dancer, c. 1910. Autochrome. The International Museum of Photography at George Eastman House.*

**PLATE 3** *Louis Ducos du Hauron: Angoulême, France, 1877 (three-color subtractive print). The International Museum of Photography at George Eastman House.*

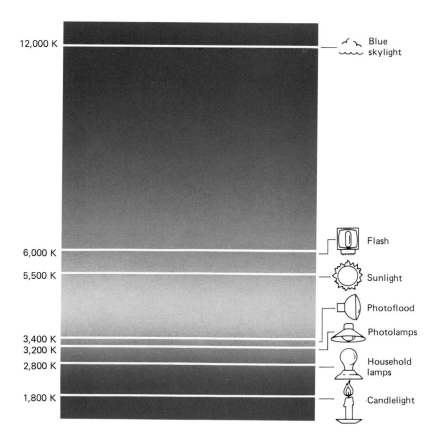

12,000 K — Blue skylight

6,000 K — Flash

5,500 K — Sunlight

Photoflood

3,400 K — Photolamps

3,200 K

2,800 K — Household lamps

1,800 K — Candlelight

**PLATE 4** *Color temperature scale. See page 128.*

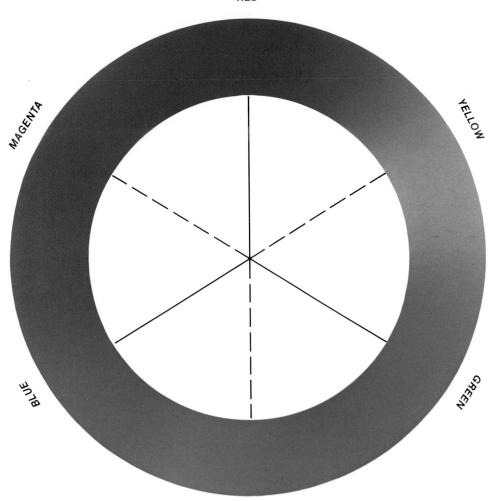

**PLATE 5** *Photographic color circle. Reprinted courtesy of Eastman Kodak Company. This photographic color circle represents the entire visible spectrum. The six designated colors—red, green, blue, cyan, magenta, and yellow—are single points equidistant from each other on the continuously changing band of light. The three* **additive primaries** *(connected by solid lines), if combined in equal amounts, produce white light. The* **subtractive primaries** *(connected by dashed lines) similarly combine to form black.*

*Each color on the circle can be produced by combining its adjacent ones. Magenta is thus a combination of red and blue, yellow a combination of red and green light. Colors directly across the circle from each other are* **complements;** *together they form* **neutrals**—*white, gray, and black. The relationship of the six designated colors is fundamental to all color photography.*

A

B

**PLATE 6** *Photographs made on daylight film with fluorescent light.* **A:** *without filter.* **B:** *with FL-D filter.*

A

B

**PLATE 7** *Dodging in color.* **A:** *Normal, "straight" print.* **B:** *Print dodged with color filter, as described on page 145.*

**PLATE 8** *Chicago & Northwestern Railway Snowplow, 1984.*
*Compare with Figure 9-1.*

**PLATE 9** *Bernard Freemesser: [untitled], 1975.*
*Author's collection.*

**PLATE 10** © Joel Sternfeld: Palmerton, Pennsylvania,
November 1982. Pace/MacGill Gallery, New York.

**PLATE 11** Freeman Patterson: Desert, Sossusolei,
Namibia, 1986. Masterfile, Toronto.

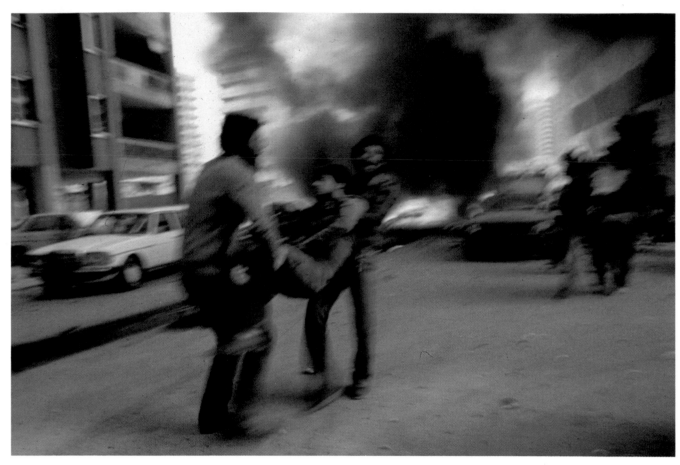

**PLATE 12** *Alfred Yaghobzadeh: People carrying wounded and dead to safety after heavy shelling, West Beirut, Lebanon, 1984. Sipa Press, New York.*

## Making Color Corrections

To make the correction, *add the excess color value to the filter pack*. For example, if a print is judged to be 20 too yellow, add a *20Y filter* to the pack.

Alternatively, the *complementary* color value may be *removed* from the pack. If the trial print appears 30 too green, for example, remove that much magenta from the pack.

Instructions on the viewing filters may indicate adding or removing only half of the required change. I have found in practice that making a change for the *full value* of the desired correction builds skill and confidence in judgment much more quickly. If you overshoot you can easily cut back, but slowly creeping up on a needed change wastes time and material.

If two colors appear to dominate the print, correct for the more dominant color first. Table 11-4 will guide you in making the changes.

**TABLE 11-4** CORRECTING PRINTS MADE FROM COLOR NEGATIVES

| If trial print appears too | Make this change in the filter pack |
|---|---|
| Red | Add Magenta + Yellow |
| Green | Remove Magenta |
| Blue | Remove Yellow |
| Cyan | Remove Magenta + Yellow |
| Magenta | Add Magenta |
| Yellow | Add Yellow |

Whenever you change the filter pack you must also recalculate the exposure. Some filter sets contain a calculator for this purpose, or you can consult Table 11-5 below. Note that magenta filters have greater exposure factors than yellow ones. To use the factors, *divide the old exposure time by the factor of each filter removed from the pack, and multiply the result by the factor of each filter inserted in the pack.* This will give you the new exposure time.

The calculation looks like this: Old exposure time ÷ (factors of filters removed) × (factors of filter added) = New exposure time.

If more than one filter is removed or added, multiply the factors in each group and use the product in the calculation above. Two examples follow:

**TABLE 11-5** EXPOSURE FACTORS OF COLOR PRINTING FILTERS

| Filter value | Exposure factors | | |
|---|---|---|---|
| | Cyan | Magenta | Yellow |
| 50 | 1.6 | 2.1 | 1.1 |
| 40 | 1.5 | 1.9 | 1.1 |
| 30 | 1.4 | 1.7 | 1.1 |
| 20 | 1.3 | 1.5 | 1.1 |
| 10 | 1.2 | 1.3 | 1.1 |
| 05 | 1.1 | 1.2 | 1.0 |

EXAMPLE I.  A print made at 10 sec. @ f/11, 40M and 70Y, is judged to be 10 too green. A new print thus requires 30M and 70Y filtration. To change the pack for this, the 40M filter must be removed and the 30M filter inserted. The exposure factors for these filters are as follows: 40M 1.9; 30M 1.7. The exposure correction therefore is:

$$10 \div 1.9 \times 1.7 = 8.95$$

The next print should be made at 9 sec. @ f/11, 30M and 70Y filtration.

EXAMPLE II.  A print made at 14 sec. @ f/11, 45M and 75Y, is judged to be 20 too red. A new print thus requires 65M and 95Y filtration (red = magenta + yellow; both values must be increased to remove it from the print). The original filter pack contained these filters: 40M + 5M + 50Y + 20Y + 5Y. To change the pack, the 40M and 20Y filters must be removed, and 50M, 10M, and 40Y filters inserted. The other filters remain in the pack and do not affect the exposure calculation. Exposure factors for the filters removed and added are:

40M 1.9;  20Y 1.1;  50M 2.1  10M 1.3;  40Y 1.1

The exposure correction therefore is:

$$14 \div (1.9 \times 1.1) \times (2.1 \times 1.3 \times 1.1) = 20.1$$

The next print should be made at 20.1 sec. @ f/11, 65M and 95Y filtration.

Also, be sure your pack contains *only two colors* (plus the UV filter.) If all three colors (cyan, magenta, and yellow) are present, you have *neutral density* in the pack, and this will only increase the exposure time without changing the color.*

When you have evaluated the trial print and recalculated the exposure and filter pack, write the old and new data on the back of the trial print and repeat the exposure→processing→evaluation sequence.

## DODGING AND BURNING

Dodging and burning can improve color prints by lightening or darkening small areas of the picture. The technique is exactly the same as it is for black-and-white.

Colors can also be intensified or subdued locally in the print by these techniques. For such changes, color filters can be held under the lens for part of the exposure or for additional time as needed. Use a filter of moderate value, such as 40 or 50, for a brief period. *To intensify a color, use the complementary filter. To soften or subdue a color, use a filter of the same color.* Plate 7A, for example, was printed in the normal manner. In Plate 7B, however, the sky has been

---

* To eliminate neutral density, subtract the cyan value from all three colors. This will reduce the cyan value to zero.

dodged with a 50Y filter for part of the exposure time; the sky thus printed a deeper blue.

In some cases you might have to use two filters of different hues to produce the desired effect. To soften green areas, for example, use cyan and yellow filters together. As in black-and-white, some practice will be needed to use these techniques with confidence.

## PRINTING COLOR NEGATIVES MORE EFFICIENTLY

With a basic black-and-white enlarger, you must remove and replace color-printing filters to make changes in color. This method is economical but cumbersome. Enlargers designed especially for color work, on the other hand, have continuously variable filters built into them (see Fig. 11-5). Color changes are made by turning dials or by punching in a series of numbers on a keyboard, a more convenient and efficient arrangement. Such refinement, of course, comes at a higher price.

### Color Enlargers

There are two general types of color enlargers. One type contains variable cyan, magenta, and yellow filters, and uses a standard white light source similar to black-and-white machines. Filtering this white light *subtractively* allows the print to be made with a single basic exposure. The enlarger heads shown in Figure 11-5 work this way.

The other type of color enlarger, shown in Figure 11-6, works with red, green, and blue light sources in an *additive* mode. This requires three separate exposures for each print—one for each color—and a more complex device to control these exposures. The

Beseler/Minolta 45A Enlarger Light Source System, which can be fitted to most 4 × 5 enlargers, uses repeating flash tubes filtered to the three primary colors: red, green, and blue. It also includes an analyzer with an on-easel probe to collect data and control the exposures.

Either system has its advocates, and either type of enlarger makes color printing easier, faster, more accurate, and more consistent. Other devices are available separately to analyze the colors of negatives before printing and to make routine color-printing operations more efficient, but in most cases their cost places them beyond the reach of all except high-volume, commercial users.

### Color Print Processors

Drums and trays similarly provide simple and inexpensive ways to process color prints, but most such devices can safely handle only one print at a time. If you need to make color prints in quantity, a more efficient means of processing them will save much time and chemicals, and give more uniform results.

Roller-transport color print processors, which have been available for larger print sizes and quantities for many years, are now made for smaller volume work too (Fig. 11-7). Some use the chemicals once and then discard them, while others provide for automatic replenishment of the chemicals as each print passes through the machine, thus using the solutions more economically. Either type accepts exposed paper continuously, and most newer ones have standby modes and other energy-saving features built in. Some have print dryers built in or attached to them.

While any of these machines is much more costly than drums or trays are, the time saved and the consistent processing quality they provide make them indispensable for commercial laboratories.

**11-5** *Color heads for typical color enlargers. Courtesy Charles Beseler Company and RT/Omega Industries.*

**11-6** Beseler/Minolta 45A Enlarger Light Source System. Courtesy Charles Beseler Company.

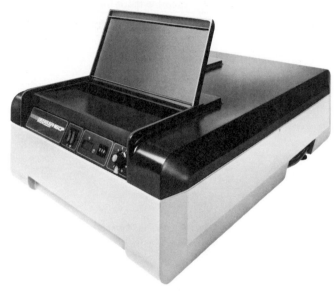

**11-7** Beseler 16 Auto Print Processor. Courtesy Charles Beseler Company.

## MAKING COLOR PRINTS FROM SLIDES

Slides and prints are both *positive* images, so making a print from a slide without an intermediate negative requires a different printing system than printing from negatives does. Two such systems are available. One involves a reversal printing paper that processes much like color slide films, with the dyes formed by the color developer during the processing. Kodak Ektachrome 22 paper works like this. It can be processed in Kodak R-3000, Beseler 3-step Reversal Print, or Unicolor RP-1000 chemicals.

### Cibachrome

Another system, which works on a different principle but is simpler to use, is *Cibachrome*, outlined here. Cibachrome is a *dye-bleach* or *dye-destruction* process. As we have previously noted, almost all other color materials have their dyes formed chromogenically, that is, during processing. The dyes in Cibachrome, however, are manufactured in the materials rather than formed by development. They have excellent color purity and are more permanent than those of most other color materials.

***The Materials.*** Cibachrome materials are exposed in an enlarger just like other papers, but processing is different. Three solutions are involved: developer, bleach, and fixer. Because the print is exposed from a positive color slide, the latent image will be a negative one. The developer converts this to a black-and-white silver negative, much like the first processing step for slide films. In the next step, the bleach destroys the silver images in each of the three emulsion layers and the dyes positioned with them. Dyes elsewhere are not affected, and these remain in the material to form a positive color image. Fixing then dissolves all silver compounds, and washing removes the dissolved chemicals. Finally, the print is dried.

Cibachrome A II material comes in two forms. The glossy-finish material is coated on a white, opaque, polyester base. The less costly pearl-finish material is made on a resin-coated paper base similar to other color papers. The materials are always packaged with the emulsion side facing the label on the inner bag.* Both materials have a built-in masking feature that improves color reproduction and minimizes excessive contrast. *Both print materials must be handled in total darkness.*

***The Chemicals.*** Ilford Cibachrome Process P-30 chemicals, available in convenient kits, are required for these materials. The bleach in this process contains a *strong acid*. It must be handled in *adequate venilation* and *combined with the other solutions after use* to neutralize it for safe disposal. The chemicals work best when used once and discarded. *None of the Cibachrome materials and chemicals are interchangeable with those of other color systems.*

***Exposing Cibachrome Materials.*** Place the slide in the negative carrier of your enlarger and be sure no raw light comes through sprocket holes or around the outside edge of the film. Carriers that accept 2 × 2 in. slide mounts are available for some enlargers, or the slide can be unmounted and handled like a 35mm negative.

The initial exposure should follow the instructions packed with the Cibachrome material. For an 8 × 10 print from a 35mm slide, try a 30-second exposure time at various apertures. Filter recommendations are given on each package; heat-absorbing glass and a UV filter should be used along with the suggested filter pack. Remember: no safelight may be used; *total darkness is required.*

***Processing Cibachrome II Materials.*** The P-30 process runs at 24° ± 1°C (75° ± 2°F). Drum processing is

---

* In white light the emulsion side of unprocessed material appears gray-brown; the base side white.

recommended, and Ilford makes a well-designed drum for this purpose. The Cibachrome Mark II processing drum permits each chemical to be drained out as the next solution is poured in, speeding the process and making solution retrieval easy. The 8 × 10 drum can be converted to process 11 × 14 prints by simply replacing the center tube, an inexpensive accessory.

To process Cibachrome material, you'll need the items shown in step 1, below. *Work only in a well-ventilated area* and follow the step-by-step instructions. The process is summarized in Table 11-6 on page 150.

## PROCESSING CIBACHROME PRINTS

**1 / what you need to process Cibachrome**

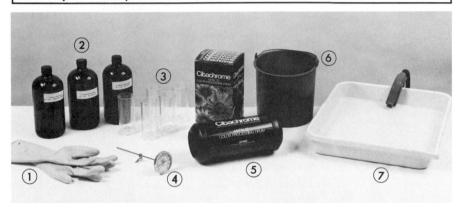

1. A pair of rubber gloves.
2. Cibachrome P-30 Chemicals.
3. Five 100 ml (3 oz) containers or cylinders to hold the premeasured solutions. Clean baby-food jars will do for four of them.
4. An accurate thermometer.

5. Cibachrome Mark II Color Processing Drum.
6. A 2-liter (½ gallon) plastic pail to collect and combine the used solutions for safe disposal.
7. A tray of running water for washing the print.

**2 / assemble the drum**

The lower end has four small holes in it. Place the light-baffle disk in it, **marked side up,** and press the tube firmly into the end.

**3 / load the drum**

**In total darkness,** load the material in the drum with the emulsion side facing **inward** away from the tube. Be sure the print material is entirely inside the drum.

**4 / close the drum**

Press the top end (containing the funnel) and the notched cup together, and insert them carefully into the loaded tube. Be careful not to scrape the paper with the edge of the cup. Room lights may now be turned on.

**5 / prepare the solutions**

Measure 75 ml (3 oz) of each chemical into clean containers. **Wear rubber gloves** and rinse the measuring cylinder after each use. Now fill the fourth container with 75 ml of water, and place it **between** the developer and bleach containers. Bring all solutions to **24°C (75°F).**

Pour the developer into the upright tube and immediately lay the drum down on a level surface.

Roll the drum rapidly for the first 15 seconds, then more slowly and evenly thereafter for **3 minutes.**

Use the last 15 seconds of the developing time to empty the drum by holding it upright over the pail. As the drum empties, pour the premeasured rinse water into the top of the drum.

Roll the drum back and forth slowly for **30 seconds.** Then drain the water out for 30 seconds as you did the developer before.

As the rinse water is draining out, pour the bleach into the top and roll the drum back and forth for **3 minutes.** Discard the bleach into the pail the same way as before.

Pour the fixer into the top as the bleach is draining out the bottom. Again roll the drum back and forth for **3 minutes.** Discard the used bleach into the same pail with the other solutions.

Open the drum **carefully** and gently remove the print. Wash it in a tray of running water for **3 minutes.** A tray siphon will insure good washing.

Wipe both sides of the print gently with a squeegee and hang the print from a clothes-line to dry in the air, or use a hair dryer for quicker results (not over 160°F). The print emulsion is fragile until dry.

Empty the pail of **combined** chemicals down the drain. **Do not discard the chemicals individually.** Disassemble the drum and thoroughly wash all parts.

149

**TABLE 11-6** PROCESS P-30 FOR CIBACHROME MATERIALS

The temperature of all solutions and washes is 23°–25°C (73°–77°F). Use a processing drum and wear clean rubber gloves for the first four steps. Work only in a well ventilated area.

| Step | Agitation | Time in Minutes |
|---|---|---|
| 1. Cibachrome P-30 Developer | Rotate drum 20–25 rpm and drain | 3 |
| 2. Wash in measured amount of water | Rotate as above; drain for ½ min. | ½ |
| 3. Cibachrome P-30 Bleach | Rotate as above and drain | 3 |
| 4. Cibachrome P-30 Fixer | Rotate as above and drain | 3 |
| 5. Final wash in tray with running water | Continuous, rapid flow in a tray | 3 |
| 6. Dry—air dry, not over 70°C (160°F) | | |

*Disassemble the drum and wash all equipment thoroughly after use. Be sure to combine the used solutions before discarding them.*

**Evaluation.** Cibachrome prints have a reddish cast when wet, so for accurate evaluation the print must be dry. As with other color printing methods, first judge the exposure, then the color balance. Because Cibachrome printing is positive-to-positive, corrections for exposure and color balance are just the opposite of negative-positive systems. *Reducing the exposure makes the print darker, increasing it makes it lighter.* The *change* required is typically about four times that needed for negative-positive materials.

Color corrections are reversed too, as Table 11-7 indicates. To correct an excess of a color, *remove it from the filter pack* (or add its *complement* to the pack). The amount of filtration change needed to produce a given effect is approximately three times that needed for negative-positive materials such as Ektacolor. Occasionally, after a new filter pack is chosen, a new trial print for exposure correction may be needed.

**TABLE 11-7** CORRECTING PRINTS MADE DIRECTLY FROM COLOR SLIDES

| If print appears too | Make this change in the filter pack |
|---|---|
| Red | Add Cyan |
| Green | Remove Cyan + Yellow |
| Blue | Add Yellow |
| Cyan | Remove Cyan |
| Magenta | Add Cyan + Yellow |
| Yellow | Remove Yellow |

*Larger changes in filter values will be required than with negative-positive materials.*

Cibachrome prints appear to have somewhat more contrast than the original slides from which they were made. This will usually be advantageous to an original image that is soft, or low in contrast, but it might be troublesome if the contrast of the original slide is high. In such cases, a different method of making a print might yield a better result. This involves making a special color negative—an *internegative*—from the slide, and then printing the internegative like any other color negative (p. 139). Making the internegative is best left to commercial laboratories, since the procedure is unusually sensitive to changes in exposure and filtration.

## FINISHING COLOR PRINTS

### Spotting

Color prints are spotted in much the same way as black-and-white ones. Small, white areas should be spotted out with color retouching dyes intended for the type of paper used. *Liquid retouching colors*, available as sets or as individual colors, work well for this purpose. You will also need a #0 or #1 sable brush, a small piece of blotting paper, and a palette cup for blending colors.

After picking up the desired color of dye on your brush, roll it briefly on the blotting paper to remove excess liquid, and apply it to the print with a stippling motion until the color fills the spot and it blends in with the surrounding area.

Larger areas can be spotted with *dry retouching colors*. These come in sets of small jars and are applied to the print with a cotton cosmetic puff. Breathe on the cake of color desired, rub it gently with a clean cotton puff, and transfer the color to the print with a light, circular motion. You can repeat the procedure to increase the color, or use another clean, dry cotton puff to remove some of the color and lighten it. Once you have achieved the desired change, gently expose the treated area for a few seconds to steam from a tea kettle to set the dye. When you do this, be careful not to get the print wet.

### Print Supports

Most color prints look good on mount boards or mats of moderate brightness, and neutral tints such as tan, steel-gray, or gray-blue will generally look bet-

ter than white or black. White tends to desaturate the colors it surrounds unless it is used very sparingly, that is, as a narrow border. Black has the opposite effect; wide, black areas of a board surrounding a color print may overwhelm it rather than enhance it, and black mats scuff and soil easily.

One useful idea is to enhance the dominant color in the print by echoing it softly in the mat, that is, by using a mat of a similar hue but a lighter or subdued tint. Picture-framing shops have L-shaped samples of various colored mat boards that can be held against the print to test the effect. In general, brightly colored mats and mounts of any hue should be avoided. Acid-free mount boards are best, but materials buffered with carbonate compounds (which are safe for black-and-white prints) should not be used for color work.

### Matting Color Prints

The best way to protect and present color prints up to 11 × 14 in. in size is to place them behind *window mats* using *corner mounts* as described on pages 117 and 121–122.

Prints larger than 11 × 14 in. generally should be *mounted* on a solid support to keep them flat and protect their corners. As a rule, corner mounts alone will not adequately support larger prints in a vertical position, as on a wall or in a frame. Illustration board, plastic foam-core materials, and tempered masonite all work well as supports; they are available from art supply and framing shops in several thicknesses.

### Mounting Color Prints

Color prints are mounted just like black-and-white ones on RC paper (pp. 116–120). *Cold mounting is recommended* because it is safe for color prints and is easy to do. Detailed instructions will be found with the mounting material used. Dry mounting (with heat) may also be used, but the temperature of the mounting press must not exceed 99°C (210°F). Seal ColorMount Tissue is recommended for dry mounting. A sheet of teflon-coated *release paper*, also available from Seal, should be placed over the print before it is inserted into the press. With either the cold or hot procedures, *every piece of material must be absolutely clean.*

### Framing Color Prints

Once matted or mounted, color prints can be displayed in frames behind glass. *The print surface, however, must be separated from the glass by a small air space.* A window mat (described above) will provide this for smaller prints, or a framing material that provides such separation can be used for larger prints. Without such an air space, the print surface in time may stick to the glass, and any attempt to separate the print will destroy it.

## SLIDES FROM NEGATIVES

Although the best slides are made on slide films with original camera exposures, they can also be made from color negatives. The procedure is not practical to do in your own darkroom in small quantities, but the service is available from most commercial color laboratories. They will also mount the slides for projection.

## BLACK-AND-WHITE PRINTS FROM COLOR NEGATIVES

Black-and-white prints can be made from color negatives just as they can from black-and-white ones, but ordinary black-and-white enlarging papers distort the tone values since they are not sensitive to all colors in the film. Reds in the subject will print too dark on them, and blues too light. Exposure times, moreover, may seem unreasonably long.

The special *panchromatic* papers listed in Table 11-8 will produce better results. Panchromatic papers show each original subject color in its proper shade of gray, resulting in more natural-looking prints. Because they are sensitive to all colors of light, these papers must be handled and developed in *total darkness*, without a safelight. You expose them just like other graded black-and-white RC papers (without filters), and develop them in Dektol 1:2 like any other black-and-white RC paper. Once they are fixed, of course, the light may be turned on. The slight inconvenience of working in the dark is offset by the superior print tones obtained.

**TABLE 11-8** PANCHROMATIC PAPERS FOR MAKING BLACK-AND-WHITE PRINTS FROM COLOR NEGATIVES

|  | Paper | Contrast |
|---|---|---|
| KODAK | Panalure II RC | normal |
| KODAK | Panalure II Repro RC | low |
| ORIENTAL | New Seagull RP Panchromatic | normal |

*Handle these papers only in **total darkness**. All papers have a glossy surface.*

## HOW STABLE ARE COLOR PHOTOGRAPHS?

As every box of color film and paper reminds us, dyes used in these products can change in time, so the question of color photographs fading is one that needs to be discussed. Although the dyes used in many color photographs today are considerably more stable than those of a decade ago, the truth is that color photographs begin fading or changing the moment they are made. The changes occur slowly, to be

sure, but they are unavoidable. What causes them, and how can they be minimized?

### Why Color Photographs Fade

The major causes of color photographs fading or changing are (1) absorbed energy from heat and light, (2) chemical reactions with polluted air or with improper packaging and storage materials, and (3) chemical retention or changes in the acidity or alkalinity of the film caused by variations in processing.

Chemical deterioration can be minimized by proper processing, and since the time in various processing steps, especially the last wash, has an important bearing on the resulting stability of the film or print, manufacturers' recommendations should be carefully observed. Photographs should be stored only in properly designed envelopes or packages under the most favorable conditions possible. *The Life of a Photograph* by Lawrence E. Keefe, Jr. and Dennis Inch (see bibliography, under Technical Manuals) is an excellent reference for detailed information on this topic.

Once the risks mentioned above have been minimized, further efforts should be directed to keeping polluted air and undesirable energy—heat, light, and humidity—from reaching the materials.

### Light-fading and Dark-fading

At this point the problem becomes complex. Some changes occur mainly from prolonged exposure to light, and the combined effect of such changes is known as *light-fading*. Other changes seem to occur independently of such exposure to light, and are caused mainly by heat, humidity, chemicals (pollutants) in the air, and time. The combined effects of these changes are known collectively as *dark-fading*, but the name is a bit misleading because *they occur in the light as well as in the dark.*

To complicate matters even more, the light-fading and dark-fading characteristics of a given material are usually not the same, and one material may have different fading characteristics of each type than another. Because of these differences, a color film that may have good stability in the dark, for example, may not fare well with repeated exposure to light. On the other hand, films that are designed for duplicating and for continuous projection are often not the best candidates for long-term survival.

A few guidelines, however, appear to be generally applicable to color materials. Products that use complete azo dye molecules in their emulsions, such as Cibachrome materials, have light-fading characteristics superior to most films and papers whose colors are formed chromogenically, that is, during development. Exposure to light, especially daylight or fluorescent light (both of which are rich in ultraviolet), should be minimized. Ideally, *color prints should be displayed only in tungsten light*, which is generally free from destructive ultraviolet radiation. Color slides should be projected only for brief periods—one minute or less. If longer, sustained projection is required, such as for continuous display, duplicate slides (available from commercial labs or through photo dealers) should be used and the originals stored safely in the dark.

*In dark storage, color photographs must be protected from excessive heat and humidity.* Over long periods, high humidity is more destructive to color photographs than heat, but the two conditions together are worse than either alone. A relative humidity of 20–30 percent and a temperature of 20°C (68°F) is ideal for dark storage of most color films and prints. Lower temperatures down to 2°C (35°F) will extend this safe storage life considerably, but *only* if the photographs are properly sealed against the high humidity that often accompanies such temperatures. Ultimately, of course, the cost of maintaining such long-term conditions must be balanced against the value of the photographs and the need to preserve them.

---

## SUMMARY

1. Color printing requires a light-tight darkroom and has three phases: *exposure, processing,* and *evaluation.* Exposure requires a set of colored filters, and processing is best done in a light-tight drum or tube. Process EP-2 chemicals are used for prints from color negatives; other requirements are the same as for black-and-white work.

2. Each color image requires *two trial prints*: the first for exposure, the second for color balance.

3. The *EP-2 process* for drums or tubes is summarized in Table 11-2.

4. *Exposure* is judged the same as in black-and-white. *Color correction* requires two judgments. Which color is excessive, and how excessive is it? Color-print viewing filters can help you make these decisions. Use a filter whose color is the complement of the excessive one in the print. Table 11-4 summarizes this procedure. Some *exposure adjustment* may also be required (see Table 11-5).

5. *Dodging and burning* of color prints can be done as in black-and-white. Colors can also be intensified or subdued by using a variation of this technique.

6. Color printing can be done more efficiently with *color enlargers* and *processing machines*. These enlargers have colored light sources or filters built in, and most processing machines accept prints continuously.

7. Prints can also be made from color slides. The most popular system is *Cibachrome,* a dye-destruction process using azo dyes pre-manufactured in the material rather than analine dyes formed in development. The dyes are bleached and removed where they are not needed for the positive image.

8. The *Cibachrome P-30 process* is best done in a special drum or tube. *Some of the chemicals are hazardous to your health and your plumbing* if improperly handled. Good ventilation and rubber gloves are required, and the used

chemicals must be combined before they are disposed. The process is summarized in Table 11-6.

9. *Evaluation of color prints made from slides* is the opposite of those made from negatives. More exposure makes the print lighter, less makes it darker. Color correcting procedures are also reversed (see Table 11-7).

10. Color prints can be *spotted* just like black-and-white ones using liquid retouching dyes or dry retouching colors made for them. Finished prints can be *matted, mounted, or framed*, but care must be taken to avoid damaging heat and to insure an air-space between the print and any covering glass.

11. Excellent *black-and-white prints* can be made *from color negatives* by using panchromatic papers in total darkness. These papers provide much better tone values than ordinary black-and-white papers do.

12. Color dyes can change in time, so *color photographs eventually fade*. Some materials fade faster than others, but all such changes can be minimized by proper processing, storage, and display conditions.

# OUR PHOTOGRAPHIC HERITAGE

**12-1** *Adolphe Braun: Countess Castiglione Holding a Frame as a Mask, c. 1870. The Metropolitan Museum of Art, Gift of George Davis, 1948.*

Photographs have been a familiar part of our life for so long that it is hard to imagine a world without them. But as pictures, and particularly *reproduced* pictures go, photographs are relatively new: drawing and painting had been practiced for centuries before the first photographs were made, and reproductions in the form of prints (woodcuts, lithographs, and engravings) all predated the photograph. Even the camera was used by artists working in older media long before photography was invented.

The photograph, of course, was a unique image. It quickly became popular because it appeared realistic, and widespread because it filled an important need. Realistic illustrations could be made better and quicker by photography than any other way, creating a demand for pictures that led to its rapid improvement and astonishing growth. As photography grew, it led to a revolution in seeing and thinking that is still going on, and which is still changing our life and our culture.

Our story begins in the fifteenth century with the introduction of printing in western Europe. With printing came the need for reproducible pictures on paper, and two pioneering examples stand out: playing cards and religious symbols. The former were duplicated because they quickly wore out; the latter enabled the faithful to have inexpensive religious symbols at home. Soon thereafter these pictures appeared in books. Of course, until printing was invented, books had been illustrated the same way they had been written—by hand.

As feudalism declined, cities grew in population and trade between them prospered. This led to an influential middle class of merchants (especially in Italy), the ex-

pansion of universities, and a growing demand for books. As the collective faith of the Middle Ages gradually gave way to individual thinking and a desire for knowledge, artists and writers helped to supply the factual information needed. They studied the world around them and portrayed mankind with dignity at the center of their universe. From this humanistic viewpoint, art and nature, mathematics and science were all considered as a single body of knowledge; the greatest scholar of the fifteenth century was a painter, Leonardo da Vinci.

Two of Leonardo's predecessors, the great Florentine architects Filippo Brunelleschi and Leon Battista Alberti, introduced a mathematical basis for rendering space in art. *Linear perspective* helped to create a standard of natural realism—a resemblance to nature—in pictures. As more people tried to draw from nature, the limited skill of some artists (evident in the misshapen table in Figure 12-2) led to the invention of mechanical drawing aids. Many such devices were developed during the sixteenth century, but one of the most useful was a much older one, the *camera obscura*.

## THE CAMERA OBSCURA

A *camera obscura* (darkened room) was described as early as the tenth century by the Arabian scholar Alhazen, using a principle known to Aristotle in the fourth century B.C. for observing eclipses of the sun. Leonardo detailed it in his notebooks (leading many people to think he had invented it), and Albrecht Dürer, the German artist, knew of it in the early sixteenth century. A tiny hole in one

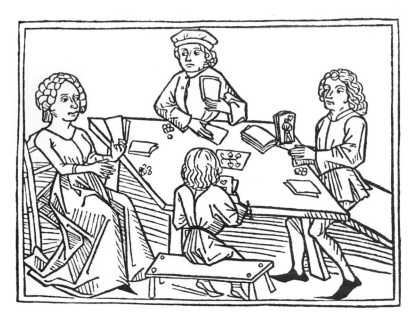

12-2 *Meister Ingolt: Card players. Woodcut from Das goldene Spiel. (Augsburg) Günther Zainer, 1472. Lessing J. Rosenwald Collection, The Library of Congress.*

side of a room admitted rays of light in such a way that an inverted image of what was outside the room appeared on the inner wall opposite the hole. About 1550 a lens was added to the opening, making the image brighter and clearer.

All descriptions prior to 1572 indicate that the early camera obscura was, in fact, a room, but in the seventeenth century, portable devices appeared. The first were wooden huts, then tents and covered chairs, and finally small boxes such as Canaletto undoubtedly used to paint his sweeping views of eighteenth-century Venice. Antonio Guardi, Jan Vermeer, and other leading artists also used the camera obscura. By 1685, a mirror had been added to project the image right-side up, and in this form the camera obscura remained substantially unchanged for nearly two hundred years (Fig. 12-3).

Meanwhile book illustration was dominated by woodcuts and copper engravings. The former were useful for cheap copies but could not convey shading very well. Engravings gave better reproduction, but because copper was a soft metal, the plates wore out quickly and so were used primarily for more costly and limited editions. Master artists prepared the original drawings, but preparation of the plates was left to other craftsmen who translated the originals into the linear construction of the printmaking medium (Figs. 12-2 and 12-3 were produced this way). Because many people were involved, the subtleties and style of the original image were often lost in the process.

Pictures, however, continued in demand. Around 1797 lithography was invented and wood engraving was revived. Lithographs were printed with greasy ink from the flat surface of a porous, wet stone; wood

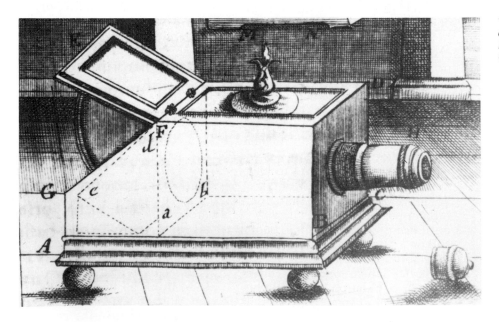

12-3 *Johann Zahn: Reflex camera obscura, 1685. Gernsheim Collection, Harry Ransom Humanities Research Center, University of Texas at Austin.*

engravings were cut across the grain of a block (as on the end of a board) instead of running parallel to it, as a woodcut was made. Wood engravings produced more copies than copper, while retaining most of the detail and shading possible with metal plates. Popular editions of pictures and illustrated books were printed in ink this way for another century. Meanwhile the fascinating image of the camera obscura continued to challenge some of the best thinkers of the Industrial Revolution to find a way to "draw" an image quickly and accurately.

## INITIAL INVESTIGATIONS

### Schulze and Scheele

Almost everything that makes photography possible has been known since 1725, when Johann Heinrich Schulze, a German scientist, discovered that *light darkened silver salts*. Although he didn't realize it, this was the fundamental reaction on which virtually all photography was to depend. The only missing technical link was a means to preserve the image once light had formed it. In 1777 the Swedish chemist Carl Wilhelm Scheele discovered that silver chloride, a white powder that was soluble in ammonia, would not dissolve in it once it had been *blackened* (changed to silver metal) by exposure to light. Ammonia thus could dissolve the light-sensitive salts, leaving the silver metal and its image unchanged. Unfortunately, however, neither Schulze nor Scheele saw a picture-making application for their important discoveries.

### Wedgwood and Davy

Two fundamental ideas make photography possible. One is optical, the other chemical. The first person to see the connection between them was Thomas Wedgwood, youngest son of the famed English potter, Josiah Wedgwood. Thomas took note of the earlier work by Schulze and Scheele, and using his father's camera obscura, tried to record images from nature as early as 1799, using silver nitrate. But his compound was not sensitive enough to produce a visible picture. He also coated pieces of white leather with silver nitrate; on these he placed leaves and other objects for exposure in the sun. Wedgewood's collaborator, Humphry Davy, repeated the camera experiments using silver chloride, which was more sensitive to light. Neither Wedgwood nor Davy produced an image with the camera, but both got impressions of the objects placed directly on their sunlit materials. All efforts to preserve these images failed, however, as the continuing action of light darkened the materials after the objects were removed. Ill health forced Wedgwood to abandon the work, and in 1805 he died without reaching his goal.

## NIEPCE AND HELIOGRAPHY

The next attempt was made by a French inventor, Joseph Nicéphore Niepce (Fig. 12-4), of Chalon-sur-Saône, who apparently succeeded in making a paper negative with the camera in 1816. He experienced the same problem that had baffled Wedgwood and Davy—the image continued to darken when removed from the camera—so he began to look for a material that would be lightened rather than darkened by exposure.

Most of Niepce's early experiments were copies of engraved prints, but in the summer of 1826 or 1827 he succeeded in making a view from the window of his attic workroom (Fig. 12-5). Rediscovered by historians Helmut and Alison Gernsheim in 1952, *the world's first photograph* is on a plate of polished pewter metal and is the only surviving example of Niepce's work with the camera. Niepce named his process *heliography,* or sun writing (see box, p. 160).

Niepce's camera was fitted with a prism to correct the lateral reversal of the image. That made objects in the scene, such as the long roof and a distant tree, appear in their correct positions. His plate required almost a day-long exposure, and since the sun changed its position during that time, objects appear to be illuminated on both sides simultaneously. Niepce made another camera view on a glass plate about 1829, but it was later destroyed.

In 1827, through his lensmaker, Niepce was introduced to another experimenter, Louis Jacques Mandé Daguerre (Fig. 12-6). Cautiously, they formed a partnership to perfect and exploit the heliographic process, but in 1831 Niepce died. Daguerre continued the work alone, eventually perfecting what had eluded the earlier inventor.

**12-4** *C. Laguiche: Nicéphore Niepce, c. 1795. Pencil and wash drawing. Gernsheim Collection, Harry Ransom Humanities Research Center, University of Texas at Austin.*

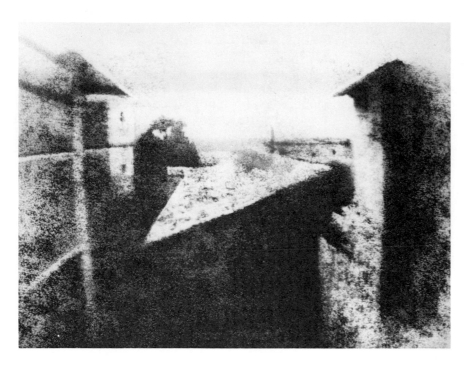

12-5 *Nicéphore Niepce: View from his window at Gras, near Chalon-sur-Saône. The world's first photograph, c. 1827. Actual size. Gernsheim Collection, Harry Ransom Humanities Research Center, University of Texas at Austin.*

12-6 *Charles Richard Meade: Portrait of Louis Jacques Mandé Daguerre, 1848. Daguerreotype, 16 x 12 cm. The J. Paul Getty Museum.*

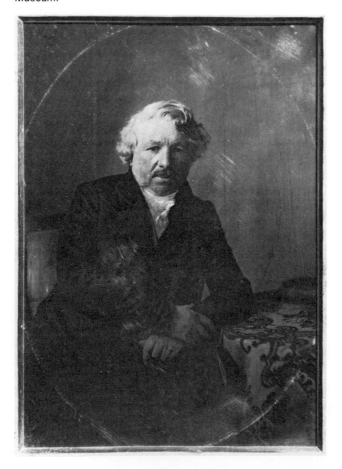

## THE DAGUERREOTYPE

Daguerre had already become famous in Paris as the proprietor of the *Diorama*, a theatrical presentation wherein large paintings on thin material could be viewed by changeable combinations of reflected and transmitted light. The illusion of realism was heightened by including actual objects in front of the picture planes, much like the three-dimensional displays we see today in natural history museums. The Paris Diorama was such a crowd pleaser that Daguerre and his partner (who does not otherwise figure in the story of photography) opened another in London within a year.

The Dioramas achieved much of their realistic illusion because they were painted in meticulous perspective, and for that, of course, Daguerre used a camera obscura when sketching the pictures. Since he realized how much work it was to *draw* the camera images, Daguerre was naturally interested in Niepce's efforts to "fix the image . . . by the action of light." Before his death, Niepce had switched from plates of pewter to sheets of silver-plated copper. Daguerre repeated Niepce's experiments without success, but in 1835 he unintentionally exposed an undertimed plate to the vapor of mercury (which had spilled from a broken thermometer), and noticed that the image appeared stronger. By 1837 he had permanently desensitized, or fixed, the fumed plate (see box, p. 160). His earliest surviving daguerreotype is reproduced in Figure 12-7.

In January 1839, Daguerre made public the details of his achievement. "It requires no knowledge of

**12-7** *L. J. M. Daguerre: The Artist's Studio. The earliest surviving daguerreotype, 1837.*
*Société Française de Photographie, Paris.*

drawing,'' proclaimed the announcement, ''and does not depend on any manual dexterity.'' The public was absolutely fascinated with the new images. Daguerreotypes were favorably compared to Rembrandt's etchings, and ''daguerreotypomania'' swept Paris. Painters, of course, were alarmed, and some, like Paul Delaroche, saw it as a real threat to their livelihood. ''From this time on,'' he exclaimed, ''painting is dead!''

Well, not quite. But it never was the same again. As a means of recording information, the daguerreotype surpassed anything seen before. But the pictures had a ghostly quality about them too, especially when made outdoors. While every detail of streets and buildings was clearly etched, exposures were too long to record moving objects, and virtually no sign of life was apparent. Long exposures also made studio portraits difficult to make at first, but some early operators like Richard Beard, who opened the first studio in London in 1841, overcame this problem by using smaller plates, better camera lenses, and chemical accelerators (Fig. 12-8). Each daguerreotype, being a direct image, was reversed from left to right. This was corrected by using a prism lens on the camera (as Niepce had done) or a mirror lens, as Beard and most American operators preferred.

Once exposure problems were overcome, daguerreotypes were used primarily for portraits, previously available only to the wealthy and famous.

The realistic likenesses satisfied most people, and when made by capable artists, their incredibly beautiful tonal scale could render the subtle modeling of side-lit faces with amazing delicacy. Family groups

**12-8** *Richard Beard: Portrait of an unknown man, London, c. 1842. Daguerreotype. Author's collection.*

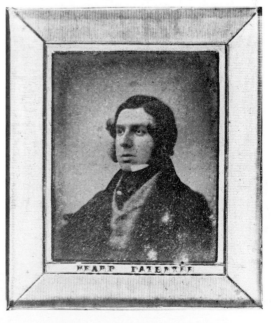

# THREE EARLY PHOTOGRAPHIC PROCESSES

## HOW HELIOGRAPHS WERE MADE

Niepce's first successful heliograph was made on a plate of polished pewter metal spread with a thin layer of bitumen of Judea, an asphaltic varnish. Wherever sufficient light struck the bitumen (as in highlights) it hardened, but where the exposure was insufficient (shadows), or held back by the dark lines of an engraved print in contact with the coating, the bitumen remained soft.

The unhardened bitumen was then dissolved in a solution much like paint thinner—a mixture of oil of lavender and turpentine. This revealed a faint, positive image, which was washed with water and dried.

## HOW DAGUERREOTYPES WERE MADE

Daguerreotypes were made on sheets of copper that were silver-plated on one side. The silver side was highly polished, and was then placed face down in a box containing iodine. This vaporized onto the plate, creating light-sensitive silver iodide.

Next the plate was transferred in a light-proof holder to the camera, where it was exposed. Initially, exposures lasted several minutes, but later they were reduced to a few seconds in bright daylight. After being covered again, the plate was removed from the camera to a darkened room.

In the darkroom the plate was placed face down over a vessel containing heated mercury, which deposited a white amalgam on the exposed (highlight) areas. Next, the unexposed silver iodide was dissolved with common salt or sodium thiosulfate, and rinsed away with water. Then the plate was gently dried over an alcohol lamp.

American daguerreotypists increased the sensitivity ofthe plates by buffing them to a highly polished finish, and by introducing accelerators to the silver iodide coating. They often used a mirror camera so that the image on the plate would not be reversed from left to right. Since the mercury adhered to the silver lightly, touching the plate would damage the image. Protective cases called *pinchbecks* were introduced. Similar to cases used for miniature paintings, each contained a paper matt or brass spacer and a cover glass to protect the image. *Each daguerreotype was a unique positive image*; the plates could not be duplicated except by re-photographing them.

## HOW CALOTYPES WERE MADE

Calotypes were made from negatives on paper that had been immersed in sodium chloride and then floated, face down, on a bath of silver nitrate. The resulting silver chloride was sensitive to light.

After exposure in the camera, the paper was developed by reapplying a solution of silver nitrate in gallic acid to the sensitive side of the sheet, and heating the sheet to bring out the negative image. The picture appeared when the reapplied solution deposited additional silver on the latent image, a now obsolete process known as *physical development.** Once developed, Talbot's calotype negatives were preserved by Herschel's method—with hyposulfite of soda (hypo), a method we still use today.

Calotype negatives typically were printed on silver chloride (salt) paper, by long exposures in direct sunlight (as shown on the right side of Fig. 12-13). Most calotypes were made in England, Scotland, and France; the process never became popular in America.

---

* This process has since been replaced by **chemical development,** in which silver is produced by a reaction **within** the latent image rather than by an external deposit on it.

---

**12-9** [*Photographer unknown*]: *Family group. American daguerreotype, c. 1850. Author's collection.*

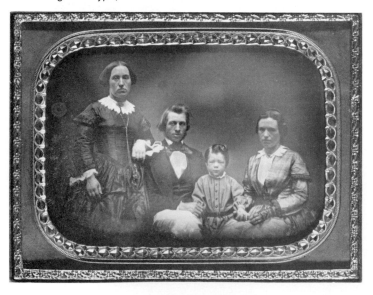

as well as individuals were carefully posed, (Fig. 12-9), and occasionally the plates were tinted with water-color pigments to increase the illusion of realism, or toned with gold-chloride for an elegant finish. Daguerre's instructions were published in 29 editions in six languages, and daguerreotypes became the standard form of photograph throughout Europe and America for more than twenty years.

## TALBOT AND PHOTOGENIC DRAWING

In the fall of 1833, an English scientist and scholar, William Henry Fox Talbot (Fig. 12-10), was also seeking a way to preserve the camera image. Unaware of the pioneering work of Niepce and Daguerre, Talbot had devised his own experiments for making images by the direct action of sunlight on paper. By 1835 he had discovered a way to coat paper with light-sensitive silver chloride. After two hours' exposure

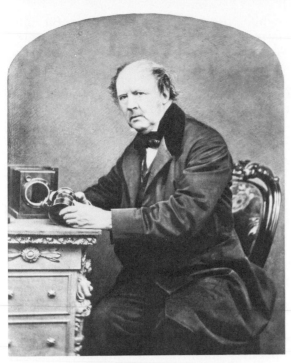

**12-10** *John Moffat: William Henry Fox Talbot [n. d.]. Carbon print. Trustees of the Science Museum, London.*

through various materials in contact with it, an image with its light and dark tones reversed appeared on the paper, which Talbot then preserved with a strong solution of salt water. This, of course, was the same contact method first tried by Wedgwood and Davy more than thirty years earlier, but where they had failed to preserve the image, Talbot succeeded.

Next he increased the sensitivity of the paper by repeated applications of chemicals, and exposed it in small cameras made for him by a local carpenter (Fig. 12-11A). One of these camera negatives, now preserved in the Science Museum in London, is a view through the central library window at Laycock Abbey, the Talbot family home near Chippenham in Wiltshire (Fig. 12-11B). Lilac colored, and only about an inch square, it is the earliest existing negative, and the second oldest surviving photograph in the world.

Talbot named his process *photogenic drawing*. Over the next few years he turned to other interests, and in 1839, when news of the daguerreotype reached him in England, the earlier experiments had been all but forgotten. Quickly realizing what was at stake, however, Talbot rushed to claim priority for his earlier discovery. His report to Britain's Royal Society (which served as a clearing house for scientific information) contained an important observation:

If the picture so obtained is first *preserved* so as to bear sunshine, it may be afterwards itself employed as an object to be copied, and by means of this second process the lights and shadows are brought back to their original disposition.*

With this statement, Talbot introduced the *negative-positive principle* that has become the basis for most photographic processes ever since.

Talbot's paper to the Royal Society was widely reported in the British press in February 1839, but his photogenic drawings—coarse paper *negatives*

---

\* W. H. F. Talbot, *Some Account of the Art of Photogenic Drawing* (London: privately printed, 1839), Sec. 11.

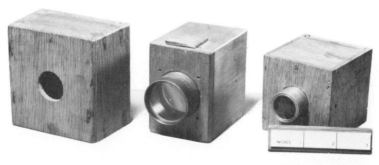

**12-11A** *Talbot's experimental cameras, 1835–39. Crown Copyright. Trustees of the Science Museum, London.*

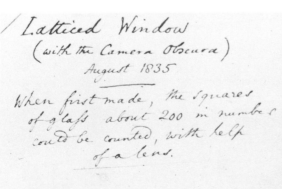

**12-11B** *William Henry Fox Tablot: Latticed Window, 1835. The earliest existing negative. Actual size. Trustees of the Science Museum, London.*

about one inch square—simply failed to capture the imagination of a public clamoring for daguerreotypes. The latter pictures were larger *positive* images, much more brilliant and detailed.

Meanwhile, the well-known scientist, Sir John Herschel, independently repeating Talbot's and Daguerre's experiments, discovered that *hyposulfite of soda* was a better preserving or fixing agent than salt water. Herschel shared his information with Talbot and suggested that they conduct their future investigations together, but Talbot refused.

## THE CALOTYPE

Disappointed by the response of the scientific community to his discoveries, Talbot continued to experiment alone. In September 1840, while resensitizing a batch of photogenic drawing paper that he had greatly underexposed and therefore thought could be used again, Talbot noticed the former images suddenly appear. In a way remarkably similar to Daguerre's encounter with spilled mercury five years earlier, Talbot discovered a *latent* or *hidden image* that could be made visible by *development*. Exposures were thereby reduced from hours to a minute or less, and these improvements Talbot immediately patented in England and France in 1841, and in America six years later.

The *calotype*, as Talbot called this improved process, was prepared and exposed much like a photogenic drawing (see box, p. 160). Because it was made on paper rather than metal or glass, the calotype recorded masses of tone better than fine detail. The best examples, like that by David Octavius Hill and Robert Adamson of Edinburgh (Fig. 12-12), show vigorous use of light and shadows. Other fine examples came from Talbot's own establishment in Reading, west of London (Fig. 12-13). Here we see Talbot himself at the camera in the center, while assistants make other calotypes and set contact frames out in the sun for printing.

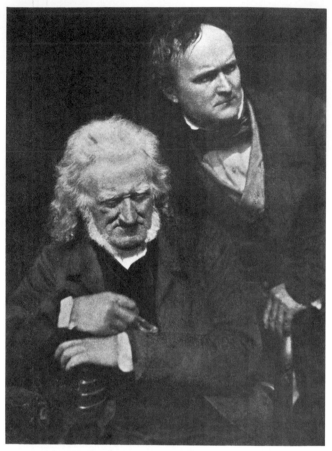

**12-12** *Hill & Adamson: John Henning and Alexander Ritchie, c. 1845. Calotype. The International Museum of Photography at George Eastman House.*

**12-13** *Talbot's Establishment, Reading, 1844–47. Trustees of the Science Museum, London.*

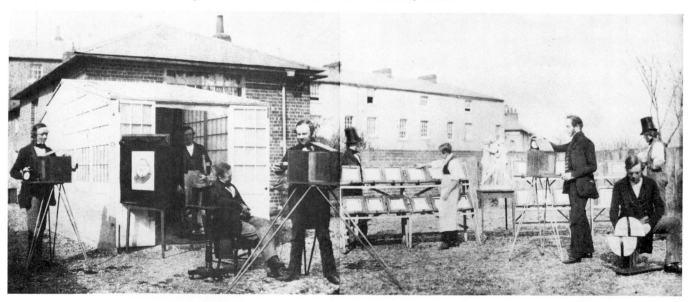

In France, Louis Désiré Blanquart-Evrard opened a photographic printing shop in Lille similar to Talbot's in Reading. Although Talbot *printed out* his calotype positives with light alone, Blanquart-Evrard produced his prints by *developing out* the image, the method we still use today. He also introduced *albumen paper*, in which the sensitive salts were dispersed in the whites of eggs. This produced a clear, glossy coating capable of retaining more detail from the negative than silver chloride (salt) paper could. Albumen paper remained in general use for more than forty years.

## PHOTOGRAPHY COMES TO AMERICA

The first photographs made in America are still unknown to us. Most historians credit D. W. Seager of New York, but his images have never been found. The oldest existing American photograph is a daguerreotype made by Joseph Saxton of Philadelphia in October 1839 (Fig. 12-14). Saxton was a scientist at the United States Mint, from which his view was taken.

The most famous pioneer American daguerreotypist, however, was Samuel F. B. Morse, a professional portrait painter, a professor at New York University, and better known to most of us as the inventor of the telegraph. Morse had seen Daguerre in Paris earlier in 1839, and when news containing the details of the daguerreotype arrived in New York in September, he was ready to experiment.

The United States was still feeling the effects of a depression that began in 1837, when rampant land speculation and unregulated banking caused such financial panic that banks had to be closed. With unemployment high, any new idea that promised an opportunity for business or a job was eagerly grasped. Daguerreotyping required little investment, and Morse quickly found himself sought by others wishing to learn the craft. Among his students were Edward Anthony, Mathew Brady, and Albert Southworth. Within a few years these enterprising men had established a new American industry.

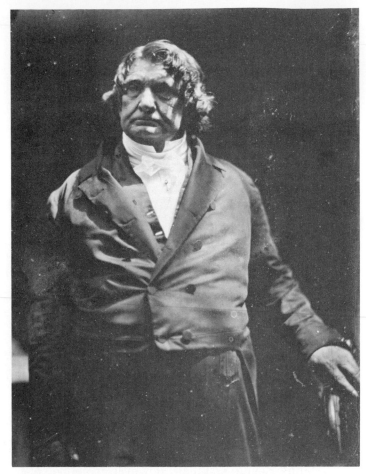

12-15　*Southworth & Hawes: Lemuel Shaw, 1851. Daguerreotype, actual size. The Metropolitan Museum of Art, Gift of I. N. Phelps Stokes, Edward S. Hawes, Alice Mary Hawes, and Marion A. Hawes, 1938.*

Edward Anthony began photographing members of Congress in 1843. When fire destroyed his collection nine years later, he and his brother Henry formed a partnership to sell daguerreotype supplies. Their firm of E. and H. T. Anthony and Company became the major American supplier of photographic materials for half a century.

Albert Southworth and Josiah Hawes of Boston produced remarkably natural daguerreotypes, such as that of Chief Justice Lemuel Shaw of the Massachusetts Supreme Court (Fig. 12-15). They claimed that they exposed all plates themselves, never using "operators"; major collections of their portraits and views are now preserved in three museums. John Plumbe, Jr., a railroad man and entrepreneur, owned a chain of 14 daguerreotype studios in eastern and midwestern cities. He, too, was careful to hire competent employees, and he acquired a reputation for quality views (Fig. 12-16).

Daguerreotyping also attracted speculators, few of whom had any talent. Dentists, blacksmiths, cobblers, and shopkeepers made portraits as a sideline, often with poor results. In small towns, operators sometimes posed as magicians, making the practice of photography little more than a con game.

12-14　*Joseph Saxton: Old Central High School, Philadelphia, 1839. The oldest surviving daguerreotype in America. Actual size. Historical Society of Pennsylvania.*

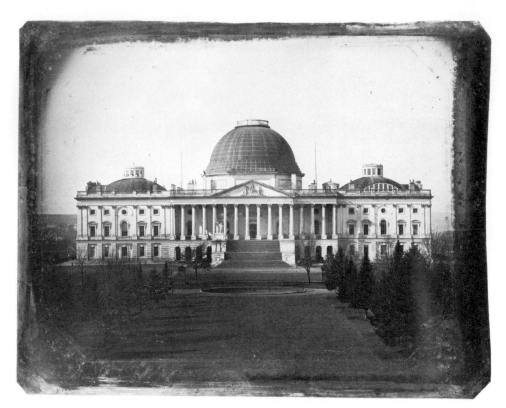

12-16 *John Plumbe, Jr.: East Front, United States Capital, c. 1845. Daguerreotype. The Library of Congress.*

## MATHEW BRADY

12-17 *Levin C. Handy: Mathew B. Brady, c. 1875. Daguerreotype. The Library of Congress.*

Some daguerreotypists, however, were men of vision, and the most famous of them was Mathew B. Brady (Fig. 12-17). His studios in New York and Washington daguerreotyped the great and near great of a prosperous but deeply troubled era. The Mexican War of 1846–47 had given the United States vast territorial gains, and these in turn produced a westward outlook and migration that were dramatically stimulated by the discovery of gold in California in 1848. The trouble, of course, was that peculiar institution—slavery—which supported a southern economy based almost entirely on cotton, and which reared its ugly head again and again as each western territory came up for admission to the union.

More than any other early American photographer, Brady sensed the usefulness of photographs as historic records of a changing time. By 1850 he had organized his business so that he could afford to photograph people and events for their importance rather than merely for profit. He and his Washington studio manager, Alexander Gardner, photographed nearly every president and other government officer of cabinet rank or above, from John Quincy Adams to William McKinley. Many of these historic images have since been reproduced in history books and on postage stamps. Brady took his camera into the field, too, and when the first major battle of the Civil War erupted at Bull Run in 1861, he was there.

By July of 1863, Gardner had left Brady's studio and set up his own, taking with him two more of

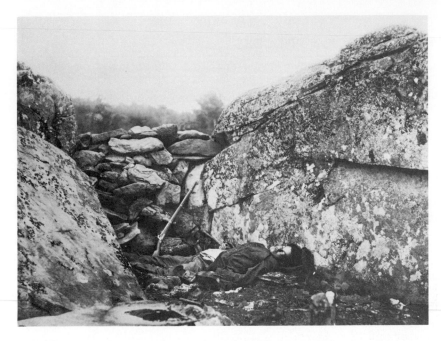

**12-18** *T. H. O'Sullivan: Home of a Rebel Sharpshooter, 1863. The Library of Congress.*

Brady's best employees, T. H. O'Sullivan and J. F. Gibson. These three made the first photographs of the Gettysburg battlefield, before the dead had been buried. Sometimes, however, they got carried away with their work, and rearranged scenes for added impact. Civil War historian William Frassanito has confirmed that O'Sullivan's famous photograph of a rebel sharpshooter (Fig. 12-18) was staged; even the rifle was not a military one. Frassanito's research (see bibliography, under History of Photography) has taught us that before we accept photographs as historical evidence, we must document them. We like to believe that photographs don't lie, but sometimes photographers do.

Brady and his staff were not the first cameramen to photograph warfare. A few daguerreotypes from the Mexican War (c. 1847) survive, but they show no combat. Roger Fenton, sent to the Crimean War in 1855 by his London publisher, returned to England with more than three hundred photographs of military encampments and battlefield views, but no combat pictures. Many of the best photographs attributed to Brady and his employees, like that of the ruins of Richmond (Fig. 12-19), were taken after the battle was over. Although the Richmond photographs dramatically show the devastation that war produces, they were not made under fire. The reason, aside from the

**12-19** *Mathew B. Brady: Ruins of the Gallego Flour Mills, Richmond, Virginia, 1865. Albumen print, 6½ x 8¼ in. The Museum of Modern Art, New York. Purchase.*

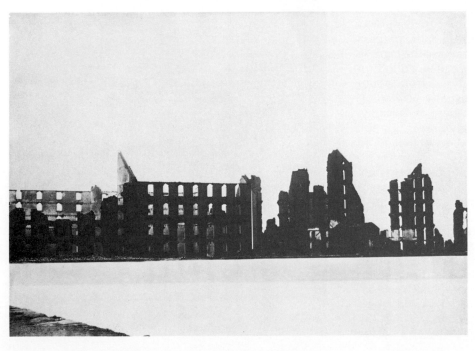

## THE WET COLLODION PROCESS

**Collodion** was made by treating absorbent cotton with nitric acid to form nitrocellulose, and then dissolving that in a mixture of ether and alcohol to form a clear, sticky liquid. It was used in field hospitals to form a flexible, skin-like coating over open wounds, protecting them until the victim could be given proper medical care. When poured on glass and allowed to dry, collodion became a tough film.

In 1851 an English sculptor and photographer, Frederick Scott Archer, adapted the process to making negatives. Archer added potassium iodide to the collodion, and before the coating had dried, he dipped the plate into a silver nitrate bath. This formed a suspension of silver iodide all over the damp collodion surface.

The plate was exposed *while it was still wet*. If the collodion dried, its sensitivity was lost and the saturated iodide solution crystallized on the surface, making the plate unfit for use. This gave the process its popular name, the **wet plate.**

After exposure, the glass plate was developed by candlelight in pyrogallic acid or iron sulfate to produce a negative image, and fixed with sodium thiosulfate (hypo). Finally the plate was washed and dried.

Two forms of collodion images were made by the thousands everywhere. One was the small glass plate (usually called an **ambrotype**) that was backed by dark paper or cloth to make the weak image look positive, and cased like daguerreotypes were. The portrait by C. R. Moffett of Mineral Point, Wisconsin (Fig. 12-20), shows this negative-positive effect (the left half is seen by transmitted light, the right half is backed by black paper).

The other, more common collodion image was the **ferrotype** or **tintype.** For this the collodion was coated on a small, thin sheet of iron that had first been painted with a black lacquer to seal it. Tintypes, made casually and quickly, were inexpensive and popular (Fig. 12-21). Thousands were taken of Civil War troops, who eagerly bought them because they were sturdy enough to be mailed home.

---

danger of working under combat conditions, was that most of these photographers used the wet collodion process to record their views, and this was a technique unsuited for combat work (see box).

### THE COLLODION ERA

Collodion was easier to work than the daguerreotype and much more sensitive to light than the calotype. *It yielded a negative image on glass*, from which unlimited numbers of high quality paper prints could be made. The only disadvantage of the process was that the darkroom had to accompany the camera wherever it went. In spite of this problem, collodion became the common negative material from about 1855 until 1880. The plates were usually printed on albumen paper. Francis Bedford's view of Torquay, a holiday town on the English Channel (Fig. 12-22), shows the excellent tone quality and detail that could be obtained by this method.

Unlike the calotype, the collodion process was not patented in England, and after the calotype patent expired in 1855, photography could be freely practiced by all.

Another form of the collodion image was the *carte-de-visite*, or visiting-card photograph, invented by a Frenchman, Adolph-Eugène Disdéri, in 1854. Multilens cameras, equipped with a device to reposition the $6\frac{1}{2} \times 8\frac{1}{2}$ in. (16.5 × 21.5 cm) plate between exposures, enabled studio operators to quickly take eight pictures and process them as one (Fig. 12-23). The resulting albumen print was cut up and pasted

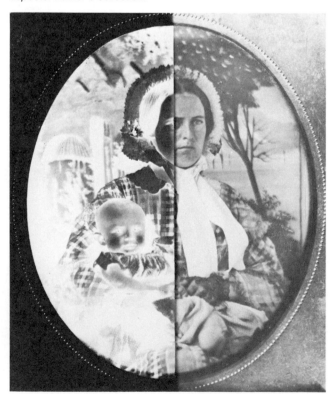

**12-20** *C. R. Moffett: Woman and Child, Mineral Point, Wisconsin, 1858. Ambrotype showing negative and positive aspects. Author's collection.*

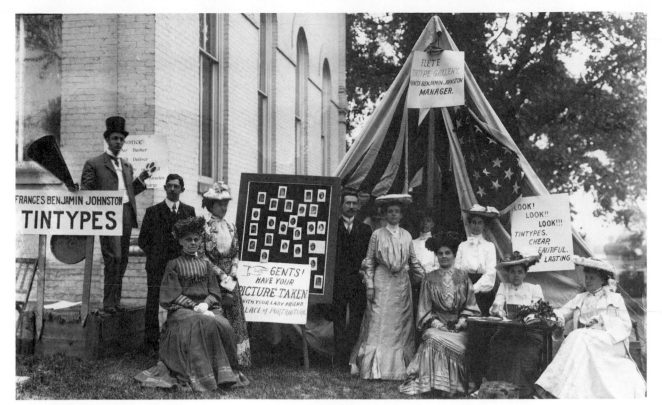

**12-21** *Frances Benjamin Johnston: Her tintype gallery and "studio" at a county fair in Virginia, 1903. The Library of Congress.*

**12-22** *Francis Bedford: Torquay, England, c. 1860. Albumen print. Author's collection.*

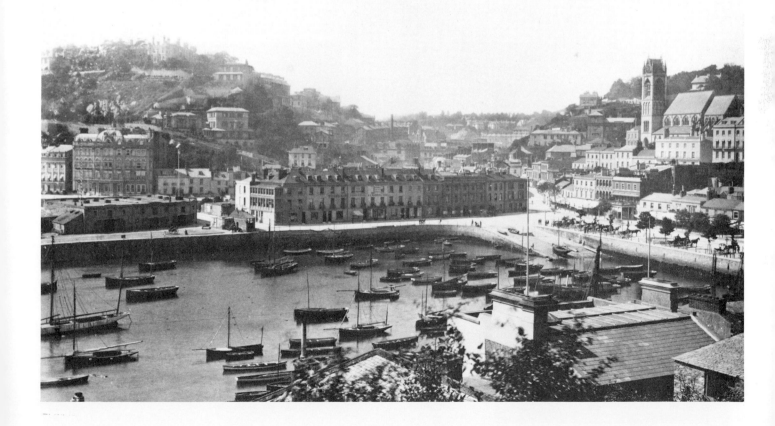

on individual card mounts about $2\frac{1}{2} \times 4$ in. (10 × 6.5 cm), similar to what we now call business cards.

Most early card photographs were full-length portraits (Fig. 12-24), and the style remained popular for decades. People left them as calling cards; Oliver Wendell Holmes called them "the social currency, the sentimental 'greenbacks' of civilization." *Photograph albums*, introduced in 1861 for collecting and storing these cards, soon appeared in many European and American homes. A larger card style, the *cabinet photograph*, appeared in England in 1866. First used for publicity pictures of royalty and theatrical people, it soon became the standard studio portrait format throughout the western world (Fig. 12-25).

12-25 *James Fairclough: Unknown woman, County Durham, England [n. d.] Cabinet photograph. Author's collection.*

12-24 *T. Partridge: Unknown girl, South Devon, England [n. d.]. Carte-de-visite. Author's collection.*

## EXPEDITIONARY PHOTOGRAPHERS IN THE AMERICAN WEST

A decade before the Civil War, daguerreotypists had accompanied geographic expeditions as they charted rivers and mountains across unsettled western land. Few plates of these pioneer western photographers have survived; most are known only from brief mention in government reports.

Others worked eastward from the Pacific coast. Robert H. Vance, a pioneer San Francisco daguerreotypist, and his apprentice Isaac Wallace Baker worked the gold fields and mining camps of California (Fig. 12-26), while Carleton E. Watkins (who also learned photography from Vance before taking over the latter's studio in San Jose) was among the first to photograph Yosemite Valley in the 1860s (Fig. 12-27).

After the war, the government again sent expeditionary teams westward. Alexander Gardner and Captain Andrew J. Russell, fresh from the war, joined railroad survey and construction parties. As the Union Pacific built westward from Omaha, the Central Pacific pushed eastward from Sacramento. Russell was one of three photographers who recorded the historic meeting of the rails on May 10, 1869, at Promontory, Utah (Fig. 12-28).

T. H. O'Sullivan joined the Clarence King survey of 1867 across Nevada and Idaho, and in 1871, after returning from Panama (where he worked on a canal route survey), O'Sullivan joined Lt. George M. Wheeler's expedition in the southwest. Wheeler's group explored the Grand Canyon of the Colorado by boat, and two years later, the dry but awesome canyonlands of Arizona and New Mexico. O'Sullivan's mastery of the wet collodion process under extremely difficult conditions produced some of the finest nineteenth-century landscape photographs of the American West (Fig. 12-29).

Other notable frontier photographers included L. A. Huffman, who photographed from horseback in Montana Territory, and J. C. H. Grabill of Deadwood, Dakota Territory, who photographed the Plains Indians. Grabill's view of a Sioux encampment (Fig. 12-30) was probably made shortly after the Battle of Wounded Knee.

The best known frontier cameraman, however, was William Henry Jackson, who was the official photographer for the Hayden Surveys from 1870 to 1879. Jackson's photographs of the Yellowstone region, made in 1871, convinced Congress to place the area in public trust as our first National Park. After 1875, Jackson photographed the Rocky Mountain region with a 20 × 24 in. "mammoth" wet-plate camera (Fig. 12-31). In *Time Exposure*, his autobiography published in 1940 (when he was 97), Jackson recounted his difficulties with pack mules on slippery

**12-26** *Isaac W. Baker: Murphy's Camp, California, 1853. Daguerreotype. The Oakland Museum.*

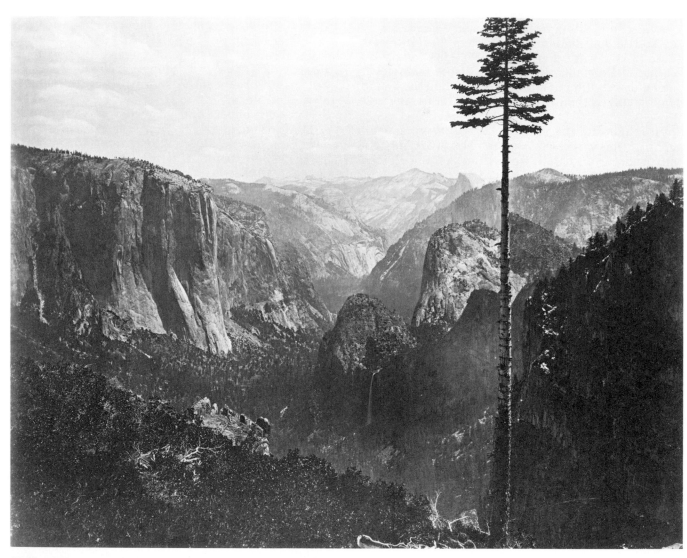

**12-27** *Carleton E. Watkins: Yosemite Valley from the "Best General View"*
*No. 2, c. 1866. The Library of Congress.*

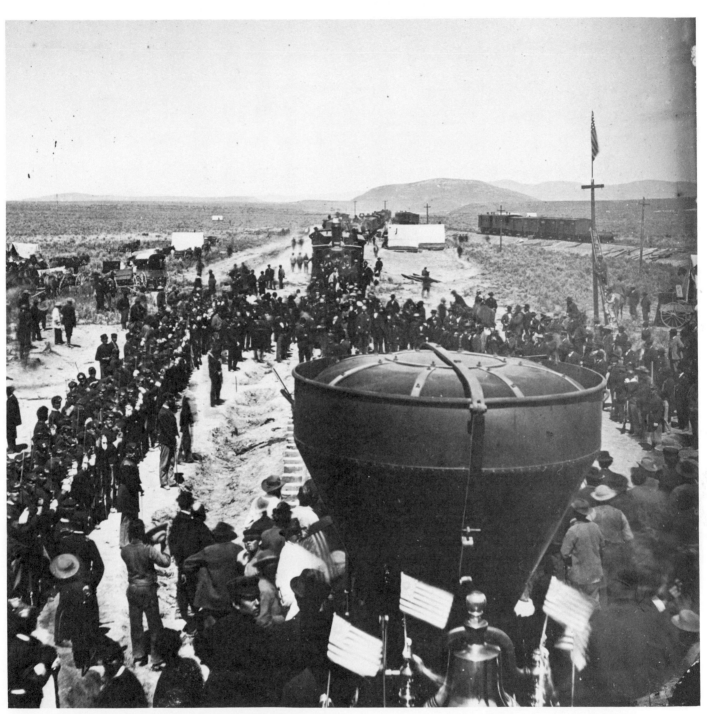

**12-28** *Andrew J. Russell: Meeting of the Rails at Promontory, Utah, 1869. Russell Collection, The Oakland Museum.*

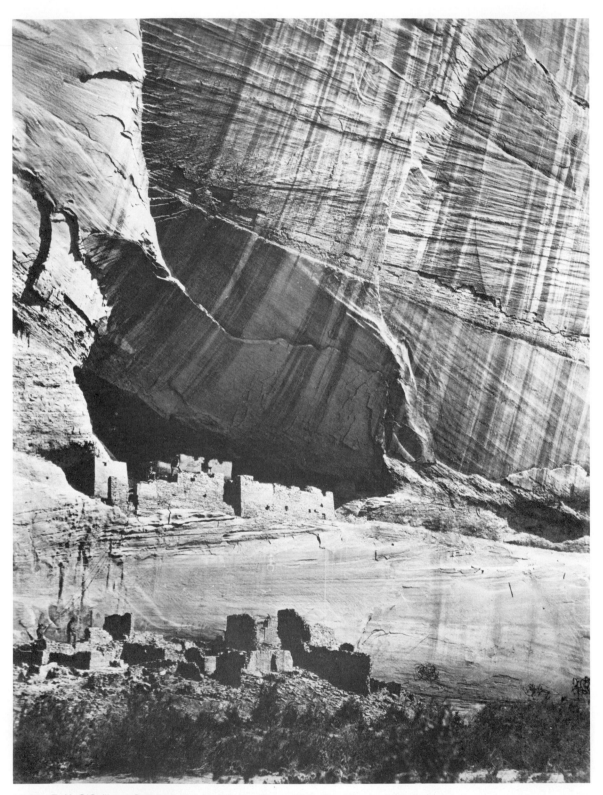

**12-29** *T. H. O'Sullivan: Cañon de Chelly Cliff Dwellings, 1873. The Library of Congress.*

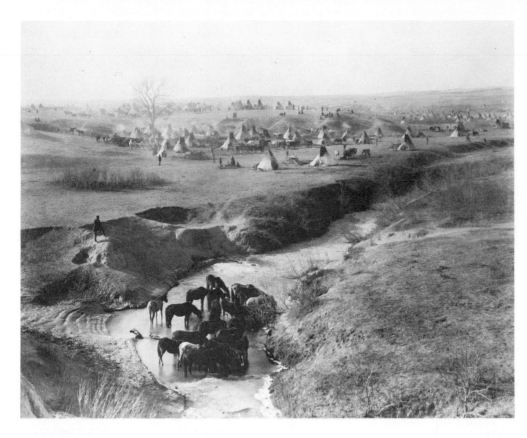

**12-30** *J. C. H. Grabill: Sioux Encampment near Brule, Dakota Territory, 1891. The Library of Congress.*

**12-31** *William Henry Jackson: Ouray, Colorado, c. 1885. The International Museum of Photography at George Eastman House.*

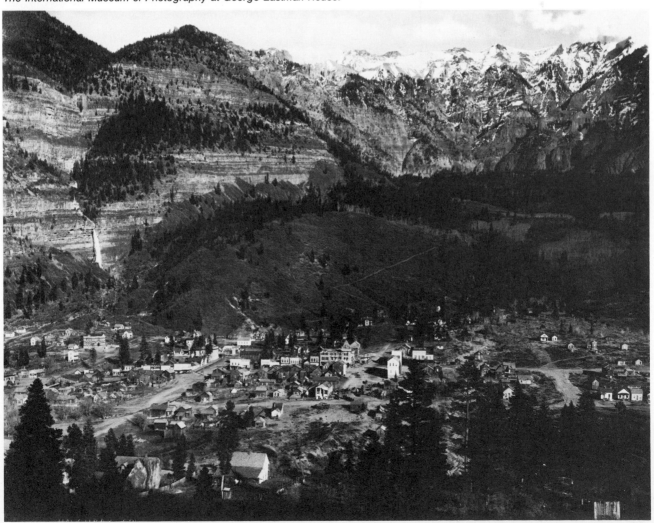

mountain trails.* Most territorial photographers, like F. Jay Haynes of Fargo, made paired stereoscopic negatives with twin-lens cameras (Fig. 12-32). These three-dimensional pictures (Fig. 12-33), which quickly became a fad in more settled areas of the country, were an important source of income for frontier photographers.

## GELATIN DRY PLATES

As we look at the clarity and detail in these century-old western photographs, we tend to forget that wet-plate photography outdoors was difficult in the best of circumstances. Everywhere the camera went, the darkroom had to go too, for collodion plates had to be sensitized, exposed, and developed on the spot. If the coating dried, it was useless for photography.

In 1871 Dr. Richard Leach Maddox, an English physician and amateur photographer, solved this problem when he replaced collodion with *gelatin*, an equally clear but *dry* vehicle for the silver salts. In 1878 Charles Bennett, another Englishman, discovered how to make these gelatin plates a hundred times more sensitive to light, and they immediately replaced collodion everywhere.

Gelatin dry plates had three great advantages over collodion:

1. They freed photographers from the hassle of wet collodion; photographers could leave the darkroom behind when they went into the field.
2. Because gelatin plates did not require coating just before

**12-32** *F. Jay Haynes: Our Artist at the Great Falls of the Missouri River, Montana, 1880. Haynes Foundation Collection, Montana Historical Society, Helena, Montana.*

---

* Jackson died in 1942 at the age of 99.

**12-33** *F. Jay Haynes: Fording the River Gibbon Canyon, Yellowstone National Park, c. 1880. Mrs. Bonnie Douglas, Jackson, California.*

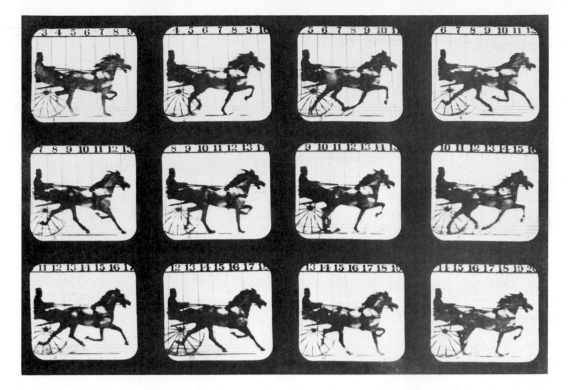

**12-34** *Eadweard Muybridge: Abe Edgington Trotting at 2:24 Gait, Palo Alto, California, 1878. Stanford University Museum of Art, Muybridge Collection.*

exposure or developing immediately afterward, they could be made at a central factory and shipped to photographers. Thus an industry was born.

3. Their tremendously higher sensitivity to light made photography of action possible for the first time.

### Photographs of Action

One of the first photographers to fully use these advantages was Eadweard Muybridge, an Englishman working in San Francisco. His ingenious photographs of Leland Stanford's trotting horses in 1878 (Fig. 12-34) were one of the first deliberate attempts to analyze movement with the camera. To make them, Muybridge invented an electric camera shutter that per-

mitted exposures in bright sunlight as brief as 1/1000 second.

The idea to analyze motion, however, was not Muybridge's alone. Five years earlier, a French physiologist, Etienne Jules Marey, had conducted similar experiments without the aid of photography, and in Philadelphia, the noted painter Thomas Eakins used a device of Marey's design to make successive exposures of a moving figure on a single plate (Fig. 12-35). Muybridge's monumental *Human and Animal Locomotion* (eleven volumes containing more than 20,000 photographs), completed in 1887, is an encyclopedia of motion still unsurpassed today. Muybridge also invented the *zoopraxiscope*, a projection machine that resynthesized motion from still pho-

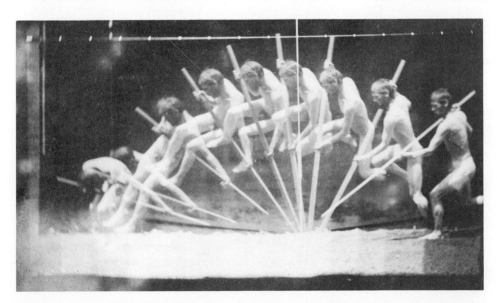

**12-35** *Thomas Eakins: Marey Wheel photograph of George Reynolds, c. 1884–85. Philadelphia Museum of Art, gift of George Bregler.*

tographs. Because this device led directly to the development of the cinema, he is regarded by many as the father of motion pictures.

## ROLLFILM: PHOTOGRAPHY FOR EVERYONE

Although gelatin made instantaneous exposures possible, fragile glass plates still made outdoor photography cumbersome. An American amateur photographer, George Eastman, soon found a solution. Eastman was a bank clerk in Rochester, New York. "At first I wanted to make photography simpler merely for my own convenience," he recalled, "but soon I thought of the possibilities of commercial production." In 1878, Eastman, like others, had switched from collodion to gelatin plates. Within a year he invented a coating machine, and soon he was manufacturing plates for other photographers. His goal, however, was to replace the glass plate with unbreakable film. Although he marketed a flexible, opaque paper-based product in 1885, Eastman realized that a *transparent* flexible base was needed for the gelatin emulsion. The next year he hired a young chemist, Henry Reichenbach, to find it.

In May of 1887, Rev. Hannibal Goodwin of Newark, New Jersey applied for a patent on a flexible, transparent rollfilm made of *nitrocellulose*. More than two years elapsed before the patent was granted, and meanwhile Reichenbach had invented and patented a similar product. Eastman began making this film, and in 1888 he produced a small, lightweight rollfilm camera, the *Kodak*, to use it (Fig. 12-36). The public response was immediate and overwhelming.

Goodwin's heirs sued Eastman, who eventually settled the matter and went on to produce cameras by the thousands. Eastman also provided *a service to develop and print the snapshots* taken with them (Fig. 12-37). "You push the button, we do the rest" became a household phrase, and within a decade, people everywhere were taking their own photographs. Legions of "button pushers" in Europe and America

12-37 [*Photographer unknown*]: *Bathers, c. 1888. Snapshot taken with No. 2 Kodak. The International Museum of Photography at George Eastman House.*

turned photography into a fad. Camera clubs and popular photographic magazines appeared. While thousands of people pursued photography for fun, a few asked more serious questions.

## IS PHOTOGRAPHY ART?

English amateurs first raised the question in the 1850s. By imitating painters' compositions, they sought acceptance from more traditional artists. Some, like Julia Margaret Cameron (the first notable woman photographer), posed her children and friends in romantic, Victorian settings (Fig. 12-38). But more avid photographers such as Oscar Rejlander and Henry Peach Robinson labeled their efforts "high art." Rejlander printed his most famous composition, *The Two Ways of Life*, from more than thirty separate negatives. This famous allegorical photograph, reminiscent of Raphael's sixteenth-century fresco, *The School of Athens* in the Vatican, contrasted sensual delight on the left with industry and charity on the right (Fig. 12-39). H. P. Robinson's later pictorial scene was equally synthetic but less ambitious; only three negatives were combined (Fig. 12-40).

Robinson issued prints by annual subscription, and the popularity of his work provoked another English amateur, Dr. Peter Henry Emerson, to protest such artifice and argue for a direct way of seeing and photographing. In *Naturalistic Photography*, published in 1889, Emerson suggested a reasoned approach to camerawork that stressed characteristics unique to photography: a clarity and richness of tone that were

12-36 *Original Kodak Camera (rollholder removed), 1888. Reprinted courtesy of Eastman Kodak Company.*

**12-38** *Julia Margaret Cameron:* Enid *(from Tennyson's "Idylls of the King and Other Poems"). The Metropolitan Museum of Art, David Hunter McAlpin Fund, 1952.*

**12-39** *Oscar Rejlander: The Two Ways of Life, 1857. Collection of the Royal Photographic Society, Bath.*

**12-40** *Henry Peach Robinson: Caroling, 1887. Trustees of the Science Museum, London.*

**12-41** *Peter Henry Emerson: Gathering Waterlilies, East Anglia, 1886. From the album* Life and Landscape on the Norfolk Broads. *London, 1886. Platinum print, 7¾ x 11½ in. The Museum of Modern Art, New York. Given anonymously.*

possible only with direct, unmanipulated images. Although his prints were rich and beautiful (Fig. 12-41), Emerson was not a persuasive critic, and he soon abandoned the controversy to his opponents.

A decade later, an American amateur, Alfred Stieglitz, took up the cause. Stieglitz was editor of the Camera Club of New York's prestigious quarterly journal, *Camera Notes*, in which he published the finest pictorial photography he could obtain from European as well as American exhibitors. The interests of American clubs, however, typically were more social than artistic, and their exhibits or "salons," as they were called, displayed photographs full of painterly artifice. Through his influence in *Camera Notes*, Stieglitz sought to counter this trend. He also tried and exhibited alternative processes such as gum, bromoil, carbon printing, and photogravure (Fig. 12-42). Most serious American amateurs used bulky plate cameras on tripods; Stieglitz showed them what could be done with a hand camera—and patience.

### The Photo Secession

Few club members, however, shared Stieglitz's crusading attitude. Facing diminished support from within the club, he resigned as editor, and with twelve other dedicated photographers, he organized the *Photo Secession* in 1902 as an independent exhibiting group.

Within a year, Stieglitz produced the first issue of a fiercely independent quarterly, *Camera Work*, with superb reproductions in each issue. By 1905 he had opened "291," a gallery on New York's Fifth Avenue, to exhibit the newest and most controversial work in photography and other arts.

The Photo Secession demonstrated the difference between photographs as records of fact and photographs as personal expression. They showed that criteria appropriate to the former could not suffice for the latter. Stieglitz's influence grew enormously, and with the help of other photographers like Edward Steichen, he succeeded in getting photography recognized as a fine art in its own right, and on its own terms.

Sensing that battle won, Stieglitz increasingly promoted painting and sculpture in his gallery, and in 1915 some of the Secessionists withdrew to form the Pictorial Photographers of America, an exhibiting group with more traditional tastes. Their first president was Clarence H. White, a respected member of the Photo Secession and one of photography's foremost teachers. Stieglitz continued on his own course, recognizing people like Paul Strand, whose work was direct and intense (Fig. 12-43). Charles Sheeler, another American independent, was a painter who also used the camera directly. Many of his photographs became studies for drafting his meticulous, clean-edged canvases.

**12-42** *Alfred Stieglitz: The Terminal, New York, 1892. From* Camera Work, *No. 36, 1911. Photogravure, 10 x 13 in. The Museum of Modern Art, New York. Gift of Georgia O'Keeffe.*

**12-43** *Paul Strand: Blind Woman, New York, 1916. The Metropolitan Museum of Art, The Alfred Stieglitz Collection, 1933.*

## SOCIAL AWARENESS

While some photographers argued the merits of photography as art, others used the camera to record daily life. At the turn of the century, an obscure Parisian, Eugène Atget, made hundreds of poetic photographs with an old view camera on a tripod. When people were included in his photographs, they were not the famous or wealthy but the common street people he seemed to know best (Fig. 12-44).

Meanwhile, other photographers were discovering the power of the camera to change life. The failure of the Irish potato crop in the 1840s and a succession of European revolutions had caused a tide of immigration to America in the decades that followed. Letters and photographs sent home by newly settled Americans portrayed them as well fed and relatively prosperous, and lured by the promise of a new beginning, the immigrants came. Many of them settled in New York City, their port of entry, jobless, often destitute, and forced to live like animals in unbelievably squalid housing where crime was rampant.

All this seemed intolerable to Jacob Riis, a police reporter for the New York *Sun*, who covered the tenements and their misery. Riis knew these ghettos well since he had come as an immigrant himself in 1870. His 1890 book, *How the Other Half Lives*, campaigned effectively for housing reform; it is still considered a classic. But Riis was not convinced that his words

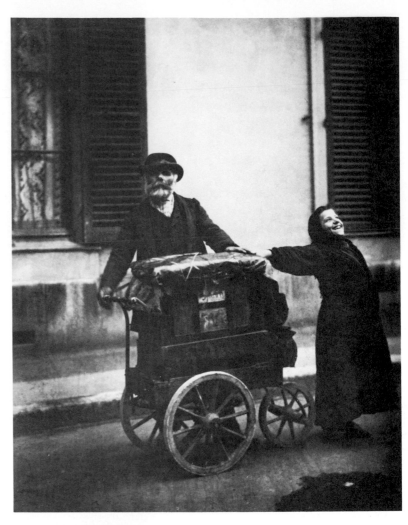

**12-44** *Eugène Atget: Organ Performers, Paris, 1898–99 (gelatin-silver print by Berenice Abbott). Author's collection.*

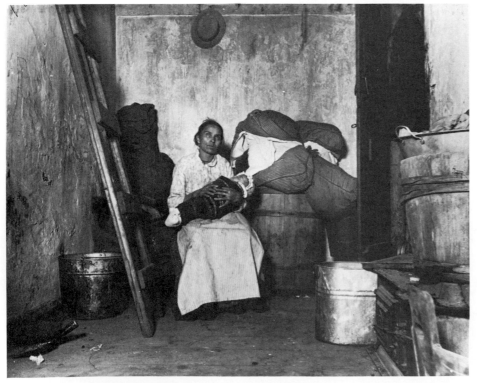

**12-45** *Jacob Riis: Italian Ragpicker's Home in Jersey Street, New York, 1888. Museum of the City of New York.*

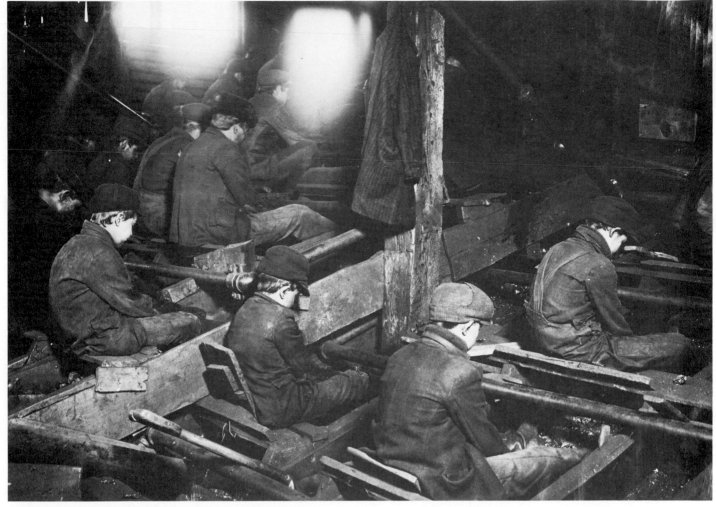

**12-46** *Lewis W. Hine: Boy Breakers, South Pittston, Pennsylvania, 1911.*
*The Library of Congress.*

alone would change things, so he illustrated the book with revealing, compassionate photographs (Fig. 12-45), many of which he had taken at night with a view camera and flashpowder, sometimes at great risk to his own life. Even though they were crudely reproduced by an early photomechanical process, their message was convincing.

Lewis W. Hine, a sociologist also trained as a photographer, was similarly concerned about the exploitation of children in America's industries. Hine's photographs of their deplorable working conditions (Fig. 12-46) insured the passage of protective child-labor laws. Later he photographed extensively for the American National Red Cross.

## DIRECT PHOTOGRAPHY

After World War I, pictorial photography again became popular and camera clubs renewed their activities in Europe and America. Most photographers favored impressionistic and manipulated pictorial styles, but a few exhibited photographs made in a direct and unmanipulated manner that we now call classic (see next chapter).

### Group f/64

In 1926, Edward Weston, who had been a leading California pictorialist, returned from three years in Mexico. Impressed by the simple, earthy lifestyle there, he changed his thinking about photography and switched from an impressionistic style to a vigorous and direct one. Others who saw his photographs (Fig. 12-47) were similarly impressed with their intensity, and in 1932, several of Weston's friends, including Ansel Adams, Imogen Cunningham, and Willard Van Dyke, formed an informal association around him.

They called themselves *Group f/64* and exhibited expressive photographs that were direct and clear. At the same time, they argued their convictions in the press with other photographers who favored more traditional pictorial styles.

The direct style that Group f/64 championed in America had its parallel in Germany, where Albert Renger-Patzsch published a collection of realistic photographs, *The World Is Beautiful*, in 1928.

**12-47** *Edward Weston: Artichoke Halved, 1930. © 1981 Arizona Board of Regents, Center for Creative Photography.*

**12-48** *László Moholy-Nagy: Love Thy Neighbor, c. 1925. Gelatin-silver print, 11⅛ x 8¼ in. The Museum of Modern Art, New York. Given anonymously.*

## EXTENDING THE VISION

Other photographers regarded the camera primarily as a tool for enlarging an artist's vision. The American Alvin Langdon Coburn made abstract examples as early as 1917, but the movement progressed more rapidly in Europe, where Man Ray (an American associated with the Parisian Dadaists) and László Moholy-Nagy (a Hungarian artist from Germany's leading center of art and design, the *Bauhaus*), made *photomontages* (Fig. 12-48), and *photograms*—pictures without a camera. Avant-garde filmmakers, with their intense interest in closeup shots and spontaneous movement, also influenced this trend.

## DOCUMENTARY PHOTOGRAPHY

During the 1930s the most prominent artistic photographers were largely divided between an aggressive pursuit of realism and a search for deeper meaning in abstract forms. Other photographers, however, preferred to deal with life more directly, and they were supported in this approach by the publication of picture magazines such as *Life* and *Look*.

In the midst of the great depression, Dorothea Lange brought an intensely human concern to the plight of migrant workers in the West (Fig. 12-49). Walker Evans and other members of the Farm Security Administration team made a similar examination of sharecroppers in the South (Fig. 12-50) and factory workers in the East. All helped to make the

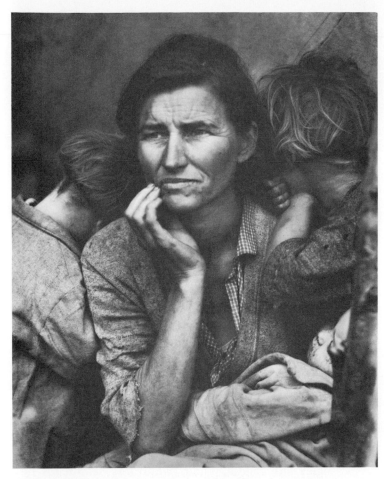

**12-49** *Dorothea Lange: Migrant Mother, Nipomo, California, 1936. The Oakland Museum.*

**12-50** *Walker Evans: Kitchen in Floyd Burroughs's Home, Hale County, Alabama, 1936. The Library of Congress.*

nation more aware of the social and economic inequality that President Franklin Roosevelt's "New Deal" attempted to correct.

## FORCES OF MODERNISM

Since World War II, several broad forces have combined to shape the content and appearance of photography in the last half of the twentieth century. Considered as a whole, they have moved photography into the modern era along five paths that have interwoven with each other and with other arts and technologies.

Many photographic artists are pursuing a classic

**12-51** *Henri Cartier-Bresson: Abruzzi, 1953. Magnum Photos, Inc.*

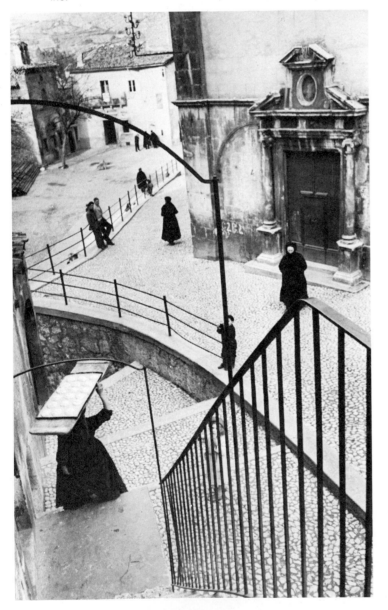

vision of what has always made photographs different from other visual images, and their work is discussed more fully in Chapter 13.

European photojournalists like Henri Cartier-Bresson (Fig. 12-51), Alfred Eisenstaedt, André Kertész, and Paul Martin shaped a tradition that developed into what we now call the journalistic approach. Today's news and documentary photographers, reporting on the human condition, have produced some great photojournalism and television stories, discussed more fully in Chapter 14.

Other concerned photographers have sought to reveal inner meanings through outward appearances at various levels of *abstraction*, as discussed in Chapter 15.

Still others have sought to erase the boundaries that have traditionally defined the photographic medium by *combining it with other art media*. Some of these efforts are discussed in Chapter 16.

Another major factor shaping modern photography has been the pervasive presence of *color*. After two decades of cautious trial, today's photographers have embraced color technology with great enthusiasm. Color photographs vastly outnumber black-and-white, most consumer magazines are now published in color, and the art world no longer views color photography with apprehension about its permanence as it did (with good reason) not long ago. Color photography is discussed more fully in Chapters 9, 10, and 11.

Photographers are also freely combining technologies and media. Their continuing search for new meaning in life and in their pictures has suggested that some redefinition of what photography is—and can be—may be in order in this electronic age.

But the past still fascinates many photographers and students, and it is these people, of course, who will continue to enrich our understanding of photography's history through their own discoveries. Some people have shown interest in recreating the vintage processes of the past, but a word of caution is in order. Most of these historic processes, such as the daguerreotype, required chemicals that are now known to be extremely hazardous to human health. Recreating them is therefore not recommended. Other nineteenth-century processes, however, may be safely repeated with modern materials. Susan Shaw's excellent reference, *Overexposure: Health Hazards in Photography*, and William Crawford's book, *The Keepers of Light*, respectively detail the risks and the opportunities. Both are listed in the bibliography, under Technical Manuals.

## SUMMARY

1. The *camera obscura* was used as a drawing aid long before the invention of photography, and *reproduced* pictures have been with us since the fifteenth century.

2. In 1725 Johann Schulze in Germany discovered the light sensitivity of silver salts. In 1777 Carl Scheele in Sweden found that silver chloride, after exposure to light, would not dissolve in ammonia. These two discoveries were the technical basis for forming and preserving the photographic image, but neither scientist foresaw this useful application for his work.

3. The first person to see the connection between the camera obscura to form the image and the use of silver compounds to record it was Thomas Wedgwood in England, around 1799. He and Humphry Davy successfully made contact images in sunlight, but none with the camera. But they were unable to preserve their images, which quickly faded.

4. In France, Joseph Nicéphore Niepce first succeeded in preserving a camera image around 1826. His positive view on a pewter metal plate is the world's oldest surviving photograph. Niepce named his process *heliography*.

5. After Niepce died, Louis Jacques Mandé Daguerre perfected the process in 1837 and announced the *daguerreotype* to the world in 1839. Daguerreotypes were silver-plated sheets of copper. Mercury formed the highlights of the positive image; silver the shadows. The mirror-like plate was cased behind glass to protect it.

6. In England, William Henry Fox Talbot produced a paper picture, with light and dark tones reversed, in 1835. Talbot called his process *photogenic drawing*. His friend, Sir John Herschel, called these images *negatives*, and suggested hyposulfite of soda (hypo) to fix or preserve them. We still use this method today.

7. Talbot also discovered that a brief exposure of his paper in the camera formed an invisible image which could later be made visible by development. He also created a paper positive that he called the *Calotype* by exposing another piece of sensitized paper through the original negative image, thus introducing the *negative-positive principle* that has been fundamental to virtually all photography ever since.

8. In France, Louis Blanquart-Evrard introduced *albumen paper* made with egg-whites, which made smooth, glossy prints possible.

9. The oldest surviving American photograph is a daguerreotype made by Joseph Saxton of Philadelphia in 1839. However, Samuel F. B. Morse, the inventor of the telegraph, was the most famous pioneer daguerreotypist in the U.S.A. Among his trainees were Edward Anthony, Mathew Brady, and Albert Southworth. These three men established photography as a major American industry.

10. Brady photographed many presidents and other notable Americans. During the Civil War he sent photographers into the field, but they often "staged" their pictures for more dramatic effect.

11. Most photographers of the 1860s used the *collodion* process, adapted by Frederick Scott Archer. A glass plate had to be coated, sensitized, exposed, and developed *while it was still damp or wet*. If the coating dried prematurely, it lost its sensitivity. Collodion images on glass were negatives, but it the plates were backed by dark material, they could be viewed as positives. Such plates were called *ambrotypes*; typically they were portraits. A variation of the process produced *ferrotypes* or *tintypes*, positive images on thin sheets of lacquered iron. After 1855, collodion became universal.

12. The *carte-de-visite* (visiting card) was made from a collodion plate exposed in a multi-lens camera. Then the albumen print was cut into individual images and mounted on small cards. These were collected in *photograph albums*. After 1866, a larger version of the card, the *cabinet photograph*, became the standard format for studio portraits.

13. In California, San Francisco daguerreotypists worked the gold rush mining camps, and Carleton Watkins was among the first photographers to enter the Yosemite Valley. Other photographers worked westward from the Mississippi with railroad survey parties. T. H. O'Sullivan, a master of the collodion process, and William Henry Jackson joined government surveys of the west during the 1860s and '70s. Most frontier photographers made stereo views.

14. In 1871 Dr. Richard L. Maddox replaced collodion with *gelatin*, making a *dry plate*. In 1878, Charles Bennett discovered how to increase its sensitivity a hundred times, and dry gelatin plates replaced wet collodion. Gelatin plates were prepared in factories (instead of by the user), and their much higher sensitivity permitted photographs of action.

15. Early experimenters with *motion* in photography included Eadweard Muybridge and Thomas Eakins. Muybridge's classic study *Human and Animal Locomotion*, with more than 20,000 photographs, remains unsurpassed.

16. In 1888, George Eastman introduced a simple, hand-held camera, the *Kodak*, and flexible *rollfilm* to use in it. He also provided a *developing service*. People everywhere took their own photographs; camera clubs and popular photographic magazines appeared.

17. In England, Julia Margaret Cameron, Oscar Rejlander, and Henry Peach Robinson made photographs that imitated painters' compositions. Peter Henry Emerson argued for the detail and clarity that only photography could provide. Both styles had their followers.

18. In America, Alfred Stieglitz greatly influenced the development of photography as a *fine art*. In 1902 he founded the *Photo Secession* to exhibit work independently from conservative camera clubs. He also published *Camera Work*, an elegant quarterly journal. Other important American photographers of this period were Charles Sheeler, Edward Steichen, Paul Strand, and Clarence H. White.

19. In turn-of-the-century Paris, Eugène Atget made clear, lyric photographs of city life. In New York, Jacob Riis, a police reporter, used his camera to crusade for cleanup of the slums and a better life for their immigrant dwellers. His 1890 illustrated book, *How the Other Half Lives*, is still a social classic. A generation later, Lewis Hine's photographs of children being exploited by American industry resulted in the passage of strict child-labor laws.

20. In 1932, Edward Weston, Ansel Adams, Imogen Cunningham, Willard Van Dyke, and other California photographers formed *Group f/64* to promote and exhibit clear, direct photographs while others were showing soft, impressionistic work.

21. In Europe, Man Ray and László Moholy-Nagy introduced an era of abstraction in photography by exhibiting *photomontages* and cameraless images called *photograms*.

22. Farm Security Administration photographers like Walker Evans and Dorothea Lange helped the nation understand the effects of the Great Depression on the poor and on those who could not vote.

23. Since the forties, interaction with other arts and the advent of picture magazines have produced well-defined classic, journalistic, and abstract or symbolistic directions. Color photography now dominates almost all of these areas, and today electronic technologies are being blended with photographic ones.

# 13

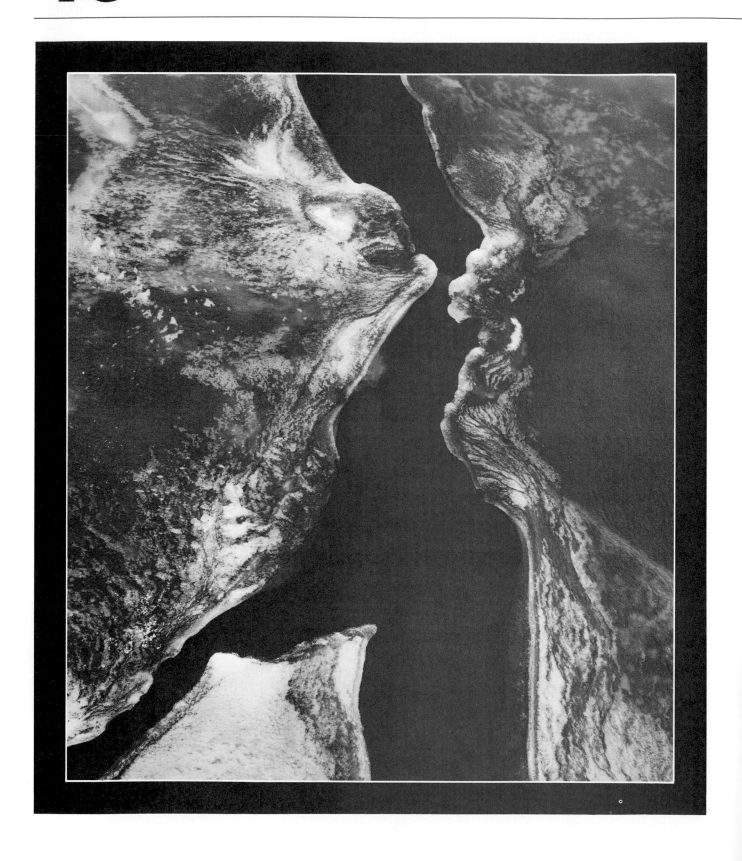

# THE CLASSIC APPROACH

The classic approach to making a photograph encourages us to discover the most important things about a subject, visualize them as simply and directly as possible, and present them in a photograph as forcefully as we can. This approach to the image employs methods and produces results that we identify more strongly with photography than with any other means of making pictures. These methods include forming a clear, sharp image with a lens, recording that image directly on film without manipulation, and then processing and printing the negative to produce the strongest possible visual statement.

Photographs made in this manner usually are rich in *continuous tone* and *detail*. They often use *light* to reveal significant form and texture, to define space, and to unify the image as a picture. The work of earlier masters like Edward Weston and Ansel Adams has inspired many other photographers to create images in this direct, classic style. Stu Levy's photograph of Oneonta Creek (Fig. 13-1) is a fine example.

Using this approach to photography, we can create an illusion of reality so strong that the presence of a camera, and sometimes even that of the photographer using it, can go unnoticed. We can convey to the viewer of our picture an extraordinary sense of *being there*. In effect, a classic photograph says to its viewer, "You are here, witnessing this moment, seeing this object or event." And since seeing is believing, what you see must be true. Photographs made like this create a feeling of *presence* for us, and our willingness to equate *seeing* with *believing* reinforces it.

Nowhere has this power of directly perceived photographs been more deliberately and effectively used than in advertising and package design, where it persuades people to buy goods and services by vividly describing these things and by making them attractive and desirable. Photographs help to create a want or need by stating facts and arguments more convincingly than mere words can. Thus when the camera is used in this direct, classic manner, the resulting photographs seem to do what photographs do best: communicate a wealth of visual information, accurately, efficiently, and convincingly. Moreover, such photographs are least suggestive of pictures that could be made better by drawing or painting. More than anything else, classic photographs have an unquestionable *photographic* appearance.

Today we take such images for granted. From drivers' licenses to billboards, classic photographs are part of our daily life. Simple snapshots are the most common and unsophisticated examples. Common, of course, because they are produced by the millions. And unsophisticated because people who take snapshots typically are more conscious of what happens in front of their cameras and less aware of the photographs that will result. The contents and meaning of such photographs usually are not discovered until they see their prints for the first time—a different experience than looking through the camera's viewfinder when the pictures were made. Casual photographers, then, rarely visualize their products—photographs—because they are too preoccupied with the original event and the process of picture-taking. It is not surprising, then, that most people's snapshots of the Golden Gate Bridge or the Statue of Liberty look like thousands of others.

Creative photographers, how-

ever, are primarily concerned with *what their pictures mean*. Photographing creatively therefore requires us to look at our subject more carefully, to confront it deliberately, and to *perceive an image or idea* from that encounter. Our inspiration may come from someone or something in front of our camera, from another picture, or from a feeling within ourselves. The next step is to *visualize our image*—to think about it in pictorial terms—and then, by using appropriate techniques and methods, to *make a photograph* that we believe will most effectively convey our idea to a viewer. Throughout this process, which may be slow and deliberate or quick and largely intuitive, creative photographers keep the end result—*the photograph*—in mind. Unlike snapshooters, creative photographers follow through.

## SELECTION: THE FIRST STEP

More often than not, the classic approach is most successful when it is used to visualize a single object or idea with the greatest possible strength. Mathias Van Hesemans's photograph of rope lava from Hawaii's Pele Volcano provides an example (Fig. 13-2). What this photograph appears to be saying is clear, evident, and forceful. So the first suggestion for working in the classic manner is to *select and visualize a single idea*, to concentrate on seeing one thing as clearly as possible.

Because the natural world is often more chaotic than orderly, photographers usually begin by sorting

**13-2** © *Mathias Van Hesemans: Rope Lava, Pele Volcano, Hawaii, 1980.*

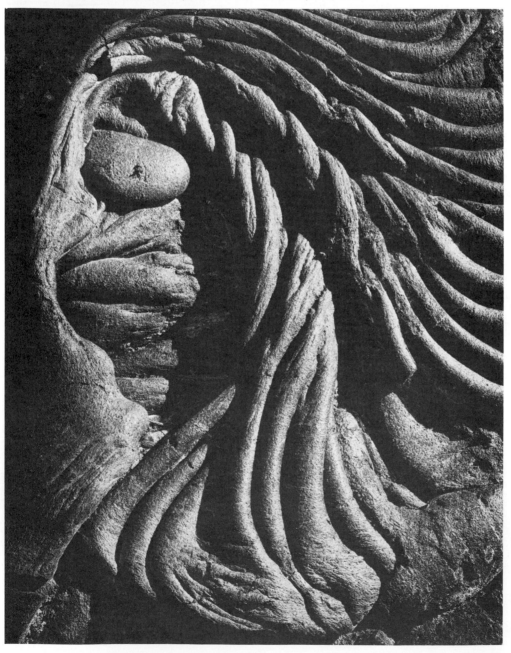

out from the environment the raw material of the picture. This act of selection can be intuitive or carefully reasoned; it may be instantaneous or involve a succession of decisions. No matter how it is done, it involves all that we see, all that we know, and all that we have experienced. Since the camera alone cannot choose one thing or reject another, *selection* is the most important decision that we photographers can make. It is the primary step to all forms of photographic visualization.

## FRAMING THE SUBJECT

Whenever we point a camera at something, we hang a frame on the real world. We select what is significant within our field of view and locate it inside the framework of the picture's edges. Thus we isolate the image from all that lies beyond the frame. Set apart in this manner, our image takes on a new significance. John Szarkowski, in *The Photographer's Eye*, points out how important this act of isolating the image is to the photographer:

To quote out of context is the essence of the photographer's

craft. His central problem is a simple one: what shall he include, what shall he reject? The line of decision between in and out is the picture's edge. While the draughtsman starts with the middle of the sheet, the photographer starts with the frame.*

We can demonstrate this by overlapping two L-shaped pieces of cardboard to form an adjustable frame. Move this cutout slowly around in front of one eye, and notice the effect. Holding the frame close to the eye, for example, will show the effect of a wide-angle lens. Objects close at hand occupy a large part of the space, and being larger in scale, they may seem more important. Moving the frame to arm's length has the same effect as increasing the focal length of the lens or further enlarging the picture. Now fewer things, at a greater distance, compete for our attention.

Framing objects apart from their surroundings causes other things to happen. When John Sexton photographed Shiprock, New Mexico (Fig. 13-3), he kept the horizon line low in the frame and thus dwarfed the peak under a greater expanse of sky.

---

*John Szarkowski, *The Photographer's Eye.* © 1966, The Museum of Modern Art, New York. Reprinted with permission.

**13-3**  © *John Sexton: Shiprock, New Mexico, 1986.*

**13-4** *Aaron Siskind: Martha's Vineyard 108, 1954.*

There, as in so much of the American West, the open space simply overwhelms a visitor, and Sexton captured this feeling by including more sky than land in his view. By surrounding these two things, then, and by eliminating everything else, the frame establishes a new relationship between them. The frame can also shape the space around objects, as Aaron Siskind shows us in *Martha's Vineyard 108* (Fig. 13-4).

And then there is that "line of decision"—the picture's edge. The edge cuts objects in two and discards one part; the remaining part may be used to suggest the whole, or the picture may simply show an uncommon fragment of a common object and thus give it a new meaning of its own. Fragments tend to extend a viewer's perception beyond the confines of the picture itself; things that are visible in the photograph may allude to others that are not.

Because of their cut-off feature, then, a picture's edges become important parts of its structure and geometry. Ignoring these edges weakens snapshots, where the effort too often seems unconsciously directed toward centering people or objects within the frame. To avoid this problem, we should take care when composing a picture in the camera (and again when cropping the picture in the enlarger) to use the framed space of the picture format fully—in other words, to *fill the frame*.

## CLOSING IN

Another way to fill the frame with our subject is to get closer to it. Photography, as we know, can record an immense amount of detail. Closing in helps to reduce this abundance of detail without dimin-

ishing its clarity. The classic approach encourages us to see things at close range, to get to know our subjects intimately. Mark Goodman's photographs of people often display this intensity (Fig. 13-5). Getting close

**13-5** *Mark Goodman: A Young Girl Holding a Jar Containing a Lunar Moth, Millerton, New York, 1977.*

lets him concentrate on how his subjects really look, without irrelevant objects diluting the intensity of either his vision or his picture. We too can visualize many of our pictures at close range. Most cameras allow us to focus the lens directly as close as 1 meter (3¼ ft), and even closer with special lenses or attachments.

## LIGHT AND FORM

*Form*—the shape of objects within the frame—does not always dominate a classic photograph. But often it is such an important part of the image that it becomes the picture's major organizing element. In typical work, where the image resembles the object photographed, we usually try to reveal the form of our object or the significance of our event by isolating it from its surroundings and presenting it in a graphically effective manner. How we do this depends, of course, on the objects themselves and on our point of view. But in photography, it also depends on *light*.

Light shapes the appearance of objects. Light and its absence (shadow) can separate those objects from their surroundings, reveal their forms, and thus create the illusion of depth in a two-dimensional image.

Our ability to set apart an object from its environment (sometimes called a figure-ground relationship) can be strengthened in a photograph by careful attention to light and shadow. Marilyn Bridges's photograph of Glastonbury Tor in Somerset, England (Fig. 13-6) gains much of its dramatic power from the low angle of the light.

**13-6** *Marilyn Bridges: Glastonbury Tor, Somerset, England, 1985.*

Light can also function as a powerful magnet to draw us into a picture and to unify its structure. As a rule, our eyes tend to find brighter values more quickly than darker ones, and to look at them longer. This is what happens when we look at the famous photograph of the Sierra Nevada by Ansel Adams (Fig. 13-7). These are the mountains that John Muir long ago called "the range of light." The snow-covered peaks attract us first; we discover the grazing horses later. However, the photograph is not that simple. The dark mass and wavy profile of the lower ridge also compete for our attention, forming a counterpoint to the sunlit mountain tops above, and adding to the magic of a spectacular mountain landscape on a cold winter morning. Adams was a musician as well as a photographer; it is not surprising that many viewers sense a musical structure in the image.

We can strengthen our pictures graphically by taking advantage of this phenomenon at opportune times. For example, if an object and its immediate surroundings can be framed so that dark areas occupy the corners of the picture (as in Fig. 13-2), the center of the image will become more interesting and visible because it is brighter. This helps to unify the picture, to give it a sense of completeness when we view it.

Sometimes when a desired effect does not occur naturally, it can be introduced by the photographer.

The corners can be slightly darkened by *burning* when the print is made (p. 115). If done carefully and sparingly, it will not call attention to itself. The viewer may thus continue to explore the picture, undiverted by corner tensions, and the essential unity of the image is thereby preserved.

## LIGHT AND TEXTURE

Sunlight, when not diffused by haze or clouds, is strongly directional. The focused beam from a studio or theatrical spotlight has a similar quality. We can use such directional light with its attendant shadows to emphasize surface qualities of a subject and thereby more accurately reveal or define it. Surfaces, of course, often tell us much about what lies beneath or beyond them, and of all the ways to render them graphically, photography is unsurpassed.

Again, a simple demonstration is convincing. Outdoors, after dark, point any directional light source (such as a flashlight) at a board fence or a brick wall. The light illuminates the surface evenly within its circle, just as car headlights appear on a closed garage door. We can see the surface, its color, and perhaps

**13-7** *Ansel Adams: Winter Sunrise, The Sierra Nevada, from Lone Pine, California, 1944.*

a pattern in its design, but we cannot see its structure—its tactile quality; we can only imagine how it *feels*. Now move the light close to the wall or fence and aim it nearly parallel to that plane. Instantly the light picks out the raised portions; the three-dimensional quality of that surface, even if it is slight, becomes vividly apparent. Examined very closely, the light appears to bathe higher spots while the intervening valleys lie in shadow. From farther away, however, highlights and shadows resolve into a revelation of *texture,* that quality of a surface that gives it a richness of character, a stronger identity, and gives the viewer a heightened sense of awareness. The light must come from one direction, preferably the side or rear (in relation to the subject), and must rake or skim across the surface rather than strike it directly. Morley Baer's photograph of a hitching post (Fig. 13-8) uses light this way. His focus, of course, had to be needle-sharp on the post; that all-important sense of being able to "feel" the textured surface would have been lost in an unsharp image. This is because the bits of light and shadow that form texture are very small; if they were not sharp (as in the background of Baer's photograph), they would be invisible. Also, the tone scale that shades the textured surface must be properly recorded to complete the illusion of reality. Neither highlights nor shadows can be lost, and that demands correct exposure in the camera.

**13-8** *Morley Baer: Hitching Post, San Juan Bautista, 1987.*

**13-9** *Charles Cramer: Summer Sunrise, Yosemite, 1985.*

## DIFFUSED LIGHT

Charles Cramer's photograph of Yosemite Valley (Fig. 13-9) conveys a different feeling. Made in sunlight diffused by morning mist, the light evokes a sense of power and mystery in the image. It also tends to unify the picture.

The important point to remember is that there are numerous ways to use light in photography in addition to its essential role in the recording process. Whenever light will reveal the most important qualities of a subject, or convey the significance of an idea in our photographs, it should be used vigorously and imaginatively.

## THE IMPORTANCE OF TECHNIQUE

Most serious photographers argue that questions of technique should remain subservient to expression at all times. They believe, quite simply, that the ends to which the photographic process is used should determine one's choice of tools and procedures. In some of the variant and non-silver processes outlined elsewhere in this book, technique and statement are so directly interrelated that they cannot be considered

separately. In the classic approach, however, this is not the case. Its direct simplicity makes it easy to consider ends apart from means, purposes separate from techniques. This, in turn, allows us to keep the emphasis where it belongs—on what we are saying, rather than how. Once we have decided what we want to say, however, we still have to make a photograph to convey our idea, and this is when technique becomes important.

If our technique is going to serve us well, there are three things it should do for us. First, and most important, it should give us the freedom to express our vision and present our statement as effectively as we can. Toward this end, it should be consistent with our ideas and our personality, as individual and precise as each of us is, yet flexible enough to interpret whatever we see. Second, it should provide us with the means to do this under different working conditions. We should be able to make a photograph anywhere we see the opportunity for one. Third, our technique should give us the discipline and confidence necessary for consistently good results. Only then may we consider ourselves free to make photographs creatively.

Any technique consistent with a classic approach should be as simple and straightforward as possible. It should make the fullest possible use of *light* and the response of film and paper to it. After all, *light* is what separates photography from all other picture-

**13-10** *Harrison Branch: Bodie, California, 1981.*

making processes, and it is what distinguishes photographs from all other kinds of pictures. By choosing our materials wisely and using them with care, we can produce black-and-white photographs with a range of tones from brilliant white to jet black, and color photographs with a similar range of values. *Broad tonal scales* are essential to brilliant prints, and brilliant prints command a sensation of intense presence more effectively, as a rule, than softer ones do. A soft print may sing delicately and gracefully, but a brilliant one sings joyfully.

### Full-scale Prints

What makes a print brilliant? Why do one photographer's prints seem vibrant and alive, while another's appear muted or lifeless? Choice of materials has some effect: glossy papers can produce richer shadows and a longer tonal scale than matte (dull) papers can. (However, using them doesn't guarantee such results; dead, gray prints can be made on glossy paper too!) Good craftsmanship in exposing and processing the negative is always desirable. But one essential requirement for a brilliant black-and-white print, and one frequently overlooked, is the presence of *clean white and deep black areas* in the picture. The areas need not be large nor relatively important

in subjective terms. The only requirement is that they be *present, and noticed, by the viewer.*

Black and white may symbolize many opposites, such as despair and hope, misfortune and opportunity. In addition black and white are the key tones or values of the classic silver image. They are visual anchors. And they are *tonal absolutes*, the only ones in the photographic image. All other tones are relative to them.

Each of these absolutes can be defined in practical photographic terms. *White* is the clean, pure reflection of the white paper base, undimmed by any visible deposit of silver in the emulsion after processing. White is the result of processing unexposed photographic paper.

*Black*, on the other hand, is the impression we get from the darkest and heaviest deposit of silver that an exposed and fully developed print will yield. Any other value, by definition, is a shade of gray.

Regardless of how many shades of gray we can see in a black-and-white photographic print, our impression of a print's tone scale eventually hinges on these two absolute values—white and black. If gray tones are the only ones present, the print will look muted and unexciting. But if its tonal scale stretches from one extreme to the other, as in Harrison Branch's photograph from Bodie, California (Fig. 13-10), an appearance of brilliance will be unmistakable.

Making a black-and-white photograph with a long tonal scale is not difficult, but neither is it automatic. It requires an understanding of how sensitive materials work, a feeling for what the tones of the print convey to a viewer, and the confidence that comes from disciplined practice.

### Prints in Color

The classic style in contemporary color photography is best exemplified by photographers who are always conscious of the *color* of light as well as its direction and intensity, who use color as form, and whose choice of materials and techniques usually leads to color prints or transparencies of outstanding brilliance and saturation. Examples can be found in the work of Stephen Shore, Joel Sternfeld, (Plate 10), and many others. In addition, many professional photographers who produce food, fashion, and advertising illustrations rely on the visual power of what is essentially a classic style.

## DEVELOPING AN INDIVIDUAL STYLE

In the previous chapters we outlined photographic techniques for black-and-white and color work that are practical and to the point. With sufficient practice you can refine many of these procedures to make them more expressive of your skill and more responsive to your ideas. This will help you explore new areas in photography with vigor, imagination, and confidence, and gradually your personal style will begin to emerge.

### The Zone System

To aid this exploration, many experienced photographers make their working methods systematic, and some of these systems include visualizing the image as well as executing the photograph. Any system that does this has the additional advantage of tying together *seeing* and *photographing*, thus providing an orderly means to progress from a visualized idea to the finished picture—from *object* to *image*.

One of the best and most famous systems of this kind for black-and-white work is the *Zone System* made famous many years ago by Ansel Adams, and periodically refined by him, Minor White, and others. It provides a common language for relating the *subject*—what is in front of the camera—with the *negative*, the *print*, and the photographer's own interpretive *ideas*. When fully utilized, the Zone System can help us to visualize our own expressive print as we consider various possible interpretations of a subject before our camera. Once choices are made, the system will direct us through the camera exposure, negative processing, and printing steps to produce the desired interpretive print, allowing us to visualize the photograph at any stage of its evolution. The system is a reliable yet flexible tool.

Like any systematic technique, the Zone System first requires you to discover exactly what your tools and materials will do. This means testing them to establish their behavior under *your* working conditions. The procedures are too extensive for inclusion in this book, but they are superbly explained and detailed in *The New Zone System Manual* by White, Zakia, and Lorenz and in *The Practical Zone System* by Chris Johnson (see bibliography, under Technical Manuals). If you are interested in developing a systematic black-and-white technique, and are willing to invest the time and effort required to learn it, you should study either of these manuals with care. Several principles of the Zone System can also be applied to making color photographs with transparency (reversal) films.

### A Way, Not a Goal

Any technique, whether a simple, empirical procedure or a methodical one like the Zone System, is only a means to an end. It offers a way, not a goal. The classic approach, like any rationale, is a means rather than an end. If the procedures and techniques become goals themselves, our photographs will very likely become sterile, unoriginal, and ultimately meaningless. A technically brilliant negative, for example, is rewarding only if it produces an effective, compelling print. The print, in turn, will function the same way only if we as photographers have something to say. But directly visualized images, produced in the classic manner by the interaction of light, lens, and photographic materials, can help us define our personal objectives as we photograph, and thus lead us toward our own individual style.

## SUMMARY

1. Classic photographs usually are rich in *continuous tone* and *detail*. They often use *light* to reveal significant form and texture, to define space, and to unify the image. Frequently they convey a feeling of *presence*—of being there—to the viewer.

2. Snapshooters typically are concerned with the act of *taking pictures*; creative photographers with what the resulting pictures *mean*.

3. *Selection* is the first and most important decision a photographer can make; this act determines what will and will not appear in the photograph.

4. *Framing* isolates the subject from the rest of the real

world, giving new meaning to objects within the frame and shaping the surrounding space.

5. Photographers generally should work to *fill the frame*. Getting closer to the subject helps do this by reducing the amount of detail in the picture without reducing its clarity.

6. *Light* can be used to shape the appearance of objects in a photograph, and thereby determine how their *form* is revealed. This creates the illusion of *depth*. Light skimming across a rough surface can reveal its *texture* and thus strengthen a feeling of realism.

7. *Technique* is important as a means to an end; it is not a goal in itself. A classic technique should give a photographer the freedom needed for personal expression and the discipline needed for consistently good results.

8. Brilliant prints with *broad tonal scales* are a hallmark of the classic black-and-white style. Such prints require areas of *clean white* and *deep black* tone to convey the impression of brilliance. Black and white are tonal absolutes; any other value is gray.

9. In color photography, the classic style is characterized by sensitivity to the *color* of light as well as to its other qualities, by use of *color as form*, and by brilliant color transparencies or prints.

10. Making your technique systematic can often aid in developing an individual style. One of the best ways to do this is by using the *Zone System*, a means of relating the subject, negative, print, and your own interpretive ideas in an orderly, predictable way.

# THE JOURNALISTIC APPROACH

While the classic approach is concerned primarily with the essence of an object or idea, the journalistic approach is concerned with its *context* as well. The classic photographer may be content to show the facts of the matter in a simple and direct way, but the journalistic photographer asks additional questions: where and when did the event take place? Journalistic photography considers how an object is related to surrounding objects: it places an object in space. This approach also considers what preceded and what follows the moment of exposure: it acknowledges a continuum of time.

## SPACE AND TIME

Photography does not recreate space or time but changes them in subtle ways. A camera image has its own individual structure, determined by the lens, and photographers must be aware of this. To a photographer, *space* is not simply the area framed by the viewfinder; it is also the arrangement of its contents. We may include everything within our field of view, or we may be more selective and limit our attention to a single plane that we direct the lens to isolate.

Similarly, we must understand what surrounds our subject in *time*. Every exposure, long or short, is only a moment plucked by the camera from an irreversible sequence of events. In real time this sequence is usually predictable, but the meaning it gives our pictures can vary. Some of Walker Evans's photographs, such as the roadside stand shown in Figure 14-2, are documents of the old South at a particular point in time. Other photographs he made that same summer suggest more universal truths. The interior of Floyd Burroughs's home in Alabama (see Fig. 12-50) speaks of dignity and pride in the midst of poverty.

A peculiar power of the camera is that once it isolates a moment, that moment becomes suspended in the present—it is here and now. Frank O'Brien's photograph of a baseball game (Fig. 14-1) literally stops the action cold. But Cheryl Nuss's photograph of Pope John Paul II comforting a young AIDS victim in San Francisco (see Fig. 1-6) suspends a different kind of moment, one full of emotional impact. Each of these very different images presents an unforgettable memory, and their power to do this transcends the moments of their creation.

The camera's shutter and its viewfinder frame are both *selectors* that we must use with judgment to sort out time and space. Decisions must often be made quickly. The photograph by Brazilian photographer Sebastião Salgado (Fig. 14-3) reminds us that in the real world of changing events there is rarely a second chance to get the shot.

## DEPTH OF FIELD AND SELECTIVE FOCUS

We interpret space with a camera by controlling how its lens forms the image. As the camera frames objects at different distances from the lens, some of those objects will be rendered sharper than others. The area of greatest sharpness is called the *depth of field*, and it includes everything between two limits, near and far, of acceptable clarity in the image.

When Mary Ellen Mark photographed gypsy children in Barcelona (Fig. 14-4), she wanted the

14-2   *Walker Evans: Roadside Stand in the Vicinity of Birmingham, Alabama, 1936. The Library of Congress.*

14-3   *© Sebastião Salgado: Guatemala, 1978. Magnum Photos, Inc.*

14-4   *Mary Ellen Mark: Barcelona, 1987. From* A Day in the Life of Spain. *Mary Ellen Mark Library.*

picture to relate the people to their caravans in the background. By focusing on the children and using a moderately large aperture, Mark limited her depth of field and effectively separated one from the other. Although both the people and their caravans are included in the picture (showing the relationship between them), our attention, like hers, is directed primarily to the children and the mask.

Focusing selectively to emphasize a person or an object is a useful technique for organizing the space of a picture and for making one part of a picture more important than another. This effect can be seen directly in an SLR or view camera: objects at one distance will be sharp and clear, but others nearer and farther away will appear less sharp, or fuzzy. The transition is gradual, and is most noticeable when the focused object is at close range. Under these conditions the depth of field is shallow, focus is selective, and foreground and background are easily separated.

As the lens is stopped down to smaller apertures, or focused on objects at greater distances, the depth of field increases. The aperture of many SLR cameras can be momentarily stopped down to preview the depth of field at various settings. Other types of cameras often contain a depth of field indicator on the focusing scale (see Fig. 2-20).

### Hyperfocal Focusing

Photographers often face a different problem: how to get most or all of the image sharp. Andrew Borowiec's photograph of the Wheeling Suspension Bridge, the first bridge over the Ohio River (Fig. 14-5), uses the bridge itself to guide our eye into the space. To do this, the near part of the bridge is just as important to the picture as the far part; all of it has to be shown clearly. By rendering both the foreground and the background sharp and clear, the photographer tied them together.

Borowiec brought his entire field of view into sharp focus by using *hyperfocal focusing* (p. 21). Other ways are also useful to increase depth of field. Using a wide-angle lens and placing your camera close to an important element of the picture, as in Figure 3-14, also tends to increase depth. To a lesser extent, the amount you enlarge your picture also affects the sensation of depth. The more an image is enlarged, the more it will lose its acutance and appearance of sharpness. The less you enlarge the image, the more easily these qualities will be preserved.

In practice, of course, some of the factors that maximize depth of field often must be compromised to support others that work against it. For example, you might have to get close to your subject and use a large aperture because little light is available. *Adjusting the aperture* is usually the best way to control depth of field.

## PERSPECTIVE

Ever since the Renaissance our way of seeing has been conditioned by the camera's lens. For centuries we have represented what is extremely large by a mark that is extremely small; a vanishing point on the horizon signifies unlimited space. We call this device *central perspective*, and most photographers rely on

**14-5** *Andrew Borowiec: Suspension Bridge, Wheeling, West Virginia, 1987.*

it to give their images an illusion of depth. Central or one-point perspective is a product of a single point of view, and this is what a camera's lens provides. Thus objects at different distances, even though they may be the same actual size, are shown as they appear to the eye—receding or getting smaller as they are farther away, as Borowiec's picture shows (see Fig. 14-5).

Other ways of representing space in pictures, although less familiar, are also a part of our visual experience. Jim Alinder, for example, chose a high viewpoint, eliminating the horizon line (Fig. 14-6). That gave his picture a flat plane on which the important elements are sprinkled about without some appearing more important than others.

What happens in a picture to make us aware of the space within it? We see a scene in perspective or perceive depth in a picture because we readily notice *change*. If we can sense a change in space or in the relative size of similar objects, we immediately know that we are not looking at a flat, perpendicular plane. But once that change is not apparent, we're not so sure. This raises a question: should the picture appear to be flat or have depth? Should it be a window or a panel? As the foregoing examples show us, photography permits it to be either one; our own vision, rather than the camera's, decides the difference.

## TIME AND MOVEMENT

Nothing attracts our attention to change more strongly than *movement* does. We sense something to be moving when it changes its position relative to other objects that do not move, or are still. As an object moves it changes the space around it. It also changes in *time* as well as space, and thereby creates a happening or event. *Time* is the interval between events, and, as such, the dimension on which we measure all change.

### Freezing Action

Time and motion, as Einstein reminded us, are relative concepts, and photographers use several techniques to make them visual. Modern cameras and films make it easy to stop action by using extremely short or fast shutter times. In good light, a great deal of action can be momentarily stopped at 1/500 or 1/1000 second, as Rich Haro has done in Figure 14-7. Figure 14-1 was also made this way. And if the light is not bright, such short exposures can often still be used with today's fastest films.

On the other hand, a feeling of action can also be created by using a much longer exposure, as Deanna

**14-6** *Jim Alinder: Cornhusker Fans, Lincoln, Nebraska, 1973.*

Dawn has done (Fig. 14-8). This can be created by leaving the shutter open longer than the usual fraction of a second. Since the exposure time must be related to the object's relative motion, no simple rules apply. Times of 1/30 second to several seconds offer a useful range for experimenting, and they often will reveal visual images that cannot be seen with the eye alone (for another example see Figure 1-7). Of course longer exposures require smaller apertures; more time must be balanced by less light to avoid overexposure. Slow films may be helpful, especially in bright sunlight.*

### Panning

The technique that Deanna Dawn used is called *panning*. It requires the photographer to track the moving object so that its image is held still in the viewfinder. Panning the camera renders the moving objects more clearly than the background, which blurs. It is best done with a camera that has a manual or shutter-priority exposure system.

Panned pictures contain an unmistakable feeling of *movement*, but the object usually remains identifiable. The technique is often used in sports photography, where it can capture both the fact and feeling of a rapidly moving event. *Sports Illustrated* and similar magazines contain many other examples.

All this concern for time and movement does not mean that space can be forgotten, for it cannot be separated from time. A moving figure needs space to move in. Framing that space *ahead* of the bicyclists, as Deanna Dawn has done, gives them someplace to

---

* Agfapan APX 25, Ilford Pan F, Kodak Ektar 25, or Kodachrome 25 films.

**14-8** *Deanna Dawn: Bicyclists, 1987. Panned photograph.*

**14-7** *Rich Haro: Whitewater Rafting, North Fork of the American River, 1986.*

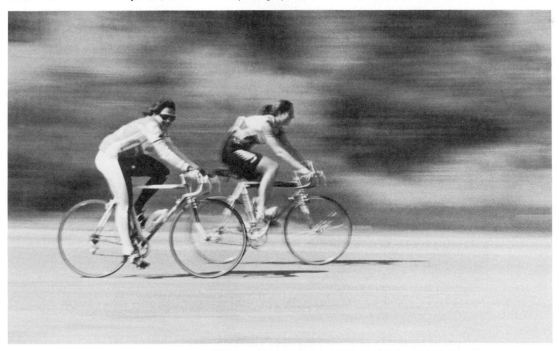

14-9 *James Garcia: Fast Break, 1983. From* The Daily Journal, *Fergus Falls, Minnesota.*

go, and gives us a chance to extend the action in our mind's eye. On the other hand, framing the space *behind* the moving object might suggest that it is moving away from something. Thus the way we include space around an object in motion can affect the meaning of our picture.

## Capturing the Moment

Because time and space are inseparable, the *moment of exposure* will affect the content and meaning of our picture as much as any other factor. Our timing, then, must be carefully chosen; we must anticipate when the image in our viewfinder will convey the most meaningful moment of the event in the most dynamic arrangement of space. This is what Henri Cartier-Bresson called the "decisive moment," and it is a mark of distinction that many contemporary photographers strive to attain in their work. Bruce Gilden's *New York City* has it (see Fig. 1–3); so does James Garcia's remarkable photograph of a fast break in a basketball game (Fig. 14-9).

Quite often, events captured in such photographs are almost completely beyond the control of the photographer. For the late Garry Winogrand, the act of photographing was an act of discovery, an attempt to "find out what things look like in their photographs." His was a craft of compulsive observation and intuitive selection, the opposite of a classic approach. A large element of luck contributed to many of his pictures (Fig. 14-10), which often managed to capture the essence of chaos.

14-10 *Garry Winogrand: Venice, California, c. 1982–83. Estate of Garry Winogrand.*

**14-11** *Niwat Pao-in: Refugee in Camp at Phanat Nikhom, Thailand, c. 1985. Courtesy Euphrat Gallery, De Anza College.*

## DOCUMENTARY PHOTOGRAPHY

During the last fifty years we have seen several major organized efforts to photograph the human condition. The massive project of the Farm Security Administration in the 1930s and '40s (see examples by Lange and Evans, Figs. 12-49 and 12-50) began the trend. *Life* and *Look*, the famous picture magazines, continued it through the fifties and sixties, and when they ceased publication (*Life* later reappeared as a monthly), numerous federal, state, and regional projects provided additional documentary opportunities.

Subsequent events of world history and our continuing examination of American life have produced some fine examples of documentary photography at home and abroad. Niwat Pao-in's photograph from a refugee camp at Phanat Nikhom, Thailand (Fig. 14-11) is a vivid reminder to many new Americans that getting here was not easy. Nor was it always so for others who were born here. Photographers such as Eugene Richards continue to remind us to look at ourselves and at the way many of us must live. His recent book, *Below the Line: Living Poor in America* is a searing testimonial to the grinding effect of poverty on American society (Fig. 14-12). Living poor is not living pretty. Moreover, as Richards discovered,

**14-12** © *Eugene Richards: from* Below the Line: Living Poor in America, *1986. Magnum Photos, Inc.*

many aspects of poverty are not visual. Tape-recorded comments of his subjects often revealed the debilitating effects of ill health on the poor more forcefully than his pictures did. With electronic media and its technology widely available, some of the best documentary work today records both words and pictures firsthand, and often uses the real-time medium of video, rather than still photography, for greater impact.

What, then, distinguishes documentary photographs from others made in the journalistic style? The documentary photographer is first of all *a realist with a point of view*. Whether that perspective is sympathetic or antagonistic depends not on what the camera can do but rather on the values and judgments of the photographer using it. The basic intelligence, education, perceptive and interpretive abilities of the mind behind the camera are what make the difference. A documentary photographer seeks understanding, not art; honesty, not objectivity. Most photographs look believable, but it takes an honest photographer to enhance them with the dignity of truth, and a dedicated one to give them a sense of purpose. To those of us who would photograph our fellow humans, this is a challenge and a responsibility of the highest order. .

## PHOTOJOURNALISM: THE PICTURE STORY

Perhaps no photographer has ever taken that responsibility more seriously than the late W. Eugene Smith, whose classic picture stories are among the finest *photographic essays* ever produced.* Essentially, a picture story or photographic essay is a *sequence of images developing a theme*. Rooted in the documentary work of the 1930s, the concept matured with the editorial direction of *Life* and *Look* magazines, which published many of its finest examples.

Sometimes the photographer's outline for an assignment is carefully researched and planned in advance. Known as a *shooting script*, it keeps the photographer close to the story line and thus helps both the photographer and the editor construct a series of *related* images. It also helps to insure adequate picture material for a cohesive unit with a beginning, a middle, and an end.

Other photographers prefer to work without such a script. Often choosing projects that they care deeply about themselves, they photograph as opportunities permit, assembling a more loosely organized web of pictures to tell the story. They often do their own editing.

In either case, actual shooting may involve hundreds of exposures. After processing to contact sheets, the pictures are *edited*—selected and cropped—to choose the most important images from the total, and to sequence them for effective presentation.

Most photojournalists, of course, are content to observe and report, but Eugene Smith was a notable exception who often became passionately involved in the stories he photographed. In 1975, after living for three years in Minimata, Japan, Smith (with the help of his wife, Eileen) completed his most famous essay. *Minimata* is the story of a city and its people poisoned by industrial waste. The mother and her dying child (Fig. 14-13), as critic Susan Sontag has noted, form a Pietà for pollution victims everywhere. Smith did not complete the story unscathed; the project nearly cost him his eyesight and his life.

Today the photographic essay is usually produced in *color* (see Plate 12), since virtually all large-circulation magazines are produced and printed that way. The *Smithsonian* magazine contains excellent examples in the *Life* and *Look* tradition, and *National Geographic Magazine*, which pioneered the use of color photography in the print media more than half a century ago, has published many others. Television, too, has successfully borrowed the essay format for programs like "Sixty Minutes" and "20/20."

Journalistic photography, of course, is published by other print media too. Travel and conservation magazines, corporate employee magazines (house organs), and many special-interest magazines use color photographs; greeting cards, posters, and popular music packaging represent additional markets often accessible to beginning photographers as well as established professionals.

## LAWS AND REGULATIONS

The enormous complexity and expense of the mass media, both printed and electronic, impose certain restrictions and responsibilities on anyone using them. Photographers and filmmakers must respect people's *right of privacy*, which is essentially the right to be left alone. If they expect to publish or broadcast their work, photographers and video cameramen must also be aware of laws pertaining to *libel*, and be familiar with government *regulation of the public airwaves* used by much television broadcasting. Occasionally they must chart a course between their own honest response to a controversial situation and what the regulated media will permit them to show. Magazine photographers, too, have long complained about editors who trim their stories to fit space controlled by advertising budgets. But advertising sales reflect readership, and readers generally choose magazines for their editorial content, not their ads. All who work with the mass media must understand this important relationship.

## ELECTRONIC TECHNOLOGY

Books, which take time to produce, are still convenient and durable packages for visual ideas. Recent improvements in the technology of printing, includ-

---

* "Country Doctor," *Life*, September 20, 1948; "Spanish Village," *Life*, April 9, 1951; and "Nurse Midwife," *Life*, December 3, 1951.

**14-13** *W. Eugene Smith: Tomoko in the Bath, from* Minimata, 1972. © *Estate of W. Eugene Smith. Black Star.*

ing electronically digitized, laser-scanned halftones for reproducing photographs, have made high-quality printing more accessible to publishers, and have sharply increased the number of opportunities for publishing color photography.

But some projects cannot wait. News, obviously, is always time-sensitive, and this is where electronic technology has an advantage over the traditional photographic and printing ones. Journalistic photography undoubtedly will continue to use more electronic technology and media. Television, of course, is in nearly every American home. The hybrid camera (Chapter 2) is already here, and news photographs, like "eyewitness" TV stories, can now be transmitted live via satellite from the event to its viewers and readers. However, the technical quality and visual resolution of a televised image cannot yet compare to that made with silver-halide photography. Each has its advantages, and neither is about to replace the other. Whatever mixture of media and technology the future brings, journalistic photography in its various forms is sure to be a vital part of it.

## SUMMARY

1. The journalistic approach to photography considers *context* as well as facts; it places a subject or event in *space* and *time*.

2. *Space* includes the arrangement of everything within it; *time* is a sequence of events, the continuum on which we measure all *change*. The camera's viewfinder frame, its shutter, and its aperture are all *selectors* with which we isolate space and time.

3. *Selective focus* can help us isolate foreground from background (or vice versa) and thus clarify a picture's message. *Large apertures* are required, and the camera must be close to its subject.

4. *Hyperfocal focusing* is useful to get the *maximum area of a picture sharp* from foreground to background. This technique makes all parts of the image equally clear, unifying its space. Small apertures are required, and the camera must focus on a point between the nearest and farthest distances shown.

5. *Central perspective*, produced by the camera's lens because of its single point of view, gives pictures an illusion of depth.

6. *Movement* attracts our attention to change. An object moving in space also changes the space around it, and it changes itself over a span of time. The camera's *shutter* can select a brief moment of time and thereby arrest or "freeze" movement.

7. Many shutters can also be set for longer exposures. *If the camera itself is moved* during this time to follow or track the movement, the moving object can be shown clearly against a blurred or streaked background. This technique is called *panning*.

8. *Documentary photographs* look realistic but also *express a particular point of view*. They try to help the viewer understand that point of view, and are not concerned with being "neutral" or artistic.

9. A *picture story* or *photographic essay* is a series of related pictures produced and sequenced to develop a theme or idea. Some photographers use a *shooting script* to develop the story; others produce projects that are often self-directed as opportunities arise. Typically, many pictures are taken and *edited* from contact sheets to select the most powerful and important images.

10. Photographers working for the *mass media* are occasionally constrained by the way advertising budgets limit *editorial space*, by *laws* pertaining to *libel* and *privacy*, and by *government regulation* of the media themselves. They must understand these matters in addition to the other aspects of their work.

11. *Electronic technology* has an advantage over photographic and print media for time-sensitive news pictures, but at present the image quality of the two systems is not yet comparable. Each has useful applications, but neither will soon replace the other.

# THE SYMBOLISTIC APPROACH

More often than not, we use photographs to take the place of the real objects and events they represent. Snapshots, for example, refresh our memories of people, places, and occasions; news photographs keep us informed about a rapidly changing world, and catalog illustrations make shopping easier. Whenever we use photographs this way, the pictures function as convenient windows to the real world. But while a photograph usually portrays a bit of the real world, it can simultaneously stand for something else that is not real or physical, such as an emotion or an idea. Thus while showing us an impression of an object or event, it can also represent a feeling about an altogether different experience. In other words, while a photograph *signifies* one thing, it can also *symbolize* another.

In the *symbolistic approach* we give a photograph this dual role. This approach communicates a visual impression of the real world like other approaches do, but what is more important, it *also transforms* that impression to convey another, quite different meaning. In this latter regard the photograph functions much as a catalyst does in chemistry: it makes possible a change of meaning without becoming changed itself in the process.

## THE PHOTOGRAPHIC METAPHOR

Most of us are familiar with a figure of speech called a *metaphor*. As a literary device we use it to speak of one thing as if it were another, unrelated thing: "Beauty is a witch," wrote Shakespeare, "against whose charms faith melteth into blood." Or, "all the world's a stage, and all the people

players on it." Words, of course, are one kind of symbol, and if they can be used in this manner, photographs—another kind of symbol—can too. The photographic metaphor may be less familiar, but it functions the same way as the verbal one does. It operates as if it were something else: the picture becomes a symbol of something unrelated to it.

Olivia Parker's photograph *World of Wonder* (Fig. 15-1) is full of interesting mechanical forms and details, but it probably holds little appeal to us as a factual record. Instead we are more likely attracted to it by the visual contrasts it contains, and by the combination of two- and three-dimensional objects placed in careful balance by the photographer's perceptive eye. The photograph speaks of things that are both durable and perishable, delicate and powerful; it symbolizes these and other qualities while showing us a bit of discarded reality. Although it seems to be saying several things at the same time, its emotional message—what it says about feelings—is more engaging for many viewers than what it tells us about the objects it portrays.

For all its symbolism, however, the photograph is still an image of real objects and their shadows. Whatever *else* it conveys must depend largely on what each of us who looks at the picture brings to that encounter. Perhaps the image will remind us of certain experiences in our own life. Whatever we find in the picture, of course, will condition our response to it, and just as different people see different things in an inkblot, each of us will probably sense different meanings in this photograph. The transformation occurs, then, not in the photograph but in the mind of each *viewer*, who thereby becomes

**209**

an essential element in equating the image with its symbolic message.

Perhaps we are more accustomed to looking for such symbolism elsewhere. Painters and sculptors, of course, have employed it since ancient times, and from the early twentieth century on they have been submerging detail and identity to reveal underlying truths through their work. More slowly, perhaps, photographers realized that they, too, could see beneath the surface. In nineteenth-century camera work, symbolic vision was rare: a few images attributed to Mathew Brady, such as the *Ruins of the Gallego Flour Mills in Richmond* (see Fig. 12-19), seem to possess this quality. In the early twentieth century, however, the symbolistic style gradually emerged.

### Alfred Stieglitz: Equivalence

Alfred Stieglitz was possibly the first photographer to realize the power of this metaphoric approach. In 1907, on a voyage to Europe, he looked down from the steamship's upper deck and noticed the steerage, where passengers paying the lowest fare were herded together like cattle. In the interplay of shapes between the funnel and stairway, straw hat and winch, mast and suspenders, Stieglitz sensed a picture full of emotion. "I stood spellbound for a while, looking and looking," he recalled many years later. "I saw . . . a picture of shapes and underlying that the feeling I had about life." Rushing back to his stateroom for his camera, he returned to find all as he had left it, and exposed his plate.

*The Steerage* (Fig. 15-2) is one of the great humanistic statements in photography, a powerful reminder of the immigrant experience in that era of American history. Can anyone looking at this picture today not be reminded of all "boat people," enduring hardships and risking their lives to escape to a better life? Ironically, however, the Stieglitz photograph does not show immigrants coming to America but

15-2 *Alfred Stieglitz: The Steerage, (1907), from* Camera Work, *No. 36, 1911. Photogravure (artist's proof), 7¾ x 6½ in. The Museum of Modern Art, New York. Gift of Alfred Stieglitz.*

disillusioned settlers returning home. For these people the American dream did not work, and they are shown returning to their European homeland by the only means they can afford. Although *The Steerage* symbolizes one idea, it actually shows another; it portrays one experience while it represents the opposite.

Later, Stieglitz photographed clouds to see if he could express his feelings through them. He called these cloud photographs *equivalents*. Through their shapes and forms he tried to convey his feelings, and when others who had not shared his original experiences were able to get a similar feeling from those photographs, Stieglitz knew he had succeeded.

Since then, of course, many other photographers have rediscovered that if we can respond as *photographers* to the objects and experiences we bring before our camera, and transform what they mean to us through equivalency, then we can also respond as *viewers* to a photograph and transform its meaning

in the same way. Moreover, almost anything we find can be used to make a photographic metaphor. If it suggests an idea otherwise unrelated to what it actually shows, then the transformation is possible.

Richard Stevens in some of his photographs experiments with metaphor. He photographs small objects arranged on folded paper to explore how such pictures might generate ideas and feelings (Fig. 15-3). Stevens chooses objects for what they suggest to him. "I was concerned with exploring how certain arrangements of object, light, shadow, tone, and texture initiated responses akin to those engendered by the stone, space, and light in old stone monuments and cathedrals," he recently noted. He has experimented with art papers from all over the world. "I found paper to be a fresh, exciting material," he remarked, "pliant to the hand and richly suggestive to the mind."

Stevens's photograph functions like a metaphor, but at the same time it appears to be classic in style. This is not unusual. Photographs made with one ap-

**15-3** *Richard Stevens: [untitled], 1985.*

proach or style in mind often have characteristics of another. Like those in other arts, styles or approaches in photography are not mutually exclusive: they can and often do overlap.

Minor White, who pursued the equivalence idea for many years after Stieglitz died, recognized this phenomenon another way. White suggested in his writing and teaching that there are many levels or degrees of equivalence through which photographic images can involve us. Carl Chiarenza's images often seem to operate this way. Through its tones, shapes, and textures, his photograph in Figure 15-4 (one-third of a triptych) may suggest to some people ideas or experiences that are completely unrelated to the picture's actual subject matter. Chiarenza calls his three-part image a *noumenon*, which is something understood intuitively or perceived in the mind, without the aid of the senses. It is thus the opposite of a *phenomenon*, which is observed or otherwise sensed. As Chiarenza puts it, "I want my pictures to attest to how little we know and how much we feel." Others, however, may simply appreciate his photograph as an elegant and beautiful image, and that is sufficient reason for its existence.

Photographs like the foregoing examples by Parker, Stevens, and Chiarenza point out another value of the *equivalent* or *metaphor* to the creative photographer: its power to evoke a response about something that *cannot* be photographed through other things that *can*.

Jerry N. Uelsmann (who is discussed in the next chapter) has long pursued this idea. Over the years, Uelsmann has assembled a large library of symbolic images. Selecting from this visual storehouse, he com-

**15-4** © *Carl Chiarenza: Noumenon 247 (from a triptych), 1984–85.*

bines his choices to construct a world of fantasy all his own. His photographs (such as Figure 16-1) often bring together the natural and unnatural in interesting ways. Uelsmann uses photography's foundation of realism to intensify our involvement with his fantastic world. Even if we feel like strangers in his world, we cannot ignore it.

## THE PHOTOGRAPH AS A MIRROR

Whenever we identify with a picture and feel our way into it, we transfer a bit of our own personality to it. We might say, then, that a photograph functioning as an equivalent or metaphor acts to some degree like a *mirror* in which we see ourselves. We're likely to sense this in any picture with which we can easily get involved, and identifiable elements usually help. Test this idea yourself with photographs in this book, especially those that show familiar locations or that show people in familiar roles.

If a photograph can act as a mirror for its viewer, it can also convey the personal thoughts of the photographer who made it. Such self-examination characterizes much contemporary work, and it ranges from obvious symbolism to deeply personal imagery that may have meaning only to the photographers themselves. Better photographs of this type, however, transcend such individual concerns to communicate their symbolic content to a larger audience. Marsha Adams, for example, expresses a strong feminist idea in her photograph, "Just Ice" (Fig. 15-5). The inhospitable setting for this drama intensifies the thrust of her message.

Susan Friedman also uses a personal symbolistic approach in her photograph from a series titled "Women Carrying Clouds" (Fig. 15-6). Here the photographer functions as a director. Her dramatic moment raises many questions: Where is the scene laid? What is the occasion? Why are these women dressed this way? The photograph invites us to provide our own answers as we probe for meanings and associations.

**15-5** *Marsha Red Adams: Just Ice/Joshua Tree National Monument, 1986.*

**15-6** *Susan Friedman: [untitled]. From a series "Women Carrying Clouds," 1985.*

## CONCEPTUAL PHOTOGRAPHY

Although most photographers use the camera to record or interpret the real world, some use it to convey ideas without such references to actual objects or events. Paralleling conceptual movements in other art media, *conceptual photography* appeared in the late '60s and early '70s as an outgrowth of the photographic metaphor.

In the usual metaphoric photograph the *content* of the picture contains the symbolism: it shows one thing, as we have seen, but stands for another. In conceptual work, the photograph itself generally is less important than the idea behind it. It usually *suggests* the underlying idea or thought, rather than illustrating it, and in accordance with its minimized role, the print may appear rough or unfinished, the opposite of one made in the classic style (Chapter 13).

Zeke Berman's training as a sculptor is evident in his conceptual use of photography (Fig. 15-7). Like many other photographers today, he is concerned with three-dimensional ideas that are articulated within the two-dimensional frame of the photograph.

Berman connects dark forms with delicate light ones in such a way that our assumptions about his physical world are immediately challenged.

Looking at photographs like these, and trying to engage the photographers' ideas associated with them, may well expand our own perceptive and communicative skills. It may also help to break down the mental and emotional separation that often occurs between us and the photographs we make, and that should help us to become more involved with our images. Increasingly sensitive and expressive photographs should result.

What ultimately separates an expressive photograph from a mere record, then, is what also makes a sensitive musical performance different from a mechanical reading of the score. It's the same thing that makes literature stand apart from mere writing, and makes poetry a special form of both. There may be no single word that adequately describes this essential difference, but one that Alfred Stieglitz liked to use certainly comes close: *spirit.*

Whatever we choose to call it, spirit is the moving force behind the symbolistic approach, and it clearly nourishes the ideas which allow photographs, like other symbols, to be used in ways that expand our thinking and our visual experience.

**15-7** *Zeke Berman: [untitled], 1984. Photograph courtesy Liberman & Saul Gallery, New York.*

## SUMMARY

1.  While a photograph shows a bit of the real world, it can also stand for something else that is not related to what it actually shows. Thus it can function like a *metaphor* in literature, signifying one thing but symbolizing another.

2.  Every photograph is a *picture of* something. Whatever else it conveys or suggests to a viewer depends, in part, on what experiences the viewer brings to the photograph. The transformation of meaning occurs not in the photograph but in the mind of the viewer.

3.  Alfred Stieglitz was among the first to realize that photographs could do this. *The Steerage*, which he made

in 1907, is a famous example. Stieglitz also photographed clouds to convey his feelings. He called those photographs *equivalents*.

4.  Whenever we get involved with a metaphoric image, it becomes a kind of *mirror* in which we can see ourselves.

5.  Creative photographers often use the photographic metaphor to express ideas about things that *cannot* be photographed through other things that *can*.

6.  *Conceptual photographs*, like similar work in other arts, try to emphasize *ideas* that lie behind their making rather than stressing the works themselves. The actual photographs thus become less important than the ideas they convey.

7.  Some photographs appear to function as metaphors while others do not. What seems to separate the two kinds of images is an intangible quality called *spirit*.

# 16

# AWAY FROM REALISM

**16-1** *Jerry N. Uelsmann: [untitled], 1987.*

In the three preceding chapters we discussed several attitudes about making photographs that have become important to contemporary work. All involve selecting subject matter based on a realistic view of the world, visualizing it in a personal way, and presenting the photograph as a conventional color print or a silver-bromide black-and-white image. In recent years, however, many photographers have moved away from realistic representation to produce images that look different from traditional photographs. Although their pictures are made by the action of light on a light-sensitive surface, they often bear little resemblance to the majority of photographs that are familiar to us.

## PHOTOMONTAGES AND MULTIPLE EXPOSURES

Some photographers *combine separate negative and positive images* to produce new and imaginative visual statements. Most modern cameras do not permit multiple exposures to be made easily and directly, so photographers usually make separate images in the camera and combine them later in the darkroom, a technique known generally as *photomontage.*

The most celebrated contemporary photographer who works in this manner is Jerry N. Uelsmann. While acknowledging that most photographs are visualized before exposure and produced by a standard technique, Uelsmann views the darkroom as a "visual research lab, a place for discovery, observation, and meditation." He terms his method *post-visualization*, insisting that the photographer remain free to revisualize the image at any point along the way to its completion. This way of making photographs combines the ana-

lytic methods of conventional photography with the synthetic ones of painting and drawing: images made initially by selective elimination through the camera are then revisualized and combined through an elaborate printing procedure. Several enlargers may be used, with each negative set up separately and masked or shaded so that only desired areas print.

In Figure 16-1 we can see how Uelsmann works. The sun breaking through the clouds is one image; the cupped hands holding the shell, another. The tiny female figure is a third; its shadow a fourth. These four images were then combined into a single picture by artful masking and multiple printing. Uelsmann's basic technique was demonstrated by Oscar Rejlander (Fig. 12-39) and H. P. Robinson (Fig. 12-40) in England more than a century ago, but Uelsmann has refined it using modern equipment and materials with consummate skill.

The freedom to construct such multiple images has appealed to many other photographers. Shirley Fisher uses the photomontage technique to produce what she calls "inner landscapes," unique blends of fantasy and reality (Fig. 16-2). Here she has created images of an aura and a sky, and combined them with a view of Stonehenge.

Another way to produce multiple images, which many older cameras will permit, is to make a series of successive exposures on the same frame of film. This technique, too, is an old one, demonstrated by Thomas Eakins over a century ago (Fig. 12-35). *If your camera allows you to recock the shutter without advancing the film,* you can make several successive exposures of light-colored objects against a dark background on the same frame of film. If the images overlap each other very little, a full, normal exposure can be

given each one. If much overlapping occurs, however, try giving each image about half or a third of its normal exposure, and if the resulting black-and-white negative is too low in contrast, repeat the process but develop the film about 50 percent longer than before. The procedure is less predictable with color film, and in either case a bit of experimenting will be needed.

## HIGH CONTRAST IMAGES

Alternatives to conventional photography need not be complex. One of the simplest is the high contrast image, sometimes called a *dropout* because gray tones are dropped out or eliminated, leaving only black and

**16-2** *Shirley Fisher: Stonehenge, 1983.*

white. J. Seeley's photograph (Fig. 16-3) appears complex but is actually a simple contact print with only two tones, white and black.

Special films, obtainable from many photographic dealers, can be used to create this effect. For 35mm and rollfilm cameras, Kodak Technical Pan Film is obtainable in familiar 36-exposure cartridges, in long rolls (which must be cut and loaded into reusable casettes in a darkroom), and in 120 rolls. This film is panchromatic—sensitive to all colors of light—and must be loaded into its developing tank, like other pan films, in total darkness. Its ISO (ASA) rating is 50/18° for high contrast, or 100/21° for very high contrast results. It should be processed according to the instructions supplied with it; Kodak HC-110 developer is recommended.

Another type of film useful for high-contrast images is known as *Kodalith film* (see box).

---

## USING KODALITH AND SIMILAR HIGH-CONTRAST FILMS

The trademark *Kodalith* designates a family of special films that yield extremely high-contrast images. Although intended primarily for reprographic and photomechanical work for the printing trade, several of these graphic arts films are useful in general photography when images of extreme contrast are desired.

Kodalith Ortho Film 6556, Type 3, is the 35mm product, available in 100 ft rolls for darkroom reloading into reusable casettes; Kodalith Ortho Film 2556, Type 3, is an identical film that comes in 4 × 5, 8 × 10, and larger sheets. Kodak Ektagraphic HC Slide Film is the same as Kodalith, and is available in 36-exposure 35mm cartridges. A few similar products are made by other manufacturers.*

The films mentioned above are *orthochromatic* and can be handled under a *red* safelight such as a Kodak 1A.† *In such illumination the emulsion side appears lighter than the base.*

**Exposure in the Camera.** These films can be used in a camera like any others, but they are rather slow and sensitive only to blue and green light. In daylight, try an ISO (ASA) rating of 5 or 6, and bracket your exposures in half-stops.

**Exposure in the Darkroom.** Regular rollfilm and 35mm negatives can be printed on Kodalith Ortho and similar films using a contact proofing frame and the enlarger as a light source. Set up the enlarger exactly as you would for making contact sheets (pp. 97–98) but use no printing filter, only white light. With the lens stopped down about halfway, make a series of test exposures of 1, 2, 4, and 8 seconds by the familiar test-print method.

**Processing.** Any of several Kodalith developers will produce excellent results when used as directed on their packages. *These developers must be prepared as two separate solutions: parts A and B must be stored separately* because they deteriorate in a few hours when combined. When you are ready to develop, follow either procedure below.

### PROCEDURE FOR FULL-LENGTH ROLLS

1 / Develop full-length rolls like regular film in a small tank. Mix together equal amounts of parts A and B to make enough developer to fill the tank. Use the solution at 20°C (68°F).

2 / Agitate continuously for the first 30 seconds, and intermittently thereafter. Develop for about **3 minutes.**

3 / Rinse the film in a stop bath (like you used for printing) for 10 seconds, and fix it in any film fixer for 2 minutes.

4 / Open the tank and wash the film in running water for 5 to 10 minutes. Then bathe it in Photo-Flo for 30 seconds and hang it up to dry.

### PROCEDURE FOR SHEET FILMS OR SHORT STRIPS OF 35MM

1 / Sheet films or short strips of 35mm film may be processed in trays like photographic paper. Fill the first tray with Kodalith developer (combined A and B) about one-half inch deep. A second tray should contain a stop bath like you make for print processing, while a third tray is needed for a similar quantity of any film fixer.

2 / Slide the exposed film into the developer **face up,** then lift it and tap its edge sharply against the tray to dislodge any bubbles of air that may be clinging to it.

3 / From this point on, agitate the film constantly by rocking the tray side to side, then front to rear. Handle the film as little as possible until development is completed. The exact time depends on the type of developer used, but will usually be about 3 minutes.

4 / Stop development and fix the film as you would a paper print. Lithographic films fix quickly; twice the time required to clear the unexposed emulsion is sufficient.

5 / Wash the film for 5 to 10 minutes in running water (a tray siphon is convenient), bathe it in Photo-Flo, and hang it up to dry.

---

* Polaroid Type 51 material can also be used for high-contrast images (see Appendix A).

† Kodalith Pan Film is panchromatic and requires total darkness.

**Evaluation.** A correctly exposed Kodalith or similar film image—negative or positive—will look different from an ordinary negative or print. Hold your litho film image up to the light and look for these points:

1 / *Black areas should be even-toned and so dense that virtually no light gets through them. Weak gray tones indicate too little exposure; streaks signal uneven development.*

2 / *Blacks should be free from pinholes. These are caused by dust particles and are most numerous in underexposed images.*

3 / *Clear areas should be clean-edged; any veiling indicates too much exposure.*

4 / *Examine the width of any lines in the image. If black lines are too thick and clear lines are broken or poorly defined, the image is overexposed. If thin clear lines appear too wide, and thin black lines are broken, the image is underexposed.*

5 / *The shape of small image areas should look correct. Clear areas that are too large indicate underexposure; black areas that seem "puffy" indicate overexposure.*

This evaluation checklist may be helpful because *exposure of lithographic film is rather critical*: once its threshold point is crossed, small increases in exposure rapidly make the image darker. If you exposed the film in the darkroom, make a note of the enlarger setting, f/ stop, and time that give the best results.

Small negatives (35mm) may be enlarged onto litho film instead of being printed by contact. Either way, of course, litho-film images printed from ordinary camera negatives will be high-contrast *positives*. If a high-contrast negative is needed, simply transfer the image again by the same process, exposing a new piece of litho film through the positive you just made. Wait until the first film has dried (don't try to print from it wet), and keep the two emulsions face to face for sharp results. The final negative can always be placed in the enlarger upside down to give a correctly reading image.

**Opaquing.** Most litho film images will contain tiny pinholes in solid black areas, and these may be removed by painting them with photographic *opaque*. This is a thick, watercolor paint available in red or black (the red is easier to see when you use it). Apply the opaque to the emulsion with a sable brush. When touched up, the negative may be printed like any other.

**16-3**  *J. Seeley: Teggo Sheggo 2, 1987.*

## TONE-LINE OR SPIN-OUT IMAGES

An extension of the high-contrast treatment described in the box is the *tone-line* or *spin-out process*, which converts any major *difference* in image tone, such as a line in a picture where dark and light areas meet, to a thin black line on a white ground. Any sharp negative can be used, but one with a strong graphic arrangement of light and dark areas will usually yield a more successful result (Fig. 16-4). The procedure is outlined on page 222.

## NEGATIVE IMAGES AND PHOTOGRAMS

Almost all photographic processes use a reversal of values: exposure darkens the sensitive material, and processing produces a negative. Furthermore, we almost always regard the negative as a step toward another image, a positive. This is practical for most uses of photography, but there are applications where the negative image is just as convenient as a positive one. Information stored on microfilm is usually kept as a negative image, and X-ray films are negative images too. And as anyone who uses a computer knows, any visual image that can be created, stored, or transmitted electronically can easily be flipped between negative and positive states.

Negative images, of course, are as old as photography itself. The English pioneer William Henry Fox Talbot reproduced plant specimens and lace as negative images in 1835, later calling them "photogenic drawings." Almost a century later, the Hungarian artist László Moholy-Nagy and the American Man Ray also pursued the cameraless technique. Since then many others have tried it. Moholy-Nagy named his pictures *photograms*, and the term generally has been used ever since to describe similar photographic images made without a camera.

**16-4** *Simone Poff: Untitled tone-line photograph, 1988.*

## HOW TO MAKE TONE-LINE OR SPIN-OUT IMAGES

Two litho film images, one positive, one negative, must be made from the original photograph (Fig. 16-5A). If the original negative is smaller than 4 × 5 in., the first litho image (a positive) should be enlarged to that size, since it is very difficult to control the line formation with smaller images. Best results are obtained if the litho film image is made as large as the final print, but any size from 4 × 5 in. up will usually give satisfactory results. Use the method described in the preceding box. The second lithographic image (a negative) can then be contact printed from the first. It is essential that both litho images be **exactly the same size.**

1 / *Tape either image to the underside of a contact proofing frame glass so that **its emulsion is against the glass.** Thin, transparent tape (the "magic" variety) works best. Take care to work as dust-free as possible.*

2 / *Next, tape the other litho image over the first so that the two are **back to back** and **exactly aligned in register** (a light table will make this step easier). Use care to get all parts of the image perfectly aligned, or uneven line formation will result. The emulsion of this second litho image must **face away from** the first one.*

3 / *Properly assembled, the sandwich will look uniformly dark when viewed by light coming through it, since each litho image masks out the clear areas of the other. However, this sandwich will permit a thin band of light to pass through it along the tone edges of the two images, but only if that light strikes it at an oblique angle. Perpendicular rays, as you can easily see, are virtually blocked.*

4 / *Since the tone edges in the image lie in all directions on the picture plane, the exposing light must strike the sandwich from all sides, but always at an oblique angle to the film itself. The easiest way to do this is to place the printing frame on a turntable in the darkroom. A phonograph set for 33⅓ rpm works well, or a kitchen turntable or "lazy susan" may be used. The exposing light can be a bare bulb in the ceiling. It must be situated at about a 45° angle from the turntable (Fig. 16-5B).*

5 / *Turn off any white lights. Use a red safelight for the next three steps. Working under the safelight, place a sheet of unexposed litho film in the contact frame so that its emulsion **faces** the sandwich taped there. Close the frame.*

6 / *Start the frame spinning and expose the film for several seconds. A few trials may be necessary to establish the correct time, but **it must be at least one complete revolution of the frame.***

7 / *Process the exposed film by the usual method for Kodalith described in the previous box.*

8 / *Thin, weak lines mean a longer exposure is needed, but if thick, bleeding lines result, shorten the exposure time or use a weaker light bulb.*

You can reverse the tones of the resulting image by contacting it again on litho film. This will yield a negative that will produce dark lines on a white ground in the print (Fig. 16-5C). The final image may resemble a detailed ink drawing, but it is thoroughly photographic and can be directly combined with other photographic images.

The process is simple and purely photographic; it requires nothing more than light and photographic paper, with various objects or materials that will absorb some of the light placed between them. Anything will do: the range of creative possibilities is almost limitless.

Robert Heinecken, whose work and teaching have influenced a whole generation of younger photographers, has used negative images made in a camera (Fig. 16-6) to counteract the factual authority of positive ones. Like many photographers, Heinecken finds them a useful antidote to the gospel of realism. Moreover, he refuses to take seriously any definition of photography that erects limitations on the medium, preferring instead an open-ended rationale and the greater freedom for continuous exploration and discovery that it gives him.

## SOLARIZED IMAGES

*Solarized prints*, as they are popularly but incorrectly called, appear to have a combination of negative and positive tones.* This effect, discovered in 1860 by Armand Sabattier, is caused by interrupting the development of an image with a brief exposure to raw light, and then continuing development of the image until the desired effect is obtained. Adjacent highlights and shadow areas in such images are often

---

* The correct name for the effect described in this section is the *Sabattier effect*. Solarization, on the other hand, correctly names a partial reversal of highlight values that can occur after processing in a negative that was given a single, massive overexposure. The two effects are not similar.

**A**

**16-5** *Tone-line or spin-out technique.*
*A: High-contrast source image.*
*B: Setup for exposure.*
*C: Tone-line variation.*

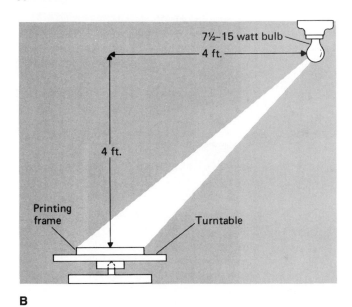

7½–15 watt bulb

4 ft.

4 ft.

Printing
frame

Turntable

**B**

**C**

**16-6** *Robert Heinecken: Erogenous Zone System Exercise, 1972.*

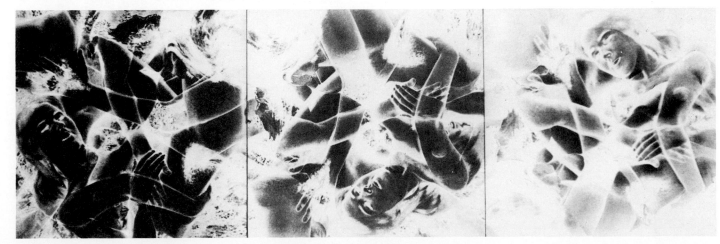

## HOW TO MAKE SABATTIER (SOLARIZED) PRINTS

1 / *Prepare two trays of print developer. Dilute the stock solution 1:2 (or your usual way) for the first tray, and 1:10 (or a similar ratio) for the second. You'll also need a tray of water, of stop bath, and of fixer.*

2 / *Begin with a moderate-to-high contrast negative, and a high-contrast **graded** paper (No. 4, 5, or 6). Make a trial print in the usual way to produce a series of exposures in strips.*

3 / *Develop this print in the regular developer, but rinse the print in **water** after development. Do not use an acid stop bath. Carefully squeegee or blot the excess water off the print surface.*

4 / *Remove the negative from the enlarger and **stop down the lens two or three stops** from its former setting. Now expose the same test print to raw enlarger light for a few seconds, in a test pattern **uncovered at right angles** to the original exposure pattern. The best exposure times will tend to be shorter than those used for the initial exposure pattern.*

5 / *Now develop the print again **in the diluted developer** and watch the print closely. When the result seen in the tray is acceptable, stop development, this time with an acid stop bath.*

6 / *Fix, wash, and dry the print in the usual way for the type of paper used.*

separated by thin, light-colored lines called *Mackie lines*, which add to the distinctive effect. Either negative or positive images can be used as a starting point, and the technique works well with color print materials as well as black-and-white. Jim Millett's photograph (Fig. 16-7) illustrates the general effect.

A Sabattier effect is determined by four variables:

1. The initial exposure to a negative or positive, as with any other print.
2. How long this first exposure is developed.
3. The time, intensity, and color of the raw light exposure.
4. The conditions of the second development (time, formula, etc.).

The procedure outlined in the box above provides

**16-7** *Jim Millett: Cimetière Montmartre, 1977.*

a starting point for further experimenting with black-and-white materials. It can be expanded or adapted as desired.

Many variations of the Sabattier procedure given in the box are possible. Different developers may be used for each immersion; subtle changes in color tones (warm to cool black) can thus be produced on some black-and-white papers. Some workers, for example, use exhausted developer for the second development. By keeping careful notes of your procedure with each of the four variable steps, you can quickly determine useful ranges for each. More detailed information on solarizing prints can be found in Jim Stone's excellent guide, *Darkroom Dynamics* (see bibliography, under Technical Manuals).

## NON-SILVER PROCESSES

Most non-silver processes have two characteristics in common. First, *they do not use conventional silver-bromide printing papers or dye-coupler printing materials* for their end products. Second, because the materials they do require have much less light-sensitivity than conventional ones, almost all of these processes start from *negatives or positives as large as the finished work.* They are basically contact-printing processes rather than enlarging ones.

Some of these processes have been handed down to us from the latter days of the nineteenth century, when many photographers began to experiment with alternatives to albumen and silver-chloride papers. Few such historic processes and materials have remained commercially useful, but some have again become popular with contemporary artists. In addition, new processes based on old principles adapted to modern materials have been introduced, and in recent years, electronically generated, stored, and altered images have been introduced to photography through some of these methods. Today's photographic artists have a richer choice.

Non-silver processes offer several advantages to the artist-photographer. Color may be freely introduced, for example, without getting involved in the complex chemistry and exacting materials of modern color photography. Prints carefully made on good materials by some non-silver processes usually are more permanent and less fragile than conventional photographs, and photographic images may even be transferred to and duplicated on surfaces that were not originally sensitive to light.

It is not our intention here to provide detailed, step-by-step instructions for making prints by these processes. Sources for such information are listed in the bibliography. Our purpose instead is to point out that the familiar silver-bromide print is not only a final state of modern photographic images, but also a bridge to several other forms of them.

Most of these processes, as we noted, require negative or positive images as large as the final print, and these are easy to make by conventional means. Three simple procedures for making such images are given in the box below.

---

### HOW TO MAKE ENLARGED NEGATIVES AND POSITIVES

#### KODALITH DIAPOSITIVES

Kodalith ortho film, described earlier in this chapter, can be used to get an *enlarged positive* image, from which a negative can then be made by contact printing. Litho-film diapositives and negatives made from them will have high contrast, and this method is therefore useful to enlarge small, original negatives of low contrast. Refer to the box "Using Kodalith and Similar High-Contrast Films," p. 219, for working procedures. In this application, however, try developing both the enlarged positive and its contact-printed negative in Dektol diluted 1:8 (one part stock solution to eight parts water) for about 60 to 90 seconds. The dilution ratio can be varied somewhat; more dilution will produce lower image contrast.

#### PAPER DIAPOSITIVES

Single weight, fiber-base paper prints can be used to make intermediate negatives by contact on a sheet of Kodalith or similar film. Some brands of paper have the manufacturer's name lightly printed on the back, and these should be avoided, but other brands of smooth, glossy paper are useful. This procedure offers a somewhat less expensive route to large Kodalith negatives, since size for size, paper is cheaper than film.

#### PAPER NEGATIVES

Paper prints (positives) may also be used to make paper negatives by contact. To insure good image definition, uniform contact is very important, and this is easily obtained if both sheets of paper are wet. Here's the procedure:

1 / *In the darkroom, under a safelight, soak the positive print and a sheet of* **unexposed, single weight enlarging paper in water until they are limp.**

2 / *Drain them and press them together with a roller in a clean, flat-bottomed tray so that they are emulsion to emulsion* **with the positive print on top.** *Use care to roll as much moisture as possible out from between them.*

3 / *Expose this damp sandwich under the enlarger to white light as you would a contact print. A larger aperture may be necessary. If your enlarger has a wooden baseboard, protect it from getting wet by covering it with plastic wrap or several layers of newspaper.*

4 / *Separate the two prints and process the undeveloped one.*

Once you have converted your image to an enlarged negative or positive state, any of several non-silver processes may be used to print it. Let's look at some of them.

### Iron Processes

In 1842 Sir John Herschel discovered that certain organic iron salts are reduced when exposed to light, and from his investigations came the *cyanotype*, the familiar blueprint known to engineers and construction people everywhere. Blueprint paper contains a coating of ferric ammonium citrate and potassium ferricyanide; exposing it to ultraviolet light forms a weak, blue-green image that turns bright blue when rinsed with water and dried. Because the water washes away the unexposed iron salts, no fixing is required.

Other printing processes are also based on this principle. *Platinum printing*, which binds a platinum salt to an iron one, gives rich, long-scale prints that often have an uncanny sensation of depth. They are expensive to make, but are among the most permanent prints obtainable. Turn-of-the-century photographers such as Frederick H. Evans and P. H. Emerson used the platinum process (Fig. 12-41). Among today's workers, George A. Tice has produced beautiful prints by this method. It is impossible, however, to repro-duce the subtleties of a fine platinum print with an ink-on-paper reproduction process; you simply have to see the original print to appreciate it.

CAUTION: Some of the chemicals used for coating and developing platinum paper are highly toxic and potentially explosive if mishandled. Proper safety precautions need to be taken when working with them.

*Vandyke brown prints* are made by a process similar to cyanotype and platinum, but with different sensitizing and developing chemicals. CAUTION: Some developers may contain potassium dichromate to control contrast; this highly toxic chemical is a suspected carcinogen and must be handled with extreme care.

### Gum Bichromate

Gum bichromate is a non-silver process that uses a colloid, *gum arabic*, which is made light-sensitive by *ammonium dichromate*. The gum carries a *pigment* (watercolor, poster paint, or tempera) and it can be manipulated to produce various color combinations. The attraction of gum printing for many workers lies in its capacity to add areas of subtle color and texture to a monochromatic print. Diane Cassidy's photograph (Fig. 16-8) shows these characteristic effects.

**16-8** *Diane Cassidy: My Dad, 1981.*

Light hardens the sensitized gum arabic, making it less soluble; unexposed areas are then carefully removed with water, leaving the harder image on the support. A print may be recoated and locally reprinted in a different color several times, adding creative opportunities to the process.

Both the gum emulsion and the paper or cloth on which it is coated must be prepared by the photographer. CAUTION: The sensitizers used, ammonium dichromate or potassium dichromate, are highly irritating to the skin and toxic if inhaled; they are also suspected carcinogens. Rubber gloves, eye protection, and proper ventilation of the workspace are necessary.

Patented in 1858, gum printing first became popular around the turn of the century. Like the iron processes, it requires a negative large enough to make a contact print.

## Kwik-Print

The Kwik-Print is a modern contact process for making colored prints on white polyester or vinyl plastic sheets, or on certain fabrics to which sizing is first applied. Fourteen colors are available in liquid form for coating the various materials, and they can be applied by brushing, wiping, or airbrush. When this coating dries, it becomes sensitive to ultraviolet light. It is then printed from a large negative like gum bichromate, which renders the exposed areas insoluble. The print is washed in water to remove the unexposed, still soluble color; then the sheet is dried.

Single colors can be used, or combinations can be successively built up to form the image. The procedure must be repeated on the same sheet for each color desired. The colors can be *registered*, that is, carefully positioned with respect to each other, so that combinations of colors and tones can be constructed. Line, halftone (see below), or continuous-tone negatives may be used; a good deal of image manipulation is thereby possible.

Procedures for Kwik-Print are relatively simple, and inexpensive starter kits containing all required materials are available. Hazards of Kwik-Print are similar to those of gum bichromate; brushing or wiping the sensitizer onto the material is safer than airbrushing, since the latter procedure can create toxic vapor in the air.

Complete instructions for this and other non-silver processes are included in *Breaking the Rules* by Bea Nettles and in the *Handbook of Alternative Photographic Processes* by Jan Arnow (see bibliography, under Technical Manuals).

## Photo Screen Printing

The photo screen printing process is well suited to making large prints with bold colors. The final image is in *ink* and can be printed on almost any surface to which it will stick; T-shirts, glass bottles, wood, metal, and plastic objects (as well as paper)

have been used. No light-sensitive materials are required in the final stage.

Photographic screen prints require a *positive image* as a starting point, and as with other methods described here, it must be as large as the final print. Any photograph that can be reduced to a black-and-white, high contrast image by the previously described litho film method may be printed by the screen process. However, if the photograph contains important gray tones, these must first be converted to black through a halftone process.

*Halftone.* The halftone is an image produced by conversion of gray tones to a pattern of *tiny dots* that vary in size but are uniform in tone. In a halftone litho film, for example, all dots are solid black, but their varied size permits different amounts of clear space between them, allowing the eye to blend the two values into shades of gray (Fig. 16-9). Examine any reproduced photograph in this book through an 8X magnifier and you'll see the pattern of halftone dots. Halftone conversion is not difficult with modern materials. For screen printing, original photographs on sharp, 35mm negatives can be directly used as source material because they can be enlarged in this preliminary operation.

Here is how photo screen printing works. A film positive is used to expose a negative gelatin image on a temporary plastic support called *screen-process film*. This material is available either unsensitized or presensitized and ready for use, but the two types must be exposed and developed in different ways (the presensitized material is safer to use since it does not need dichromate sensitizing). With either type, the negative image on the screen-process film is then imbedded in a fine, screen-like material (traditionally silk but now more commonly nylon, polyester, or

**16-9** *Detail of halftone image.*

**16-10** *Sheila Pinkel: Nuclear Vision, 1984. Copy machine print with charcoal.*

other material) that has been stretched over a wood frame. Then the temporary support is stripped away after softening it with a solvent, leaving a negative image in gelatin on the screen.

Ink made specially for this process is placed above the screen within the frame. Finally, the paper or other material on which the image is to be printed is placed under the frame and the ink forced through the screen mesh with a squeegee. The open areas, of course, are located where there is no gelatin, and thus a positive final image is obtained.

Screen inks come in brilliant and even fluorescent colors, and since no special preparation of the paper (or other final material) is necessary, a large edition of identical prints can be produced. The major hazard of this process lies in the solvents used for stripping; skin contact and breathing the fumes must be avoided.

### Other Non-silver Processes

*Photolithography.* This is another important ink-on-paper process. In its offset form it accounts for most of the printed material we use today, including this book. Direct photolithography, however, is more feasible for the artist-printmaker since it does not require elaborate printing equipment. The direct process reproduces a somewhat shortened tone scale with an ink-like image quality; halftone negatives (see previous section) help retain more tones but sacrifice fine detail.

A flat, metal plate is sensitized with a commercial *resist*, and the image contact-printed onto it from a high-contrast negative. Prepared for printing, the plate is essentially a flat surface composed of printing areas that accept ink but repel water, and non-printing areas that retain water but repel ink.

The prepared plate is positioned on a press, wet, and then inked. Paper is placed in contact with the inked plate, and both are drawn together under a pressure roller that insures even contact between them. In this manner the ink is transferred directly to the paper. Many colors of ink and paper may be used, and the process is well suited to editions of moderate quantity.

*Electrostatic Systems.* These systems depend on the fact that light will increase the electrical conductivity of non-crystalline selenium or zinc oxide. Such materials, when properly charged electrically and exposed to light through an image, can retain an electrical charge pattern corresponding to the image that was printed on them.

*Xerography* is the best known of these processes. Introduced in 1948, it has been refined and packaged into a wide variety of copy machines by several manufacturers including Canon, Kodak, Sharp, and Xerox. All work initially as described above, but produce the image temporarily on a charged, revolving metal cylinder. The cylinder with its image is then coated with a resinous toner that sticks only to the charged image pattern. Finally, a piece of ordinary, smooth paper is briefly given an electrical charge opposite that of the particles on the drum, and as the paper passes under the drum it picks up the charged toner pattern from it. Heating the paper fuses the particles and sets the image, resulting in a positive print or copy on the paper. Sheila Pinkel's print, *Nuclear Vision* (Fig. 16-10) adds charcoal to the result of a copy-machine process.

Most such systems reproduce only in black, but various color copy systems are appearing on the market even as they undergo continued refinement. In the decade ahead, color copies should become much less expensive and more widely available.

**Computer-generated Images.** The computer revolution has swept photographic artists, like those in other media, into its wake, and images generated by these versatile machines are finding their way into the work of creative photographers. The images being produced are as different from one another as the programs used to create them, but all have a certain recognizable visual quality that stems from their digital or bit-mapped nature. Michael Brodsky's photograph from his "Media Probes" series (Fig. 16-11), provides an example.

The simplest computer images are merely photographs of the computer's display screen; more complex techniques can involve scanning the photographic image, converting it to digital display, reprocessing that information to alter its appearance, and then generating a new form of it as the output of the process. Paul Berger's print (Fig. 16-12) is the result of such procedures.

In this chapter we have noted the more important alternative photographic processes, many of which can be combined with each other and with other media. The quantity of inventive work that photographers are now producing by these methods suggests that alternatives like these to the traditional silver image will continue to have a major influence on creative photography in the years ahead.

**16-11**  *Michael Brodsky: Media Probes: Lose a Turn, 1986.*

# SUMMARY

1. Photography has a rich vocabulary of images, many of which depart from the realism of conventional black-and-white and color prints. One way is through *multiple exposures* or *multiple printing*. Photographer Jerry Uelsmann calls his method *post-visualization*.

Another way is to *reduce or eliminate the gray tones*. In some examples all tones except black and white are eliminated, producing a *high contrast image* or *dropout*. Special films, such as *Kodalith* materials, are used to obtain this effect. A variation of this technique produces *tone-line* or *spin-out* images.

A third method is to make images *without using a camera*, or to display images in a *negative* rather than a positive state. Examples include *photograms* and *refraction prints*, made directly by the action of light on the printing paper. *Solarized prints* appear to have both negative and positive tones, with adjacent highlight and shadow areas separated by Mackie lines.

2. *Non-silver processes* start from traditional silver images as large as the final print is to be: they are *contact processes*. Litho films or paper negatives can be used to make the enlarged negative or positive images needed. For their final prints, however, they do not use silver-based materials or chemistry.

3. Three non-silver processes are based on the chemistry of *iron compounds*: the *cyanotype*, or blueprint; the *Vandyke brown print*; and the *platinum print*.

4. Other non-silver processes allow the introduction of individual colors by *pigments* incorporated in the photographic image. Among them are *gum bichromate* and *Kwik-Print*, a modern variation that is faster and easier to work.

5. Two *ink processes* of particular interest are (a) *photo screen printing*, which permits the use of bold colors and works on various materials; and (b) *photolithography*, which in its offset form is used commercially for most ink-on-paper printing.

6. *Xerography*, a widely available copy machine process, is another important non-silver process with creative imaging possibilities. Some machines copy in color, and new technologies for this purpose are continually being introduced.

7. *Computer-generated images* originate as digitized data in a computer, or as images converted to that state from more traditional visual sources. As new technology becomes available in this rapidly changing field, new ways of producing such images will continue to attract photographers as well as artists in other media.

# LARGE FORMAT PHOTOGRAPHY
## View Cameras and Sheet Film

Large format photography, as the term is typically understood, means using a *view camera* and *sheet film*. In Chapter 2 we described the view camera as an expandable chamber or box, with a lens and shutter on the front and a ground glass focusing screen at the rear. Although old in principle, the modern view camera is a precise instrument that can be configured to do a variety of photographic assignments.

## THE VIEW CAMERA

The major parts of a typical view camera are shown in Figure 17-2. The camera has four characteristic features which, although not exclusive, serve to identify it among other cameras:

1. **Interchangeable lenses.** All view cameras provide for them.
2. **Adjustable lens and film positions.** All view cameras have one of these features; many have both.
3. **A long or interchangeable bellows.** Most have one or the other.
4. **Large sizes of sheet film.** 4 × 5 and 8 × 10 inches are typical.

The most important reason to use a view camera rather than another type is for the *control of the image* that this camera provides, mainly because of the interchangeable lenses and the adjustable positions for the lens and the film. Let's take a closer look at these and other features of the view camera.

### Interchangeable Lenses

All view cameras have a means of interchanging lenses, usually by removing and replacing lensboards on the camera's front. This allows the photographer to change the size of the image, or to change the camera's position for better control of distortion and perspective while maintaining a given image size. For example, when you photograph outdoors it is often necessary to position the camera farther from the subject than you would like. From this greater distance, a longer focal-length lens will let you fill the ground glass with a larger image. Indoors, you may find yourself in the opposite situation, squeezed into a small room from within which you cannot frame enough area with the camera. A shorter focal-length or wide-angle lens can solve this problem for you.

These same advantages are available on an SLR camera that has interchangeable lenses, but most SLR lenses fit only one specific camera brand, whereas view camera lenses, which are usually mounted on flat square boards, are more freely interchangeable between different brands of equipment.

### Adjustable Lens and Film Positions

The ability to adjust the lens and film positions is the view camera's most important feature. Repositioning the camera's lens (without changing other parts) allows you to create an image of precise cropping and size, and to place its plane of sharp focus at an angle that will include more important parts of the object pictured. Few other cameras allow you to do this.

Similarly, repositioning the camera back (and film) allows you to eliminate or exaggerate converging lines and distortion, and it gives you additional control of sharpness or unsharpness in the

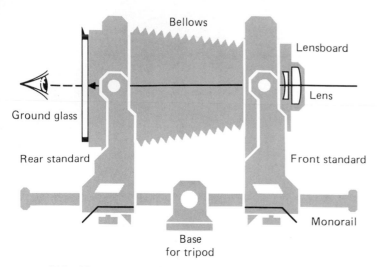

**17-2** *Major parts of a view camera.*

stant-picture films in black-and-white or color. The film can be processed and inspected while the camera remains set up for the shot.

Another advantage of the view camera over other types is the planning that its use requires. A view camera must be set up on a studio stand or tripod (Fig. 17-1), and each picture must be composed on the ground glass before it is recorded on film. This requires close attention to the image; indeed, the view camera can help you separate the *image* of a photograph from its *subject* in the real world more effectively than other cameras can. You will need skill and patience to use this type of camera, but learning to work with it can encourage you to discover pictures as it builds your discipline and increases your skill. To a thoughtful or creative photographer, these are real assets.

image. While most cameras have rigid bodies that do not allow you to reposition the film in relation to the lens, the view camera has the special advantage of adjustable lens/film positions.

### Long or Interchangeable Bellows

This versatile feature makes the use of long focal length lenses possible and allows the camera to be focused over a great range of distances. With such a bellows small objects can often be photographed 1:1 (where the image is as large as the object). Furthermore the same camera can be used for photography at medium and long distances by partly collapsing it. Older view cameras usually have a single long bellows; newer models often allow the standard bellows to be removed and exchanged for longer or shorter ones. A removable bellows also allows some view cameras to be collapsed flat for easy carrying in an attaché case when not in use.

### Large Sheet Film Sizes

Generally speaking, the larger the film size, the sharper the image possible, although the quality of modern films and lenses has made this feature less of an advantage than it once was. Other notable advantages stem from the use of *sheet film* rather than rollfilm:

1. **Versatility.** Many kinds of black-and-white and color film are made in the sheet film format.
2. **Adaptability.** Films can be processed one at a time, and the time of development can be changed from one sheet to another to control contrast.
3. **Proofing.** Trial exposures can quickly be made on in-

## LENS COVERING POWER

All view camera lenses produce circular images, and we usually position the rectangular ground glass and film within that circle (Fig. 17-3). With most lenses, the perimeter or outside of the image circle is less sharp than the central area, and this limits the area within which the film can usefully be positioned.

The size of the image circle, or *covering power*, varies directly with the focal length of the lens. Longer focal-length lenses produce larger image circles, and therefore permit more lateral movement of camera parts to position the lens and film. Shorter focal-length lenses restrict such movements.

To take advantage of the view camera's movable lens and film positions, many photographers choose a lens with a focal length about 40 percent greater than the diagonal dimension of the film they are using. On a 4 × 5 in. camera, for example, a lens of about 210 mm (8½ in.) is typical. This focal length will give sufficient covering power to allow the swings, tilts, and shifts (see next section) to be effectively used. A lens of 150 mm (6 in.) focal length will cover a 4 × 5 in. film, but permit little adjustment of the image within its circle. Lenses shorter than 125 mm (5 in.) may permit no adjustment at all.

## VIEW CAMERA ADJUSTMENTS

When all of a view camera's adjustments are in their center or "zero" positions, the camera looks like Figure 17-4. Notice that the lensboard and ground glass are at right angles to the bed or monorail, and parallel to each other. The lens is centered in front of the ground glass.

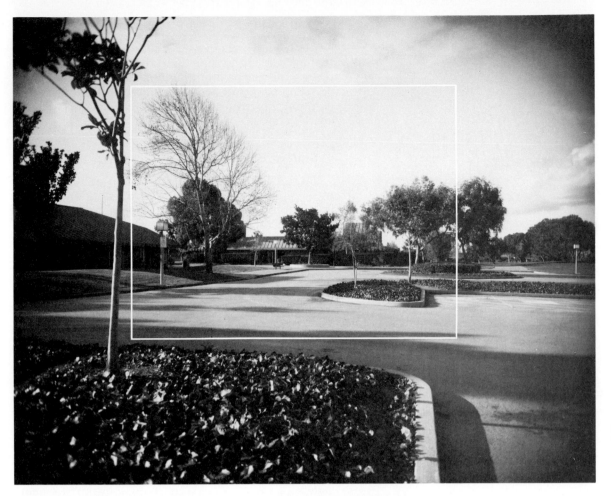

**17-3** *Covering power of a lens. In most cameras, only the central portion is used.*

**17-4** *View camera centered*

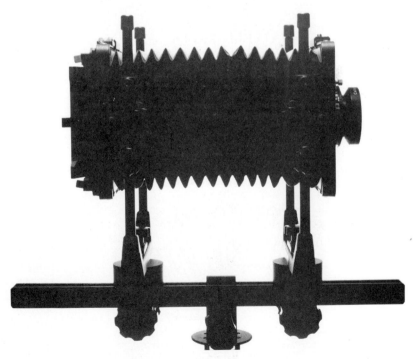

**17-5** *View camera adjustments.* **A:** *rising and falling adjustments;* **B:** *shift or slide adjustments;* **C:** *swing adjustments;* **D:** *tilt adjustments. Courtesy Komamura Photographic Co. and Calumet Photographic, Inc.*

A

B

C

D

## Rise and Fall

Many view cameras have a rising and falling front that allows you to reposition the image *vertically* on the ground glass without moving the camera (Fig. 17-5A). If your tripod has no vertically adjustable center column, this camera adjustment can be used to make such a change.

## Shift or Slide

Shift or slide adjustments, which are often built into both the front and rear camera standards, allow repositioning of the image *horizontally* (Fig. 17-5B). Although the extent of these movements is limited by the camera's design and by the covering power of the lens, front and rear shift movements can sometimes be combined, if needed (by shifting the lens to the left and the ground glass to the right, for example), to increase the amount of lateral adjustment available.

The rising and falling front, together with the shifting or sliding front and rear adjustments of the camera, offer a quick way to reposition the image if a minor but precise change is needed.

## Swings

The term *swing* is generally used to describe a movement of the front or rear standard around a vertical axis (Fig. 17-5C). Swinging the *rear* standard (containing the ground glass) *changes the shape of the image by altering the position of horizontal lines;* swinging the *front* standard (containing the lens) changes where the *plane of sharp focus* will lie.

Swings are useful to correct the shape or appearance of subjects with long, parallel horizontal lines as, for example, the front of a long, low building (Fig. 17-6 A and B). Swings can also be used to exaggerate a shape by deliberately distorting it.

## Tilts

The term *tilt* is used to describe a similar movement of the lens or film plane around a horizontal axis at right angles to the lens axis and camera bed or monorail. Tilting the *rear* standard of the camera (containing the ground glass) *changes the shape of the image by altering the position of vertical lines.* Tilting the *front* standard (containing the lens), like swinging it, changes where the *plane of sharp focus* will lie. These movements are shown in Figure 17-5D.

Tilts are useful to correct the shape of images with long or important *vertical* lines as, for example, the facade of a tall building (Figure 17-7 A and B). By tilting the ground glass (rear standard) so that it is *parallel* to the subject plane, vertical lines will remain vertical rather than converge.

Tilts are especially useful if the camera must be pointed up or down at an angle to frame the subject or to show its top and side. Without them, the shape of the subject will be distorted by the angle, but by

A

**17-6** *Building photographed with the camera in the centered position (A) and with the camera swung to correct the perspective (B). In the corrected view, the far end of the building is taller.*

B

A

B

**17-7** *Tall building photographed with the camera pointed upward and centered (A), and with the back tilted parallel to the building (B). Notice the converging vertical lines in A.*

A              B

**17-8** *View photographed with the camera centered* **(A)** *and with the lensboard tilted to increase the depth of field* **(B)**. *Both photographs were made at the same aperture.*

tilting the rear element of the camera, the shape can be corrected. Tilting the front standard forward can place the plane of sharp focus parallel to the horizontal plane of the subject (Fig. 17-8 A and B), thus effectively increasing the depth of field from front to rear.

Swings and tilts are among the view camera's most useful features, but because they must usually be adjusted together, they can be confusing. The following points may help you remember their functions and correct uses.

## USING SWINGS AND TILTS

1. Moving the *rear standard* (ground glass) in or out on the camera bed or monorail brings the image into *focus* but does not change its size.

2. Moving the *front standard* (lens) in or out on the camera bed or monorail *makes the image larger or smaller* and *also changes the focus*. Therefore, to focus the image, adjust *only* the rear standard; to change the image size, adjust the front standard and then refocus by adjusting the rear standard as needed.

3. Swinging and tilting the *rear standard* (ground glass) *changes the shape* of the image. On some cameras it also will alter the focus, but that can be corrected by refocusing the camera.

4. Swinging and tilting the *front standard* (lens) *changes the plane of sharp focus* without changing the shape of the image. This can be useful to increase the effective depth of field where it is needed without stopping down the lens.

5. For sharpest focus, the planes of the ground glass (image), lensboard, and the plane of sharp focus in the subject must all intersect on a common line or at infinity (Fig. 17-9). This is sometimes known as the *Scheimpflug rule*, after its inventor.

## Reversing and Revolving Backs

These adjustments allow you to quickly change between horizontal and vertical formats. A *reversing* back can be positioned only for one or the other. A *revolving* back is useful in any position; it can be rotated around the center of the ground glass and locked at any angle. However, only the ground glass and film position rotate; the axes of the swings and tilts do not. Therefore the rotating back should not be used as a substitute for leveling the camera, but only to enhance the composition or design of the image. (Fig. 17-10).

**17-9** *The Scheimpflug Rule. Sharpest focus is obtained when the planes of the subject, lensboard, and groundglass (or film holder) all intersect on a common line (or at infinity).*

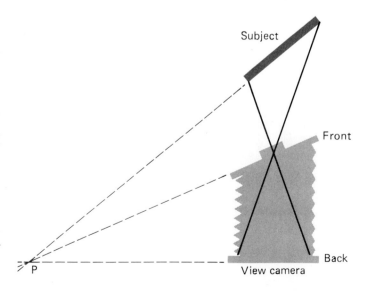

Subject

Front

Back

P           View camera

**17-10** *Appropriate use of a view camera's rotating back.*

## A WORKING PROCEDURE

From the preceding discussion, it is evident that using the view camera can be quite confusing, to say the least. To avoid confusion, I recommend that you follow the step-by-step procedure given below.

## HOW TO USE A VIEW CAMERA

| 1 / set up the camera | 2 / center or "zero" all adjustments | 3 / open the shutter and the aperture |
|---|---|---|

Set up your tripod and fasten the camera securely on it. Your camera position will depend somewhat on the focal length of your lens and on the workspace available. Level the camera.

This step is very important because any part that is out of alignment to start will change the focus and make further adjustment difficult.

You can use the press-focus button (if your shutter has one), or set the shutter on T, cock it, and press the cable release once. The aperture should be wide open.

/continued

## 4 / frame and focus the picture

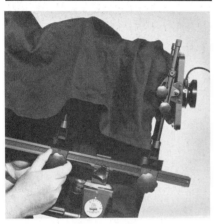

Adjust the tripod head first to roughly frame the picture, and the **rear** standard to focus it. As you look at the ground-glass image under the focusing cloth, move the ground glass closer to the lens to focus greater distances, or farther back from the lens to focus closer ones.

## 5 / adjust shapes with rear controls

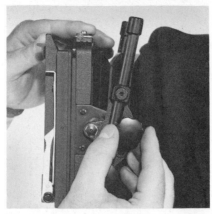

**Tilt** the back to make vertical lines parallel, and **swing** the back to adjust horizontal ones. Also use the rising front or shift, if needed, to reposition the image. Always observe the ground-glass image as you make these adjustments.

## 6 / fine-tune focus with front controls

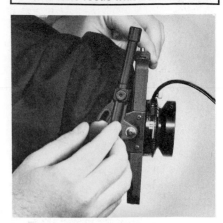

Place the plane of sharpest focus so it includes the most important parts of the image. This will improve the apparent depth of field.

## 7 / recheck focus; tighten adjustments

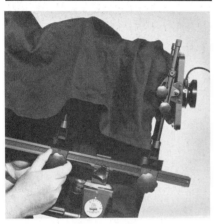

You may want to check the focus on the ground glass with a magnifying glass or loupe, especially in the corners of the image. Stop the lens down first to check the depth of field. When the image looks OK, lock the adjustments to prevent their unwanted movement.

## 8 / close shutter and set exposure

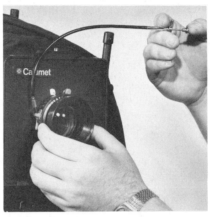

Use the press-focus button (or the T setting again) to close the shutter. Set the proper shutter time and aperture for the exposure. If the subject is closer than infinity, increase the exposure for the extended bellows.*

## 9 / insert the film holder

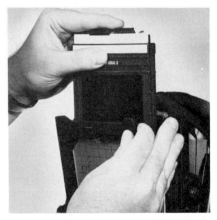

Carefully pull back the ground glass and insert the film holder. **Be sure the holder seats correctly and snugly in the camera back.** Now withdraw the dark slide facing the lens.

## 10 / make the exposure

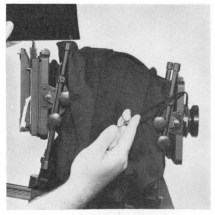

Cock and release the shutter. Immediately replace the dark slide so the **black side** of the tab shows.

## 11 / remove the film holder

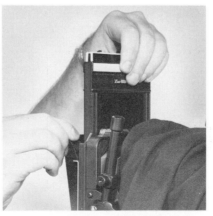

Pull the ground-glass **slightly back** and then lift the film holder out of the camera.

## 12 / recenter all adjustments

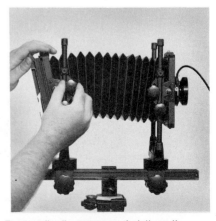

Return all adjustments to their "zero" or center positions before closing the camera or returning it to its case.

* This is sometimes called the **bellows factor.** The formula is **(lens-to-film distance)$^2$ ÷ (focal length)$^2$**. Be sure to use the same units for both measurements, and **multiply** the exposure by this factor.

## SHEET-FILM HOLDERS

Most sheet film is marked with a notching code that identifies the type of film and lets you determine the emulsion side in the dark (Fig. 17-11). *When the notches are on the top of the sheet, toward the right side, the emulsion faces you.*

Each film holder accepts two sheets—one on each side. The film must be loaded so that its emulsion faces *outward*. Otherwise, the exposing light would strike the base rather than the sensitive emulsion. Of course, if you are loading color film or panchromatic black-and-white, total darkness is required.

A sheet-film holder has three parts: the *holder body*, which contains two slots at one end and two flaps at the other, and two identical *dark slides*. The top of each dark slide is smooth and black on one side, but the other is white or shiny with raised bumps (Fig. 17-12). The bumps let you identify the white side in the dark. The slides can also be locked once they are inserted into the holder.

Most photographers use the following code:

Loaded and unexposed—white (bumpy) side out and locked.
Loaded but exposed—black (smooth) side out and locked.
Empty holder—black side out and unlocked.

Film holders should be cleaned prior to each loading, and a soft, camel's hair brush, a paintbrush (used

**17-11**  *Sheet film. Notice the notching codes.*

only for this purpose), or an anti-static brush work well. Small cans of pressurized freon gas, available from photo dealers, are also useful. Be sure to dust under the guides on each side and under the flap at the end. Dust the dark slides, too.

The illustrations on page 242 show the loading procedure. It should be practiced in the light (using spoiled film) before being attempted in the dark. Pay particular attention to how things *feel*, as that will be your best guide to success in the dark.

**17-12**  *Sheet-film holder. Notice the raised marks on the slide. These can be felt in the dark.*

# HOW TO LOAD SHEET-FILM HOLDERS

**1 / get everything ready**

On a clean, dry darkroom table, brush all dust out of your holders and stack them with the slides inserted just far enough for the holders to grab them. Be sure the **white (bumpy) sides** are facing outward. **Now turn out all lights.**

**2 / in darkness, open the film box**

Set the three-part box lid aside where you can find it later in the dark. Unseal the stack of film, remove the cardboard end sheet (omitted from some brands), and locate the notches.

**3 / insert a sheet into the first holder**

Slide the sheet of film, **emulsion side up,** under the long guides inside the holder. Be sure the notched end of the film lies within the space provided so that the end flap will close tightly. Then close the flap.

**4 / close the dark slide**

If the film is properly seated in the holder, the dark slide will close smoothly. If the slide does not close properly, recheck the seating of the film. Lock the slide with the tab provided.

**5 / now load the other side**

Turn the holder over and repeat steps 3 and 4 for the other side. Continue this procedure until all holders have been loaded.

**6 / reclose the film box**

Insert the pack of unused film into the **innermost** lid, and be sure all three parts of the box **close completely** over each other. Now the lights may be turned on again.

## PROCESSING SHEET FILM

Sheet film can be processed manually in tanks or trays. The *tank method* is convenient if you have more than a few sheets to do at a time, but it requires more equipment and chemicals than tray processing does. The *tray method* is easy for a few sheets of black-and-white film and uses chemicals more economically, but involves greater risk of scratching the film if more than one sheet is processed at a time. *Either method requires total darkness.*

*Tube processing*, such as recommended in Chapter 11 for processing color prints, is especially useful for processing sheets of color film, and once the tube is loaded in the dark, the actual processing can be done in the light.* *Any of these methods takes practice*, which can be done in the light using spoiled film and water.

The chemical sequence is identical to that used for rollfilm (see Chapter 6 for black-and-white films, Chapter 10 for color). Some photographers, however, prefer to start the process with a water presoak (ahead of the developer) to insure more uniform development.

### Tank Processing

Tank processing requires four sheet-film tanks (Fig. 17-13). The films, suspended in special hangers, must be transferred from tank to tank; pouring solutions

---

*Tray processing is not recommended for color sheet films because it oxidizes chemicals rapidly and sharply reduces their capacity.

into and out of a single tank (as you did with rollfilm) is not feasible here. Typical tanks made for this purpose require 2, 4, or 13.25 liters ($\frac{1}{2}$, 1, or $3\frac{1}{2}$ gallons respectively) of solution. For black-and-white film processing, prepare the solutions as follows:

1. **Developer.** Recommendations are packed in each box of film. Kodak HC-110 developer, mixed to make a *stock solution*, is then diluted one part stock to 7 parts water (1:7) to make a *working solution* for use in the tank. Other developers popular with sheet-film users are D-76 (used as a stock solution) and T-Max Developer (for pushing T-Max films). See Table 17-1.
2. **Water rinse or stop bath.** If a water rinse is used in the second tank, it can also be used for presoaking if desired. A stop bath, however, is more efficient for stopping development promptly, especially if many sheets are processed together. I recommend a solution of 1 part 28% acetic acid to 30 parts water (1:30). A standard stop bath for black-and-white prints (page 97), can also be used. *Warning: do not use an acid stop bath for presoaking!*
3. **Fixer.** Any standard film fixer may be used. Prepare it as you would for rollfilm.
4. **Washing Aid.** This is optional and should be prepared the same as for rollfilm.
5. **Washing.** The rinse (or stop bath) tank can be emptied after the film is fixed and this tank used for washing (used stop bath should be discarded).

Because of the larger amount of solution needed to process sheet film in a tank, you may wish to *replenish* the developer (as explained on p. 87), and save it for reuse. The fixer and washing aid may be stored and reused until their capacity is exhausted. The 9-step sequence starting on page 246 shows how to load developing hangers and process sheet films in a tank line.

---

**17-13** *What you need to process sheet film in a tank line.*

1. Timer
2. Four tanks (the second from the left is for rinsing and washing)
3. Thermometer
4. Film developing hangers
5. Holders with exposed sheet film

**TABLE 17-1**   DEVELOPING TIMES FOR SHEET FILMS IN TANKS

### KODAK D-76 OR ILFORD ID-11 PLUS DEVELOPER
Use the developer as an undiluted stock solution.

#### Tank Development

Agitate hangers continuously for the first 30 seconds, then for ten seconds (two alternating lift cycles) each minute thereafter. Times shorter than 5 minutes are not recommended as they may produce uneven development.

| | KODAK Tri-X Pan Prof. 4164 | ILFORD HP5 | ILFORD FP4 KODAK Plus-X Pan Prof. 4147 Super-XX Pan 4142 | KODAK T-Max 100 Prof. 5052 | KODAK Royal Pan 4141 T-Max 400 Prof. 5053 | |
|---|---|---|---|---|---|---|
| 18°C | 7 minutes | 8 minutes | 8½ minutes | 10 minutes | 10½ minutes | 65°F |
| 20°C | 6 minutes | 7 minutes | 7½ minutes | 8 minutes | 9 minutes | 68°F |
| 21°C | 5½ minutes | 6½ minutes | 7 minutes | 7¼ minutes | 8½ minutes | 70°F |
| 22°C | 5 minutes | 6 minutes | 6½ minutes | 6½ minutes | 8 minutes | 72°F |
| 24°C | Not Recommended | 5 minutes | 5½ minutes | 6 minutes | 6½ minutes | 75°F |
| 25°C | Not Recommended | Not Recommended | 5 minutes | 5½ minutes | 6¼ minutes | 78°F |

*The above times will produce medium-contrast negatives suitable for printing in most enlargers. Increase times for more contrast; decrease them for less. For printing in diffusion or cold-light enlargers, increase times by 20%.*

### KODAK HC-110 DEVELOPER
Stock solution diluted 1:7 (Dilution B)

#### Tank Development

Agitate hangers continuously for the first 30 seconds, then for ten seconds (two alternating lift cycles) each minute thereafter. Times shorter than 5 minutes are not recommended as they may produce uneven development.

| | ILFORD HP5 | ILFORD FP4 KODAK Plus-X Pan Prof. 4147 Super-XX Pan 4142 | KODAK Tri-X Pan Prof. 4164 | KODAK Royal Pan 4141 T-Max 400 Prof. 5053 | KODAK T-Max 100 Prof. 5052 | |
|---|---|---|---|---|---|---|
| 18°C | 7 minutes | 7½ minutes | 8 minutes | 8½ minutes | 10 minutes | 65°F |
| 20°C | 6 minutes | 6½ minutes | 7 minutes | 7½ minutes | 8 minutes | 68°F |
| 21°C | 5½ minutes | 6 minutes | 6½ minutes | 7 minutes | 7¼ minutes | 70°F |
| 22°C | 5 minutes | 5½ minutes | 6 minutes | 6½ minutes | 6½ minutes | 72°F |
| 24°C | Not Recommended | Not Recommended | 5 minutes | 5½ minutes | 6 minutes | 75°F |
| 25°C | Not Recommended | Not Recommended | Not Recommended | 5 minutes | 5½ minutes | 78°F |

*The above times will produce medium-contrast negatives suitable for printing in most enlargers. Increase times for more contrast; decrease them for less. For printing in diffusion or cold-light enlargers, increase times by 20%.*

**TABLE 17-2**  DEVELOPING TIMES FOR SHEET FILMS IN TRAYS

### KODAK D-76 OR ILFORD ID-11 PLUS DEVELOPER
Use the developer as an undiluted stock solution.

#### Tray Development

Agitate films continuously, cycling them from bottom to top. Times shorter than 5 minutes are not recommended as they may produce uneven development.

| | KODAK Tri-X Pan Prof. 4164 | ILFORD FP4 | ILFORD HP5 KODAK Plus-X Pan Prof. 4147 Super-XX Pan 4142 | KODAK T-Max 100 Prof. 5052 T-Max 400 Prof. 5053 | KODAK Royal Pan 4141 | |
|---|---|---|---|---|---|---|
| 18°C | 6 minutes | 6½ minutes | 7 minutes | 8 minutes | 9 minutes | 65°F |
| 20°C | 5 minutes | 5½ minutes | 6 minutes | 6 minutes | 7½ minutes | 68°F |
| 21°C | Not Recommended | 5 minutes | 5½ minutes | 5½ minutes | 7 minutes | 70°F |
| 22°C | Not Recommended | Not Recommended | 5 minutes | 5 minutes | 6½ minutes | 72°F |
| 24°C | Not Recommended | Not Recommended | Not Recommended | Not Recommended | 5½ minutes | 75°F |

*The above times will produce medium-contrast negatives suitable for printing in most enlargers. Increase times for more contrast; decrease them for less. For printing in diffusion or cold-light enlargers, increase times by 20%.*

### KODAK HC-110 DEVELOPER
Stock solution diluted 1:7 (Dilution B)

#### Tray Development

Agitate films continuously, cycling them from bottom to top. Times shorter than 5 minutes are not recommended as they may produce uneven development.

| | ILFORD FP4 KODAK Plus-X Pan Prof. 4147 Super-XX Pan 4142 Tri-X Pan Prof. 4164 | ILFORD HP5 KODAK Royal Pan 4141 | KODAK T-Max 100 Prof. 5052 | KODAK T-Max 400 Prof. 5053 | |
|---|---|---|---|---|---|
| 18°C | 6½ minutes | 7 minutes | 7½ minutes | 8 minutes | 65°F |
| 20°C | 5½ minutes | 6 minutes | 6½ minutes | 6½ minutes | 68°F |
| 21°C | 5 minutes | 5½ minutes | 6 minutes | 6 minutes | 70°F |
| 22°C | Not Recommended | 5 minutes | 5½ minutes | 5½ minutes | 72°F |
| 24°C | Not Recommended | Not Recommended | Not Recommended | 5 minutes | 75°F |

*The above times will produce medium-contrast negatives suitable for printing in most enlargers. Increase times for more contrast; decrease them for less. For printing in diffusion or cold-light enlargers, increase times by 20%.*

# HOW TO PROCESS SHEET FILMS IN A TANK LINE

### 1 / arrange the hangers for loading

Flip the top bar of each hanger open and stack the hangers against a wall or in an empty tank. Some hangers have a clip instead of a bar at the top. Have your exposed film or holders nearby. **Turn out the lights.**

### 2 / load the hangers

In darkness, remove a sheet of exposed film from its holder or box and slide it carefully into the hanger channel. Note where the notches are. Then flip the top bar closed and set the hanger aside. All hangers and films should face the same way.

### 3 / start the development

Pick up the loaded hangers **as a group** and **slowly** lower them into the tank of developer. **Tap them a couple of times** sharply on the top of the tank to release any air bubbles that might form. If a water presoak is used, this tapping may be omitted. The hangers should be about $\frac{1}{4}$ in. apart.

### 4 / agitate the hangers

Lift all the hangers together partly out of the tank, tilting them about 45° to one side. Slowly reimmerse them in the tank and lift them as a group again, this time tilting to the other side. Continue this movement for 30 seconds.

### 5 / repeat the agitation pattern

Once each minute, lift and tilt the hangers as before. Drain the hangers for about 5 seconds from one corner, then **slowly** reimmerse, lift again, and drain them from the other corner. Each double cycle should take about 15 seconds; do not rush this step as it will pump developer through the holes in the hanger frame.

### 6 / transfer hangers to the stop bath

When the development time is up, transfer the hangers as a group to the stop bath or rinse tank. Agitate once each minute as before. Repeat this procedure in the fixer tank. After about 5 minutes (in fresh fixer), white lights may be turned on. Fix for twice the time it takes to clear all milkiness from the film.

If a washing aid is used, wash in running water for a minute or two and rinse off the tops of the hanger bars. Then dip the hangers in the **washing aid** for the required time, and return them to the wash tank for a final wash in **fresh running water.***

Flip open the top bar and remove the films one at a time. Bathe each film for 30 seconds in a tray of Photo-Flo Solution and hang it up from a corner to dry. Films should dry undisturbed; be sure one film cannot touch another.

Place each film in an archival preserver. Wash and dry the hangers thoroughly before using them again.

* If no washing aid is used, give the films a single, 30-minute wash in running water.

### Tray Processing

Tray processing requires four trays as large as the film. Slightly larger trays (5 × 7 in. trays for 4 × 5 in. films) will make interleaving agitation easier to do. The wash tray should be larger than the others and should have a good supply of fresh water but a gentle flow. A tray siphon (recommended for prints) should *not* be used with sheet films as the turbulence it produces may damage two or more sheets of film washed together.

Developer, rinse water (or stop bath), fixer, and washing aid are placed in the trays in the same sequence as for tank processing. Follow the 6-step procedure shown.

## HOW TO PROCESS SHEET FILM IN TRAYS

In darkness, fan the sheets of film **face up** lightly in one hand like playing cards. Keep the hand holding them dry until all are immersed.

Place the first film gently on the surface of the solution with your other hand, and press it into the solution. Repeat with the other sheets, one at a time. A 1-minute water pre-soak makes this easier.

Push all films gently toward one corner of the tray.

/continued

Carefully pull the bottom film out from under the stack and place it on top of the stack, pressing it under the surface of the solution.* Carry a little solution on the film surface for easier repositioning. Repeat this step constantly until time is up.

Transfer the films one at a time to the next tray without breaking the rhythm, and continue the process. When fixing is completed, lights may be turned on.

Use a gentle flow of water in a tray. If two or more sheets are washed together, be sure the water does not spin them against each other as that might scratch them. Continue handling the films as shown in step 8 of the tank-processing sequence with hangers.

\* Agitate a single sheet by rocking the tray constantly, alternating side-to-side with end-to-end motion.

## TIPS FOR PROCESSING SHEET FILM

1 / Practice loading and handling hangers in the light (with spoiled film) before you do it for the first time in the dark.

2 / Use care when loading and lifting hangers so that their corners do not scratch adjacent films. Lifting hangers together (rather than one at a time) will minimize this risk.

3 / Tank developing of sheet film uses **intermittent** agitation; tray developing uses **continuous** agitation. Different developing times apply to each procedure; be sure you use the correct one (see Tables 17-1 and 17-2).

4 / If you replenish the developer, be sure you measure the solution accurately and count the number of sheets processed. A simple log sheet will help you keep track of this.

5 / Insufficient agitation may result in a buildup of bromide ions on the film surface, and as these settle to the bottom of the tank, they produce characteristic streaks of uneven density in the images. Vertical agitation alone will also produce this effect. Regular agitation, with **draining from alternate corners,** should avoid this problem.

6 / Do not bathe hangers in Photo-Flo; it sometimes leads to streaky development if the hangers are not sufficiently washed after each use.

7 / Do not dry film in hangers, as this often leaves a pattern of marks from the hanger on the edges of the film. Hang the films separately from a corner and be sure they cannot touch each other while drying.

## SUMMARY

1. The *view camera* has four characteristic features: interchangeable lenses, adjustable lens and film positions, a long or interchangeable bellows, and large sizes of sheet film. It must be used on a tripod or stand.

2. The main advantage of a view camera is *precise control of the image*. And because the camera uses *sheet film*, exposures can be processed one at a time (or given individual development) and instant-picture films can be used to proof exposure and lighting arrangements while the camera is still set up.

3. *Lens covering power*, which varies directly with its focal length, must be sufficient to permit lateral movement of the camera's parts. A good rule of thumb is to use a lens whose focal length is about 40 percent greater than the diagonal dimension of the film (210 mm for a 4 × 5 in. camera).

4. The *rising and falling front* allow careful vertical positioning of the image on the ground glass. The *front and rear shift or slides* allow a similar lateral movement of the image.

5. *Swinging the rear standard* (ground glass) changes the shape of the image horizontally; *tilting the rear standard* changes the shape of the image vertically.

6. *Swinging the front standard* (lens) relocates the plane of sharp focus from one side of the image to the other; *tilting the front standard* relocates this plane from top to bottom of the image. Tilting the front (lens) forward can also effectively increase the depth of field.

7. *Moving the front standard* (lens) back and forth on the monorail or camera bed changes the image size and focus.

Similarly moving the *rear standard* (ground glass) changes only the focus of the image.

8. *Reversing or revolving backs* permit quick change between horizontal and vertical formats.

9. The *Scheimpflug rule* states that the planes of the film, lensboard, and of sharp focus in the subject must all intersect on a common line, or be parallel to each other (and thus intersect at infinity).

10. Sheet film has notches to identify and orient it properly. When the notches are on the top, toward the right, the emulsion faces you.

11. *Sheet film holders* must be loaded in the dark with the film emulsion facing outward. Clean each holder and its slides carefully before loading it, and observe the code for the dark slides.

12. *Black-and-white sheet film can be processed* in open tanks with hangers, or in a tray if only a few sheets are involved. Tubes or drums are recommended, however, for color film. The chemical sequence is the same as for rollfilm. An optional water presoak is sometimes used ahead of the developer to insure uniform development.

13. Because of the larger volume of developer needed for tank processing, *replenishment* of this solution is often advantageous.

14. Handling and processing sheet film requires care. You can *practice this in the light* with discarded film before doing it in the dark.

15. Remember that the *tank and hanger method uses intermittent agitation*, while *tray processing uses constant agitation*. Developing times are different for each method.

# FLOOD AND FLASH
# Photography by Artificial Light

**18-1** *Ceramic containers photographed with artificial light.*

Light is one of a photographer's most useful tools. It not only provides the basic energy that makes photography possible, but it is an important designing element to use in creating a picture. In Chapter 13 we pointed out how light can model shape and form, reveal textures, and heighten the illusion of three-dimensions in our two-dimensional picture space.

In Chapter 3 we made a distinction between natural and artificial light. We defined natural light as light coming from the sun; daylight, or course, is its most familiar form. To a photographer, natural light is in reality existing light that cannot be controlled at its source. Instead, we take it pretty much as it comes, and work with its direction, intensity, color, and with the shadows it often creates.

Artificial light, on the other hand, is light that *can be controlled at its source*. This is a useful distinction for photographers, since how light is produced is usually less important than how we use it. Broadly considered, there are two types of artificial light: *continuous light*, which includes most forms of electric light that are part of our daily life, and *intermittent light*, which occurs as brief pulses or flashes that are familiar to photographers everywhere.

Continuous light offers several advantages over the intermittent type, and some of these are particularly valuable to photographers who are not fully aware of how light behaves. We shall therefore consider it first, and later apply its principles to flash. Flash may be more convenient for many uses, but its brief duration makes any study of its behavior more difficult.

## CONTINUOUS LIGHT

Continuous artificial light is available wherever electricity is. Its most familiar forms, the *tungsten-filament lamp* and the *fluorescent tube*, can be used by photographers just as they come. For studio photography of small objects, ordinary household lamps will often suffice. But where the area to be lit is large, or where the existing light is dim, special photographic lamps are useful, and for color photography they have other important advantages.

### Photographic Lamps

Most continuous photographic lamps are usually called *photofloods*. These are simply ordinary light bulbs whose tungsten filaments burn at an abnormally high rate. They give more light than regular bulbs, but burn out much sooner.

Photographic light bulbs have ASA code designations for easy identification, as shown in Table 18-1. The lamps most preferred by professional photographers are the 250 watt ECA and the 500 watt ECT. These 3200K bulbs have long, stable lives and are suitable for color photography with tungsten-balanced color films. They fit ordinary, screw-base sockets but should be used with good reflectors. Some lamps (such as the 500 watt EAL) have reflectors built into them. They are more expensive than the other bulbs mentioned, but are also more convenient to use, needing only screw-base clamp-on sockets to hold them.

**TABLE 18-1**  PHOTOGRAPHIC LAMPS

| ASA Code | Type | Watts | Color Temp. | Life |
|---|---|---|---|---|
| BBA | No. 1 Photoflood | 300 | 3400K | 3 hrs. |
| BDK | Reflector Flood | 100 | 3200K | 4 hrs. |
| BEP | Reflector Flood | 300 | 3400K | 4 hrs. |
| BFA | Reflector Flood | 375 | 3400K | 4 hrs. |
| EAL | Reflector Flood | 500 | 3200K | 15 hrs. |
| EBV | No. 2 Photoflood | 500 | 3400K | 6 hrs. |
| ECA | Studio Lamp | 250 | 3200K | 20 hrs. |
| ECT | Studio Lamp | 500 | 3200K | 60 hrs. |
| ECV | Studio Lamp | 1000 | 3200K | 60 hrs. |

Many types of *tungsten-halogen* lamps are also used in photographic work. These lamps are compact and operate at very high temperatures. They have a high, stable light output over a long, useful life, and do not darken with age as regular tungsten lamps do. Because they operate at high temperatures, however, these lamps must be used only in equipment designed for them; adequate ventilation is essential. These lamps also require extremely careful handling. The quartz tube must not be touched under any circumstances; mere traces of perspiration or human skin oil on the lamp may cause it to heat unevenly and fail.

## LIGHT FUNCTIONS

The key to using artificial light is to consider its function first. Although some lamps are more useful than others for a particular job, almost any kind of light source can perform several tasks adequately. Four functions are fundamental:

1. **Key light.** This is the main source of illumination; it dominates all other lights wherever it is used. Key light is the artificial equivalent of direct sunlight in nature. Being the most important light, it casts the most important shadow. Its directional quality unifies a picture and determines the mood of a scene.
2. **Fill light.** A fill light illuminates the shadows cast by the key light, replacing their darkness with enough light to record detail with tone or color. Thus it functions like skylight on a clear, sunny day. It should never equal the key light in intensity on the subject, for then it would be another key light and not a fill. Equally important, the fill light should cast no significant shadow of its own.
3. **Accent light.** As its name implies, this one adds small, local highlights or accents to an otherwise evenly lit area. It is commonly used in portraiture, for example, to highlight the hair, and in commercial photography to make details of objects more visible. An accent light may ap-

pear as bright as the key light or even brighter, but it never dominates a picture as a key light does. It is strictly a local touch, never the main show. The highlights it makes, when carefully placed and sparingly used, will add brilliance to a finished photograph.
4. **Background light.** This light illuminates the background, that is, *the space beyond the subject being photographed*, and not the subject itself. It provides tone separation in the photograph between the subject and the space around it. Your picture is a two-dimensional frame, and this light gives a stronger feeling of *depth* within that frame.

For good results, two principles overshadow all others: *build the lighting one function at a time*, and *keep the lighting simple*. Check the lighting as you go, *always from the camera position* (it will look slightly different from any other angle). The way it appears at the camera lens, of course, is the way it will appear in your photograph.

Simple procedures for photographing people and small, inanimate objects are given below. They should not be considered hard and fast rules, but rather as starting points for your own further experimenting.

## SIMPLE PORTRAIT LIGHTING

Here is a suggested procedure for simple portraits. It will work fairly well with floor and table lamps at home, with portable floodlamps of any kind, or with studio lamps designed for professional use. The kind of lamp you use is less important than how you use it. You may have to remove the shades from home lamps or equip them with brighter bulbs (150 and 200 watt bulbs are available wherever housewares are sold, or the screw-base bulbs listed in Table 18-1 may be used). In any case, be sure that no part of a lampshade touches any of these bulbs, for they get quite hot. The following sequence of diagrams and pictures will show you how to proceed.

# SIMPLE PORTRAIT LIGHTING

## 1 / begin with the key light

For a typical head-and-shoulders portrait, the key light should be a foot or two higher than the face, and to one side of the camera, as shown in the diagram. When you have the effect you want on the face, check the shadow to see that it doesn't dominate the picture frame.

## 2 / next, add the fill light

Usually the fill light should be on the opposite side of the camera from the key light. Keep it at about your subject's eye level. It should be a good deal less intense than the key light; use a dimmer lamp or move the light back from the subject until the balance of shadow-to-highlight looks good. It may help to feather this light, that is, to rotate the light and its reflector more toward the camera than toward the subject so that its full itensity does not fall on the subject's face. This will also avoid spilling this light onto the background.

## 3 / now add an accent light for a highlight on the hair

Place any small, focused light (such as a reading light) above and behind the subject, opposite the key light, and aim it at the hair. Check it very carefully from the camera position, preferably through the viewfinder, and adjust it until it gives a suitable highlight. Remember: it should not dominate the lighting on your subject but only add an accent.

## 4 / use a background light (optional) to add depth

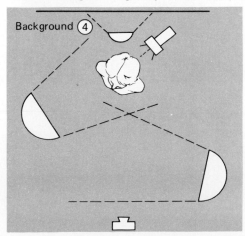

The background light helps give the illusion of a three-dimensional space. Place this light low, behind the subject and aim it at the background. Its effect should be seen just over the subject's shoulders. Keep it subdued; it must not be brighter than the key light and should not call attention to itself.

## Basic Lighting Styles

In simple head-and-shoulders portraits you will generally want to show your subject in a pleasing way. You can call attention to your subject's more attractive features and minimize unattractive ones by *careful placement of the key light.*

By directing the key light to the side of the face *away* from the camera (**short lighting** style) you can make a full face look slimmer (Fig. 18-2).

By directing the key light to the side of the face *closer* to the camera, and letting the fill light illuminate the far side, you can make a thin face look fuller (Fig. 18-3). This arrangement is called **broad lighting.**

A third style of lighting places the key light *directly in front of* the sitter's face, just far enough above the camera so that it creates a small, butterfly-like shadow under the nose (Fig. 18-4). This style is known as **butterfly lighting**, and it has been widely used in glamour photography to flatter the subject. Notice that it tends to emphasize high cheek bones and minimize a protruding nose. (Avoid placing the light too high as this will create deep, dark eye sockets.)

## Tips for Posing

The first and most important rule is this: *Keep it simple.* You are working with a human being, not just a bunch of lights!

Next, the workspace: Allow enough space between your subject and the background—at least four feet—for shadows to fall outside the picture frame and for the background light to do its job.

Try angling one shoulder of your sitter toward the camera just enough to hide one ear from its view. This will give the picture more depth and a less mechanical, more natural appearance.

Use a longer-than-normal focal length lens if one is available. Position a 35mm camera *vertically* (on a tripod, of course), and use a lens of at least 100 mm focal length. That will let you place your camera about six feet from your subject, and it will avoid the distortion that a closer viewpoint can cause. A 135mm lens works well on a 120 rollfilm camera. With either format, use a somewhat shorter lens, at a greater distance, for groups of people.

If you use an automatic exposure system or a hand-held external meter, remember that a Caucasian face

**18-2** *Short lighting. Key light illuminates side of face away from camera.*

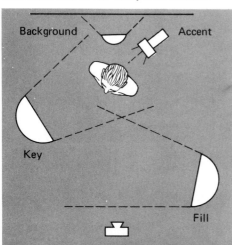

**18-3** *Broad lighting. Key light illuminates side of face toward camera.*

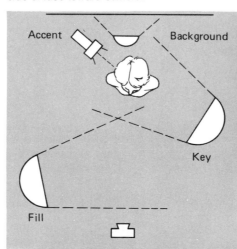

**18-4** *Butterfly lighting. Key light illuminates front of face from above camera.*

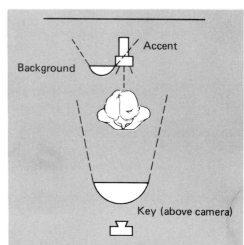

is not medium gray. If your sitter's face fills the frame, you may have to override the meter to compensate for this. See page 28.

Finally, talk to your sitter as you work, and move as briskly as you can. Lights heat up, and they can bake the last traces of emotion out of anyone seated under them too long! And don't forget: Keep everything simple!

## LIGHTING SMALL OBJECTS

The procedure for lighting small objects is basically the same as for portraits, although we now must consider additional shapes. People's heads are basically spherical, with the most important features in front. Objects can be cubic, cylindrical, or spherical, with other surfaces and planes equally important to their structure and identity. The major difference in

the way you light each of these three basic shapes has to do with where the key light is placed.

### Cube-Shaped Objects

The diagram and photo sequences below show a simple procedure for lighting cube-shaped objects.

### Cylinders and Spheres

Cylindrical objects are easier to light than cubes. The key and fill lights should generally be opposite each other, but both slightly toward the camera position. For example, if you place the key light at the two- or three-o'clock position (with relation to the object being photographed), place the fill at the seven or eight o'clock position. Follow the sequence shown in the diagram and photographs on page 256.

## HOW TO LIGHT CUBE SHAPES

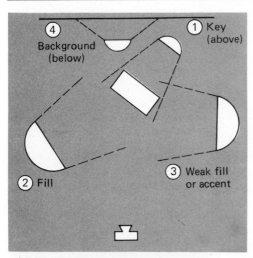

**1 / place the key light first**

Position the key light behind the object, high and off to one side, so that it throws a shadow of the object toward a lower corner of the picture.

**2 / next, add the fill light**

Direct the fill light at the side of the object facing the camera. Use enough illumination here so that details can be clearly seen, but not so much that the front becomes as bright as the key-lit top.

**3 / now light the third side**

Add a second fill light or accent light to illuminate the third side of the object that can be seen in the camera. Make this third side less bright than the other two. Making each side a different brightness will strengthen the appearance of depth.

**4 / add a background light if needed**

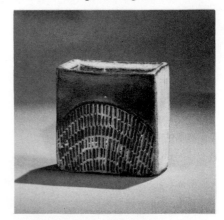

This light will separate the object from its background, just as in portraits, and increase the feeling of depth. Its effect should be visible just over the object (in the viewfinder), and not on the object itself. Because the key light comes from behind, however, a background light may not be needed; it depends on the shape of the object.

# HOW TO LIGHT CYLINDERS AND SPHERES

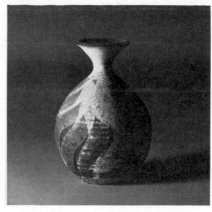

## 1 / start with the key light

*If the top of the object is visible to the camera, start building the light as for cubic objects. Position the key light above and behind the object so that it throws a shadow toward a lower corner of the picture frame. If the top is not visible, place the key light lower **but in front** of the object.*

## 2 / add the fill light

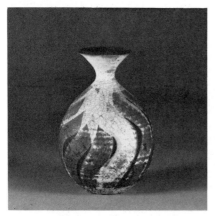

*Place the fill light opposite the key light but level with the object so that it illuminates the round side evenly from top to bottom. The falloff from highlight to shadow, which gives the illusion of roundness, should be visible on the object to **one side of** the center line and generally not on the center line itself.*

## 3 / add a background light if needed

*If no tone separation between the object and the background is visible, a background light will help strengthen the illusion of depth. An accent light can be added to highlight a particular detail on the object.*

**18-5** *Shadowless (bounce) lighting.*

**18-6** *Shadowless and key light combined.*

## SHADOWLESS LIGHTING

Shadowless lighting combines the key and fill functions in a single, large, diffused light source. This source can be created by bouncing a directional light off of a reflector, such as a white card or *umbrella*, or by enclosing a light source in a large, white box called a *softbox*. Two or more such lights placed on either side or around an object will create an aura of soft light that is essentially directionless, and therefore shadowless. This lighting arrangement effectively simulates the diffused skylight of overcast days.

*Shadowless light*, as this is called, illuminates an *area* rather than an object within it. It is ideal for photographing things that have shiny surfaces or important black parts. Such lighting minimizes the contrast between black and chrome, for example, on small appliances and similar objects (Fig. 18-5). Indirect lighting is also useful when photographing small objects from a close viewpoint. If there is not enough space to use direct light, indirect light may work quite well.

Once set up, shadowless or indirect light is easy and efficient to use, requiring little adjustment for various kinds of objects. But it is not well suited to showing textures or shapes; direct light is better for that.

### Combining Shadowless and Direct Light

Professional photographers who must photograph many objects in a single work session, such as for catalog illustrations, have found that a combination of direct and shadowless light enables them to work quickly and efficiently to make such photographs. This combination is particularly useful if an object has an important shape but also has surfaces that are highly reflective and therefore troublesome with direct lights.

The basic lighting is the shadowless or bounce setup described in the preceding section. A single, direct accent light is added to this basic shadowless setup (Fig. 18-6). The accent light serves as a weak key light, outlining the shape but not overpowering the overall light. This time, the key or accent light should be added *after* the shadowless light setup is

arranged. Adjust its distance (or its intensity) until the desired balance can be seen with the eye.

For calculating exposure, a gray card may be helpful (see p. 39). Place the card in the bounce-lit area, and read it with the camera or hand-held meter positioned about a foot in front of the card. Then reposition the camera to properly frame the picture.

## INTERMITTENT LIGHT: FLASH

Photoflash has become a popular source of artificial light that has made photography possible almost anywhere. It has three advantages over continuous light described earlier in the chapter:

1. It is compact and portable, and goes anywhere the camera does. Ken Light used this advantage of flash to illuminate a car trunk full of abandoned, undocumented immigrants near the Mexican border (Fig. 18-7).
2. It is brief enough to stop or "freeze" movement in most picture situations.
3. The light is about the same color balance as daylight, so that daylight color film can be used with it without filtering.

The major disadvantages of flash are that you don't have a chance to direct the light as freely and as specifically as you can with floods or spots, and with most flash units you cannot see or study the light before you take the photograph. Both of these problems, of course, can be overcome with practice.

### Flash Units

In modern, electronic flash units (Fig. 18-8), an electric charge is applied to wires at each end of a small glass tube filled with xenon gas. Triggering the unit ionizes the xenon, and in this state it conducts the electric charge across it with a brilliant flash of light. The gas is not consumed in the process, and as soon as another charge can be placed on the tube, another flash is possible. Moreover, the flash is extremely brief: typical times range from 1/500 to 1/70,000 second in modern units, short enough to stop or "freeze" action in most situations.

Because of these features, electronic flash units have virtually replaced the chemical flashbulbs of a few years ago. Chemical bulbs produced their light by burning shredded metal wire in a bulb filled with oxygen. The wire was consumed in a quick, brilliant flash of light, but each bulb could be used only once. This older method was inexpensive, but also inconvenient.

**18-7** © 1988 Ken Light: "Indocumentos" discovered in trunk of a car abandoned by their coyote, San Ysidro, California.

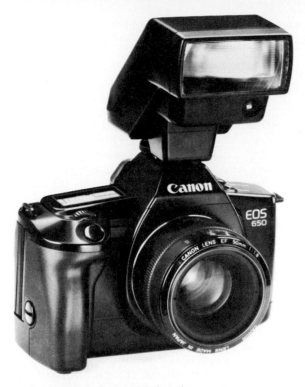

**18-8** *Electronic flash unit in hot shoe of camera. Courtesy Canon USA, Inc.*

**18-9** *PC cord connection on camera.*

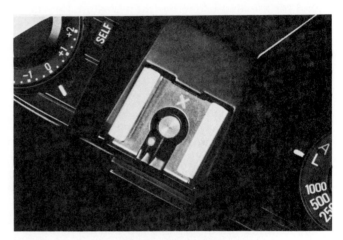

**18-10** *Hot shoe on camera.*

### Synchronization

To use flash with most cameras, the light must be *synchronized* (timed to coincide) with the opening of the camera's shutter, and this requires an electrical connection between the flash unit and the camera. Most better cameras have a connection for a *PC cord* from the flash unit (Fig. 18-9),* or a *hot shoe* on top of the camera body (Fig. 18-10). Some hot shoes are *dedicated*, meaning that they can use only a flash unit made specifically for that camera; others can accept any of several brands or models (read your camera's instruction book to learn which type your camera has). Of course, if your camera has a built-in flash, as most automatic cameras now do, no cord or shoe is needed.

Leaf shutters, which are found on many larger cameras, will synchronize with the flash at any time setting provided they have an "X" switch or contact on them. But focal-plane shutters, which are found on many 35mm cameras, present a special problem: the flash duration is much shorter than the time required for the shutter opening to travel across the film frame and make the exposure (see Fig. 2-32). To avoid the partial frame exposure that would result, the flash must be used only with shutter settings that expose all of the frame simultaneously. Shutter dials often have the shortest time at which this occurs marked in color or with a special symbol (Fig. 18-11).

**18-11** *Flash setting on focal-plane shutter dial.*

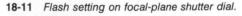

---

* If the camera has both X and M connections, use the X for electronic flash and the M for chemical (one-use) flashbulbs.

## Exposures with Flash

Exposures with flash are affected by most of the same factors that affect exposure with natural light: intensity, film sensitivity, and aperture. Shutter time settings (as noted above) and the lamp-to-subject distance are also important. The inverse square law, a basic principle of physics, states that as light spreads out from a source, its intensity diminishes as the square of the distance increases. In other words, at twice the distance from the source, there is only one-fourth the intensity of light. Small changes in the light-to-subject distance, then, will produce large changes in the illumination on that subject.

Modern electronic flash units usually have a sensor to measure the luminance of the flash reflected by the subject just like an exposure meter does. The sensor is connected electronically to the flashtube, and when enough light has been reflected back to it from the subject (according to the ISO rating of the film for which you have preset it), the remaining flash charge is sidetracked into a storage capacitor where it is saved for the next use rather than wasted. Recycling time is thus shortened and battery life extended.*

The closer to the unit the subject is, the shorter the duration of the flash. When these flash units are used very close to a subject (5 ft or less), the actual exposure time (the duration of the flash) may be so short that reciprocity failure may be experienced (see p. 31). Under such circumstances the development time (of black-and-white film) may have to be increased for adequate negative density.

Some dedicated flash units for auto-focus cameras also contain an infrared focusing system to allow the camera to focus its lens before the flash illuminates the subject (the flash alone would be too brief for the focusing system to respond).

Flash units for older cameras usually contain a calculator that *correlates the light distance with the aperture.* This is the critical relationship. Users of older flash units that do not have such calculators on them, or flash units made for chemical (one use) bulbs, must refer to *guide numbers.* Tables of these numbers can be found in the instructions supplied with the units or on the flashbulb packages. *Divide the guide number by the lamp-to-subject distance (in feet) to obtain the correct aperture setting.* For example, if your subject is 15 ft away from the lamp and the guide number is 120, set the aperture at f/8.

## FLASH TECHNIQUES

Because flash is often preferred for its convenience, techniques for using it should be simple and convenient too. The easiest and most popular techniques are single flash and bounce flash. Multiple-flash tech-

niques are more complicated, but they often provide superior results.

### Single Flash

A guiding thought we mentioned for continuous (flood) lighting deserves to be echoed here: *keep it simple.* And what is simpler than a single flash unit on the camera? This, of course, is where most flash units are used, and for sheer convenience, you can't beat it. But for photographic effectiveness, it's hard to pick a poorer location: the light is so close to the lens axis that faces and objects flatten out under its even illumination, backgrounds are underexposed, and shadows sometimes add a grotesque dimension to figures (Fig. 18-12). With a single flash, your only light is a key light, so careful placement of it makes all the difference.

If the situation demands quick recording, as fast-breaking news events or candid photographs usually do, the ability to respond quickly outweights all else. And with most simple cameras, of course, it isn't possible to move the flash to another location.

But in most other situations, the picture will be improved if the light is lifted a foot or two above the camera and slightly to one side. Extension cords for flash units (Fig. 18-13) make this possible. Watch out for windows, mirrors, or shiny surfaces that will kick the flash right back to the camera lens; avoid this by aiming the light obliquely rather than squarely at the

**18-12** *Flash-on-camera effect.*
*Farm Security Administration photograph.*
*The Library of Congress.*

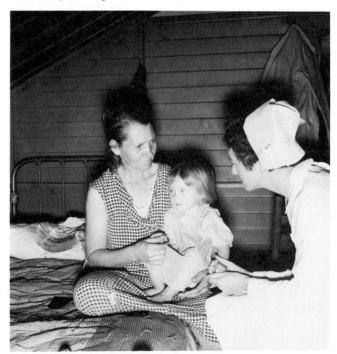

---

* In some older units, the unused charge is directed to a "quenching" circuit where it is dissipated, and this requires a full recharging cycle for the next use.

**18-13** *Flash unit used with extension cord.*

surface. People with eyeglasses present a similar problem: ask them to tilt their head downward ever so slightly; reflections will then be directed below the camera rather than into it. Finally, if you have an older flash unit that is not equipped with an automatic sensor, figure the exposure on the subject's distance from the *light*, not the camera.

## Bounce Flash

Bouncing the flash off a reflecting surface such as a low, light-colored ceiling is another effective way to use a single flash. Many flash units allow you to aim their heads upward while attached to the camera (Fig. 18-14). Instead of the light striking the subject

**18-14** *Flash unit on camera with head angled upward.*

**18-15**  *Bill Owens: Self-portrait with a Friend.* © *Bill Owens, from* Suburbia.

directly, most of it bounces off the ceiling and falls softly as a broader, more diffused source. Bill Owens shows how this works (Fig. 18-15). Here he bounces the light off the ceiling; his light falls softly on the dressing table and is not blasted back to the camera by the mirror.

Bounce flash works well for closeups of people and interior details: its soft light from above avoids the unpleasant shadows and risk of overexposure that sometimes accompany direct flash at close range. And bounce flash often is the best way to illuminate the greater field of view covered by a wide-angle lens.

Modern flash units make bounce-flash exposures easy and automatic, but older units without exposure sensors require an increase in exposure due to the greater distance the light must travel. Two or three f/stops more will usually suffice.

### Multiple Flash

Just as pictures with flood lights are usually improved by using separate lights for different functions, such as key light, fill, or accent, better flash

pictures can often be made with more than one light source. Multiple flash takes more time to set up than single flash does, but it softens the blunt, intrusive effect of a single flash on the camera and gives the subject a more natural appearance. As with flood lights, a second flash unit allows you to use key and fill lights for better modeling and more even illumination. You can see the effect in Russell Lee's photograph (Fig. 18-16). The key light was placed high and to the left side, where it outlined the woman and child. A second light on the camera softened the shadows of the key light, and gave good detail throughout the picture.

Although Lee made his photograph years ago with manual equipment wired together, many modern flash units contain an electric eye or trigger that will set them off in response to another flash nearby. Some are made expressly for this purpose; these are called *slave units* since they flash only when the camera light does, and need no connecting wires. They can be used as key, fill, accent, or background lights, and can be fastened to a stand or clamped to anything handy like a door or curtain rod.

**18-16** *Russell Lee: Lunchtime at the Nursery School, FSA Mobile Camp, Odell, Oregon, 1941. The Library of Congress.*

Exposure with multiple flash is no different than with a single light, so long as each light serves a different function. As with flood lights, *exposure is based on the key light*, not the fill. If you must figure the exposure manually and the off-camera light is your key, calculate the exposure from that light rather than the camera's position.

### Synchro Sunlight

This technique uses a single flash on the camera as a fill light to soften or open shadows cast by the sun (Fig. 18-17A). When people are photographed outdoors, for example, they can turn their backs to the sun so that their faces are in the shade. This eliminates squinting (Fig. 18-17B). A flash used on the camera will then lighten the facial shadows (Fig. 18-17C).

Exposure with this technique is based on sunlight, just as with other outdoor situations. Automatic cameras will usually handle such situations pretty well if they are at least six feet from the subject. With manually set cameras, the technique is a little more involved:

1. First, set the shutter at the time or speed recommended for flash with that camera.
2. Then use the meter (internal or hand-held) to determine the correct aperture.
3. Divide that f/ number into the guide number for the unit to determine the proper distance needed from the flash to the subject.
4. Positioning the camera at that distance will balance the effect of the flash and the sun. If you wish to move in closer to the subject, hold a single thickness of a handkerchief over the flash to soften and diminish it; this will give a more natural effect.

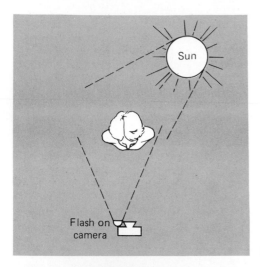

**A**

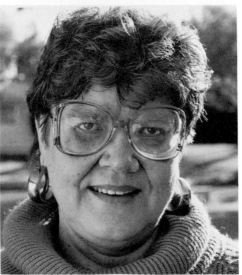

**B**

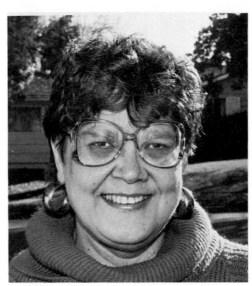

**C**

**18-17** *Synchro-sunlight technique.* **A:** *Diagram of setup.* **B:** *Photograph made without flash.* **C:** *Photograph made with flash fill.*

## SUMMARY

1. To photographers, artificial light is light that can be controlled at its source. Its most important forms are continuous light (*tungsten-filament* and *fluorescent*), and intermittent light (*electronic flash*).

2. *Photoflood bulbs* are ordinary light bulbs specially made to give brighter light over a shorter life. Many are balanced for 3200K and can be used with tungsten color films without filters. *Tungsten-halogen lamps* are also widely used, but these compact lamps get very hot and require well-ventilated fixtures. All photo lamps have ASA code designations.

3. The four fundamental functions of artificial light are: *key light*, *fill light*, *accent light*, and *background light*. Artificial light should be simple, and be built one function at a time. Always check the light from the camera position.

4. The *key light* dominates a scene and casts the most important shadows. It defines shapes and sets the mood of a scene. The *fill light* softens the shadows of the key light to reveal tone and color in them. *Accent lights* emphasize details or small areas, while a *background light* separates a subject from the space around it and adds depth to the picture.

5. For portraits, several basic lighting styles are useful. *Short light*, which can make a full face appear slimmer, is the most popular. Here the key light illuminates the side of the face away from the camera. *Broad light*, which can make a thin face look fuller, directs the key light to the side of the face nearer to the camera. *Butterfly light* (named for the small shadow it produces under the nose) uses the key light directly above the camera and lights the front of the face fully. It tends to emphasize cheek bones and minimize a protruding nose, and is often used in glamour photography.

6. When *posing* people, work quickly and simply. Angling one shoulder toward the camera usually gives the picture more depth and a more natural appearance. Have at least four feet of space between the subject and the background, and use a longer-than-normal focal-length lens, if possible, so that the camera can fill the frame from at least six feet away. That way distortion will be minimized.

7. Most small objects are basically *cubes*, *cylinders*, or

*spheres.* The lighting setup is similar to that for portraits, but the position of the key light varies. *For cubes, the aim is to show three sides as separate planes,* revealing shape and depth. Three lights (key, fill, accent) are needed, and a background light is often useful. *For cylinders and spheres, the aim is to show roundness.* This requires key and fill lights, with accent lights if needed to highlight important details.

8. *Shadowless lighting* is useful for objects that have shiny surfaces or important black areas. It is usually created by bouncing one or more key lights off of a reflecting surface, such as a white card or umbrella, thereby creating an area of soft, diffused light. *Combined shadowless and key light* offers the advantages of both together. The setup is basically shadowless (indirect) for easy adjustment from one object to another, but an accent (direct) light can then be positioned to model the shape enough to reveal it.

9. *Electronic flash* has three advantages over flood lighting: it is portable, quick, and similar in color to daylight. Its disadvantages: it cannot be set up as freely as flood lights, nor studied as carefully before you use it. The extremely brief flash is created when an electric charge is conducted through ionized xenon gas in a small glass tube.

10. The flash must be *synchronized* with the opening of the camera's shutter. This is usually done through a *PC cord* or *hot shoe* on the camera. Some hot shoes are *dedicated*, accepting only a flash made specifically for that camera; others are universal. Leaf shutters synchronize at all speeds, but most focal-plane shutters synchronize only at certain settings.

11. The most important factor in flash exposures is the *lamp-to-subject distance.* Most newer units contain sensors to control the flash duration automatically, but older units require manual calculators using *guide numbers.*

12. A *single flash* technique usually works best if the flash is held slightly above and to one side of the camera rather than on the camera itself. This requires an extension cord but drops many shadows out of the picture.

13. *Bounce flash* techniques aim the light upward, bouncing it off a light-colored ceiling or white card to fall softly and broadly on the subject. Bounce flash works well for closeups of people and for wide-angle interiors. Older, manual flash units require an increase in exposure to compensate for the longer light-to-subject distance involved.

14. *Multiple flash* techniques allow you to assign functions (key, fill, accent) to two or more lights simultaneously, placing them to improve the picture's depth and background detail. *Slave units* allow the various lights to be fired simultaneously without wiring them together. Exposure is based on the key-light distance.

15. *Synchro-sunlight* techniques use direct sunlight as a key or accent light, with the flash unit on the camera filling in the shadows. This is useful for outdoor portraits, since people can face away from the sun and thus avoid squinting. Exposure is based on sunlight and is easiest with an automatic flash unit.

# CAREERS AND EDUCATIONAL OPPORTUNITIES

Photography touches our lives in so many ways that it would be hard to describe all the opportunities it presents to someone seeking a career. In a society that uses visual communication so widely, the opportunity for employment in some form of photographic activity is limited only by how willing we are to look for it. New careers continue to grow from new technological developments and from a steady increase of leisure activities in our society.

## PHOTOGRAPHY AS A CAREER

Taken as a whole, the photographic career field is primarily a *service business* , although an important manufacturing one lies at its base and makes that service possible. Photography is the keystone of other major industries too. Printing, electronics, and information storage and processing systems, for example, all rely heavily on it for many of their manufacturing processes. Photographic skills are also a valuable asset to many people in other fields such as medicine, education, business, and engineering. But as a service business, photography is fundamentally concerned with *people and their needs*; it helps satisfy their desires to express themselves, to learn, to communicate with others, and to get more enjoyment out of life.

Certain types of photographic work have become well defined by practice, and it may be helpful to anyone considering such a career to describe some of the more important ones here.

## INDUSTRIAL PHOTOGRAPHY

An industrial photographer's work generally supports that of other people working in the re-

search, development, production, marketing, and public relations areas of a corporation. Thus the industrial photographer is an important member of a team, a communications specialist whose assignments vary from routine reproduction tasks to imaginative problem-solving. Some of the photographic services an industrial photographer provides may represent the best way to gather certain data; others may be the only way to accomplish a particular task.

Scientists and engineers use photography constantly. When attached to the proper devices, a camera can reveal things too small for the human eye to see and events too brief for it to observe. Through time-lapse techniques, an event that occurs too slowly for humans to perceive can be seen in its true relationship. As Figures 19-1 and 19-2 suggest, the nature of industrial and corporate photography is as varied as the businesses themselves are. In recent years this has been one of the fastest-growing segments of the field, supporting the rapid and imaginative expansion of technology in our society. Frequently this type of work offers the additional benefits of employment with a large and well-established company.

## COMMERCIAL PHOTOGRAPHY

This is another wide-ranging category of photographic work. Generally the commercial photographer is a business person who serves the needs of other businesses much like the industrial photographer serves a corporate or governmental employer. The typical commercial studio business is small by corporate standards, and specialization is common in this area. Architectural

267

**19-2** *Lewis Stewart: Lineman Dave Inouye changes an insulator on a 115 kilovolt power line, 1988. Courtesy Pacific Gas and Electric Company.*

views, advertising illustrations, product photographs (for instruction booklets, service manuals, and catalogs), educational and training materials, photographs to support legal proceedings—these all are examples of work loosely categorized as commercial photography. Figures 19-1 and 19-3 are typical of commercial work. Although commercial photography is a steadily expanding field, it is highly competitive and difficult for a new person to break into without an on-the-job apprenticeship to gain relevant experience.

Apprenticeships give one the opportunity to learn by assisting a professional photographer with actual assignments rather than by simulating such problems as schools commonly do. Most arrangements provide a small wage during the training period, during which the trainee is exposed to much of the studio's routine work and business. Agreements usually are temporary, but they can often lead to regular employment at a later date.

Success in commercial photography and in portraiture (described below) rests heavily on a number of factors, four of which are crucial. First, a successful commercial photographer must be able to *understand the client's needs in the client's own terms and language.* Second, the photographer must have *imagination* and the *artistic and technical ability* to produce pictures that communicate the ideas and show the products of the client to best advantage. Third, the photographer must be able to *work under the*

**19-3** *Tom Wyatt: Banana split, 1984. Courtesy Tom Wyatt Photography, San Francisco.*

*direction of others*, and to deliver the photographs on time. What a commercial photographer sells, of course, is primarily service, not merchandise, and if a good working relationship with clients (who are business people themselves) can be built and maintained, a photographer should be able to capture an impressive part of this competitive field.

A fourth factor in the success of a commercial or portrait studio is the *owner's profit motive*. This incentive is particularly important to a photographer who will often be tempted to sacrifice good business practice for artistic excellence. A balance between these two aspects is necessary if the business is to survive. And since new commercial or portrait photographers can rarely afford to hire business man-agers, *they should have basic business training and skills themselves.*

## PORTRAIT PHOTOGRAPHY

Because they are oriented toward local consumer markets, portrait studios are more visible to the public than other segments of the photographic industry. They are also more traditional. *Portraiture, of course, means dealing with people*, and a high percentage of successful portrait studios do well because they cater to the wants and life styles of their communities. Although most portraits are made in studios, many

**19-4** *Judy Tembrock: Environmental portrait, 1987.*

are also made in client's homes or outdoors. Judy Tembrock's environmental portrait (Figure 19-4) is a fine example. Portraiture also includes weddings and school groups, the latter a profitable segment which can be used to introduce the studio product to the community.

A great deal of portraiture for today's consumer market is done by regional and national chains or their franchise operators with portable studio setups in department stores and shopping centers. Typically, orders are processed at centralized laboratories and returned to the local outlets for delivery. One-hour portrait studios, which process the photographs on the spot while the customer is shopping nearby, represent the latest variation on this marketing idea. The rest of the business is done by independently owned studios, and about 80 percent of these are individual proprietorships with few employees.

As a rule, then, the field offers a career opportunity primarily to a man or woman starting an independent business, but because this trade is easily entered it is fiercely competitive and not always profitable to a newcomer. Many people enter the business by photographing weddings; a knack for dealing with people and the ability to produce and sell a quality product are vital for success.

## GRAPHIC ARTS PHOTOGRAPHY

This field is part of the printing trade, where offset lithography now dominates all other ink-on-paper processes. Offset uses photography for its basic pro-

duction methods, and wherever printing is done, graphic arts photography will be found. Some segments of this area, such as newspaper, magazine, and book production, and the manufacture of printed packaging, are large, well-established fields. Precision applications of graphic arts photography include map-making and the reproduction of engineering drawings.

*Graphic arts photography is precise mechanical work.* Recent advances in printing technology, including the use of laser scanners (which have revolutionized color printing), have required greater skill of technicians in this field, especially in those aspects of the work that precede camera operation. *Computerized, digital image processing is now widely used in this area*, and anyone who would like to enter this field should be familiar with computers and how they work.

## PHOTOGRAPHS FOR THE MEDIA

The field of newspaper and magazine photography, once clearly defined, has been reshaped by television and by recent advances in color printing. Motion picture and video production now accounts for a large share of this market, and consumer magazines that once were primarily black-and-white photography markets are now almost exclusively color. Such publications rely heavily on *free-lance photographers*, who sell their work through *agencies* to any meida that will buy it. Although easily entered, free-

lancing is a highly speculative business, often conducted part-time by people who are also otherwise employed. *Stock photographs* (made for a library or file, from which reproduction rights for their use are sold over and over to different buyers) are an important aspect of this business, and photographic skills are easier to market if you also have reportorial skills and can write a story to accompany the pictures.

Entry opportunities are more frequent on small-town and weekly publications and in public relations work; employment on large, daily newspapers almost always requires at least a four-year college degree. Media photography today includes the production of stills, films, and video programs for television use. This is another highly competitive area where an apprenticeship will be helpful.

## PHOTOGRAPHIC RETAILING

This field is part of a larger consumer market that has grown as increasingly automatic cameras make picture-taking easier than ever before. Much of the photo retailing scene, like that of many other consumer products, is now centered in mass-merchandising outlets such as department and discount stores. Independent, specialty photo dealers, although much less numerous, are organized to sell service and advice, along with their merchandise, to a product-oriented market sustained by heavy consumer advertising in TV and print media.

*A pleasant personality and an effective selling technique are prime requirements for this work.* Photographic training is helpful, of course, but your abil-

ity to sell will be valued more than a thorough knowledge of products and their uses. The field is often used as a step to other kinds of work.

## PHOTOFINISHING

This highly automated and computer-controlled area of photographic work has two major segments. One is closely related to the retailing business just described, and is geared to *process the thousands of rolls of color film* dropped in mailboxes and left each week at drug stores, photo shops, and other retail counters everywhere. Competition for new and repeat business is very keen, and the work is profitable only in large volume with highly mechanized handling. Order sorting and other manual work is done largely by unskilled people trained on the job.

Skilled openings in wholesale photofinishing go to people with demonstrated managerial ability and a working knowledge of photographic color processes, chemistry, electronics, or computer systems. The retail finishing trade is very seasonal, although advertising has helped to spread its volume over more of the winter months. One-hour labs in camera shops and shopping centers are now an important part of this business.

The other segment of photofinishing is related to the commercial and portrait businesses discussed earlier. This aspect is known as *trade* or *custom finishing*. Here the emphasis is on producing photographs that will be resold under the photographer's own name. Such clients demand high quality and prompt service at fair prices. Custom labs (Fig. 19-5)

**19-5** *Kevin Scott: Finishing a display print, 1989. Courtesy Custom Color Lab, Palo Alto, California.*

tend to employ more skilled people than other finishers do, and usually provide a variety of specialized services. Most handle only color, but a few do black-and-white work too. They are located in every metropolitan area of the country, and the field is still expanding.

## PHOTOGRAPHIC MANUFACTURING

The manufacture of photographic supplies and equipment, of course, is fundamental to all the other industries mentioned here. For many years, most American photographic manufacturing was located in Rochester, NY, and in a few other northeastern cities. While much of it is still concentrated there, it is now an international industry.

American manufacturing is heavily concentrated on films and papers, processing chemicals and supplies, and on some highly specialized photographic equipment used in commercial, industrial, and photofinishing work. Most cameras and many other products are imported.

Relatively few jobs in this manufacturing industry require photographic skills, but they do call for various technical abilities common to many other industries: chemistry, optics, accounting, business management, marketing, technical writing, advertising, and a variety of engineering skills. Photographic skills *are* needed, however, by people who represent a manufacturer to its ultimate customers, especially to the commercial, industrial, and media segments of the field. Manufacturers technical service representatives, or "tech reps" as they are called, must know their company's products thoroughly, and also how those products can solve a studio's or client's problem. Much of the work these tech reps do is educational—showing photographers how to get better results for their customers, as shown in Figure 19-6. Other requirements are similar to sales work.

## PHOTOGRAPHY IN EDUCATION

Because photographs have unparalleled power to convey information and ideas, they are indispensable tools in education and in academic research. Yesterday's *visual aids* have become today's *visual lan-*

**19-6** *Kodak Technical Service Representative (TSR) at work. Reprinted courtesy of Eastman Kodak Company.*

*guage*, vital to the instructional process at every level.

Many school districts, colleges, and universities employ photographically trained personnel. If you enjoyed your school or college experience, or are considering teaching as a career, don't overlook this area for applying your interest in photography. The stimulation that comes from helping other people shape their lives and their future is rewarding to many who choose careers in the educational field.

## OPPORTUNITY FOR ALL

Our brief look at the photographic career field is by no means complete; only its major segments are described here. Relatively few people engaged in photographic work are photographers in the sense of creating original images. Many, many more are technicians, trained and qualified in one or more aspects of this wide-ranging field. But because photography plays such an important part in so many areas of human endeavor, it deserves serious consideration by anyone who is planning for the future.

*Photography has opportunities for physically limited people too, particularly for the blind.* Some operations at various levels of skill must be performed in total darkness, where lack of sight is no obstacle. Manual dexterity, however, is necessary, but many people with other limitations can find rewarding work in a photographic career.

Although some segments of photographic work (particularly in graphic arts, television, and the print media) are covered by organized labor contracts, *the field as a whole is not.* Some industrial photographers and photo technicians may be included in agreements that also apply to co-workers in other departments. But in the areas of portraiture, weddings, commercial photography, and advertising illustration (known collectively as *professional photography*), *the field is comprised of many very small businesses.* Compensation therefore is determined largely by the usual factors of supply and demand, and to a lesser extent by education and experience. As a rule, though, people who have specialized training and some college education begin with higher wages or salaries, or tend to advance more rapidly, than those who do not have these advantages. And many mid-management positions in industry require at least a two-year college degree.

## PHOTOGRAPHIC INSTRUCTION PROGRAMS

Photographic instruction is offered by more than a thousand American colleges and universities. It tends to be concentrated in art and communication or journalism departments, reflecting its major ex-

pressive and communicative functions. Some programs are also found in departments of industrial arts, physical science, and photography, television, or motion pictures alone. In recent years more than 500 college and university departments offered a major photography program leading to a *bachelor's degree*, and there is every indication that the number has grown since then. More than a hundred community colleges offer an *associate (two-year) degree* in photography, while nearly a hundred universities have *graduate programs* leading to master's degrees in art, fine arts, communication, and photographic science.

### Academic Degree Programs

A closer look at these college and university programs shows that they vary widely in aims and means. Like the career field itself, photographic instruction has no standardized content in the United States. Even at the entry level, courses with such common titles as "basic photography" differ markedly in objectives, content, and means of evaluation. This need not be a problem if you are willing to shop around before applying for admission; that way, you'll be more likely to find a program suited to your own particular interests and needs. But these same differences between programs make evaluation of them on any basis other than individual achievement rather difficult.

Community-college programs in photography tend to be closely related to local or regional job opportunities, although many of them also offer fine arts instruction as well. Most community colleges offer you the chance to begin your academic study there and then transfer the work completed to a university for credit toward a four-year degree. There is no standard pattern, and *transferability should not be assumed, but checked out in advance.*

Programs at four-year colleges and universities show the greatest variety of both objectives and resources. Most reflect the expertise of their instructional staffs and the capabilities of their equipment and facilities. Art-department programs dominate the undergraduate level, with communications or journalism-related ones a close second. Numerous other programs are related to educational technology and the development of instructional materials, and a few specialized ones provide technical training in the closely connected areas of computers, electronics, and photographic engineering. At some colleges, courses in still photography and video are important units of broadly conceived, liberal arts programs in the humanities and interdisciplinary studies.

*Graduate programs in photography,* according to a recent survey, *are primarily centered in the fine arts*, but many are offered in film-TV and graphic arts as well. As a rule, these are focused primarily on preparing people to become teachers, and entry to these programs is usually limited and competitive.

**19-7** *William Bullough: Jay Dusard (right) and Huntington Witherill (center) lead a field camera demonstration at Point Lobos during The Friends of Photography's Annual Members Workshop, 1986. Courtesy The Friends of Photography.*

### Workshops and Short Courses

In addition to the academic degree programs described above, numerous independent organizations and art centers offer short courses and workshops from time to time. These cater to individual interests or specialized topics, and many of them offer you the chance to learn from a distinguished photographer or artist in an informal atmosphere (Fig. 19-7). Most vary in length from a a day or two to several weeks, and they are widely available internationally each summer. The Friends of Photography in San Francisco, the International Center of Photography in New York, The Photographic Center of Monterey Peninsula in Carmel, California, and the Maine Photographic Workshops in Rockport have extensive and varied programs. Information on many other such courses can be found in *Afterimage* (see bibliography, under Periodicals).

---

### FURTHER INFORMATION

An excellent source of additional information on formal educational programs in the United States and Canada is a periodic assessment compiled by the educational community and published by Eastman Kodak Company. *A Survey of Motion Picture, Still Photography, and Graphic Arts Instruction* lists more than a thousand colleges, universities, and technical institutes that offer some kind of photographic instruction beyond the high-school level. It notes the general types of courses offered by each responding school and indicates the departments in which they are located. It also extracts various tabular data from the survey replies. Copies of this publication are available for a small charge from Eastman Kodak Company, Department 454, Rochester, NY 14650. Ask for Publication No. T-17 by the title above.

Another useful book that expands the information in this chapter is *Opportunities in Photography Careers* by Bervin Johnson, Robert E. Mayer, and Fred Schmidt (see bibliography, under General Works). This book describes the career field in general terms, outlines a few of the more specialized college programs that prepare one for it, and lists many more sources of additional information.

The best way to determine whether a particular program is what you are looking for is to visit the department where it is offered. Talk to the staff and the students, look at the work being done, and ask what the graduates of that department are doing. Also ask about entry requirements, openings (many departments have limited space), and costs. These vary widely, and in most programs you must furnish part of your equipment and materials in addition to paying tuition and fees. The more firsthand information you can obtain in this manner, the better equipped you will be to choose the best opportunity available to you.

Good hunting, and good luck!

# SUMMARY

1. The photographic career field is primarily a *service business* concerned with *meeting the wants and needs of people*. An important manufacturing business, however, lies at its base and makes the service possible.

2. *Industrial photographers* generally support the work of other people in the research, development, manufacturing, marketing, and public relations areas of a company.

3. *Commercial photographers* are business people who serve the needs of other businesses in the community. Many specialize in architectural, advertising, or product photographs. Entry to this field is often through an *apprenticeship* to gain the necessary experience. Business skills as well as photographic ones are needed to ultimately be successful.

4. Portraiture is the photography of *people*, and a knack for dealing with people is a primary requirement here. *Weddings and school groups* are part of this area, and much of today's portraiture for consumers is done by chains and franchisers.

5. *Graphic arts photography* is exacting mechanical work, used to prepare plates for ink-on-paper printing. This trade, which is dominated by offset lithography, increasingly relies on laser scanners and computerized image processing.

6. Photographs for the media—*newspapers, magazines, and television*—are a major segment of the industry. Newspapers still rely heavily on black-and-white, but consumer magazines are now virtually all color. Many publications rely on free-lance photographers, who sell their work through agencies. Stock photographs (for which only the reproduction rights are sold) are also part of this area.

7. *Photographic retailing* is largely centered in department and discount stores, but some independent photo dealers specialize in selling service and advice as well as merchandise. *Ability to sell* is the major qualification for this work.

8. The *photofinishing industry* has two parts. One processes large volumes of color films for drug stores, camera shops, and other retail outlets. This segment includes thousands of one-hour labs, is highly automated, and employs relatively unskilled people. The other part of the finishing industry includes *trade or custom laboratories*, which process and print work for professional photographers. These labs employ skilled people and generally handle only color work.

9. The *photographic manufacturing* industry is the one that makes all the others described here possible. Most jobs in this industry do not require photographic skills, but "tech reps," who represent the manufacturers to their customers in the commercial, industrial and media fields, need sufficient photographic training to help customers solve their problems.

10. The field of *education* offers many opportunities to apply photographic skills in the production of visual materials to support teaching and research.

11. Photography has employment opportunities for the *physically limited* too, especially for the *blind*. Much photographic work is done in total darkness, where lack of sight is not an obstacle.

12. *The photographic field as a whole is not covered by organized labor contracts*, although certain areas of it are partly unionized. Some portraiture and most commercial photographs are produced by *very small businesses*, who base compensation largely on supply and demand. As a rule, people who have some specialized training begin with higher wages or salaries, and advance more rapidly, than those who do not.

13. More than a thousand American colleges and universities offer photographic instruction. It tends to be concentrated in art and journalism or communication departments. Many institutions offer programs leading to an academic degree. Additionally, many independent art centers and similar organizations offer workshops and short courses where you can learn from a distinguished photographer or artist. Such programs are widely available in the summer.

# 20

# IMAGE AS OBJECT
## Looking At Photographs

We began this book by describing how photographs differ from other kinds of pictures, and by noting that although they are based on objects or experiences in the real world, photographs essentially are concerned with creating an illusion of reality rather than reconstructing it. We have also shown how photographs can be created from an internal world of thoughts and feelings as well as from an external one of objects and events, and how they do not always have to be pictures of something, but can simply be pictures.

When we create a photograph, we often begin by perceiving what is before us with the help of what is within us. Consciously or unconsciously, all that we are and all that we know influence the way we visualize our images. We select our subject or "raw material" and a point of view. Sometimes we carefully plan the picture space or choose the best moment for the exposure; at other times we may work quickly and impulsively. When we think everything is right, we make a picture. Sometimes we continue working with the image in the laboratory or darkroom, postvisualizing the photograph through yet another stage of its development. But no matter how we produce it, at some point or other the image is cast free to begin a life of its own. Exit now the photographer, the image maker. Enter here the viewer and the critic.

## HOW WE LOOK AT PHOTOGRAPHS

We make a photograph one way, but we look at it another. The image does not take shape before us step by step, as it did when we made it, but instead confronts us all at once. Unlike a video or a movie, a still photograph exists complete in a single moment of time; no assembly is required.

We come to know the picture, as a rule, much more slowly. It usually contains more than we can grasp in a single glance, so we need time to examine it. The still photograph has an advantage in this respect over the moving picture: it isn't fleeting; it doesn't disappear.

If the image states its theme vigorously and has sufficient impact, it will usually compel our attention. And if the picture presents its message in an imaginative way, it will usually retain our interest. Walker Evans's famous Bethlehem scene (Fig. 20-2) has these qualities. Looking at this picture, we can imagine the lives of people in these houses, lives perhaps beginning there, being sustained by the products of the blast furnaces beyond, and ending eventually in the foreground to overlook the places where they lived and worked. Ellen Land-Weber's richly detailed photograph of a lumber company's blacksmith shop in Scotia, California (one of the last company towns in the United States), also has a story to tell (Fig. 20-3). Here is a visual narrative, a bit of history still functioning in the present, and raising the question of how long it will continue to be useful.

Reading these rich images for the stories they contain can be rewarding in the same way that a good literary narrative is absorbing. Many other photographs in this book have likewise been chosen for the quality of visual experience they contain. Not all tell a story, but each has something to say to us if we can see it.

**20-2** *Walker Evans: Bethlehem, Pennsylvania, 1935. The Library of Congress.*

**20-3** *Ellen Land-Weber. Pacific Lumber Company Blacksmith Shop, Scotia, California, 1987.*

## WHAT WE SEE IN PHOTOGRAPHS

New photographers are often surprised to learn that what people see in their photographs is sometimes different from what the photographers think they are showing them. People, being human, see what they want to see in a photograph, as in anything else they experience. This may or may not be what is actually there, for what people will allow themselves to see in a photograph is conditioned by many external and internal factors. Automatic behavior, for example, often governs our reaction. If three or more different sounds reach us at the same time, we tend to respond to the loudest and screen out the others. Similarly, we tend to see moving objects more readily than still ones, and bright reflections in a picture more easily than darker values.

But photographs that look simple are often complex, demanding more from us than a single-level response. Consider, for example, John Mickelson's photograph of a San Francisco street vendor hawking his wares during the Pope's visit (Fig. 20-4). The picture raises many questions about the occasion and how different people responded to it.

Margaret Bourke-White's picture (Figure 20-5) illustrates another important point: a photograph removed from its original context may convey a new or different meaning. Sent by *Life* magazine to photograph the great Ohio River flood of 1937, Bourke-White found these black refugees from a flooded section of Louisville waiting in line for food. Ironically, however, the billboard against which she photographed these victims gives a completely different meaning to the picture today.

The way we respond to any photograph, of course, is as individual as we ourselves are. We're always comparing what we see with what we know, judging the picture's message by whatever has meaning in our own life. This process is different for each one of us, and it tends to explain why two people can look at the same picture and get completely different messages from it.

**20-4**  *John Mickelson: Street Vendor, Pope's Visit, San Francisco, 1987.*

**20-5**  *Margaret Bourke-White. At the Time of the Louisville Flood, 1937. LIFE Magazine © Time, Inc.*

## OBSTACLES TO SEEING PHOTOGRAPHS

Because photography is a cognitive art, a way of learning and knowing things, we tend to make certain demands on photographers and their images. One of these is our frequent insistence that a photograph should resemble something real, that it should present such a convincing illusion of reality that we need not consider it an illusion at all. *Identity* is a very strong element in photographs, one that isn't easily set aside. Yet we must be prepared to do this occasionally if we are going to see photographs with open eyes and allow ourselves to be reached by them. We must be able to get beyond the "picture of" syndrome to see what else might be there. Even a simple, direct image like Mathias Van Hesemans's photograph of lava (see Fig. 13-2) might suggest to us something quite different from its subject matter.

Such awareness does not come easily; too many things get in the way. A few of these obstacles are familiar photographic ones, technical flaws that obscure the photographer's intentions before anyone else can encounter the image. But *most of these ob-structions lie with us as viewers*, not with the photographs, and they are therefore harder to recognize. Personal experiences that are vivid in our mind, for example, may steer us sharply to one interpretation of a picture that inadvertently excludes other, equally valid ones. Or what we think a photograph should look like—a generalized preconception of the image—may not square with the example before us. These are perfectly human shortcomings, but they are obstacles nonetheless. Discarding such visual and mental constraints at the outset, if we can, will let us explore beyond them.

Christian Vogt's photograph (Fig. 20-6) provides a useful example. Through the simple device of one frame within another, Vogt successfully interjects a note of the supernatural into an image taken directly from the real world. The photograph functions on several levels; on one, dynamic tension between the clearly defined inner area and the vignetted elements outside it contributes to a sense of mystery. To perceive this we must be able to feel whatever stimulation to our senses his image offers. If we try to look at it with an open mind, more of the photographer's message will like come across to us.

**20-6** *Christian Vogt: Frame Series, 1974–75.*

## APPROACHES OR STYLES

Once we make contact with an image, the approaches or styles presented in Chapters 13–16 may help us understand what a photograph seems to be doing, and to judge how well it succeeds. We discussed the classic approach first, because it is easy to understand and also because most other approaches grew from it. Other major directions or approaches—journalistic, symbolistic, conceptual— were then presented in that order, corresponding to the increasing difficulty many people seem to have understanding them. High-contrast and related images, multiple images, non-silver processes, and color photography, although fitting all of the previously considered categories, were treated separately because of the different techniques involved.

*It is important to realize that any stylistic labels such as the approaches we have designated are only guidelines at best. Many photographs will appear to fit several categories because they are complex images that function in different ways for different viewers.* Criteria that we established for the symbolistic approach in Chapter 15, for instance, can be applied to numerous other photographs elsewhere in this book. Much contemporary work in particular is difficult to categorize, for photography today is going through a period of intense experimentation and varied stylistic growth, producing images that challenge traditional values and even question the very nature of photography itself. Although often confusing to the novice, such ferment can eventually reward both photographers and viewers alike, and any definitions of approaches in photography must remain open-ended to deal with such continual change.

## VIEWING PHOTOGRAPHS

The only way to experience what photographic images have to offer, of course, is to look at them. Ink-on-paper reproductions, such as those in this book, are a useful step in that direction, and good photographic copies, such as well made and projected slides, are even better. But original prints are the best of all. What photographers like Harrison Branch try to convey (Fig. 20-7) can often be communicated best

**20-7**  *Harrison Branch: Westgard Pass, California, 1982.*

through the subtle detail, color, and tones that are possible only in an original fine print.*

Most American and Canadian art museums and galleries display fine photographs just as they do other arts, and many do so continually. The following institutions, each of which has a large permanent collection of fine photographs, are most notable in this regard:

Ansel Adams Center, San Francisco
Art Institute of Chicago
International Center of Photography, New York
International Museum of Photography at George Eastman House, Rochester, NY†
The J. Paul Getty Museum, Malibu, CA
Minneapolis Institute of Arts
Museum of Fine Arts, Houston

The Museum of Modern Art, New York
Museum of Photographic Arts, San Diego
National Gallery of Canada, Ottawa
The Oakland Museum, Oakland, CA
San Francisco Museum of Modern Art
Smithsonian Institution, Washington, DC

A number of colleges and universities also have similar resources. Among the most important are:

Art Museum, University of New Mexico, Albuquerque
California Museum of Photography, University of California, Riverside
Center for Creative Photography, University of Arizona, Tuscon
Gallery of Fine Arts, Daytona Beach Community College, Daytona Beach, FL
Harry Ransom Humanities Research Center, University of Texas, Austin
Museum of Contemporary Photography, Columbia College, Chicago
Northlight Gallery, Arizona State University, Tempe
Photography at Oregon Gallery, University of Oregon Museum of Art, Eugene
Sheldon Memorial Art Gallery, University of Nebraska at Lincoln
Visual Studies Workshop, Rochester, NY

---

* The keen public interest in photographs today, as seen in the high prices that many fine prints command from collectors and museums, has created a more subtle but important distinction, and that is the difference between a vintage and a modern print. Increasingly, the work of many photographers no longer living is being reprinted from their original plates or negatives by others using modern materials. Sophisticated collectors, of course, can tell the difference, but the novice needs to be wary.

† Working exhibits of still and motion picture equipment are also on display here.

Fine photographs may also be frequently seen at commercial galleries in most metropolitan areas. These are among the most important:

Burden Gallery, New York
Fraenkel Gallery, San Francisco
G. Ray Hawkins Gallery, Los Angeles
Neikrug Photographica, New York
Nexus Contemporary Art Center, Atlanta, GA
Los Angeles Center for Photographic Studies
Lunn Gallery, Washington, DC
Open Space Gallery, Victoria, BC, Canada
Photographer's Gallery, Palo Alto, CA
San Francisco Camerawork Gallery, San Francisco
Silver Image Gallery, Seattle
Susan Spiritus Gallery, Costa Mesa, CA
Vision Gallery, San Francisco
Weston Gallery, Carmel, CA
Witkin Gallery, New York
Yuen Lui Gallery, Seattle

Traveling exhibitions of historic and contemporary work are circulated by several of the above-mentioned organizations. These, together with locally originated shows, often may be seen in college and university galleries and museums across the country. Additional public collections of fine photographs are indicated in the sources of many illustrations in this book. Wherever you live, travel, or study, go to these galleries and museums, and look for photographs that interest you.

Galleries exist primarily to sell work by the artists who exhibit in them, and if there is a better way to experience fine photographs than on gallery walls, it is living with them at home. Fine photographs, unless they are rare, vintage prints or are by world-famous photographers, are no more expensive than similar-size prints by artists of equivalent reputation in other media. The extent of a gallery's patronage (in sales, not merely traffic) will largely determine how long and how well it is able to present art for public enjoyment. Displaying photographs in our home, moreover, is a personal act: what we hang there reflects *our* feelings as well as *our* taste, and quality photographs, along with other works of art, should be accorded this honor.

## REVIEWERS AND CRITICS

People who go to museums and galleries comprise only a part of the photographer's audience. Others who live far from metropolitan areas, for instance, may depend on someone else to see the photographs for them, and then to report on their reactions to what they have seen. Serving the needs of these people as well as the gallery-goers is the job of the reviewer and the critic.

It may be useful at this point to draw a distinction between *review* and *criticism*. Constructive criticism must review the work at hand, but not all reviews need be critical. *Reviews, in fact, are largely informational.* They describe the exhibition or event, add some background information about the artist, and tell where the work may be seen. Reviewers often comment on what they believe are the photographer's intentions, but such remarks should be labeled what they are—opinion and comment rather than fact. *Informational reviews should be written for the viewer*; they aid the photographer being reviewed to whatever extent they enlarge the size and sharpen the interest of his or her audience.

A reviewer who makes a *judgment or evaluation* about an image or exhibitor, however, crosses a thin line and becomes a *critic*. The distinction is an important one, because with that step a reviewer claims the privilege of publicly expressing his or her own opinion about a photographer's work or worth. With this privilege go certain responsibilities to the audience or readers, to the photographer or artist, and to the critic himself or herself.

First, critics have a responsibility to the artist and the reader to demonstrate that they know what they are talking about. They should be familiar with major images from the past, recognize and relate the important styles and approaches that photographers have used over the years, and understand the major directions of contemporary photographic work. A conscientious critic will call the viewer's attention to the strengths of a work as well as its weaknesses, and will refrain from taking issue with a photographer's point of view merely because it differs from his or her own. Critics are entitled to be subjective as long as they are honest, but they have an obligation to define and defend their critical standards, and to explain their conclusions to both artist and audience alike.

The art of criticism, of course, is a different kind of exercise than the arts it examines. Nineteenth-century critics of photography had only the language of painting to use, and this proved troublesome. P. H. Emerson fared somewhat better, and Alfred Stieglitz provided a model that many others since his time have found useful. Today's commentators and critics include many thoughtful, well-educated writers like A. D. Coleman, Andy Grundberg, Max Kozloff, Esther Parada, and Jean Tucker who are contributing constructive ideas to the growing dialog about this lively art.

Because so much of the world has already been photographed and rephotographed, it is fair to ask photographers to defend their personal vision. This, too, should be part of a responsible critic's role, for perhaps more than anyone else, critics of photography are suitably posed to help photographers rec-

ognize and improve on their own best efforts. Such encouragement can be nourished by what the reviewer brings to his writings from the carefully considered thoughts of others, and from his own sensitivity as a human being. The reviewer's response can draw on collective thinking, yet be a strongly personal one that makes constructive criticism, enjoyable reading, and perceptive viewing. Yet all the obstacles to seeing a photographic image that we mentioned earlier in this chapter can ambush the unwary critic. Avoiding these obstacles is only a small part of his or her task.

Photography critics also have an obligation to speak clearly to their readers. Lucid, responsible criticism attracts a discriminating audience, but obscure and irresponsible criticism turns such people away.

Finally, each one of us who looks at pictures—for we, too, are the photographer's audience—has a duty to both the artist and the critic to see the work for ourselves. Our response to the critic, regardless of whether we accept or reject his views, must begin like our response to the photographer: from a firsthand appraisal of the latter's images. Only then can the critic, the photographer, and the audience help one another to grow and mature.

Looking at fine photographs firsthand can be rare and exciting experience, and a stimulating contribution to creative and joyous living. Isn't such a life, after all, the ultimate purpose of education and of art? And isn't it the affirmation of all that we value most highly?

## SUMMARY

1. We make a photograph step by step, but *view it all at once*, slowly discovering all that it contains. If it has sufficient impact, it will usually compel our attention. Some photographs release their message in a single glance; others need to be studied longer.

2. What people see in photographs is not always what the photographer thinks is in them. *People see what they want to see in photographs*, as in anything else. Different people can look at the same photograph and get different messages from it.

3. When we look at a photograph, *we must be able to get beyond the "picture of" syndrome*—our insistence that a photograph must look like something identifiable—to see what else it may contain. Most problems in this regard lie with us as viewers, not with the pictures.

4. *Approaches or styles* may help us understand what a photograph is trying to do. Those suggested here are only guidelines at best; many photographs will fit more than one category, and some of the best, which function on different levels for different viewers, may seem to fit almost all of them. *Definitions of styles must therefore remain open-ended* to deal with this.

5. *The best way to experience photographs is to look at original prints rather than reproductions of them.* Many art museums and galleries offer this opportunity. An even better way to experience fine photographs is to display them in your home and live with them.

6. *Reviewers describe exhibits* and the artists responsible for them; *critics make judgments* about the art or the artists. A critic has special responsibilities to the viewer or reader, to the artist or photographer being discussed, and to himself or herself as a critic.

# Appendix A
# INSTANT-PICTURE MATERIALS

Instant pictures first appeared in 1948, when the Polaroid Corporation introduced a revolutionary picture-making system developed by Dr. Edwin H. Land. One of the objectives behind the development of these materials was a quick process that would deliver a print while the original motivation for the photograph was still fresh in mind. Rapid feedback from the image to the photographer was the primary goal; instant processing in the camera or film holder helped to achieve it.

The value of this feedback for teaching people of all ages to become more perceptive has been amply demonstrated over many years, and numerous other business and industrial applications for these products have been suggested by their quickly accessible images.

Instant-picture materials, like other films, are based on light-sensitive silver halide emulsions, but they differ from conventional films in most other respects. All instant film units include three essential parts:

1. A photosensitive emulsion which is exposed in the camera.
2. A receiving layer or sheet on which the positive image is produced.
3. A pod of chemicals that process the image when they are spread within the film unit after exposure.

Opaque layers or envelopes protect the light-sensitive emulsion from unwanted exposure to light. With the single exception of positive-negative films that provide both prints and finished negatives, only the positive image is retained in a usable, permanent form. Certain materials are designed to be peeled apart after development, while others are integrated, automatically timed packages that need no further manipulation.

## EXPOSURE

Instant-picture films must be exposed in cameras designed for them or in special adapter backs that permit their use with other cameras and scientific instruments. The CB-100 Land Camera Back adapts Polaroid film packs to many types of equipment. Adapters or backs are also available for Hasselblads and other professional cameras in the 6 × 6 and 6 × 7 cm (120) formats. Special film holders adapt Polaroid 3¼ × 4¼ in. packs and 4 × 5 in. films to most 4 × 5 in. cameras. Polaroid 4 × 5 sheet films can be used in almost any 4 × 5 camera with the Polaroid Model 545 Sheet Film Holder; Polaroid 4 × 5 film packs can be similarly used with the Polaroid Model 550 Pack Film Holder.

## PROCESSING OF ROLL, PACK, AND SHEET FILMS

After exposure, you grasp a paper tab or envelope and pull the film unit between two closely-spaced steel rollers in the camera or adapter (Fig. A-1). These rollers rupture a sealed pod that contains a viscous developing solution, and they spread this reagent between the negative and the receiving sheet, laminating them together, face to face. In black-and-white films a negative image of silver (corresponding to that in conventional black-and-white films) develops in the exposed material, and the unexposed silver ions are delivered to the specially prepared receiving layer through an ingenious chemical transfer mechanism that takes place in the viscous reagent. A fully developed positive print or transparency is separated from the negative 15 to 30 seconds later.

Some types of black-and-white prints are further treated by swabbing them with a print coater, which removes traces of reagent and deposits a clear polymer layer. The paper negative and the reagent adhering to it are discarded.

The mechanism in instant color films is similar but much more complex. As in conventional color films, three negative, light-sensitive image layers are incorporated in the material, each controlling a dye developer in an adjacent, underlying layer (Fig. A-2). Unlike the developers used in conventional color films, however, these dye developers are able to act both as photographic developers and as image-forming dyes. Wherever the negative image layers are exposed, light-sensitive silver halides are reduced to silver metal, and the adjacent dye developers are oxidized and trapped within the negative. Where no exposure occurs, however, the dye developer molecules migrate through the reagent to the positive image-receiving layer. There they are trapped to form a positive image of excellent brilliance and stability. The complex reaction normally takes one minute, after which the negative and positive materials are peeled apart. No coating of the end product is required.

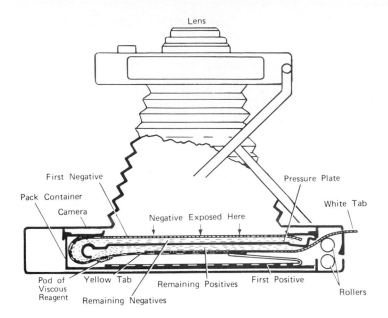

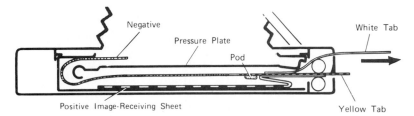

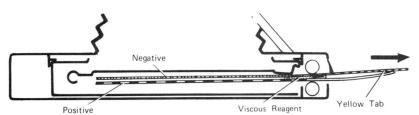

**A-1** *Construction of Polaroid Land pack films. Courtesy Polaroid Corporation.* **A:** *Film pack positioned inside camera ready for exposure.* **B:** *Pulling white tab after exposure draws negative around into position next to positive image receiving sheet.* **C:** *Pulling yellow tab then draws both negative and positive materials between rollers, which break the pod and spread the viscous reagent between the negative and positive sheets.*

**A-2** *Polaroid Spectra Film is composed of 18 microscopically-thin coated layers plus cover and base supports, and a chemical processing reagent. Courtesy Polaroid Corporation.*

| |
|---|
| Transparent plastic support |
| Positive image receiving layer |
| Clearing coat |
| Chemical processing reagent |
| Antiabrasion top coating |
| Blue sensitive silver halide emulsion |
| Primary developer |
| Yellow dye release layer |
| Yellow filter dye |
| Spacer layer containing silver ion scavenger |
| Green sensitive silver halide emulsion |
| Spacer layer |
| Magenta dye developer and releasable anti-foggant |
| Interlayer |
| Red sensitive silver halide emulsion |
| Spacer layer |
| Cyan dye developer and releasable anti-foggant |
| Timing layer |
| Spacer layer |
| Acid polymer layer |
| Opaque base |

## BLACK-AND-WHITE FILMS

Black-and-white Polaroid materials are available as $3\frac{1}{4} \times 4\frac{1}{4}$ in. rollfilms and film packs, and as $4 \times 5$ in. sheet films and film packs. Most of the films designated below are film packs, but similar materials in other forms are noted where they are available.*

**Type 42** rollfilm yields a high-quality, long-scale print 15 seconds after removal from the camera. It has an ISO rating of 200 and is panchromatic, making it ideal for general photographic use. A similar material for $4 \times 5$ cameras is designated **Type 52** in sheets and **Type 552** in 8-exposure film packs. Both have an ISO rating of 400.

**Type 53** ($4 \times 5$ sheets) and **Type 553** ($4 \times 5$ packs) films have an ISO rating of 800, develop in 30 seconds, and require no coating.

**Type 107** material yields a medium-contrast print with 15 seconds development. It has an ISO rating of 3000, and its images are somewhat shorter in tone scale than those on Type 42 film. A similar material is available in rollfilm as **Type 47** and in $4 \times 5$ sheets as **Type 57**. **Type 87**, **Type 107C**, and **Type 667** are 3000-speed pack films that develop in 30 seconds and need no coating.

**Type 51** material produces a high-contrast print, similar to those from litho-film negatives, with 15 seconds development. A blue-sensitive material, it has a speed of 320 in daylight or 125 with tungsten lamps. It is available only as individual $4 \times 5$ sheets.

The most recent additions to the Polaroid family of instant-picture films are three products designed as black-and-white proofing materials for professional photographers. **Type 54** ($4 \times 5$ sheets), **Type 554** ($4 \times 5$ pack films), and **Type 664** ($3\frac{1}{4} \times 4\frac{1}{4}$ pack films) are all ISO 100 products that need no coating after processing. Because they are identical in speed to many color films, these materials allow the photographer to proof or test a setup (and inspect the resulting photographs) before committing the assignment to conventional film of the same speed.

**Type 55** and **655** produce the only usable negatives among instant-picture films, but what superb negatives they are! Image quality is comparable to that obtainable with the best thin-emulsion conventional films, grain is virtually invisible, and the image can be enlarged as much as 25 times. A medium-contrast print is produced along with the negative.

Type 665 (pack) film has a speed of 80 and develops in 30 seconds. Type 55 is a similar material in $4 \times 5$ sheets; it has a speed of 50 and develops in 20 seconds.

After exposure and processing in the usual Polaroid way, these materials are separated to yield a print and a film-base negative that is fully developed and fixed. Within a few minutes of its removal from the holder, however, this negative must be cleared, washed, and dried.

Clearing is accomplished by immersing the film for about one minute, with continuous agitation, in an 18% solution of sodium sulfite. This solution can easily be prepared by dissolving 180 grams of anhydrous (dessicated) sodium sulfite in 1 liter of water at 25°C (77°F).† Cool the solution to 21°C (70°F) before using. After clearing, wash the negative for several minutes in running water, then rinse in a wetting agent (as you would ordinary film), and hang it up to dry.

Polaroid black-and-white prints made on Type 42, 47, 51, 52, 55, 57, 107, 552, and 665 films must be coated after processing. The fluid in the coater (supplied with the films) cleanses the print surface of residual processing chemicals and protects the images from damage by abrasion and from deterioration by contact with air. Place the print on a smooth, hard surface (the film package is convenient) and give it several wiping strokes with the coater. Use care to completely coat all of the image area, and let the coating dry completely before handling the print.

## COLOR PRINT FILMS

**Type 108 Polacolor 2 Film** comes in $3\frac{1}{4} \times 4\frac{1}{4}$ in. packs and has a speed of 80 in daylight, for which it is balanced. As the exposure time is increased beyond 1 or 2 seconds, however, the film shows a slightly decreasing sensitivity to light and a color shift toward blue. At about 4 seconds exposure, this blue shift nicely balances the increased red and yellow content of tungsten light, so that the film can be exposed in such light without filters. At shorter exposure times, however, some filtration may be necessary for proper color rendition (a guide is packed with the film). With tungsten light, the film has a speed of approximately 25.

**Type 88, 668,** and **669** are similar color films in $3\frac{1}{4} \times 4\frac{1}{4}$ in. packs, but they have a somewhat better color response with electronic flash units. **Type 58** and **59** film is a similar product in $4 \times 5$ in. sheets; **Type 559** film is a similar product in $4 \times 5$ in. packs. Types 59, 559, and 669 have an extended tonal range.

Standard development time for these films is 1 minute at 24°C (75°F), although some manipulation is possible. At shorter times, the colors are warmer but less intense; longer development up to $1\frac{1}{2}$ minutes gives increased color saturation but a cooler color

---

* Special-purpose films and $8 \times 10$ in. products are not included in this list.

† If only Type 665 film is cleared, a 12% solution of sodium sulfite (120 grams in 1 liter of water) may be used for 30 seconds.

balance. Processing at temperatures much above or below 24°C will produce similar changes.

**Polaroid Spectra Film** and other similar products are remarkable achievements of photographic technology. The negative and positive layers are combined in a single integrated unit, and the negative is exposed through the layers in which the $3\frac{1}{8}$ in. square print will later be produced (see Fig. A-2).

Immediately after exposure, the camera ejects the film. A pair of steel rollers within the camera spreads an opaque processing reagent between the negative and positive layers as the film leaves the camera. Special opaquing chemicals protect the negative layers from fogging exposure as the film is ejected into the light, and the rest of the process safely proceeds outside the camera. As with Polacolor 2 film, dye developers in the exposed areas are trapped by the developing negative, and those in unexposed areas are free to migrate to the print layer above. Even more remarkable, in some products these dye molecules diffuse up through a layer of white pigment which forms the reflective viewing base for the positive image. Other layers in the materials pace the end of development reactions and trap their alkali ions in a colorless, transparent and stable form. During this stabilizing period the opaque dyes of the reagent slowly disappear. Thus the positive image becomes visible within a few seconds, and slowly increases in density and contrast, while the negative image and reagent remain trapped below, stable and invisible.

**Type 778 Time Zero Film,** with an ISO of 150, comes in $3\frac{1}{8} \times 3\frac{1}{8}$ in. ($8 \times 8$ cm) film packs for SX-70 cameras. **Type 779** and **600+ High Speed Film** are similar products with an ISO of 640 for Polaroid 600 series cameras. Spectra cameras, of course, use **Spectra Film.**

## INSTANT 35MM SLIDE FILMS

The Polaroid 35mm AutoProcess system delivers finished, mounted slides in color or black-and-white, ready for projection within minutes after exposure in any 35mm camera. The system consists of five Polaroid films:

1. **Polachrome CS** for color slides.
2. **High Contrast Polachrome HCP** for high-contrast text and graphic slides.
3. **Polapan CT** for continuous-tone, black-and-white slides.
4. **Polagraph HC** for high-contrast black-and-white slides.
5. **PolaBlue BN** for white-on-blue negative slides, useful for text, charts, and graphs.

In addition to these films, the system includes an automatic, power-operated processor, an illuminated slide mounter, and easy-to-use slide mounts (Fig. A-3).

The films are available in 12-exposure and 36-exposure cartridges. Each roll is packaged with a matching processing pack to develop the film after expo-

**A-3** *Polaroid 35mm AutoProcess System. Courtesy Polaroid Corporation.*

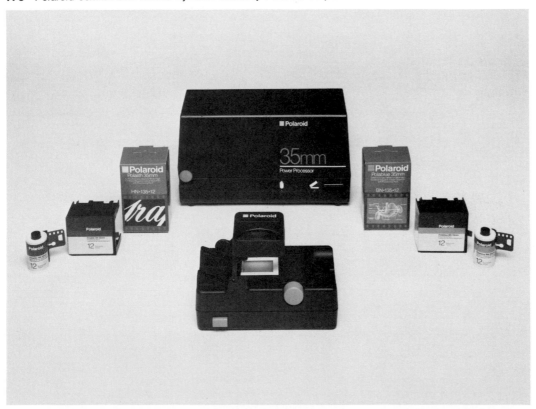

sure. The entire roll of film is processed as a single strip, and no darkroom, washing, or precise temperature controls are required. Processed films are dry and can be immediately mounted for projection. Thus the system is useful whenever fast results and immediate feedback are needed.

**Polachrome CS** and **High Contrast Polachrome** 35mm transparency films have an ISO of 40 and are based on the additive color principle. These films contain a microscopically-fine, three-color screen coated on a clear polyester base. In the camera, a film's base and color screen face the lens; its light-sensitive emulsion is thus exposed through the base and color screen which functions as a set of red, green, and blue filters. After exposure, the film is rewound into its cartridge in the usual manner.

The cartridge and its processing pack are then placed in the AutoProcessor. The processing pack contains a pod of processing fluid, a stripping sheet, and an applicator. To develop the film, you simply close the AutoProcessor; this begins an automatically-timed sequence that coats the fluid onto the stripping sheet and laminates the sheet to the exposed film as both are wound onto a takeup spool in the processor.

After 1 minute (2 minutes for High Contrast Polachrome), the processed film is automatically rewound back into its original cartridge. At the same time, the stripping sheet is rewound into its processing pack, taking several layers of the processed film, including the negative image, with it. The AutoProcessor is now opened, the processing pack discarded, and the cartridge of processed film removed to a simple slide-mounting device.

Individual frames of the film are easily positioned, cut apart, and mounted in special snap-together plastic slide mounts. The complete procedure takes only a few minutes, and the slides are ready for immediate projection or viewing.

Polapan CT 35mm black-and-white transparency film has a speed of 125 and processes in one minute. Polagraph HC 35mm high-contrast black-and-white transparency film is rated ISO 400 and processes in two minutes. PolaBlue BN 35mm blue negative film has a speed of ISO 4 in tungsten light or 8 with electronic flash; it processes in 4 minutes.

# Appendix B
# ARCHIVAL PROCESSING AND STORAGE

Prints carefully made by the methods described in Chapters 7 and 8 will last a long time without fading or discoloring, but they will not be absolutely permanent. Even with careful processing, slight traces of processing chemicals will usually remain in the print, and given sufficient time, these traces can attack the silver image and cause it to deteriorate. Storage or display of the print under less than ideal conditions, such as in polluted air or in excessive heat and humidity, can accelerate this breakdown.

If a print must last for many, many years—say, half a century or more—it must be made for the long haul and carefully stored in a protective environment. The methods used to accomplish this are known collectively as *archival processing and storage methods.* Museums and art galleries, which typically have an interest in preserving works they own or display, often insist that photographs be made this way, and many photographers, who simply want their work to last for future generations to enjoy, consider these methods standard working procedures.

Archival processing methods do not differ much from ordinary ones, but they place greater importance on certain aspects of the process and on how the prints are made. The suggestions below are intended to afford black-and-white photographs the longest possible life.

## MATERIALS

Start by using *double weight or heavier fiber-base photographic paper.* Lighter weights are simply too fragile for the repeated handling that can occur with prolonged life; and RC papers, good as they are for routine work, are not recommended for extra long life. There is evidence that over a long period of time, the emulsion layer of RC papers tends to separate from the resin-coated base, and until this problem is solved, *RC papers should not be used for archival work.*

## EXPOSURE

Prints should be made with at least a *1-inch border* of unexposed (white) photographic paper around the image. Most four-band adjustable easels can be set to mask off the outer edges of the printing paper to this extent. Chemical residues in the paper base after processing are most heavily concentrated near the edges

(into which they seeped). Deterioration from this source usually begins along the edges and works inward. Providing extra paper beyond the edge of the image itself helps to delay such effects.

## PROCESSING

The first rule of archival processing is to *use fresh chemicals* and *do not overwork them.* Developers and stop baths perform best when fresh, and full development of a print is useful since it leaves fewer silver halides to be removed in the fixing bath.

The critical steps here are *fixing* and *washing.* Two baths of fresh fixer, used one after the other, are best (see p. 110). Fix for *half the minimum* recommended time, with constant agitation, in each bath, and do not leave prints unattended in either bath. Some photographers prefer a water rinse between the two fixing baths and non-hardening fixer for the second one.*

*Washing must be thorough,* and *washing aids* such as Heico Perma-Wash or Kodak Hypo Clearing Agent are important here.† Follow the directions that come with each product, and take care to insure that prints do not stick to each other during washing. *Archival print washers* (Fig. B-1) insure this by providing a separate washing chamber for each print and by directing the flow of water through the chambers in the most efficient way.

### Toning

Toning changes the color of the silver image, but it also changes its chemical makeup to a more permanent state. Sepia toning makes the image quite brown; *selenium toning* produces a neutral black and is the choice of many fine-art photographers who use it mainly to increase the life of the print. Selenium toning coats the silver molecules with silver selenide, and this increases their resistance to airborne contaminants without changing the basic color of the print.

Toning is done after fixing, and the treatment sequence is important for good results:

---

* Ansel Adams gives two formulas for non-hardening fixers in the appendix of *The Print,* an excellent reference. See bibliography, under Technical Manuals.
† Ilford makes a convenient Archival Processing Kit for processing untoned prints. The procedure involves a single, non-hardening fixing bath and a special washing aid. Both are included in the kit.

**B-1** *Archival print washer. Courtesy Oriental Photo Distributing Co.*

1. Start with completely fixed prints (as recommended above) that have been thoroughly rinsed in water *after* the second fixing bath. Treat them in a bath of Kodak Hypo Clearing Agent or Heico Perma Wash (prepared as indicated on their packages) for 3 minutes at 20°C (68°F).

2. Wash the prints in running water, with frequent separation, for 10 to 20 minutes. While they are washing, prepare a tray of toning bath by diluting one part of Kodak Rapid Selenium Toner with **9 parts** of water (label directions will produce a distinct color change; the more dilute solution recommended will provide for longer life without changing the color of the print). Place this tray under a bright light so you can see the subtle change as toning occurs. Also prepare a *second tray* of fresh washing aid (Perma-Wash or Hypo Clearing Agent).

3. Place the print to be toned in the selenium bath and *agitate it continuously* for 1 to 10 minutes (the time will vary with different types of black-and-white papers). *Just before you see the tone you want*, remove the print from the toner and transfer it to the *second* washing aid tray. The toning continues briefly in the washing aid, so watch the print closely during these two steps (it may be helpful to keep an untoned print, made on the same paper, in a tray of water nearby for comparison).

4. Agitate the print continuously in the second washing aid for 3 minutes. Then rinse the print in running water for a few minutes.

5. Now give the print a final wash in clean running water for at least one hour. An archival print washer should be used if available.

6. Prints should be squeegeed and air-dried on plastic screens, easily made from ordinary lumber and window-screening material available at any hardware store. Do not use heat, blotters, or belt dryers, as these increase the risk of contamination from untreated prints.

7. Prints can be tested, if desired, for thoroughness of washing. Ansel Adams in *The Print* gives a formula and procedure for this purpose (see note on p. 291).

## MOUNTING AND STORAGE

Archivally processed prints must be mounted or overmatted using materials that are acid free. Many manufacturers of mounting materials supply such 100% rag content products as "archival mounts" or "museum boards." Do not use ordinary illustration boards as these are not sufficiently pure. Dry mounting (described in Chapter 8) is recommended. Seal makes an acid-free dry mounting tissue, ArchivalMount, for this purpose.

Stored prints should be interleaved only with acid-free tissue and kept in containers that are similarly free from contaminants. A complete catalog of archival supplies is available from Light Impressions Corp., 439 Monroe Avenue, Rochester, NY 14607–3717.

Additional information on the storage and display of archival photographs can be found in *The Print* by Ansel Adams, or in *The Life of a Photograph* by Lawrence E. Keefe, Jr. and Dennis Inch (see bibliography, under Technical Manuals).

# GLOSSARY

**absorption** Process by which one form of energy, such as light, is converted to another form, such as heat. Silver halide crystals react to light by absorbing it and converting it to chemical energy; filters work by absorbing certain colors or wavelengths while transmitting others.

**abstract image** Term loosely applied to nonrepresentational images in which there appears to be little resemblance to the content of their subject matter. Compare with *representational image* and *realism*.

**accelerator** Alkaline component of most developers which speeds up their action.

**accent light** Used to add a small highlight to an evenly lit area. Commonly used in portraiture to brighten the hair.

**acetic acid** Commonly used in diluted form as a bath to stop development of films and prints. See *stop bath*.

**acutance** Objective measurement of the sharpness of a photographic image as recorded by a film emulsion.

**additive color synthesis** Method of combining red, green, and blue light to form all other colors. Television uses such a system.

**agitation** Way to keep fresh processing solutions in contact with an emulsion, and simultaneously disperse products of the reaction.

**angle of coverage** See *lens coverage*.

**antifoggant** Component of developers which prevents them from acting on unexposed silver halides. Also called a *restrainer*.

**aperture** Opening, usually adjustable, which governs how much light passes through a lens. Also called the *diaphragm* or *stop*. See *relative aperture*.

**aperture-priority exposure system** Through-the-lens exposure meter coupled to the camera controls in such a way that when you set the desired aperture, the meter selects the proper exposure time. Often found in cameras with electronic shutters. Compare with *shutter-priority exposure system*.

**apron** Crinkle-edged, plastic strip spiraled in Kodak 35mm and rollfilm processing tanks to position the film. Also, the continuous belt of a rotary print dryer for fiber-based photographic paper.

**archival processing** Processing methods that produce photographic images of maximum stability. Properly stored, such images will last many, many years without fading or deteriorating.

**artificial light** In practice, light that a photographer can control at its source. Most is electrically produced.

**ASA** American Standards Association, the former name of the American National Standards Institute. Until recently, ASA designated *film speed*, but it has now been replaced by an international designation, ISO. See *ISO*.

**background** General term for what lies behind the main subject in a picture.

**background light** Light source which illuminates an area behind the subject in a picture but not the subject itself. Often placed behind the subject and thus hidden from the camera by it.

**back lighting** Light coming toward the camera from behind the subject. It sometimes produces a silhouette effect and is a technique often used with accent lights.

**barndoors** Pair of adjustable metal baffles which can be fastened onto an artificial light source to restrict the spread of its illumination.

**base** Support of a photographic film or paper on which the emulsion and other layers are coated.

**bellows** Flexible, lightproof enclosure between the lens and film plane of some cameras (such as view cameras) and most enlargers. It permits movement of the lens in relation to the film plane for focusing at various distances.

**between-the-lens shutter** Any shutter located between elements of a lens. Usually a leaf shutter.

**bleach** Chemical bath which oxidizes a black-and-white silver image to a silver halide, thereby making it soluble or redevelopable.

**bleed mounting** Mounting a print without a surrounding border; that is, to the edge of the mount board.

**blix** Combined bleaching and fixing bath used in some color processes.

**blueprint** Blue-and-white photographic print made with light-sensitive iron salts. Also called *cyanotype*, it has long been used by architects, engineers, and contractors to reproduce technical drawings.

**bounce flash** Diffused source of flash illumination produced by aiming the flash unit at a reflecting surface (wall, umbrella, or ceiling) rather than the subject. Especially useful at close lamp-to-subject distances. See also *shadowless lighting* and *umbrella*.

**bracketing** Taking a series of exposures of the same subject, changing the aperture or shutter time with each, to produce the indicated exposure, some less, and others more. For example 1/500 f/8, 1/500 f/11, 1/500 f/16, 1/500 f/5.6, etc.

**brightness** Appearance of light reflected from a subject or surface and seen by the eye. It is thus subjective and not measurable. Compare with *lightness* and *luminance*.

**brightness range** Difference between the lightest and darkest areas of a subject as perceived by the eye. Compare with *luminance range*.

**broad lighting** Portrait lighting arrangement with the key light illuminating the side of the face closest to the camera. Compare with *short lighting*.

**bulb (shutter setting)** Shutter setting (B) which keeps the shutter open as long as the release is depressed. Often used for times of 1–10 seconds.

**burning in** Darkening an area within a print by an additional, localized exposure. Compare with *dodging*.

**butterfly lighting** Portrait lighting arrangement with the key light placed in front of and higher than the subject, thereby casting a small, butterfly-shaped shadow below the nose.

**cable release** Flexible cable that can be screwed into the shutter release, and which releases the shutter when pressed. Used primarily to minimize undesirable camera movement.

**camera** A device for creating images. Essentially a light-tight enclosure containing a lens (or pinhole) to form an image, and a light-sensitive material (such as film) inside to record it. Most cameras have many additional features (such as shutters, focusing mechanisms, film advance

mechanisms, exposure meters, etc.) built into them to increase their usefulness or efficiency.

**candela**  See *intensity*.

**caption**  Any brief identifying or descriptive written statement placed near a photograph or its reproduction.

**cartridge**  Any factory-loaded container of film designed to make camera loading quick and easy while protecting the film from light. Typically used for sizes 110, 126, and 35mm. Cartridges are not reusable. Compare with *cassette*.

**cassette**  Any reusable, light-tight film container designed to make camera loading quick and easy. Typically used for 35mm films to permit loading from bulk rolls (27.5, 50, or 100 ft. lengths). Compare with *cartridge*.

**catadioptric lens**  Lens which includes mirrors and refracting elements, used to reduce bulk, weight, and cost in optical systems of great focal length. Also called a *mirror lens*, it lacks a diaphragm within the lens.

**Celsius (°C)**  International temperature scale on which 0° and 100° represent the freezing and boiling points, respectively, of water.

**center-weighted meter**  Through-the-lens luminance (exposure) meter which determines its reading more from the center of the field than from the areas near the edges.

**chroma**  Measurable characteristic of a color which designates its vividness or purity. Also called *saturation*.

**chromogenic black-and-white films**  Films with multilayered emulsions that produce negative, neutral gray *dye* images rather than silver ones (as conventional films do). Their main advantage is that they can be processed and printed like negative color films but yield black-and-white images. They also have wider *exposure latitude* than many conventional silver-halide black-and-white films.

**chromogenic systems**  Films or papers and their associated chemical processes which, taken together, produce image color during processing. Non-chromogenic systems employ materials whose colors are formed during manufacture, and thus are less dependent on processing conditions for accuracy and stability.

**clearing bath**  See *washing aid*.

**clearing time**  Time required for a fixing bath to dissolve all silver halides in an emulsion, and thus make unexposed areas of a film transparent. The preferred fixing time for most emulsions is twice the clearing time.

**closeup attachment**  Supplementary lens element which attaches to the front of a normal camera lens, effectively shortening its focal length and thereby allowing it to focus objects at closer distances from the camera.

**cold mounting**  Method of mounting or backing prints with pressure-sensitive tissue rather than heat-sensitive materials. Advantageous with color prints and others which cannot safely withstand high temperatures.

**cold-toned**  Black-and-white photographic print which is bluish-black in appearance. Compare with *warm-toned*.

**color balance**  Specific proportion of red, green, and blue sensitivities in a color film that enables it to closely reproduce the colors of objects illuminated by light of a designated *color temperature*. Typically, color films are made with daylight or tungsten light color balances. The term is also used to describe the appearance of relative amounts of cyan, magenta, and yellow in a color transparency or print.

**color cast**  Overall excess of one color in an otherwise acceptable color photograph.

**color circle**  Colors of the spectrum arranged in a circle so that primary colors are equidistant and complementary colors are opposite each other. Useful in understanding color relationships.

**color-compensating filter**  Filter of a single color and density, used to change the color balance of prints and transparencies.

**color developer**  Chemical solution which reduces exposed silver halides to silver metal and simultaneously forms complementary-colored dyes wherever it reduces the silver halides. Typically, it is the only developer in negative chromogenic processes and the second developer in chromogenic positive ones.

**color temperature**  Way of designating the specific proportions of red, green, and blue wavelengths in "white" light, expressed as degrees on the Kelvin scale (K).

**commercial photography**  Business of making photographs primarily for advertising, sales, and other business uses. Includes various specialties such as architectural, fashion, food, and product illustration.

**complementary colors**  Any two colors of light or dye which will combine to form white or a neutral color. They are located opposite each other on the color circle.

**computer-generated images**  Images that have been created or modified by converting them to digital information with a computer, and then reconverting them to visual form for display or recording by other means. The process permits enhancement, modification, storage, and retrieval of the image by electronic means.

**conceptual photography**  Style in which the photographs stand for the ideas behind their making, rather than illustrating or actually showing those ideas.

**condenser enlarger**  Projection printer which uses condenser lenses to evenly concentrate the light on the negative. Compare with *diffusion enlarger*.

**condenser lens**  One or more positive lenses which concentrate light into a beam of parallel rays. Often used in enlargers and projectors to improve contrast and efficiency.

**conditioner**  Chemical solution in certain color processes which reduces the alkalinity of an emulsion to prepare it for further processing.

**contact dermatitis**  Health hazard which causes itching or skin rash on some people from contact with certain photographic chemicals. Most common offenders are para-phenylenediamine and Metol (Elon).

**contact print**  Print made by placing the sensitive paper in actual contact with the negative, and exposing the former to light through the latter. The print is thus the same size as its negative. Compare with *projection printing*.

**continuous tone**  Describes an image with a smoothly changing series of tones from light to dark, a scale typical of many silver-halide emulsions. Compare with *line* and *dropout* images, which have no gray tones.

**contrast**  Perceived difference in tone between the lightest and darkest areas of a subject or an image. Primarily controlled in subjects by lighting, in negatives by development, in black-and-white prints by paper grade or filter choice, and in color printing by choice of materials and masking techniques.

**conversion filter**  Filter used to change the color temperature of light to match the color balance of a film. Filters No. 80A and 85B are typical. Light-balancing filters are similar, but the change they make is much smaller.

**copying**  General term for duplicating or reproducing a two-dimensional image. More specifically, the process of duplicating a photographic print when no negative is available.

**corner mounts**  Mounting materials used with overmatted

prints that hold the print only by its corners. The corner mounts, rather than the print itself, are fastened to the mount board or backing material. Prints so mounted are removable from the mount and are free from adhesives and the heat or pressure needed to use them. The corner mounts are hidden by the *overmat*.

**covering power (lens)**   Size of the circular image produced by a lens, unrestricted by the camera or enlarger on which it is used. It varies directly with *focal length*.

**critical aperture**   Aperture at which a lens produces the greatest resolution of a two-dimensional subject. Usually about two stops down from the maximum aperture.

**cropping**   Making the area of a view or an image smaller by eliminating part of it.

**cyan**   Bluish-green, subtractive, primary color, the complement of red.

**cyanotype**   See *blueprint*.

**dark-fading**   Changes in color images that occur, in time, independently of exposure to light. Usually caused by the combined effects of heat, humidity, time, contact with certain chemicals (as in packaging materials), and air pollution, dark-fading can occur in the light as well as the dark. Compare with *light-fading*.

**darkroom**   Room in which all light can be controlled or excluded to permit the safe handling of photosensitive materials.

**daylight**   Mixture of direct sunlight and skylight. Also, a designated standard color balance (5500K) for films. Compare with *tungsten color balance*.

**dedicated (hot shoe or flash unit)**   Accepting only a specific brand or model of flash unit made for the camera of which it is a part. Other *hot shoes* and *electronic flash* units are universally designed and can be used with many types of cameras.

**densitometer**   Device for measuring the *density*, or ability to absorb light, of a photographic tone.

**density**   General term for the amount of silver or dye present in an exposed and processed image tone. More precisely, a measurement of *opacity*, expressed as its logarithm.

**depth of field**   Distance between the nearest and farthest planes in the subject which focus acceptably sharp at any one setting of the lens. It varies directly with the relative aperture and the lens-to-subject distance, and inversely with the focal length.

**developer**   General term for a chemical solution or bath which makes latent images on film or paper visible by reducing the exposed silver halides to silver metal.

**developing agent**   Any chemical which can reduce silver halides to silver metal. One ingredient of a *developer*. The most useful developing agents are Metol, Phenidone, and hydroquinone.

**diaphragm**   See *aperture*.

**diazo print**   Non-silver, direct-positive print made by the destruction of diazonium salts with ultraviolet radiation, and the subsequent conversion of unexposed salts to azo dyes.

**diffraction**   Spreading of light waves after they pass an aperture or diaphragm edge, which limits the image quality of a lens at apertures smaller than its critical aperture.

**diffusion**   Any scattering of light, generally lowering the acutance and contrast of images produced with it.

**diffusion enlarger**   Projection printer employing only diffused light. Compare with *condenser enlarger*.

**DIN**   Deutsche Industrie Normen. German system of expressing film sensitivity on a logarithmic scale. A 3° increase indicates a doubling of the film speed. DIN rat-

ings have recently been combined with *ASA* ratings to form *ISO* ratings. See *ISO*.

**direct photography**   Classic style of making photographs without manipulation or other nonphotographic alteration. Sometimes called *straight photography*.

**documentary photography**   Photographs made to record or interpret a subject, usually with a preconceived purpose or viewpoint in mind.

**dodging**   Lightening an area within a print by blocking the light to that area for part of the exposure time. The opposite of *burning*.

**dropout image**   See *line image*.

**dry mounting**   Method of mounting or backing prints which uses heat-sensitive tissue rather than wet adhesives. It is clean, wrinkle-free, and permanent. Compare with *cold mounting*.

**DX coding**   Pattern of black and silver squares on 35mm film cartridges that can be sensed electronically by the camera into which the film is loaded. It thus presents the camera's exposure metering system for the speed of the inserted film.

**dye**   Transparent coloring material with many uses in photography. It forms image color in films and papers, is used in filters, retouching and spotting solutions, and to extend the sensitivity of films and papers beyond the blue and ultraviolet region of the spectrum. In *chromogenic systems*, dye is formed when by-products of the development reaction combine with *dye couplers* in the emulsion layers or the processing solutions. For other applications dye is incorporated whole in the product during manufacture.

**dye bleach system**   Color printing process in which dyes existing in the sensitive paper are chemically bleached in the presence of a negative silver image. The unaffected dyes remaining thus constitute a positive image. Cibachrome is such a system.

**dye coupler**   Chemical which reacts with certain by-products of silver-halide development to form a *dye*. This is the basic mechanism of most color film and print processes.

**dye destruction system**   See *dye bleach system*.

**easel**   Device usually placed on the enlarger baseboard to hold paper flat and still during exposure. Most easels also produce a white border on the print.

**edge numbers**   Numbers printed photographically on one edge of roll and 35mm film by the manufacturer to identify individual negatives or transparencies after processing.

**edition**   In photographic printing, a quantity of prints, each an exact duplicate of the others, usually made at the same time by the same person or persons.

**electromagnetic spectrum**   Method of representing various forms of radiant energy, including light, arranged in order of increasing wavelength. Shortest wavelengths are those of gamma rays; longest ones of radio signals.

**electronic flash**   Lamp and related circuitry which repeatedly produces very brief flashes of brilliant light. Usually requires a brief recharging period between flashes. Compare with *stroboscopic light* and *flashbulb*.

**electrostatic systems**   Non-silver imaging systems widely used for document reproduction. They work by altering the electrical charge of a surface in response to light, and then transferring the pattern of that charge to other non-light-sensitive surfaces. See *xerography*.

**emulsion**   Layer of gelatin usually containing a dispersion of light-sensitive silver halides, coated on a film or paper base. This is the layer of photosensitive materials in which the image is formed.

**enlarger** Projection printer (the preferred name) which is the basic photographic printing tool. Although typically used to make prints larger than their negatives, it can also be used to expose contact prints, to reduce images in size, and to make negatives from certain positive images.

**enlarging lens** Lens made especially for use on a projection printer. It gives its best resolution with flat image and subject planes at relatively close distances, and usually has click stops for setting the aperture in the dark.

**equivalence** Style of image making in which the photograph functions as a visual metaphor, showing one thing but symbolizing another.

**equivalent exposures** Two or more exposure settings in which an increasing amount of light is balanced by a shorter exposure time, or a decreasing amount of light is balanced by a longer exposure time. For example, 1/60 sec. at f/16, 1/125 sec. at f/11, and 1/250 sec. at f/8 are all equivalent exposures.

**exhibition print** Print made expressly for direct viewing rather than for photomechanical reproduction. It will often have a greater depth of tone and be more carefully finished than a *reproduction print.*

**exposure** Act and effect of light striking a material sensitive to it. Also used loosely to designate the shutter time and relative aperture controlling it.

**exposure index (EI)** Similar to *film speed*, but it is sometimes altered to account for reciprocity effects, filter absorptions, and other such adjustments indicated by typical uses. Film speeds, on the other hand, reflect no such adjustments.

**exposure latitude** Extent to which a film or paper can be over- or underexposed and still produce acceptable results.

**exposure meter** Device which measures *luminance* and relates the measurement to film sensitivity to indicate shutter and relative aperture settings for exposure.

**exposure scale** Range of exposures required to produce a range of tones from minimum to maximum density in a particular photographic paper. The greater the exposure scale of a paper, the greater the number of gray tones it can produce, and the lower the contrast.

**exposure value (EV)** Single whole number used to designate the product of various equivalent shutter and aperture settings. Some exposure meters and cameras are marked with EV numbers.

**falling (back or front)** View camera adjustments that allow precise vertical repositioning of the image on the *ground glass* without tilting the camera forward (which would introduce distortion). Usually combined with a *rising* adjustment.

**feathering** Aiming a light in front of a portrait subject rather than directly at the person, thereby decreasing the brightness on one side of the face. The technique is also useful with product photography to give tone separation to different sides of an object.

**fiber-base paper** Photographic papers made without waterproof protection of the base. Typically they have soft gelatin emulsions, are available in a variety of weights and surface textures, can be manipulated to some extent during development, and are well suited to archival processing. Compare with *resin-coated* (RC) *papers.*

**field of view** Area in front of a camera from which its lens can form an image on the focal plane. See also *lens coverage.* Pertaining to the eye, the maximum limits of the area it can see from all orbital positions.

**fill light** Light source used to illuminate the shadows from a key light. Less intense than the key light.

**film** Light-sensitive, flexible material typically used in cameras. Its most important layers are the emulsion and the base. The three most important types produce black-and-white negatives, color negatives, and color transparencies.

**film speed** Basic sensitivity to light of a film, expressed as an ISO number or rating. The higher the number, the greater the sensitivity. In Europe, a logarithmic German scale, Deutsche Industrie Normen (DIN), is also used. See *ISO* and *DIN.*

**filter** Device which transmits or passes some colors of light while absorbing others. Used on camera lenses to change the tone or color of selected parts of an image, on projection printers to control contrast or color balance of images, and in safelights to absorb undesired wavelengths from white light. Typically a disc or sheet of acetate, gelatin, or glass.

**filter factor** Number by which an exposure calculated with a hand-held or external meter must be multiplied when a filter is used on the camera lens. The factor compensates for the absorption of the filter. Not needed with internal meters, which read the filtered light.

**first developer** Chemical bath in color reversal processes which forms black-and-white silver negative images, corresponding to the latent image of the camera exposure, in the three emulsion layers. No image color (dye) is produced in this step.

**fisheye lens** Extreme wide-angle lens. Some produce circular images with obvious distortion. Others (full-frame fisheye lenses) produce less distorted, rectangular images that fill the picture frame.

**fixing** Processing step which chemically destroys the sensitivity to light of a film or paper by dissolving its remaining silver halides.

**flare** Uncontrolled reflection of light within a lens, camera, or enlarger, which produces irregular, non-image exposure of film or paper. Image contrast and shadow detail are reduced by it, and colors desaturated. Lens shades and clean lens surfaces will minimize the problem.

**flashbulb** Small glass bulb containing various shredded metals and oxygen. When ignited electrically or percussively, it gives a single, bright flash of light useful for exposure. Sometimes grouped into cubes or rows of identical lamps (flash bars, flip flash) for successive use. Compare with *electronic flash.*

**flat** Low in contrast.

**fluorescent light** Light created by vaporizing mercury in a tube coated with phosphors. The ultraviolet radiation of the vaporized mercury is converted to light by the phosphors. This light can be used as is for black-and-white photography but requires special filtration for correct rendering with color films.

**f/ number scale** Series of numbers, usually on the lens mount, which indicates the size of the lens aperture and thereby the amount of light it can transmit or project. See also *relative aperture.*

**focal length** Distance from the rear nodal point of a lens to its focal plane when it is focused on an infinitely distant object.

**focal plane** Plane normally perpendicular to the lens axis, on which its sharpest image is formed. The ground glass or film are normally located here.

**focal-plane shutter** Camera shutter typically containing two movable curtain sections, positioned just ahead of the focal plane. An adjustable gap between the two sections exposes the film when the sections pass successively in front of it.

**focus**  The point at which rays of light from an object that pass through a lens appear to form the sharpest image. See also *focal plane* and *focusing mechanism*.

**focusing cloth**  Opaque, flexible cloth that is draped over the photographer's head and the ground glass of a view camera to shield the ground glass from external light. It makes the image on the ground glass easier to see.

**focusing mechanism**  Mechanism in a camera and enlarger that allows changing the lens-to-film (or lens-to-ground glass) distance to form the sharpest image.

**focusing scale**  Part of a camera or lens that indicates the distance on which the lens is focused.

**fog**  Any density caused by non-image exposure of film or paper. Usually caused by light, but it can also be caused by undesirable chemical reactions or exposure to X-rays.

**format**  Size and shape of the picture area of a camera, film, or print.

**free lancing**  Making photographs for sale, on order or on speculation, as an independent photographer. The term implies an irregular pattern of sales to varied customers rather than a steady or contractual arrangement.

**gelatin**  Animal protein which is the main ingredient of film and paper emulsions.

**gelatin-silver print**  General term used to identify any photographic print containing a silver image in a gelatin emulsion, and to distinguish such prints from non-silver types such as electrostatic, gum bichromate, cyanotype, etc.

**glossy**  Smooth, shiny surface or finish on photographic paper. Such papers can produce richer, deeper blacks and shadow tones than matte-finish papers can.

**gradation**  Change in density of silver or dye, and hence tone, of an image, from white through medium values to black. We perceive gradation as *contrast*.

**grade**  Numerical and verbal designation of the exposure scale of a photographic paper. Higher number grades produce shorter exposure scales and greater contrast.

**graded paper**  Single-contrast black-and-white photographic paper designed for exposure by white light. Compare with *variable-contrast paper*.

**grain**  General term describing the appearance of the tiny particles of silver metal which form a developed photographic image. They are often clumped together and when magnified several diameters, give the impression of graininess.

**graphic arts**  General term applied to those aspects of photographic work which are part of the production of ink-on-paper printing. The term includes photomechanical reproduction work but usually excludes typesetting unless it is done photographically.

**gray card**  Standard gray cardboard widely used for *luminance* readings with exposure meters. Its gray side reflects 18% of the light falling on it; its opposite white side similarly reflects 90% of the *incident light*. Its photographed image is also useful to ascertain proper color balance in color printing.

**gray scale**  Series of neutral print tones which vary by equal density differences, sequenced from light to dark. It can be photographed with other subjects and its image used to measure exposure and development with a densitometer.

**ground glass**  Glass plate etched to a translucent finish on one side, and used to form a visible image at the focal plane of a camera lens. Sometimes also used in diffusion enlargers to scatter and soften the light.

**guide number**  Number used to determine relative aperture settings (f/ stops) from lamp-to-subject distances in flash work where exposures are determined manually. It takes into account various characteristics of the light source, reflector design, and film sensitivity, all of which affect exposure.

**gum bichromate**  Non-silver system which forms images by the hardening action of light on pigmented gum arabic which has been made light-sensitive by the addition of potassium bichromate.

**halation**  Diffused, halo-like effect surrounding the image of a bright light source in some photographs. Caused by light rays reflecting from the rear surface of the emulsion or the film base, at an angle other than 90°, and thus slightly re-exposing the film. The effect is minimized by the anti-halation layer coated on the base of most films to absorb such reflections.

**halftone**  Photomechanical image or process in which shades of gray are represented by dots of varied size but uniform color. It makes possible the simulation of *continuous tone* in reproductions using one color of ink. Photographs in most books are reproduced in this manner.

**hard**  High in contrast (describing negatives or prints).

**hardener**  Component of many fixing baths and some color processes. It limits the softening or swelling of wet gelatin emulsions. Potassium aluminum sulfate and formaldehyde are commonly used.

**heat-absorbing glass**  Glass filter found in the lamphouse of many enlargers. It absorbs infrared radiation (heat) from the enlarger lamp, to which color papers are sensitive.

**highlight**  Very light, bright parts of a subject, which reproduce as dense, dark areas in a negative and light, bright areas in a print. The opposite of a shadow.

**hot shoe**  Device on some cameras which holds an electronic flash unit for use. The *synchronizing* circuit passes through contacts in the shoe. See also *dedicated hot shoe*.

**hue**  Name of a color which distinguishes it from other colors, and which varies with the *wavelength* of the light producing it. For example: red, green, yellow, etc.

**hyperfocal distance**  Distance from the front nodal point of a lens to the nearest object whose image is acceptably sharp when the lens is focused on infinity. By focusing on the hyperfocal distance, maximum *depth of field* is obtained.

**hypo**  Common name for the fixing agent sodium thiosulfate, but loosely applied to any fixing bath.

**hypo clearing agent**  See *washing aid*.

**hypo eliminator**  Mixture of hydrogen peroxide and ammonia which converts any remaining fixer in an emulsion to highly soluble compounds. Sometimes used in archival processing.

**incident light**  Light coming from a source and falling on a surface or object. Compare with *reflected light* and *luminance*.

**industrial photography**  General term which describes photographs made for businesses or industries by their own employees. Also called corporate photography. Compare with *commercial photography*, in which similar photographs are sold to clients in other businesses rather than made for other employees of the same business.

**infinity**  Great distance (for most lenses, more than 50 meters) beyond which objects focus as a unit even when at different distances from the camera. Also, the lens setting (∞) for such distant focusing.

**infrared radiation**  Invisible radiation from about 700 to 1350 nanometers on the electromagnetic spectrum. Special films sensitive to these wavelengths can be used to make aerial, landscape, pictorial and scientific photo-

graphs. In most situations, a filter must be used on the camera to exclude blue light (to which the films are also sensitive), and focusing may have to be altered.

**ink-jet printer**  Device for printing the output of a computer. Tiny nozzles controlled by electronic signals squirt ink onto a sheet of paper as it passes over a printhead. Certain kinds of pictures, as well as words, can be printed by this method.

**Instamatic cartridge**  Sealed unit of film (size 126) for certain snapshot cameras which simplifies loading and unloading them.

**instant-picture photography**  Special camera and film systems which produce processed photographs in black-and-white or color within seconds or minutes after exposure. The films and most cameras using them are made by Polaroid Corporation; other manufacturers also make devices to adapt the films to certain standard cameras.

**intensification**  Chemical treatment for increasing the density of a processed negative, usually by bleaching and redeveloping it. The treatment is most effective on highlights, least effective on shadow areas. It will not produce image density where none existed originally.

**intensity**  General term for the strength of light coming from a source. Unit of measurement is the *candela*.

**internegative**  General term for a negative made from a positive or print for the purpose of making other prints directly from it. Used for making color prints from color transparencies.

**inverse square law**  Law stating that illumination on a surface decreases by the square of its distance from the light source. Flash *guide numbers* are based on this calculation.

**ISO**  International Standards Organization. ISO designates a system of *film speeds* now universally used. The higher the number, the greater the sensitivity to light. Example: 125/22°. The first number represents the former *ASA* rating, the second the equivalent *DIN* rating. Current American practice is to drop all but the first number in favor of a simpler expression.

**Kelvin (K)**  International scale of units designating temperature. In photography it is used to designate the *color temperature* of light.

**key light**  Dominant source of light in an artificial lighting setup. It casts the strongest shadows and influences other visual aspects of a scene.

**large-format**  Term used to refer to *view camera* and *sheet film* systems, most of which produce original images larger than those from rollfilm or 35mm cameras. Standard sizes are 4 × 5 and 8 × 10 in.

**laser printer**  Device for printing the output of a computer. It uses a programmed laser beam to convert the digitized signals to a visual image, is faster than many other types of printers, can produce images of higher resolution, and can be used to print pictures as well as words.

**latent image**  Invisible image formed in an emulsion by exposure to light, to be made visible later by development.

**latitude**  Ability of a film to tolerate changes in exposure or development and still produce a usable photographic image. Usually expressed in f/ stops or a percentage of the normal exposure or development time, it varies with the film, process, and application.

**leaf shutter**  Shutter consisting of overlapping metal leaves, usually located between the front and rear element groups of a lens. Also called a *between-the-lens shutter*.

**lens**  Device of transparent glass or plastic which refracts (bends) light. Usually consists of several pieces of glass or plastic called lens elements, arranged together on a common axis. Elements can be positive (center thicker than edge) causing light rays to converge, or negative (edge thicker than center) spreading light rays apart. Various configurations of these elements comprise a typical lens. *Camera* and *enlarger lenses* form images on their focal planes; *condenser lenses* do not form images but control the direction and other qualities of light.

**lens coverage**  Area of the focal plane over which a lens can project an image of satisfactory quality. It thus corresponds to the size and format of the film and camera with which it is used.

**lens shade (hood)**  Device to reduce stray light that can enter a lens and cause *flare*.

**lens speed**  Maximum relative aperture of a lens, and thus a measure of its light-gathering ability.

**light**  Radiant energy that can be detected by the human eye. Comprising the visible part of the electromagnetic spectrum, it is the energy which makes photography possible.

**light-balancing filter**  See *conversion filter*.

**light-fading**  Changes in color images that occur, in time, primarily from prolonged exposure to light. Compare with *dark-fading*.

**lightness**  Measurable characteristic of a color which describes its ability to reflect light. Also called *value* and (inaccurately), *brightness*.

**line image**  High contrast image consisting of black and white or clear tones only. Gray tones are absent.

**litho film**  Very high contrast film designed to make *line* or *halftone* images. Requires a special developer for maximum contrast. Used for black-and-white images of extreme contrast and for photomechanical reproduction.

**logarithm**  An exponent or power of a given number. Used in photography to designate certain exposure measurements, and in the DIN system of film speed.

**long-focus lens**  Lens with a focal length much longer than the diagonal dimension of the format with which it is used. Long-focus lenses include *telephoto lenses* and *catadioptric* (mirror) *lenses*.

**luminance**  Measurable strength of light reflected from a surface or subject. Exposure meters measure this. Compare with *brightness*.

**luminance meter**  See *exposure meter*.

**luminance range**  Difference between the lightest and darkest important areas of a subject as measured by an exposure meter. Compare with *brightness range*.

**Mackie lines**  Visible processing effect that sometimes occurs along adjacent light and dark image areas. It is usually associated with the *Sabattier effect*, but can also occur in other images.

**macro lens**  Lens designed for work at very short distances, where the image may be as large or larger than the object photographed. Useful for photographing very small three-dimensional objects and specimens.

**magenta**  Reddish-blue subtractive primary color, the complement of green.

**manual exposure system**  Through-the-lens exposure system that indicates correct shutter and aperture settings but requires them both to be set manually by the photographer. Sometimes called a *match-needle system*. Compare with *shutter priority*, *aperture priority*, and *programmed exposure systems* or *modes*.

**mask**  Any opaque material cut out to protect an area of a film or paper from exposure. Also, a weak negative or

positive image made by contact from another image, and used to change the contrast or color of the latter.

**mat** Cardboard cut to form a wide-bordered window, which is placed over a photographic print. It isolates the image, enhances its appearance, and helps protect the print surface from abrasion. Also called *window mat* or *overmat*.

**match-needle exposure meter** Luminance (exposure) meter built into some cameras, which requires the user to manually adjust shutter and aperture controls until a moving pointer or needle centers on a scale or target. Also known as a *manual exposure system* when built into a camera. Compare with *aperture priority, shutter priority,* and *programmed exposure systems,* all of which have automatic functions.

**mat cutter** Device for cutting window mats accurately and efficiently. Smaller ones are hand-held; larger ones are often built into work tables.

**matte** Dull, non-glossy surface on photographic paper.

**media (mass media)** Any system by which aural, verbal, or visual ideas or information can be simultaneously communicated to large numbers of people. Examples include newspapers, magazines, radio and television broadcasting, etc.

**micro lens** Lens designed for photographing a flat field or two-dimensional object, as in copying artwork, other photographs, or in office copy machines.

**microphotography** Photographs made at a great reduction in size, as in microfilm images of business records. The opposite of *photomicrography,* which uses microscopes to make photographs greatly enlarged from their original sources.

**miniature** Term distinguishing the 35mm camera and film format from rollfilm and smaller sizes. Compare with *subminiature.*

**mirror lens** See *catadioptric lens.*

**monochromatic** Term describing light of a single wavelength, but commonly used to describe images of a single hue, such as black-and-white photographs.

**monopack** Multi-layered film or paper emulsion, each layer of which has different photosensitive properties. Monopacks are used for most color films and chromogenic black-and-white ones, and for color printing papers.

**montage** Process of assembling several images on a single sheet of paper by multiple exposures on the same print, or by cutting and mounting several separate prints adjacent to each other on a common support.

**mount** Cardboard used to back a photograph with thicker supporting material. It holds the photograph flat and often extends beyond the image to provide an isolating border. See also *bleed mounting, cold mounting, dry mounting,* and *mat.*

**M synchronization** Control setting on leaf shutters which permits them to be used with Class M flashbulbs, which require 20 milliseconds to reach peak light intensity after ignition. When so set, the opening of the shutter blades is delayed this long to permit the flashbulb to reach its peak output.

**multiple-contrast paper** See *variable-contrast paper.*

**nanometer** International unit (abbreviation *nm*) for measuring the wavelength of light. Equal to one billionth of a meter, it has replaced the equivalent millimicron.

**narrow-angle lens** See *long-focus lens.*

**natural light** Light that comes from the sun, such as daylight. Photographers, however, regard any light that can-not be controlled at its source as natural light. Compare with *artificial light.*

**negative** Any photographic image whose tones are reversed from the corresponding ones of the subject. Thus subject highlights appear dark in a negative, shadows appear light.

**negative-positive system** Any photographic material and processes in which the image is produced first as a negative, and then subsequently as a physically separate positive. Most black-and-white materials and processes work this way, but many color systems do not. Compare with *reversal system.*

**negative preserver** Thin, transparent sleeve or sheath into which negatives (or transparencies) can be placed to protect them from dust, dirt, and fingermarks. The best ones are made of clear polyethylene, permit their contents to be contact-printed without removal, and are often designed for storage in standard binders or files.

**neutral-density filter (ND)** Filter which absorbs equal amounts of all wavelengths or colors of light. Primarily used to control exposure, especially in circumstances where the shutter and aperture are inadequate for this purpose.

**neutral test card** See *gray card.*

**Newton's rings** Rings of colored light caused by interference between two wave patterns reflected from surfaces in partial contact. The effect is sometimes noticed in glass-mounted slides and in glass negative carriers of enlargers. Using similar glass-free devices eliminates the problem.

**nodal point** Either of two reference points in a lens. They are so located on the axis that light rays passing through the center of the lens appear to enter at one nodal point and leave from the other. *Focal length* is measured from the rear or emerging nodal point.

**nonrepresentational image** Any image which bears little recognizable resemblance to the subject of its content. Compare with *representational image.*

**non-silver systems** Materials and related processes which do not use silver halides for light sensitivity. Examples include cyanotype, gum bichromate, and electrostatic systems.

**normal lens** Lens with a focal length equal to or slightly greater than the diagonal dimension of the format with which it is used. A normal lens is standard on most cameras and forms an image with a field of view similar to that of the human eye.

**opacity** Light-blocking ability of a substance, expressed as the ratio of the light falling onto a surface to the light transmitted by it. *Density* is its logarithm.

**opaque** Unable to transmit light; having infinitely great opacity. Also, a watercolor pigment applied manually to negatives to block out areas so that they will not print.

**open flash** Technique which uses the entire light output of a flashbulb, unlike synchronized flash which uses only the peak intensity. Three manual operations are required in sequence: opening the shutter, flashing the bulb, and closing the shutter.

**open shade** Outdoor light condition where there is no direct sunlight, but where shadows are illuminated by a mixture of direct skylight and light reflected from the immediate surroundings.

**open up** To increase the size of a lens aperture.

**orthochromatic** Sensitive to ultraviolet, blue, and green light, but not to red. Compare with *panchromatic.*

**overdevelopment** Development for too long a time, at too high a temperature, or in too strong a solution. Causes

excessive density, contrast, and color saturation in the film or paper.

**overexposure** Exposure for too long a time, at too large an aperture, or by too intense a light. It makes negatives too dense (dark) and too low in contrast, prints too dark in all areas, and reversal images too light and diluted of color.

**overmat** See *mat*.

**override control** Camera control that permits the photographer to override the internal, automatic metering system in order to favor certain light values in a scene or subject. It thus permits individual pictures to be given greater or less than normal exposures without resetting the entire system each time.

**panchromatic** Sensitive to all colors of light (plus ultraviolet). Most films have panchromatic emulsions. Compare with *orthochromatic*.

**panning** Tracking or following a moving object by moving the camera to keep its image relatively stationary in the viewfinder. When used with long shutter times, it tends to show a well-defined object against a streaked or blurred background, and thus suggest rapid movement.

**paper negative** Negative image made on photographic paper, usually as an intermediate step to a contact positive. A useful preparatory step to several non-silver systems which are limited by their low sensitivities to contact printing methods.

**parallax error** Inability of a camera's viewing system and taking lens to frame the same area of a subject because they view it from different angles. This problem is common to most viewfinder and twin-lens reflex cameras.

**PC cord** Electrical cord commonly used to connect handheld or externally attached flash units to a camera so that the flash can be *synchronized* with the opening of the shutter.

**perspective** Means of representing three dimensions of an object on a two-dimensional surface so as to create an illusion of depth.

**photofinishing** Processing and printing of color films primarily for consumers, usually in large volume using highly automated machinery. A more specialized (and labor-intensive) aspect of the business, known as *trade* or *custom finishing*, similarly processes and prints films for professional photographers.

**photoflash lamp** See *flashbulb*.

**photoflood lamp** Tungsten-filament lamp designed to operate at 3400K. It gives a more intense light but has a much shorter life than a regular photographic tungsten lamp, which operates at 3200K.

**photogram** General term used to identify photographic images made without a camera. Typically, translucent or opaque objects are placed on photographic paper, which is then exposed to raw light and processed to reveal a pattern of light and dark areas.

**photographic essay** Series of related photographs made to tell a narrative or story. See also *photojournalism* and *media*. Contemporary essays sometimes stress humanistic content more than a narrative structure.

**photojournalism** Reporting with a camera, typically as published in newspapers, editorial sections of magazines, and television newscasts. See also *media* and *photographic essay*.

**photomacrography** Photography with a camera, the images from which are approximately the same size (or slightly larger) as the objects photographed. Compare with *photomicrography* and *microphotography*.

**photomechanical reproduction** General term identifying methods of reproducing photographic images in ink on nonsensitive paper. *Line* and *halftone* processes are commonly used.

**photomicrography** Process of making photographs which are greatly enlarged from their subjects, by joining a camera with a microscope. Compare with *microphotography*, which involves great reduction in size, and *photomacrography*, which often involves slight enlargement in the camera.

**photomontage** See *montage*.

**photon** An extremely small particle of radiant energy, such as light, that seems to act more like matter than a wave of radiant energy. The concept of photons is useful to understand how light affects film emulsions.

**photoresist** Non-silver, light-sensitive photographic material which is changed physically or chemically by exposure to light. Used in several photomechanical and industrial processes.

**photo screen printing** Combination of photography and screen printing using a *photoresist* to produce or reproduce an image on a screen-like material such as nylon or silk. The image is then printed on paper, cloth, or other materials by forcing ink through the screen with a squeegee.

**picture story** See *photographic essay*, *photojournalism*, and *media*.

**platinum print** Non-silver, contact print made by binding platinum salts to iron ones. Platinum prints have beautiful tonal scales and are among the most permanent, but the chemicals are expensive and hazardous.

**polarized light** Light waves or rays which vibrate in a single plane rather than in many directions from a source. They can be absorbed or blocked by polarizing filters. Such light is found in daylight at certain angles to the sun, and in the reflections from glossy, nonmetallic surfaces at certain angles to the incident light. Polarizing filters are useful to reduce the glare from such reflections.

**portfolio box** Container for photographs, usually made of acid-free materials, that is designed to protect them from many hazards of improper storage and handling.

**positive** Any photographic image whose tones are similar to those of the subject. Subject highlights thus appear light, and shadows dark, in the image.

**postvisualization** Method of producing photographs wherein the image is planned and created primarily in the darkroom, rather than in the camera or when the original exposures are made. Separate camera images, for example, may be combined into single images by multiple printing or other techniques. Compare with *previsualization*.

**preservative** Component of developers and fixers which retards oxidation and thus extends the useful life of these processing solutions.

**previsualization** Procedure whereby a scene or subject is studied, several final print interpretations possible from it are mentally noted, and the technique then selected to produce a chosen visualized result, all before the original exposure is made. See also *Zone System*, and compare with *postvisualization*.

**primary colors** Group of three colors from which all others can be produced. The *additive* primaries of light are red, green, and blue. *Subtractive* primaries (dyes) are cyan, magenta, and yellow.

**print** Photographic image usually made on paper. Typically a positive image produced by exposure from a neg-

ative on film, although negative images on paper are also prints. See also *paper negatives*.

**printing filter** Thin, dyed sheet (or thicker, framed square) of transparent polyester plastic that is inserted into an enlarger's light path to control the color or contrast (in black-and-white) of a print.

**process camera** Large format camera used for photomechanical reproduction. Typically it includes its own lighting system and frame for the material to be reproduced, is rigidly constructed, and has a lens of long focal length, small apertures, and high resolving power (process lens).

**processing** Sequence of operations with photographic materials that follows exposure. In general, the purpose of processing is to make latent images visible, permanent, and useful.

**professional photography** Business of making photographs for a profit, usually on direction from a client or customer. It includes commercial and industrial photography, portraiture, photojournalism, and other specialized areas.

**programmed exposure mode** Automatic exposure metering mode built into some cameras, which selects both the shutter and aperture settings (for a particular film speed and a typical situation) from a programmed list stored in the camera's electronic memory. Now a common feature of automatic snapshot cameras, programmed exposure systems in better cameras are often linked to other features, such as lens focal length, that directly affect exposure. All make routine picturemaking easier.

**projection printing** Preferred term for *enlarging*. It applies to any printing operation where the print material is exposed by an optically projected image rather than by contact, and includes reduction in size as well as enlarging.

**proofing** Making trial exposures on *instant-picture materials* in a camera, usually after an elaborate setup or lighting arrangement, to test several variables before making the final exposures. Also, the process of contact-printing negatives, or of making other prints from them for identification or filing purposes only.

**pushing** Increasing effective film speed by increasing the development time or concentration, or by using a special developer formulated for this purpose. Sometimes used to compensate for known underexposure. Pushed images typically have little shadow detail, excessive contrast, and, with most color films, an altered color balance.

**quantum theory** Theory to explain the movement of energy, including light, as particles of matter rather than radiant waves. See also *photon*.

**quartz-halogen lamp** Tungsten lamp whose filament is surrounded by a halogen gas and contained in a bulb of fused silica or quartz. This permits higher operating temperatures, longer life, and a more stable or uniform color temperature throughout the life of the lamp. The construction of these lamps requires special handling precautions.

**rangefinder** Device on some viewfinder cameras by which the lens can be accurately focused on a given distance. Common types show overlapping or split-field images, which must be aligned or superimposed to focus the lens.

**rapid access** General term identifying materials, processes, or systems which produce usable images quickly after exposure.

**RC** See *resin-coated paper*.

**realism** In general, an image style in which the content bears a strong visual resemblance to the objects photographed. To many people, the term implies a stronger resemblance than many *representational images* possess. Compare these terms.

**reciprocity effect** Reason why equivalent exposures do not produce equal densities when the exposure time is extremely short (as with some electronic flash units) or long (several seconds or more). The effect is characteristic of silver halide emulsions and varies with their sensitivity. It is often referred to as *reciprocity failure*.

**reducer** Chemical bath which removes some silver from a processed emulsion, thereby lightening the image and lowering its density.

**reflection** Changing the direction of light without passing it through another material, as with a white card or mirror. Compare with *refraction*.

**reflex camera** Camera containing a mirror at a 45° angle to the lens axis, and a ground glass above it for viewing the reflected image. Some reflex cameras also contain a prism for correct lateral orientation of the image and for eye-level viewing. See also *single-lens reflex camera* and *twin-lens reflex camera*.

**refraction** Changing the direction of light by passing it from one material to another dissimilar material, as from air to glass or vice versa. This is how lenses work, bending light rays to form an image. Compare with *reflection*.

**register** Correct alignment of superimposed images, as in photomechanical and certain non-silver systems, to create a desired visual effect or unified image. Images so aligned are said to be "in register."

**relative aperture (f/)** Diameter of a lens aperture or opening expressed as a fraction of its focal length. Designated by the symbol f/. See also *aperture* and *f/ number scale*.

**release paper** Teflon-coated paper used when dry-mounting resin-coated (RC) photographic prints. Inserted between the hot press platen and the print, it prevents the print surface from sticking to other materials when heated.

**replenisher** Solution added to a processing bath to maintain its uniform activity with repeated use. A replenisher thus replaces ingredients in the bath consumed or altered by its action on the material being processed, and thus greatly extends the useful life of the bath.

**representational image** Any image which bears a recognizable resemblance to its subject. Compare with *non-representational image* and *realism*.

**reproduction print** Photographic print made expressly for reproduction by a photomechanical process. Ideally, its exposure scale and tonal range will match the requirements of the reproductive process. Compare with *exhibition print* and *workprint*.

**resin-coated paper** Photographic paper made with a highly water-resistant base. This feature permits less chemical penetration and therefore faster washing and drying. Other economies are also obtained.

**resist** See *photoresist*.

**resolving power** Ability of a lens or film to produce fine detail in an image. More specifically, its ability to image very closely spaced, sharply drawn, parallel lines as separate tones. Measured in lines per millimeter. Compare with *acutance* and *sharpness*.

**restrainer** See *antifoggant*.

**reticulation** Fine, random pattern of wrinkling of the gelatin emulsion, usually caused by sudden temperature changes during processing. The effect is not reversible.

**retouching** Manual alteration of negatives or prints after

processing by the addition of dye, pigment, or chemicals to add or remove selected parts of the image. Portrait negatives, for example, are sometimes retouched to remove or obscure skin blemishes, stray hair, etc. Compare with *spotting*, which removes processing defects such as dust marks and scratches.

**retrofocus lens**   Special wide-angle lens design which allows it to be positioned farther from the focal plane than its effective focal length would permit. The space thus formed can accommodate the mirror of a single-lens reflex camera. Sometimes called a *reverse-telephoto lens*.

**reversal solution**   Chemical solution in some color processes, used to fog (render developable) all remaining light-sensitive silver halides in the emulsion, much as reexposure to light would accomplish.

**reversal systems**   Films, papers, and related processes designed to produce a *positive* image on the material originally exposed. Most work by exposure in the usual manner, processing first to a negative and then continuing the process to produce the ultimate positive. Most color transparency films and some color print materials work this way, although a few produce their positive images more directly. Compare with *negative-positive systems* and *dye bleach system*.

**reversing back**   View camera back (including the ground glass) which can be positioned for either horizontal or vertical pictures. Compare with *revolving back*.

**revolving back**   View camera back which can be rotated around its center and used in any position. Compare with *reversing back*.

**rising (back** or **front)**   View camera adjustments that allow precise vertical repositioning of the image on the *ground glass* without tilting the camera backward (which would introduce distortion). Usually combined with a falling adjustment.

**roller-transport processor**   Machine designed to process film or paper by passing it between a series of rollers that propel the material from one tank of solution to another. Such machines can be fed with unprocessed films or papers continuously, and are widely used to process color prints automatically.

**rollfilm**   Long strip of film wound on a spool, with opaque backing paper extending beyond both ends to permit daylight loading and unloading. The most popular size is 120.

**Sabattier effect**   Partial reversal of image tones caused by interrupting development with a re-exposure to light. The effect is popularly but erroneously called *solarization*.

**safelight**   Darkroom lamp filtered to emit only a color of light that has a minimal effect on the photographic materials used with it.

**saturation**   Purity or vividness of color, the opposite of gray. Also called *chroma*. Compare with *hue* and *lightness*, a color's other attributes.

**Scheimpflug rule**   Sharpest images in a view camera are produced when the planes of the most important features of the subject, the camera lensboard, and the ground glass all intersect on a common line or at infinity.

**selective focus**   Limited or shallow depth of field obtained with large apertures. It is used to separate objects at different distances by focusing on the most important one and letting the others stay out of focus.

**shadow**   Dark part of a subject, which reproduces as a weak, low density area in a negative and a dense, dark area in a print. The opposite of a highlight. Also, a dark area in the subject caused by interrupting a direct light source. See *key light* and *fill light*.

**shadowless lighting**   Soft, indirect lighting that appears to be non-directional rather than coming from a single main source. It is useful for photographing objects at close range, and for avoiding uncontrollable reflections when photographing objects with shiny surfaces. See also *bounce flash* and *umbrella*.

**sharpness**   Subjective term describing the appearance of lines, edges, and similar adjacent tones in images. Sharpness is lost by imperfect contact of negative and paper in contact printing, and by improper focusing of camera and enlarger lenses. See also *acutance*, which describes a similar, measurable aspect of an image.

**sheet film**   Film made in flexible, flat sheets of standard sizes, primarily for use in large format cameras. Single sheets can be exposed and processed separately, and many types of film are available in this format. A darkroom is required for handling. Compare with *rollfilm*.

**sheet film holder**   Device that typically holds two pieces of *sheet film* and permits their insertion into and removal from the camera without exposing them to non-image-forming light. The holder also contains coded dark slides that indicate the status (unexposed, exposed or empty) of each holder side, and locks to prevent their untimely withdrawal. Sheet film holders must be loaded in total darkness.

**shift (camera)**   View camera adjustment which allows precise horizontal repositioning of the image without pivoting the camera. Also known as *slide*.

**shift (color)**   Change in color or color balance of an image. The term usually designates an unintended or undesirable change, as from improper processing.

**short lighting**   Portrait lighting arrangement with the key light illuminating the side of the face farthest from the camera. Compare with *broad lighting*.

**shutter**   Part of a camera or lens that is opened by the user and closes by mechanical or electronic means, to control the time of exposure. The two main types are *leaf shutters* and *focal-plane shutters*.

**shutter-priority exposure system**   Through-the-lens exposure meter so coupled to the camera's controls that you set the desired shutter time and the meter then selects the proper aperture for exposure. Useful when photographing sports events or similar action. Compare with *aperture-priority exposure system*.

**sign**   Visual image that has a single, specific relationship to the object or event represented, and that often resembles it. Compare with *symbol*.

**silhouette**   Effect produced by back lighting alone. It shows a subject as a dark, two-dimensional shape against a lighter background. See *back lighting*.

**single-lens reflex camera**   Reflex camera which permits the user to view the subject through the taking lens by means of a movable mirror behind it and (usually) a prism above the ground glass to correctly orient the image.

**skylight**   Bluish light reflected from the atmosphere. Together with sunlight it forms daylight.

**skylight filter**   Colorless, ultraviolet-absorbing filter used to avoid an excessive bluish cast in color photographs made with skylight alone (in open shade), or on clear, sunny days at high elevations.

**slave unit**   Electric or electronic device which senses a flash unit fired by the camera, and then in turn fires other flash units as a result. Useful in multiple-flash situations

where it is inconvenient or impractical to connect all units with wires.

**slide**  General term for a 35mm or smaller positive transparency, usually mounted in a 2 in. square frame for projection. Also, an opaque shield which can be inserted into a film holder to permit its attachment to or removal from a camera without exposing the film. Additionally, a view camera movement (see *shift*).

**snapshot**  Any photograph casually made with a hand-held camera. Most snapshots are made as remembrances of people, places, or events.

**snoot**  Cylindrical attachment to a spotlight used to limit its light to a small area or spot.

**soft**  Low in contrast (describing negatives or prints).

**soft focus**  Deliberately unsharp. A diffusion disk placed over the camera lens will produce this effect primarily in highlights, where it is often used in portraiture. On the other hand, setting the enlarger lens out of focus with a sharp negative will produce a soft-focus effect primarily in shadows, where its effect is less noticeable or useful.

**solarization**  Reversal of image tones caused by a single, extreme overexposure. Compare with *Sabattier effect*, to which this term is often incorrectly applied.

**speed**  See *film speed* and *lens speed*.

**spin-out**  See *tone-line photograph*.

**spotlight**  Artificial light source that focuses or concentrates its illumination into a definite beam, usually of narrow width.

**spot meter**  Exposure meter which measures luminance from only a very narrow angle, and hence from a much smaller area of the subject than the camera normally frames. Useful for readings of selected areas of a subject rather than its entirety.

**spotting**  Manual print-finishing process of covering or coloring with dye or pigment the small defects in an image usually caused by dust in the printing system or scratches on the negative. The treatment blends the "spot" with its surrounding tone, thus hiding it. Compare with *retouching*, which is concerned with altering the recorded image.

**squeegee**  Soft, flexible device used to remove excess surface moisture from films and papers prior to drying. A similar device is used in photo screen printing to force ink through a screen.

**stabilization papers and processes**  Print materials and related processes which produce moderately stable, non-permanent images a few seconds after development. The images are stable enough for many uses such as photomechanical reproduction, but they are not as permanent as conventionally processed ones.

**stabilizer**  Chemical solution or bath used in some color processes to retard change in a photographic material over a long period of time. It reduces the tendency of dyes to fade or the color balance to change.

**stain**  Undesirable, permanent color, usually yellow or brown, in black-and-white prints and negatives. Caused by contamination of the material or by exhausted processing chemicals. In color prints, it may also appear as a cyan color cast in all white areas including unexposed ones.

**stock photograph**  Any photograph of a general nature, the use of which is potentially marketable to many buyers. Reproduction rights, rather than the image itself, are typically sold.

**stock solution**  Any processing solution which is moderately concentrated and which must therefore be diluted before use. Compare with *working solution*.

**stop**  See *aperture*.

**stop bath**  Chemical bath used in processing to stop development. Most stop baths are diluted acetic acid, but some contain a dye which changes color when the acidity is neutralized, and these are known as *indicator stop baths*.

**stop down**  To reduce the size of a lens aperture.

**straight photography**  See *direct photography*.

**stroboscopic light**  Illumination produced by an electronic lamp which flashes repeatedly in a rapid sequence. Used to analyze or suggest movement in photographs by multiple exposure. Compare with *electronic flash*.

**subminiature**  Camera and film format smaller than 35mm.

**subtractive color synthesis**  Method of superimposing cyan, magenta, and yellow images to form all other colors. Most color photography is based on this principle.

**supplementary lens**  Lens element or assembly which is placed in front of a camera lens for use, and which changes the effective focal length of the regular camera lens. See also *close-up attachment*.

**swing**  Adjustment of view camera front or rear standards around a vertical axis. Swinging the front standard changes the plane of sharp focus in the image; swinging the rear standard changes the shape of the image and is useful to correct or exaggerate distortion.

**symbol**  Visual image that represents or stands for an object or idea without resembling it. Compare with *sign*.

**synchronizer**  Device often built into a camera shutter to make its fully open position coincide with the peak light intensity of a flashbulb or electronic flash. See also *M synchronization* and *X synchronization*.

**synchro sunlight**  Outdoor flash technique using sunlight as a key light or accent light, and flash as a portable fill light.

**system camera**  Camera, interchangeable lenses, and accessories designed to work together. A working camera is often assembled from modular components (body, lens, viewfinder, film chamber, winder, etc.) selected to do a job efficiently. Such combinations offer precision and flexibility, and are widely used by professional photographers.

**Système International d'Unités (SI)**  International system of measurements derived largely from the metric system, which it has replaced.

**tacking iron**  Heating tool used in dry mounting to temporarily fasten dry mounting tissue to the back of a photograph and the front of a mount board.

**telephoto lens**  Long-focus lens with a lens-to-film distance much shorter than its effective focal length, saving space and weight compared to a lens of normal construction. See also *catadioptric lens*.

**test strip**  See *trial print*.

**texture**  Small-scale, tactile quality of a surface, clearly visible in cross lighting, that gives it character and identity. Also, a term used to designate surface characteristics or finish of photographic papers (glossy, matte, luster, pearl, etc.).

**T-grain emulsion**  Film emulsion with silver bromide crystals in tabular (rather than pebble) form, arranged so that their flatter surfaces absorb more light. These emulsions have two desirable advantages over traditional ones: higher speed and finer grain.

**thin**  Lacking sufficient density in a negative or print. Thin shadow areas in a negative are usually due to under-

exposure, thin highlights to insufficient development. In a print these causes are reversed.

**tilt** Adjustment of view camera front or rear standards around a horizontal axis at right angles to the lens axis and camera bed. Tilting the front standard changes the plane of sharp focus in the image and is useful to increase *depth of field*; tilting the rear standard changes the shape of the image and is useful to correct or exaggerate vertical distortion and convergence.

**time (shutter setting)** Shutter setting which requires two separate operations of the release. The first opens the shutter, which remains open until the release is pressed again to close it. Useful for exposure times longer than a few seconds.

**time-temperature development** Method of determining the time of development according to the temperature, with other factors such as agitation and contrast held constant. This is the typical method for most black-and-white films and virtually all color materials.

**tint** Term used to describe the color of photographic paper base. White is standard but a few papers are also made in ivory, cream, or buff tints.

**tone** General term for a single shade of gray or a color in a negative or print. Also used to designate the normal image color of black-and-white printing papers.

**tone-line photograph** Photograph in which all boundaries between areas of different tones are converted to lines. The result resembles a line drawing.

**toner** Chemical solution or bath used to change the color of a black-and-white print, as from black to a brownish or bluish hue. It works on the silver in the emulsion, leaving the whites unaffected. Some toners such as selenium are also used (in weak solutions) to protect silver emulsions from deterioration, thus making them more permanent. See also *archival processing*.

**translucent** Describes a material able to transmit light, but one which scatters the light so that objects are not clearly visible through it. Ground glass is translucent.

**transparency** Positive image on film, intended for viewing or reproducing by transmitted light. In the 35mm size, when mounted, it is called a *slide*.

**trial print** Preliminary test print usually exposed in sections with increasing times, and used to establish the best overall exposure time for that print. If the trial print includes only part of the image, it is often called a *test strip*.

**tripod** Camera support with three legs, usually adjustable for length.

**tungsten (color balance)** Designated standard color balance (3200K) for certain color films. Also designated *Type B color film*. Compare with *daylight* and *Type A color film*. See also *tungsten-filament lamp*.

**tungsten-filament lamp** Any lamp which produces its illumination by electrically heating a tungsten filament or wire to incandescence in a glass or similar enclosure from which the air has been removed. A basic source of continuous artificial light for photography.

**tungsten-halogen lamp** Compact tungsten-filament lamps that operate at extremely high temperatures. The bulb is usually made of quartz rather than glass, and contains a halogen gas that prevents the gradual darkening of the lamp with use that is characteristic of most ordinary tungsten-filament lamps. Because of their high operating temperatures, these lamps require specially ventilated fixtures and extremely careful handling even when cold.

**twin-lens reflex camera** Reflex camera with a pair of matched lenses, one above the other, which focus together. The user views the subject through the upper lens via a mirror, and records the photograph with the lower lens. Simpler in construction than a single-lens reflex camera of the same format.

**Type A color film** Color reversal film balanced for exposure by artificial light of 3400K color temperature. Photoflood lamps supply this illumination.

**Type B color film** Color negative and reversal films balanced for exposure by artificial light of 3200K color temperature. Many tungsten-filament photographic lamps supply this illumination.

**ultraviolet radiation (UV)** Invisible radiation similar to light, but of shorter wavelengths, from 10 to 400 nanometers. Most light-sensitive materials are also sensitive to ultraviolet radiation. See also *light* and *skylight filter*.

**umbrella** Large, concave reflector for indirect lighting, with a white or aluminum-colored inside surface. It is used for shadowless light.

**underdevelopment** Development for too little time, at too low a temperature, or in too weak a solution. It causes insufficient contrast and highlight density in negatives, insufficient contrast and shadow density in prints, and desaturated colors in color materials.

**underexposure** Exposure for too short a time, at too small an aperture, or with insufficient light. It produces negatives that are too thin (not dense enough), especially in shadow areas. Underexposed prints are too light, with insufficient highlight detail. Underexposed color reversal materials have good color saturation but the image is too dark.

**value** See *lightness*.

**Vandyke brown print** Non-silver contact print from a positive original that is made by a process based on iron salts. Compare with *blueprint* and *platinum print*.

**variable-contrast filter** Thin, dyed sheet (or thicker, framed square) of transparent polyester plastic that is inserted into an enlarger's light path to control the contrast of a black-and-white print. See also *variable-contrast paper*.

**variable-contrast paper** Black-and-white printing paper whose contrast or grade is changeable by using different colored filters in the enlarger. Two emulsions of different color sensitivity and exposure scale are mixed together and coated on the base as a single layer. Such papers offer economy and convenience in printing. Compare with *graded paper*.

**variable focal length** See *zoom lens*.

**verification print** Print which is made following a trial print or test strip, and used to verify the time or color balance selected from the trial print. The first in a series of workprints. See also *workprint*.

**view camera** Large format, sheet-film camera for use on a tripod or stand. Typically it has a ground glass for focusing and framing, interchangeable lenses, and various adjustable parts.

**viewfinder** Part of a camera by which the user frames the subject, and which shows the approximate field of view of the camera lens.

**viewing screen** See *ground glass*.

**vignetting** Making a negative or print in which the edges of the image fade to white or black. Used primarily in portraiture. Also, a darkening of the corners of an image caused by a lens mount or hood extending into the angle of view.

**visual field (eye)** Area that the eye can see from an immobile position. Compare with *field of view*.

**warm-toned** Black-and-white photographic print which

is brownish-black in appearance. Compare with *cold-toned*.

**washing** Processing step which removes all soluble chemicals from the emulsion and base of photographic materials.

**washing aid** Mixture of salts, which, in solution, increases the solubility of residual fixing agents, and thus decreases the washing time required for their removal from photographic materials. Not a *hypo eliminator*, and not a substitute for *washing*.

**water jacket** Container of temperature-controlled water surrounding one or more tanks or trays of processing chemicals, in order to stabilize their temperature for effective use.

**water spot** Processing defect caused by uneven drying of a film or print. Rewashing and redrying will not eliminate this problem, but use of a wetting agent or squeegee will minimize future occurrences.

**wavelength** Distance between two adjacent crests of a wave of radiant energy, and the major identifying characteristic of such radiation. Wavelength distinguishes one color of light from another, and light from other forms of radiant energy such as infrared, ultraviolet, etc. It is thus related to *hue*, and is measured in *nanometers*.

**weight** Thickness of the base of photographic paper. Single, medium, and double weight are typical.

**wetting agent** Chemical or bath which reduces the surface tension of water and thus permits it to run freely off a film or print. Films and prints so treated after washing dry cleaner and faster. Wetting agents are helpful in avoiding water spots.

**white light** Light containing all colors of the visible spectrum. Compare with light from a safelight, which does not.

**wide-angle lens** Lens with a focal length much shorter than the diagonal dimension of the format with which it is used. Such lenses are helpful when photographs must be made in confined spaces, or when large areas must be included in the field of view.

**window mat** See *mat*.

**working solution** Chemical solution ready to use, requiring no further preparation. Compare with *stock solution*.

**workprint** Any of several photographic prints showing various degrees of refinement between a trial print and a final exhibition print or reproduction print from the same negative. Final prints thus evolve by improvement through workprints.

**xenon** Inert gas used in electronic flash lamps.

**xerography** Non-silver, electrostatic reproduction process widely used for document and office copy work. It is a positive-positive and uses nonsensitive paper, but does not reproduce continuous tone.

**X radiation** Radiation with wavelengths of .00001 to 100 nanometers, located between gamma and ultraviolet radiation on the spectrum. All unprocessed films and papers are sensitive to it. X-rays pass freely through many opaque substances, but special X-ray films are able to absorb these rays to some degree.

**X synchronization** Control setting on a camera shutter which permits it to be used with electronic flash lamps. At this setting, the shutter blades open first and the lamp is flashed when they have fully opened. Compare with *M synchronization*.

**yellow** Subtractive primary color, the complement of blue.

**zone focusing** Practice of estimating the nearest and farthest distances for which the camera needs to be focused, setting the lens between them, and then using the camera without further adjustment of the focus. Useful in sports, action, and reportorial work.

**Zone System** Method of combining previsualization, film exposure, processing, and printing procedures to predetermine a desired photographic result and to select the precise means to accomplish it.

**zoom lens** Lens whose focal length, and therefore image size, is continuously variable over a given range, while the distance focused upon and the relative aperture remain constant. It is thus a convenient substitute for interchangeable lenses. Many zoom lenses also have close-focusing capability in addition to their variable focal length, which makes them useful for some kinds of photomacrography.

# BIBLIOGRAPHY

This annotated guide to additional reading, picture study, and viewing has been chosen to expand and develop the discussions in this book. Several guidelines have been used to select the titles included here. First, primary sources which have bibliographies themselves have been preferred over secondary works and sources without them. Most titles listed will therefore guide you to additional sources of information. Second, books published during the last decade have been preferred to earlier works, although some older titles and others no longer in print have been included because of their continued importance. Many of these are available in academic and public libraries. Third, books available in paperback editions have been indicated by an asterisk (*).

Nearly every important photographer is now the subject of a monograph or book, and this has made the selection of titles on the history of photography and on contemporary work particularly difficult. The year 1930 was selected as a convenient date to divide the historic from the contemporary because few living photographers were active before then, and photographers well served by recent serial titles are generally not duplicated in these sections. Of the remaining books on contemporary photographers, only recent titles on the most important people have been listed.

Popular titles on specific cameras and "how to" titles are not included because they are available at public libraries and camera shops and their subjects are often discussed in photography magazines.

A list of recent non-print materials, primarily videos, has been included in this edition.

The following dealers specialize in photographic books and issue catalogs several times a year:

Focus Photography Books
1195 Oak Street
San Francisco, CA 94117

Light Impressions Corporation
439 Monroe Avenue
Rochester, NY 14607-3717

Photo Eye Books
P.O. Box 1504
Austin, TX 78767

The following classifications are used in this bibliography:

REFERENCE WORKS
GENERAL WORKS, ANTHOLOGIES, AND COLLECTIONS
HISTORY OF PHOTOGRAPHY
CONTEMPORARY ARTISTIC PHOTOGRAPHY
PHOTOGRAPHY FOR THE MEDIA: JOURNALISTIC AND
    DOCUMENTARY
PROFESSIONAL PHOTOGRAPHY: COMMERCIAL, ADVER-
    TISING, AND PORTRAIT
TECHNICAL MANUALS
WORKS IN SERIES
PERIODICALS
NON-PRINT MATERIALS (VIDEOS, FILMS, SLIDES)

## REFERENCE WORKS

BONI, ALBERT, ed. *Photographic Literature (1727–1960)*, 1962. *Photographic Literature (1960–1970)*, 1972. Hastings-on-Hudson, NY: Morgan & Morgan. Still the only comprehensive bibliography in the field, now out of print but available in many reference libraries.

BROWNE, TURNER, and PARTNOW, ELAINE. *Macmillan Biographical Encyclopedia of Photographic Artists and Innovators*. New York: Macmillan, 1983. Brief biographies of more than 2,000 photographers, writers, curators, and photo educators from Niepce to the present. Each entry notes the person's education, institutional affiliations, publications, major exhibitions, and collections containing their work.

DE COCK, LILIANE, ed. *Photo Lab Index*. 40th lifetime ed. Dobbs Ferry, NY: Morgan & Morgan, Inc., 1989. The standard manual of collected data on current photographic materials, formulas, and processes from major manufacturers worldwide. Quarterly supplements are available by subscription to update this loose-leaf manual.

DIXON, PENELOPE. *Photographers of the Farm Security Administration: An Annotated Bibliography, 1930–1980*. New York: Garland Publishing, 1983. Primary and secondary works on the twelve most important FSA photographers. Material on Roy Stryker, the project's director, is also included.

JOHNSON, WILLIAM S. and COHEN, SUSAN, eds. *International Photography Index, 1981*. Boston: G. K. Hall, 1984. The fifth volume in a series (since 1977) that indexes articles emphasizing contemporary and historical uses of photography as creative expression and communication. More than a hundred U.S. and foreign publications are referenced.

*Kodak Index to Photographic Information*. Rochester, NY: Eastman Kodak Company. Revised annually. A useful checklist of printed information and audio-visual materials on the practical application of Kodak products and techniques in amateur, professional, and scientific work.

LANGFORD, MICHAEL. *The Master Guide to Photography*. New York: Knopf, 1982. A broadly conceived, encyclopedic reference that gives balanced treatment to visual and technical topics. Well illustrated, indexed, and cross-referenced.

McQUAID, JAMES, ed. *An Index to American Photographic Collections*. Boston: G. K. Hall, 1982. The first comprehensive index to publicly accessible collections of photographs in the United States. The 458 listings include the work of more than 19,000 photographers. Fully cross-referenced.

PARRY, PAMELA JEFFCOTT. *Photography Index: A Guide to Reproductions*. Westport, CT: Greenwood Press, 1979. An index to reproductions of photographs in more than 80 books and exhibition catalogs.

*STIEGLITZ, ALFRED. *Camera Work: A Pictorial Guide,* ed. Marianne Fulton Margolis. New York: Dover, 1978. An illustrated index to all 559 illustrations and plates in the Stieglitz series (1903–1917).

*STROEBEL, LESLIE, and TODD, HOLLIS. *Dictionary of Contemporary Photography*. Dobbs Ferry, NY: Morgan & Morgan, Inc., 1974. A dictionary of words and technical terms used in still and motion-picture photography. Terms used in professional and commercial work are emphasized, with few chemical and no historical references.

WALSH, GEORGE; HELD, MICHAEL; and NAYLOR, COLIN, eds. *Contemporary Photographers*. 2nd ed. Chicago: St. James Press, 1988. A monumental index to more than 600 internationally chosen photographers, living and dead, who have been active over the last half century. Each entry consists of a biography, major exhibition record, bibliography, and a short, signed critical essay. Most entries are illustrated.

WILLIS-THOMAS, DEBORAH. *Black Photographers, 1840–1940*, 1985. *Black Photographers, 1940–1980*, 1988. New York: Garland Publishing. Two illustrated biographic and bibliographic references that cover the contributions of more than 240 black photographers to the field over its history.

## GENERAL WORKS, ANTHOLOGIES, AND COLLECTIONS

*ADAMS, ROBERT. *Beauty in Photography: Essays in Defense of Traditional Values*. Millerton, NY: Aperture, 1981. Eight thoughtful and provocative essays to stimulate thinking about contemporary photography. His concerns include landscape, beauty, and criticism.

*ARNHEIM, RUDOLPH. *Art and Visual Perception: The New Version*, 2nd rev. ed. Berkeley and Los Angeles: University of California Press, 1974. A standard reference on the perception of visual experiences by a noted psychologist. His more recent thesis, that *all* thinking is perceptual in nature, is set forth in *Visual Thinking*, 2nd ed. (Berkeley: University of California Press, 1980).*

*ARNHEIM, RUDOLPH. *The Power of the Center: The New Version*. Berkeley and Los Angeles: University of California Press, 1988. Arnheim uses the interaction of two fundamental spatial patterns to form a theory of composition in the visual arts and to explain why certain arrangements of visual elements present more satisfying experiences than others do.

*BARROW, THOMAS F.; ARMITAGE, SHELLEY; and TYDEMAN, WILLIAM E., eds. *Reading Into Photography: Selected Essays, 1959–1980*. Albuquerque, NM: University of New Mexico Press, 1982. An anthology of recent critical essays by leading teachers, historians, and curators.

*BARTHES, ROLAND. *Camera Lucida: Reflections on Photography*. trans. Richard Howard. New York: Hill and Wang, 1981. A lively, controversial essay on the nature of photography and its role in our culture by a noted French critic.

*BOORSTIN, DANIEL J. *The Image*. New York: Harper Colophon Books, 1964. First published in 1962, this lively essay on pseudo-events and the art of self-deception by an eminent historian includes a discussion of how photography has affected our taste and culture.

*CHERNOFF, GEORGE. *Photography and the Law*, 5th ed. New York: Amphoto, 1978. Written for the lay person rather than the lawyer, this book sets forth the rights and responsibilities of both the photographer and the photographed. Updated to reflect recent revisions of the copyright law, it is very clear on questions of image ownership, privacy, and libel.

*COKE, VAN DEREN. *Photography, a Facet of Modernism*. San Francisco: San Francisco Museum of Modern Art, 1987. Sixty-six superbly reproduced photographs from this outstanding museum collection, each with a brief essay, serve to develop the author's theory of modernism in this and other contemporary art media.

*COKE, VAN DEREN. *The Painter and the Photograph*, rev. ed. Albuquerque, NM: University of New Mexico Press, 1986. A well-illustrated discussion of how painters have used photography for more than a century.

*COLEMAN, A. D. *Light Readings*. New York: Oxford, 1979. A critical assessment of contemporary photography exhibited in New York during the 1970s. Coleman's broad social perspective adds much insight to his discussion.

*EAUCLAIRE, SALLY. *American Independents: Eighteen Color Photographers*, 1987. *The New Color Photography*, 1981. New York: Abbeville Press. Two books that present a good critical survey of color photography exhibited by leading art galleries over the previous decade. Many color reproductions.

*ENYEART, JAMES, ed. *Decade by Decade: Twentieth-Century American Photography from the Collection of the Center for Creative Photography*. Tuscon, AZ: Center for Creative Photography, and Boston: Bullfinch Press/Little, Brown & Company, 1989. An excellent introduction to the collection of one of America's foremost archives of fine photographs. The book includes essays by nine historians and curators, and more than 200 reproductions.

*ENYEART, JAMES L., and SOLOMON, NANCY, eds. *Henry Holmes Smith: Collected Writings*. Tuscon, AZ: The Center for Creative Photography, 1986. A lifetime of writings on criticism and education by one of photography's most noted teachers.

GEE, HELEN. *Photography of the Fifties: An American Perspective*. Tuscon, AZ: Center for Creative Photography, the University of Arizona, 1980. A selective overview of American photography in the fifties that is well balanced between artistic and journalistic concerns. Although no color is included, each of the 31 photographers is represented by two or more images, and the source of each is noted.

*GOLDBERG, VICKI, ed. *Photography in Print*. Albuquerque, NM: University of New Mexico Press, 1981, republished 1988. A broadly based anthology of writings on photography by critics, philosophers, photographers, and other artists.

GREEN, JONATHAN. *American Photography: A Critical History, 1945 to the Present*. New York: Harry N. Abrams, 1984. An insightful overview of recent American photographs and photographers that also discusses important editors, curators, and critics of the period. Useful as an extension of Newhall's classic *History of Photography* (below), which does not reach much beyond 1960.

GREENOUGH, SARAH, and others. *On the Art of Fixing a Shadow: 150 Years of Photography*. Boston: Bullfinch Press/Little, Brown & Company, 1989. Published on the occasion of an exhibition by the same title at the National Gallery of Art, Washington, DC, in 1989. Composed of vintage prints from public and private collections worldwide, the exhibit commemorated the 150th anniversary of the public announcement of photography.

GRUNDBERG, ANDY, and GAUSS, KATHLEEN MCCARTHY. *Photography and Art: Interactions Since 1946*. New York: Abbeville Press, 1987. A thoughtfully written, well-illustrated study of the development of photography as an influence on other visual arts and as art itself since World War II. The book makes an important contribution toward defining a post-modernist esthetic in the visual arts.

HUNTER, JEFFERSON. *Image and Word: The Interaction of Twentieth-century Photographs and Texts*. Cambridge, MA: Harvard University Press, 1987. A scholarly examination of the interdependent relationship between photographs and words in pictures with captions and in writer-photographer collaborations.

*JOHNSON, BERVIN; MAYER, ROBERT E.; and SCHMIDT, FRED. *Opportunities in Photography Careers*. Lincolnwood, IL: National Textbook Company, 1985. A clearly written guide to the varied careers in photography, with emphasis on educational preparation. Contains many additional sources of information.

*JUSSIM, ESTELLE, and LINDQUIST-COCK, ELIZABETH. *Landscape as Photograph*. New Haven: Yale University Press, 1988. A stimulating critical analysis and interpretation of American landscape photography that includes its consideration as concept, symbol, popular culture, and propaganda.

KLETT, MARK; MANCHESTER, ELLEN; and others. *Second View: The Rephotographic Survey Project*. Albuquerque, NM: University of New Mexico Press, 1985. More than a hundred major sites in the American West, originally photographed by expeditionary photographers of the 19th century, were precisely rephotographed with modern equipment. The paired images show not only changes in the land but also the keen esthetic sense many early photographers brought to their work.

KOZLOFF, MAX. *Photography and Fascination*. Danbury, NH: Addison House, 1979. Thought-provoking essays on the social, moral, and esthetic implications of photography, many of which were first published in *Art Forum* and *Art in America*.

*KOZLOFF, MAX. *The Privileged Eye*. Albuquerque, NM: University of New Mexico Press, 1987. More thought-provoking essays.

LIVINGSTON, JANE, and FRALIN, FRANCES, eds. *The Indelible Image*. New York: Harry N. Abrams, 1985. A carefully selected anthology of war photographs spanning the years 1846–1984.

*LYONS, NATHAN, ed. *Photographers on Photography*. Englewood Cliffs, NJ: Prentice-Hall, Inc., 1966. Still in print, this anthology of writings by 23 photographers on their vision and their craft contains extensive biographical and bibliographical data.

*MALCOLM, JANET. *Diana and Nikon: Essays on the Aesthetic of Photography*. Boston: David R. Godine, 1980 (paperback ed., 1981). Eleven essays by the photography critic for *The New Yorker*, in which she seeks to define the medium. Personal and perceptive; illustrated.

MITCHELL, MARGARETTA K. *Ten Women of Photography*. New York: Viking Press, 1979. Raises questions about sexual identity in the creation and evaluation of photographs, a subject inadequately represented in the literature of photography.

*NILLSON, LENNART. *A Child is Born*. New York: Dell Publishing, 1986. Illuminating photographs of childbirth by a Swedish biomedical photographer who pioneered photography inside the human body.

*PERSKY, ROBERT S. *The Photographer's Guide to Getting and Having a Successful Exhibition*. New York: Photographic Arts Center, 1987. Practical advice on selling yourself and your work to gallery and museum officials, and on publicizing the event.

*PETRUCK, PENINAH R., ed. *The Camera Viewed: Writings on Twentieth-century Photography*. New York: E. P. Dutton, 1979. 2 vols. An anthology of 38 essays.

SOBIESZEK, ROBERT A. *Masterpieces of Photography from the George Eastman House Collections*. New York, Abbeville Press, 1985. Two hundred photographs from one of the world's foremost collections are beautifully reproduced and intelligently discussed.

*SONTAG, SUSAN. *On Photography*. New York: Farrar, Straus, & Giroux, 1977 (paperback ed., 1989). Six provocative essays that discuss the effect of photographs on our society and sensibilities.

*STEICHEN, EDWARD, ed. *The Family of Man*. New York: Simon & Schuster, 1986. A welcome republication of the book that reproduced Steichen's classic 1955 photographic theme-show at The Museum of Modern Art, New York.

SULLIVAN, CONSTANCE, ed. *Legacy of Light*. New York: Alfred A. Knopf, 1987. An outstanding collection of more than 200 Polaroid photographs that demonstrate the artistic potential of this instant-picture process.

*SZARKOWSKI, JOHN. *Looking at Photographs*. New York: The Museum of Modern Art, 1973. One hundred photographs from the Museum's outstanding collection, each discussed with perceptive insight by this eminent curator.

*SZARKOWSKI, JOHN. *Mirrors and Windows: American Photography since 1960*. New York: The Museum of Modern Art, 1978. The illustrated catalog of a major exhibition chosen largely from the Museum's collection to fit the author's modernist construct. Direct photographs from the late sixties dominate the choices, and much innovative work from the seventies is not included.

*SZARKOWSKI, JOHN. *The Photographer's Eye*. New York: The Museum of Modern Art, 1980. First published in 1966 and again in print, this modern illustrated classic contains a lucid statement of photography's most fundamental esthetic principles.

TUCKER, ANNE, ed. *The Woman's Eye*. New York: Alfred A. Knopf, 1973. Brief texts and portfolios of ten American women photographers. Tucker raises important questions about sexual identity in the creation and evaluation of photographs, a subject still inadequately represented in the literature of photography.

WEAVER, MIKE, ed. *The Art of Photography 1839–1989*. New Haven, CT: Yale University Press, 1989. A new history of photography as an art, published on the 150th anniversary of the public announcement of the medium.

*WITKIN, LEE, and LONDON, BARBARA. *The Photograph Collector's Guide*. Boston: New York Graphic Society, 1981. Useful to help identify various forms of photographs, the book emphasizes twentieth-century images and 1970s market values.

*ZAKIA, RICHARD. *Perception and Photography*. Rochester, NY: Light Impressions Corp., 1979. The gestalt theories of Arnheim and others are more sharply focused for photographers in this well-illustrated discussion.

## HISTORY OF PHOTOGRAPHY

Note: Additional titles will be found under *Works in Series*.

*BECKER, HOWARD S.; SOUTHALL, THOMAS; and GREEN, HARVEY. *Points of View: the Stereograph in America*. Rochester, NY: Visual Studies Workshop Press, 1979. An authoritative volume on a fascinating subject.

BRETTELL, RICHARD R. and others. *Paper and Light: the Calotype in France and Great Britain, 1839–1870*. Boston: David R. Godine, 1984. A rich resource on an early period of photographic history, based on a major exhibition in Houston and Chicago. More than 150 calotypes are beautifully reproduced.

BUCKLAND, GAIL. *Fox Talbot and the Invention of Photography*. Boston: David R. Godine, 1980. All histories detail Talbot's invention of negative-positive photography, but this book also introduces us to the inventor himself and gives us fine color reproductions of many originals from the Science Museum collection.

*COE, BRIAN, and HAWORTH-BOOTH, MARK. *A Guide to Early Photographic Processes*. London: Victoria and Albert Museum, 1984. Explains all processes through collodion. Some illustrations are in color.

*COKE, VAN DEREN. *Avant Garde Photography in Germany, 1919–1939*. NY: Pantheon Books, 1982. A good survey of this formative era, especially valuable for its concise biographies of more than 50 photographers. More than 100 illustrations.

*COLOMBO, CESARE. *Italy: One Hundred Years of Photography*. New York: Rizzoli International, 1988. An overview of photography in Italy that includes not only the Alinari Brothers and other notable native photographers, but also visitors like Eisenstaedt and Strand who photographed there.

CURRENT, KAREN. *Photography and the Old West*. New York: Harry N. Abrams, 1979; reprinted 1986. A superb collection of photographs by pioneer Western American cameramen, selected with

insight and carefully printed from the vintage negatives by William Current.

DARRAH, WILLIAM CULP. *Cartes de Visite in Nineteenth Century Photography*. Gettysburg, PA: W. C. Darrah, 1981. A thorough and well-illustrated examination of this popular form of photograph. Also illuminates the business practices of photographers prior to the 1890s.

DARRAH, WILLIAM CULP. *The World of Stereographs*. Gettysburg, PA: W. C. Darrah, 1977. Stereographs were the mass entertainment of a bygone era. This volume and Becker's are the most authoritative and comprehensive references to this fascinating three-dimensional world.

*FRANK, WALDO, and others, eds. *America and Alfred Stieglitz*. Millerton, NY: Aperture, 1979. A republication of the 1934 Literary Guild edition of articles and short stories about Stieglitz by his friends. The book relates Stieglitz at the height of his career to the community in which he functioned and to the larger world of art, literature, and society.

*FRASSANITO, WILLIAM. *Gettysburg*: *A Journey in Time*, 1975 (paperback ed. 1986). *Antietam*: *the Photographic Legacy of America's Bloodiest Day*, 1978. *Grant and Lee*: *the Virginia Campaigns, 1864–1865*; 1983. New York: Charles Scribner's Sons. Three excellent examples of the use and misuse of photographs by historians. The first and last volumes underscore the importance of documenting the photographs themselves before they are used as historical evidence, and all provide an excellent analysis of Civil War photography.

*GALASSI, PETER. *Before Photography: Painting and the Invention of Photography*. New York: The Museum of Modern Art, 1981. An exhibition catalog which explores the idea that certain characteristics of nineteenth-century paintings called photographic are older than photography itself.

*GARDNER, ALEXANDER. *Gardner's Photographic Sketchbook of the Civil War*. New York: Dover, 1959. Gardner's original *Sketchbook* was published in 1866 and has long been a classic. Dover produced a fine facsimile, which is still available.

GERNSHEIM, HELMUT. *The Origins of Photography*, 1982. *The Rise of Photography, 1850–1880: The Age of Collodion*, 1988. New York: Thames and Hudson. The first two of three volumes which eventually will form a third revised edition of his 1969 *History of Photography from the Camera Obscura to the Beginning of the Modern Era*, 2nd ed., a standard reference long out of print.

*GOVER, C. JANE. *The Positive Image: Women Photographers in Turn of the Century America*. Albany, NY: State University of New York Press, 1988. Women photographers from 1880 to 1920 are examined as professionals, amateurs, and artists in this well-researched volume.

*GREEN, JONATHAN, comp. *Camera Work: a Critical Anthology*. Millerton, NY: Aperture, 1973. The best articles and illustrations from the avant-garde quarterly published by Alfred Stieglitz from 1903–1917. Since the original volumes are very rare, this anthology, although out of print, is a useful reference.

*GREENOUGH, SARAH, and HAMILTON, JUAN. *Alfred Stieglitz: Photographs and Writings*. Washington, DC: National Gallery of Art, 1983. Shortly after Stieglitz's death in 1946, his widow, Georgia O'Keeffe selected a key set of his images for the National Gallery of Art. She also collaborated in the preparation of this volume. With 73 reproductions, this book is an important addition to the Stieglitz literature.

HAAS, ROBERT BARTLETT. *Muybridge; Man in Motion*. Berkeley and Los Angeles: University of California Press, 1976. Although out of print, this is still the best single volume on the life of this extraordinary and inventive photographer.

HAUS, ANDREAS. *Moholy-Nagy: Photographs and Photograms*, trans. Frederic Sampson. New York: Pantheon Books, 1980. The most important book on this seminal artist in more than 25 years, this is the first comprehensive monograph on him as a photographer.

HAWORTH-BOOTH, MARK, ed. *The Golden Age of British Photography, 1839–1900*. Millerton, NY: Aperture, 1984. A handsomely produced book that includes nearly 200 fine reproductions from the collections of the Victoria and Albert Museum and Science Museum in London, the Royal Archives at Windsor Castle, the Royal Photographic Society in Bath, the Scottish National Portrait Gallery in Edinburgh, and the Philadelphia Museum of Art.

*IVINS, WILLIAM M., JR. *Prints and Visual Communication*. Cambridge, MA: M. I. T. Press, 1969; republished 1985. A classic analysis of how reproduced images have affected human perception and learning, and how the advent of photography changed our cultural vision.

*JACKSON, WILLIAM HENRY. *Time Exposure*. Albuquerque, NM: University of New Mexico Press, 1986. The autobiography of one of America's most famous nineteenth-century photographers of the West, originally published in 1940 when he was 97.

JAPANESE PHOTOGRAPHERS ASSOCIATION. *A Century of Japanese Photography*. New York: Pantheon Books, 1981. An excellent introduction to Japanese photography, this comprehensive survey with a new introductory text was translated from the 1971 edition of *Nihon Shashin Shi 1840–1945*.

*JENKINS, REESE V. *Images and Enterprise: Technology and the American Photographic Industry 1839 to 1925*. Baltimore, MD: Johns Hopkins University Press, 1975 (paperback ed., 1987). The first comprehensive study of the photographic equipment and supply industry in the United States.

*LOTHROP, EATON S. JR. *A Century of Cameras*, 2nd ed. Dobbs Ferry, NY: Morgan & Morgan, 1982. Illustrated descriptions of 130 interesting cameras from the large collection in the International Museum of Photography at George Eastman House. The author is a noted collector and lecturer.

*NEWHALL, BEAUMONT. *The Daguerreotype in America*. New York: Dover, 1976. A revised and expanded version of the original 1961 edition, with extensive technical and biographical notes. This is a definitive work.

*NEWHALL, BEAUMONT. *The History of Photography from 1839 to the Present*. New York: The Museum of Modern Art, 1982. The fifth edition of a classic history that has become the most widely read book in its field. Nearly 300 illustrations.

*NEWHALL, BEAUMONT. *Latent Image: the Discovery of Photography*. Albuquerque, NM: University of New Mexico Press, 1983. This republication of Newhall's 1967 gem on the invention and discovery of photography, emphasizes the human side of the discoveries.

*NEWHALL, BEAUMONT. *Photography: Essays & Images*. New York: The Museum of Modern Art, 1980. Fifty-three readings and 200 photographs, carefully selected from original sources of photographic history.

*RIIS, JACOB. *How the Other Half Lives*. New York: Dover, 1971. Originally published in 1890, this study of New York's teeming tenements long ago became a social classic. Still in print, this facsimile edition also contains 100 modern reproductions of Riis's pioneering photographs.

ROSENBLUM, NAOMI. *A World History of Photography*, 2nd ed. New York: Abbeville Press, 1989. A new history organized by major themes rather than chronologically. Extensive notes, biographic and bibliographic information, and more than 800 illustrations.

SZARKOWSKI, JOHN, and HAMBOURG, MARIA MORRIS. *The Work of Atget*. *Vol. I: Old France*, 1981. *Vol. II: The Art of Old*

*Paris*, 1982. *Vol. III: The Ancien Régime*, 1984. *Vol. IV: Modern Times*, 1985. New York: The Museum of Modern Art. Four elegant and scholarly volumes that form the definitive work on this legendary French photographer.

WEAVER, MIKE. *Julia Margaret Cameron, 1815–1879.* Boston: New York Graphic Society, 1984. A well-written biography of a Victorian camera artist who was the first important woman photographer.

*WELLING, WILLIAM. *Photography in America: The Formative Years 1839–1900.* Albuquerque: University of New Mexico Press, 1987. A comprehensive and well-illustrated history of the first sixty years of American photography.

## CONTEMPORARY ARTISTIC PHOTOGRAPHY

Note: Additional titles will be found under *Works in Series.*

ADAMS, ANSEL. *Ansel Adams: An Autobiography.* With Mary Street Alinder. Boston: New York Graphic Society, 1985. The decade's most renowned photographer recounts a full life in photography, music, conservation, and politics. Beautifully illustrated.

ADAMS, ANSEL. *Ansel Adams: Classic Images.* Boston: New York Graphic Society, 1986. The master photographer's own selection of images from a sixty-year career. This volume includes an introduction by John Szarkowski (The Museum of Modern Art) and an essay by James Alinder, both of whom knew Adams closely.

ADAMS, ROBERT. *To Make It Home: Photographs of the American West, 1965–1986.* New York: Aperture, 1989. A retrospective collection of photographs by a literate protagonist for photography and its powers of persuasion. Here Adams eloquently argues for the protection of the rapidly vanishing natural environment in the American West.

BAER, MORLEY. *Light Years.* Carmel, CA: Photography West Graphics, 1988. Nearly fifty years of this leading West Coast landscape and architectural photographer's work are beautifully presented in this handsome volume.

BOSWORTH, PATRICIA. *Diane Arbus: A Biography.* New York: Alfred A. Knopf, 1984. An illustrated biography on this tragic and legendary woman who was much admired by a younger generation of photographers. A paperback version without illustrations was published by Avon Books in 1985.

BRIDGES, MARILYN. *Markings: Aerial Views of Sacred Landscapes.* New York: Aperture, 1986. A striking collection of low-altitude oblique aerial photographs that reveal man-made landscape features. Bridges skillfully uses light to reveal their drama and mystery.

*BUNNELL, PETER C. *Minor White: The Eye That Shapes.* Princeton, NJ: The Art Museum, Princeton University, 1989. Published on the occasion of a retrospective exhibition of work by this late photographer and teacher at the Museum of Modern Art, New York.

BURKE, BILL. *I Want to Take Picture.* Atlanta, GA: Nexus Press, 1987. An unusual artist's book that is both a personal and political statement based on a visit to Southeast Asia.

CAPONIGRO, PAUL. *The Wise Silence.* Boston: New York Graphic Society, 1983. The most important single volume on this master photographer.

CHIARENZA, CARL. *Aaron Siskind: Pleasures and Terrors.* Boston: New York Graphic Society, 1983. The definitive biography of a much-honored twentieth-century photographer whose career has spanned more than fifty years.

CHIARENZA, CARL. *Landscapes of the Mind.* Boston: David R. Godine, 1988. A beautiful example of photographs made as metaphors by a noted teacher/photographer/historian.

*CHRISTENBERRY, WILLIAM. *Southern Photographs.* New York: Aperture, 1988. A poetic evocation of the American South by one of its foremost contemporary artist-photographers.

*COKE, VAN DEREN. *Photography: A Facet of Modernism.* New York: Hudson Hills Press, in association with the San Francisco Museum of Modern Art, 1987. Written with Diana C. du Pont and based on the photography collection that Coke helped to assemble at the San Francisco Museum of Modern Art, this book presents a personal assessment of the modernist trend in the medium.

*Contemporary Canadian Photography.* Edmonton, Alberta: Hurtig Publishers, 1984. A well-illustrated guidebook to recent Canadian photography, produced by the National Film Board of Canada from its Still Photography Division collection.

DATER, JUDY. *Judy Dater: Twenty Years.* Tuscon, AZ: University of Arizona Press, in association with the De Saisset Museum, University of Santa Clara, 1986. A retrospective look at the work of a Californian who has made remarkably sensitive and penetrating pictures of people.

*DAVIS, KEITH F. *Harry Callahan: New Color Photographs 1978–1987.* Kansas City, MO: Hallmark Cards, 1988. The most important book on this mature contemporary artist to appear in more than a decade.

EDGERTON, HAROLD. *Stopping Time.* New York: Harry N. Abrams, 1987. The definitive volume on the work of this innovative photographer, inventor, and electrical engineer who is considered the father of modern flash photography. Many illustrations.

*EVANS, WALKER. *American Photographs.* New York: The Museum of Modern Art, 1988. A fiftieth anniversary edition of the Museum's 1938 classic, published to accompany a commemorative exhibition of the photographer's original prints.

GARNETT, WILLIAM. *The Extraordinary Landscape: Aerial Photographs of America.* Boston: New York Graphic Society, 1982. A stunning collection of images in color by a sensitive photographer who has flown over much of the United States in a small aircraft.

*GAUSS, KATHLEEN MCCARTHY. *Inventories and Transformations: The Photographs of Thomas Barrow.* Albuquerque: University of New Mexico Press, 1986. Barrow's experimental and innovative images challenge the viewer to reconsider the very nature of photography.

GAUSS, KATHLEEN MCCARTHY. *New American Photography.* Los Angeles: Los Angeles County Museum of Art, 1985. Brief essays on seven contemporary photographers, with fine reproductions of their work. Included are Susan Rankaitis, Richard Misrach, Mark Klett, Wendy Snyder MacNeil, John Pfahl, Barbara Kruger, and Eileen Cowin.

*GIBSON, RALPH. *Tropism.* New York: Aperture, 1987. The definitive retrospective volume on this important contemporary photographer whose sequences of graphic and surrealistic work are perhaps better known in Europe than at home.

*GOLDIN, NAN. *The Ballad of Sexual Dependency.* New York: Aperture, 1989. A cutting social commentary about life within the author's contemporary urban subculture.

GRUNDBERG, ANDY, and GAUSS, KATHLEEN MCCARTHY. *Photography and Art: Interactions Since 1946.* New York: Abbeville Press, 1987. A thoughtful, well-written study of the development of photography—as an influence on other arts and as an art itself—since the end of World War II. Painters whose work seems to promote a dialog with photographers are included, but straight photographic recording, documentary, portrait, street, political, and landscape photography are not.

*HAHN, BETTY, ed. *Contemporary Spanish Photography.* Albuquerque, NM: University of New Mexico Press, 1987. The first major survey of contemporary photography in Spain, with an essay by Joan Fontcuberta. Some illustrations are in color.

*HAWORTH-BOOTH, MARK, and others. *British Photography: To-*

*wards a Bigger Picture*. New York: Aperture, 1988. The first major survey of contemporary British photography. Beautifully illustrated.

*HEYMAN, ABIGAIL. *Dreams and Schemes: Love and Marriage in Modern Times*. New York: Aperture, 1987. A fascinating portrait of modern marriage.

HOY, ANNE H. *Fabrications: Staged, Altered, and Appropriated Photographs*. New York: Abbeville Press, 1987. A survey of 58 artist-photographers whose work is challenging, contemporary, and unconventional.

KERTÉSZ, ANDRÉ. *Diary of Light, 1912–1985*. New York: Aperture, 1987. The first complete retrospective book on this late photographer. It includes his own selection of more than 150 key images from seven decades of work in Europe and America.

MANN, SALLY. *At Twelve: Portraits of Young Women*. New York: Aperture, 1988. Classic, large-format portraits of young women comprise this latest volume of work by a young Virginian.

MEYEROWITZ, JOEL. *Cape Light*. Boston: Museum of Fine Arts and New York Graphic Society, 1978. A fine example of how the mechanistic spectrum of color film can be tuned to a photographer's personal vision. His moody and sensitive Cape Cod views have been widely praised.

MEYEROWITZ, JOEL. *The Arch*. Boston: New York Graphic Society, 1988. An abridged version of the paperback *St. Louis and the Arch* (1980).

NEWHALL, BEAUMONT. *Supreme Instants: the Photographs of Edward Weston*. Boston: New York Graphic Society, 1986. The best of several recent books about this master photographer. Unlike much recent history, Newhall's essay is written from the perspective of a personal acquaintance, and the 123 full-page illustrations include Weston's little-known work in color.

*NEWMAN, ARNOLD. *Five Decades*. San Diego, CA: Harcourt Brace Jovanovich, 1986. A half century of artful work by this master of environmental portaiture.

NIXON, NICHOLAS. *Pictures of People*. New York: The Museum of Modern Art, 1988. A fine selection of large-format pictures of people, made in the classic tradition for which this photographer has become noted.

PARKER, OLIVIA. *Weighing the Planets*. Boston: New York Graphic Society, 1987. Contains 54 photographs by an artist who combines a rich vocabulary of symbols from found objects with split-toned printing to produce handsome images. A paperback edition was published as *Untitled 44* by the Friends of Photography in 1987.

PATTERSON, FREEMAN. *Portraits of Earth*. San Francisco: Sierra Club Books, 1987. Elegant color images of African deserts and arctic landscapes by a Canadian photographer with a gifted eye. Patterson's skillful use of color and his deep concern for the land and the environment are evident in every shot.

*POMEROY, JIM, curator. *Digital Photography*. San Francisco: San Francisco Camerawork, 1988. The catalog of a pioneering exhibition by eleven artists who are experimenting with the exciting new environment of computers and photography. Includes texts by Timothy Druckery and Martha Rosler.

PORTER, ELIOT. *The West*. Boston: New York Graphic Society, 1988. A retrospective collection of previously unpublished views of the Western United States by a pioneer of landscape photography in color.

*PUTZAR, EDWARD. *Japanese Photography 1945–1985*. Tuscon, AZ: Pacific West Corporation, 1987. A new survey of Japanese photography, with text in English, by a noted scholar of Japanese literature.

SHORE, STEPHEN. *Uncommon Places*. Millerton, NY: Aperture, 1982. These elegant images of ordinary settings are a good in-troduction to a major contemporary color photographer who works in the classic style.

SMITH, JOSHUA. *The Photography of Invention: American Pictures of the 1980s*. Cambridge, MA: MIT Press, 1989. Catalog for an exhibition at the Smithsonian Institution, Washington, DC. Ninety artists influenced by post-modernism and conceptual art are featured in the show.

ST. CYR, AGNES, and others. *Twentieth Century French Photography*. New York: Rizzoli International, 1988. The first book published in America to trace the development of contemporary photography in France. Contains 300 duotone illustrations.

STERNFELD, JOEL. *American Prospects*. New York: Times Books, in association with the Museum of Fine Arts, Houston, 1987. This volume and Stephen Shores *Uncommon Places* (above) present elegant images of rather ordinary settings. They are nevertheless a fine introduction to two major contemporary color photographers who work in the classic style.

*STRAND, PAUL. *Paul Strand: Sixty Years of Photographs*. Millerton, NY: Aperture, 1976. The most important book on the life and work of this classic photographer whose contribution spanned six decades. More than 130 reproductions.

SZARKOWSKI, JOHN. *Winogrand: Figments from the Real World*. New York: The Museum of Modern Art, 1988. The first retrospective collection of work by Garry Winogrand, whom this author/curator has called "central to his generation." Some of the hundreds of photographs unprinted and unpublished at the time of Winogrand's death in 1984 are included.

TICE, GEORGE. *Urban Romantic*. Boston: David R. Godine, 1982. A retrospective monograph on this large-format photographer who is equally noted for his fine silver and platinum prints.

TUCKER, ANN WILKES. *Unknown Territory: Photographs by Ray K. Metzker*. Houston: Museum of Fine arts, in collaboration with Aperture, New York, 1984. The first retrospective monograph on this talented and intelligent photographer who is noted for his multiple exposures and large, graphic images assembled from many smaller ones. Metzker's own notes explain the 80 reproductions.

*UELSMANN, JERRY N. *Process and Perception*. Gainesville, FL: University Presses of Florida, 1985. The most recent major publication of this prolific artist's remarkable photomontages. Uelsmann explains the complex techniques that have made him famous and comments on his unique blending of fantasy and reality.

*WALKER, TODD. *Todd Walker Photographs*. Carmel, CA: The Friends of Photography, 1986. Designed and produced by the artist himself, this handsome monograph presents fifteen years of work by this creative artist and innovative printmaker.

WESTON, BRETT. *Brett Weston: a Personal Selection*. Carmel, CA: Photography West Graphics, 1986. An elegant book of photographs by this master camera artist, who personally selected them from his archive.

*WHITE, MINOR. *Minor White: Rites and Passages*. Millerton, NY: Aperture, 1978. As the editor of *Aperture* for more than twenty years, and a teacher at several major institutions, Minor White was one of the most influential photographers of his generation. This volume, with 85 photographs and a biographical essay by James Baker Hall, provides an overview of White's esthetics, teaching, and personal life.

WHITE, MINOR. *Mirrors/Messages/Manifestations*. New York: Aperture, 1982. A republication of the 1969 edition of White's masterpiece, with a new preface by Michael E. Hoffman.

## PHOTOGRAPHY FOR THE MEDIA: JOURNALISTIC AND DOCUMENTARY

Note: Additional titles will be found under *Works in Series*.

*BENSON, HARRY. *Harry Benson on Photojournalism*. New York: Crown Publishers, 1982. Frank tips on entering and working in the profession from a noted photojournalist who was Magazine Photographer of the Year in 1982.

DAVIDSON, BRUCE. *Subway*. New York: Aperture, 1986. Powerful color photographs of the New York City subway system by a major photographer of New York City life. A broader selection of his work may be found in *Bruce Davidson Photographs* (New York: Simon & Schuster, 1979), which includes photographs from his earlier, highly acclaimed *East 100th Street*.*

EISENSTAEDT, ALFRED. *Eisenstaedt on Eisenstaedt*. New York: Abbeville Press, 1985. A self-portrait of this legendary *Life* photographer, with more than 100 reproductions of his work spanning 60 years.

*FEATHERSTONE, DAVID, ed. *Observations. Untitled 35*. Carmel, CA: The Friends of Photography, 1984. A thought-provoking collection of original essays that suggest how the documentary concept of photography has changed since it was first given a name by filmmaker-critic John Grierson in the thirties.

FISHER, ANDREA. *Let Us Now Praise Famous Women*. London and New York: Pandora Press, 1987. This book recounts the roles and work of the lesser-known Farm Security Administration women photographers.

*FLEISCHHAUER, CARL, and BRANNAN, BEVERLY W., eds. *Documenting America, 1935–1943*. Berkeley, CA: University of California Press, 1988. A new critical study of the photographs made under Roy Stryker's direction for the Farm Security Administration. The role of the government in this project is fully explained.

*FRANK, ROBERT. *The Americans*, 4th ed. New York: Random House, 1986 (paperback ed. by Pantheon Books, 1986). A new edition of this unconventional view of America in the fifties. First published in 1959, it long ago became a classic.

*FULTON, MARIANNE, and others. *Eyes of Time: Photojournalism in America*. Boston: New York Graphic Society, 1988. A comprehensive examination of American photojournalism and its impact on our society. The book draws heavily on interviews of photojournalists, picture editors, and agency founders. More than 400 illustrations.

GANZEL, BILL. *Dust Bowl Descent*. Lincoln: University of Nebraska Press, 1984. This recent project compares Farm Security Administration photographs of the thirties and forties with their modern counterparts. Many people pictured in the FSA images who were still living in the eighties were rephotographed in the same places.

*GOLDBERG, VICKI. *Margaret Bourke-White*. Reading, MA: Addison-Wesley, 1987. The first major book in more than fifteen years on Margaret Bourke-White, whose photographs in the thirties and forties on assignment for *Life* magazine helped forge its journalistic style.

*HURLEY, F. JACK. *Portrait of a Decade: Roy Stryker and the Development of Documentary Photography in the Thirties*. Baton Rouge, LA: Louisiana State University Press, 1972 (paperback ed., New York: Da Capo Press, 1977). The most informative and readable account of how Roy Stryker shaped the Farm Security Administration project of the thirties into a classic example of documentary photography. Robert Doherty edited the photographs.

*KOBRE, KENNETH. *Photojournalism: the Professional's Approach*. New York: Van Nostrand Reinhold, 1980 (paperback ed., Stoneham, MA: Focal Press, 1985). A textbook on photo reporting that contains a concise history of the field, an excellent bibliography, and one of the last interviews with W. Eugene Smith before his death in 1978. Smith's famous "Nurse Midwife" photo essay is reproduced in full.

*LANGE, DOROTHEA. *Photographs of a Lifetime*. Oakland, CA and Millerton, NY: The Oakland Museum and Aperture, 1982. A rich examination of Lange's photography and personal life. An essay by Robert Coles reveals how each strongly influenced the other and made her an important role model for women photographers. An afterword by Therese Heyman notes the resources of the Lange archive in the Oakland Museum.

*LEIFER, NEIL. *Neil Leifer's Sports Stars*. New York: Doubleday, 1986. A book of outstanding photographs by one of the best sports photographers working today.

LIGHT, KEN. *To the Promised Land*. New York: Aperture, 1988. Documentary photographs of people who cross the border from Mexico to the United States, with oral histories by Samuel Orozco.

LOENGARD, JOHN. *LIFE: Classic Photographs: a Personal Interpretation*. Boston: New York Graphic Society, 1988. A new selection of the most venerable images from *Life* magazine, chosen by a former photographer and picture editor. This volume is perhaps the best of several recent ones by former Life staffers.

*MARK, MARY ELLEN. *Photographs of Mother Teresa's Missions of Charity in Calcutta. Untitled 39*. Carmel, CA: The Friends of Photography, 1986. A noted photojournalist's recent photographic essay on Mother Teresa's hospitals.

*MARK, MARY ELLEN. *Streetwise*. Philadelphia: University of Pennsylvania Press, 1988. A recent photographic essay on Seattle's street children by a noted photojournalist.

*Odyssey: The Art of Photography at National Geographic*. Charlottesville, VA: Thomasson-Grant, 1988. Nearly 300 remarkable photographs culled from the archive of this famous magazine that pioneered the use of color photography when it was still in its infancy.

*RICHARDS, EUGENE. *Below the Line: Living Poor in America*. Mount Vernon, NY: Consumers Union, 1987. An important documentary study of poverty in America today by a noted photojournalist. Made in 11 states, the pictures show many life styles and races.

RICHARDS, EUGENE. *The Knife and Gun Club: Scenes from an Emergency Room*. New York: Atlantic Monthly Press, 1988. Grim scenes full of joy and pathos from the front line of life itself are shown by this photographer's sensitive camera.

*ROTHSTEIN, ARTHUR. *Documentary Photography*. Stoneham, MA: Focal Press, 1985. An expert discussion of documentary photography by the late photographer/journalist/editor whose career spanned forty years. Rothstein examines the political, social, economic, and practical aspects of the field, and offers guidelines for future projects.

*ROTHSTEIN, ARTHUR. *Photojournalism*. Stoneham, MA: Focal Press, 1983. A classic treatise that first appeared in 1956, this volume is a republication of the 1974 edition.

*SALGADO, SEBASTIÃO. *Other Americas*. New York: Pantheon Books, 1986. Engaging photographs of Central and South American life by a contemporary Magnum photographer from Brazil.

SLEMMONS, ROD. *Like a One-eyed Cat: Lee Friedlander, Photographer 1956–1987*. New York: Harry N. Abrams, 1989. The catalog for a retrospective exhibition of this noted photographer's work. The show appeared in several American museums in 1989.

SMITH, W. EUGENE. *Let Truth Be the Prejudice*. New York: Aperture, 1985. The definitive book on the greatest photojournalist of all time. Ben Maddow wrote the biography, and all of the great photographs for which Smith became famous are here, along with a major bibliography.

*STELZER, ULLI. *The New Americans.* Pasadena, CA: NewSage Press, 1988. Recent photographs of people who have emigrated to Southern California, largely from Southeast Asia.

*WEINBERG, ADAM D. *On the Line: The New Color Photojournalism.* Minneapolis, MN: Walker Art Center, 1986. An exhibition catalog that is a good overview of recent magazine photojournalism in color. The selection of reproductions is international in scope.

## PROFESSIONAL PHOTOGRAPHY: COMMERCIAL, ADVERTISING, AND PORTRAIT

*ASMP: Professional Business Practices in Photography*, 4th ed. New York: American Society of Magazine Photographers (419 Park Avenue S., New York, NY 10016), 1986. The standard reference for anyone selling photographs to publishers and agencies. It includes a survey of recent pricing practices.

*BRACKMAN, HENRIETTA. *The Perfect Portfolio.* New York: Amphoto, 1984. Written by a noted photographer's representative, this is the best guide to producing a portfolio that will help sell your work.

*HART, JOHN. *Fifty Portrait Lighting Techniques.* New York: Amphoto, 1983 (paperback ed., New York: Watson-Guptill, 1987). Step-by-step procedures and lighting diagrams for photographing people in the studio.

*KERR, NORMAN. *Techniques of Photographic Lighting.* New York: Amphoto, 1982. One of the best guides to lighting objects in the studio. Many illustrations.

*O'CONNOR, MICHAEL, ed. *The Image Bank: Visual Ideas for the Creative Color Photographer.* New York: Amphoto, 1988. A well-illustrated book of advice from one of the nation's leading stock photography agencies.

*Professional Photographic Illustration.* Rochester, NY: Eastman Kodak Company, 1989. A guidebook to today's best and most innovative commercial photography, with more than 120 illustrations and lighting diagrams.

*ROTKIN, CHARLES. *The Professional Photographer's Survival Guide.* New York: Amphoto, 1982. A guide to the *business* of being a photographer, drawn from interviews with numerous leading professionals. The book discusses industry practices and includes sample forms, rate tables, and other helpful data.

*SCHAUB, GEORGE. *Shooting for Stock.* New York: Watson-Guptill, 1987. Practical advice for shooting photographs that have wide appeal, many uses, and thus the potential for many sales and resales to businesses and the media.

SOBIESZEK, ROBERT A. *The Art of Persuasion: A History of Advertising Photography.* New York: Harry N. Abrams, 1988. The first book to trace the evolution of photographs in advertising, written in conjunction with an exhibition at George Eastman House. Readable, well illustrated, and entertaining.

SOBIESZEK, ROBERT A., ed. *The Architectural Photography of Hedrich-Blessing.* Holt, Rinehart, and Winston, 1984. Fifty years of architectural photography by a Chicago studio famous for this work. Although currently out of print, the book is valuable because many of the world's most famous architects are represented in this collection of outstanding photographs.

## TECHNICAL MANUALS

ADAMS, ANSEL. *Polaroid Land Photography.* Boston: New York Graphic Society, 1978. A revision of the 1963 manual with added material by other authors. All contributors stress the system's capacity for instant feedback to reinforce visualization. This is the definitive reference on black-and-white Polaroid materials and equipment.

ADAMS, ANSEL. *The Camera.* The New Ansel Adams Photography Series/Book 1, 1980. *The Negative.* The New Ansel Adams Photography Series/Book 2, 1981. *The Print.* The New Ansel Adams Photography Series/Book 3, 1983. Boston: New York Graphic Society. Three volumes that constitute Adams's revision of his classic *Basic Photo Series* of 1948–1956. Book 2 contains, in effect, the "revised standard version" of his famous Zone System.

ARNOW, JAN. *Handbook of Alternative Photographic Processes.* New York: Van Nostrand Reinhold, 1982. Clear, step-by-step instructions for making non-silver photographs with printing-out processes, iron processes, pigment processes, and modern commercial processes such as Kwik-Print and liquid emulsions.

BLAKER, ALFRED A. *Handbook for Scientific Photography*, 2nd ed. Stoneham, MA: Focal Press, 1988. The best guide for photographing subjects and events that occur in the laboratory, with advice on preparing scientific photographs for publication.

*BROOKS, DAVID B. *Lenses and Lens Accessories: A Photographer's Guide.* Somerville, MA: Curtin & London, 1982. Out of print but still an excellent guide to modern 35mm camera lenses, with many photographs and diagrams.

*CRAWFORD, WILLIAM. *The Keepers of Light.* Dobbs Ferry, NY: Morgan & Morgan, 1979. A working guidebook to photographic processes used in the nineteenth century, with practical suggestions for recreating them with modern materials.

*CURTIN, DENNIS, and DE MAIO, JOE. *The Darkroom Handbook.* Stoneham, MA: Focal Press, 1979. A guide to darkroom planning and construction that combines a sensitivity to human concerns and working conditions with the means for efficient production of fine photographs.

*DAVIS, PHIL. *Beyond the Zone System*, 2nd ed. Stoneham, MA: Focal Press, 1988. A thoughtful and clearly written approach to control of the black-and-white photographic process. By substituting sensitometry for eye-match procedures used by most other authors, Davis offers a more accurate system. A separate workbook is full of practical tips and aids to organize the necessary testing procedures.

*EATON, GEORGE T. *Photographic Chemistry*, rev. ed. Dobbs Ferry, NY: Morgan & Morgan, 1984. A lucid explanation of photographic chemistry for the nonscientist and general reader.

*EDGERTON, HAROLD E. *Electronic Flash; Strobe*, 3rd ed. Cambridge, MA: M. I. T. Press, 1987. The standard reference to electronic flash written by its inventor.

GLENDENNING, PETER. *Color Photography: History, Theory, and Darkroom Technique.* Englewood Cliffs, NJ: Prentice-Hall, 1985. A guide to the most popular color materials and processes, written for artist-photographers and students.

GUILFOYLE, ANN, ed. *Wildlife Photography.* New York: Watson-Guptill, 1982. A showcase of work by ten skillful wildlife photographers, carefully chosen to be instructive to photographers as well as attractive to general readers.

HOWELL-KOEHLER, NANCY. *Photo Art Processes.* Worcester, MA: Davis Publications, 1980. A clearly written guide to almost every process except straight photographic printing, with notes on equipment needed, sources for it, and problems encountered in each process.

*JOHNSON, CHRIS. *The Practical Zone System.* Stoneham, MA: Focal Press, 1986. A guidebook to the principles of the Zone System that uses simple language and diagrams to explain the system.

*KEEFE, LAWRENCE E. JR., and INCH, DENNIS. *The Life of a Photograph*, 2nd ed. Boston: Focal Press, 1989. An excellent guidebook on crafting photographic prints for the long haul. Major

topics covered are archival processing, matting, framing, and storage.

*Kodak Black-and-White Darkroom Dataguide. Rochester, NY: Eastman Kodak Company, 1988. A convenient and popular handbook of up-to-date information on Kodak films, developers, papers, and chemicals widely used in black-and-white photography. Although limited to Kodak products, the information is applicable to comparable products of other manufactures as well.

*Kodak Color Darkroom Dataguide. Rochester, NY: Eastman Kodak Company, 1989. This convenient reference book on the most popular color films, papers, and their chemical processes contains numerous tables, charts, and information on exposure and filtering for color printing. Since most brands of color films and papers (except Cibachrome) are compatible with Kodak processes, this is virtually a universal guide to color materials.

LITTLE, ROBERT T. Astrophotography. New York: Macmillan, 1986. A step-by-step guide to photography through telescopes.

*NETTLES, BEA. Breaking the Rules: A Photo-media Cookbook, 2nd ed. Urbana, IL: Inky Press Productions, 1987. A fine resource book for making photographs with non-silver materials, including Kwik-Print, photo-screen printing, random-dot halftone, and xerography.

*PADUANO, JOSEPH. The Art of Infrared Photography. Dobbs Ferry, NY: Morgan & Morgan, 1984. A comprehensive guide to the use of black-and-white infrared film.

*PATERNITE, STEPHEN and DAVID, eds. American Infrared Survey. Akron, OH: Photo Survey Press, 1982. A sourcebook on infrared art photography, with 80 illustrations by many photographers.

*REEVE, CATHERINE, and SWARD, MARILYN. The New Photography. Englewood Cliffs, NJ: Prentice-Hall, 1984. A guide to alternative processes, image manipulation, and innovative display techniques.

*REILLY, JAMES M. Care and Identification of 19th Century Photographic Prints. Rochester, NY: Eastman Kodak Company, 1986. A well-organized, illustrated guide for precise identification and proper preservation of nineteenth-century photographs. Especially useful for students, librarians, curators, and collectors.

*SANDERS, NORMAN. Photographing for Publication. New York: R. R. Bowker, 1983. An authoritative, step-by-step guide for printing and preparing photographs for photomechanical reproduction in black-and-white and color. Explains halftone screens, color separations, duotone, and other photolithographic printing processes.

SEELEY, J. High Contrast. Stoneham, MA: Focal Press, 1980. The most thorough and imaginatively illustrated discussion of litho film art images to appear in many years. A fundamental guide.

*SHAW, SUSAN. Overexposure: Health Hazards in Photography. Carmel, CA: The Friends of Photography, 1983. Although out of print, this is a systematic guide to health hazards inherent in using photographic chemicals. A trade-name index lists chemicals contained in many photographic formulas and products.

*STONE, JIM, ed. Darkroom Dynamics. New York: Van Nostrand Reinhold, 1979 (paperback ed., Stoneham, MA: Focal Press, 1986). A well-illustrated resource book for exploring non-representational imagery and printing techniques.

*STONE, JIM. A User's Guide to the View Camera. Boston: Little, Brown, 1987. Reprinted by New York Graphic Society, 1988 (paperback ed., Glenview, IL: Scott, Foresman, 1987). A comprehensive introduction to large-format cameras. Especially good on their history and development.

STROEBEL, LESLIE, and others. Photographic Materials and Processes. Stoneham, MA: Focal Press, 1986. A thorough introduction to camera imaging and such diverse topics as sensitom-etry, optics, photometry, emulsions, development, tone and color reproduction, quality control, and others.

STROEBEL, LESLIE. View Camera Technique, 5th ed. Stoneham, MA: Focal Press, 1986. An excellent reference to large-format camera techniques.

STURGE, JOHN M. Imaging Processes and Materials: Neblette's 8th Edition. New York: Van Nostrand Reinhold, 1989. The latest update of the standard reference to photographic technology, which made its first appearance in 1927.

*WHITE, MINOR; ZAKIA, RICHARD; and LORENZ, PETER. The New Zone System Manual, rev. ed. Dobbs Ferry, NY: Morgan & Morgan, 1984. Extensive charts, graphs, and technical data support a working approach to the Zone System based on empirical (eye-match) measurements.

## WORKS IN SERIES

Aperture History of Photography. Millerton, NY: Aperture, 1976–1981. An exemplary series of books on major nineteenth- and twentieth-century photographers. The photographs are carefully selected and well reproduced, the texts concise and authoritative. Each volume contains excellent biographic and bibliographic data. Out of print but available in many libraries.
 1. Henri Cartier-Bresson, 1976.
 2. Robert Frank, 1976.
 3. Alfred Stieglitz, 1976.
 4. Wynn Bullock, 1976.
 5. Jacques-Henri Lartigue, 1977.
 6. André Kertész, 1977.
 7. August Sander, 1977.
 8. Weegee, 1978.
 9. Edward Steichen, 1978.
 10. Erich Salomon, 1979.
 11. Clarence H. White, 1979.
 12. Walker Evans, 1980.
 13. Frank Meadow Sutcliffe, 1980.
 14. Eugène Atget, 1980.
 15. Man Ray, 1980.
 16. Dorothea Lange, 1981.

*Aperture Masters of Photography. New York: Aperture, 1987 to the present. A new series that follows the History of Photography series above. Each volume has more than 40 photographs; most also have an essay by a noted photographic author.
 1. Paul Strand, 1987. Essay by Mark Haworth-Booth.
 2. Henri Cartier-Bresson, 1987.
 3. Manuel Alvarez Bravo, 1987. Essay by A. D. Coleman.
 4. Roger Fenton, 1987. Essay by Richard Pare.
 5. Dorothea Lange, 1987. Essay by Christopher Cox.
 6. Alfred Stieglitz, 1988. Essay by Dorothy Norman.
 7. Edward Weston, 1988. Essay by R. H. Cravens.
 8. Man Ray, 1988. Essay by Jed Perl.
 9. Berenice Abbott, 1988. Essay by Julia Van Haften.

*The Archive. Tuscon, AZ: The Center for Creative Photography, 1976 to the present. A periodic publication of unique or previously unpublished material from the Center's collections. The work of many modern master photographers is preserved in this archive.

*The Best of Photojournalism: Newspaper and Magazine Pictures of the Year. Columbia, MO: University of Missouri Press; and Philadelphia, PA: Running Press, 1976 to the present. A series of 13 annuals sponsored by the University of Missouri School of Journalism and the National Press Photographers Association. Each features outstanding photographs from the previous year that were published in America's newspapers.

*The Min Series of Contemporary American Photography. Tokyo: Min Gallery & Studio, 1987 to the present (available in America

from Light Impressions Corp.). A series of superbly designed catalogs of recent exhibitions of American photography in Japan. Many are produced in color, and each has a bilingual text and an introductory essay by the American critic Mark Johnstone. Titles produced to date:

1. Contemporary American Photography, Part I.
2. Robert Heinecken: Selected Works 1966–1986.
3. Grant Mudford.
4. Jo Ann Callis.
5. Anthony Friedkin.
6. Morrie Camhi.
7. Patrick Nagatani and Andree Tracey: Polaroid 20 × 24 Photographs, 1983–1986.
8. Catherine Wagner: Photographs 1976–1986
9. John Divola.
10. Bary Brukoff.
11. Michael Kenna 1976–1986.
12. Robbert Flick: Sequential Views 1980–1986.

*Pantheon Photo Library. New York: Pantheon Books, 1985 to the present. Each book in this series contains biographical information and more than 60 photographs. Titles to date include:

1. American Photographers of the Depression, 1985.
2. Eugéne Atget, 1985.
3. Henri Cartier-Bresson, 1985.
4. Robert Frank, 1985.
5. Bruce Davidson, 1986.
6. Early Color Photography, 1986.
7. André Kertész, 1986.
8. Jacques-Henri Lartigue, 1986.
9. Duane Michaels, 1986.
10. The Nude, 1986.
11. W. Eugene Smith, 1986.
12. Weegee, 1986.
13. Helmut Newton, 1987.
14. Alexander Rodchenko, 1987.
15. Brassái, 1988.
16. Lee Friedlander, 1988.
17. Robert Capa, 1989.
18. Man Ray, 1989.

*Untitled. Carmel and San Francisco, CA: The Friends of Photography, 1972 to the present. The 48 issues to date include articles and portfolios of fine photographs that range widely over historic and contemporary photography. Recent numbers include works on Michael Kenna, Frank Gohlke, Judith Golden, Wright Morris, and Roy DeCarava.

## PERIODICALS

Afterimage. Ten issues per year. Visual Studies Workshop, 31 Prince Street, Rochester, NY 14607. A lively tabloid that has made a major contribution to the discussion of photography and its social, political, and experimental concerns, while reporting on recent historical research, exhibitions, and publications worldwide. Video arts and related topics are also included. For serious advanced students and critics, it is one of the most important periodicals in the field.

American Photographer. Monthly. Diamandis Communications, 1515 Broadway, New York, NY 10036. A popular magazine that emphasizes contemporary artistic and media photography more than equipment and techniques.

Aperture. Quarterly. Aperture Foundation, 20 E. 23rd Street, New York, NY 10010. Founded by Minor White and others in 1952, this elegant quarterly has long been at the forefront of photographic thought and imagery. Stimulating articles and handsome reproductions of a wide variety of contemporary work.

Camera 35. Monthly. Popular Publications, 150 E. 38th Street, New York, NY 10022. See Popular Photography (below).

Darkroom Photography. Monthly. Melrose Publications, 9021 Melrose Avenue, Suite 203, Los Angeles, CA 90069. A popular magazine for amateur photographers that emphasizes darkroom equipment and techniques.

Petersen's Photographic Magazine. Monthly. Petersen Publishing Company, 8490 Sunset Boulevard, Los Angeles, CA 90069. Reports on new products and developments. Occasionally shows a West Coast point of view.

Photo Communique. Quarterly. Holocene Foundation, P. O. Box 129, Station M, Toronto, Ontario, Canada M6S 4T2. A Canadian journal which offers lively discussions of contemporary photographic art and its criticism, while reviewing new books and reporting on Canadian exhibitions.

Photographer's Forum. Quarterly. Photographer's Forum, 614 Santa Barbara Street, Santa Barbara, CA 93101. A well-produced magazine featuring student work from many college and university photography departments.

Photographica. Ten issues per year. Photographic Historical Society of New York, P. O. Box 1839, Radio City Station, New York, NY 10150. A journal of interest to collectors of cameras and other photographic apparatus, with notices of auctions and trading fairs.

Photomethods. Monthly. Professional Photographers of America, 1090 Executive Way, Des Plaines, IL 60018. The leading magazine for corporate, commercial, and industrial photographers and video technicians. Regular columns and departments by expert writers in the field emphasize practical solutions to photographic, technical, and business problems.

Popular Photography. Monthly. Diamandis Communications, 1515 Broadway, New York, NY 10036. Reports on new products for the amateur photographer, emphasizing cameras and accessories along with darkroom equipment and techniques.

The Professional Photographer. Monthly. Professional Photographers of America, 1090 Executive Way, Des Plaines, IL 60018. Official journal of the national trade association of portrait, commercial, and industrial photographic studios, featuring articles that help solve technical, business, and marketing problems.

Shutterbug. Monthly. Patch Publishing Company, 5211 S. Washington Avenue, Titusville, FL 32780. A tabloid newspaper full of classified ads for buying and selling photographic equipment.

## NON-PRINT MATERIALS (VIDEOS, FILMS, SLIDES)

Note: Unless otherwise indicated, all videos are ½ in. VHS format; all films are 16mm sound and color; and all slides are mounted for projection. Some materials can be rented for use. Addresses for sources are given at the end of the list.

Ansel Adams: Photographer. Produced by John Huszar and Andrea Gray, 1981. Dist. by Arthur Cantor (film) and Light Impressions (video). Film or video, 60 min. The life, work, and thinking of America's most celebrated photographer. Dialogues with Beaumont Newhall and Georgia O'Keeffe add interesting dimensions to this beautiful program, which was filmed in many of the locales with which Adams was long associated.

America and Lewis Hine. Produced by Nina Rosenblum and Daniel V. Allentuck, 1984. Dist. by The Cinema Guild. Film or video, 56 min. A remarkable documentary program produced from Hine's famous photographs of laboring children and his lesser-known motion-picture footage. Most of this production is in black-and-white.

Ruth Bernhard, Photographer. Produced and distributed by R. L. Burrill Associate Films. Film or video, 58 min. Ruth Bernhard is a San Francisco photographer famous for her studies of the nude.

*The Business of Photography.* Produced by Media West. Dist. by Light Impressions. Video, 90 min. A discussion with art directors and editors that will give you a glimpse of what professional free-lancing is like.

*Harry Callahan: A Need to See and Express.* Produced by Silver Productions, 1984. Dist. by The Center for Humanities. Video, 30 min. Famed photographer Harry Callahan tells the stories behind 300 of his photographs.

*Color from Light.* Produced and distributed by Churchill Films, 1976. Film or video, 11 min. Using color photography and color TV as examples, this program animates an explanation of how additive and subtractive color systems work.

*Commercial Illustration.* Produced by Finelight Videos. Dist. by Light Impressions. Two videos, 45 min. each. Dean Collins, a noted expert on studio lighting, shows how to photograph various products for advertising illustration and other uses. One tape features small objects done on a tabletop; the other features larger objects (such as autos) done in the studio.

*The Contemporary Photographers: Morley Baer.* Produced and distributed by R. L. Burrill Associate Films. Film or video, 25 min. Baer has been a leading West Coast landscape and architectural photographer for nearly fifty years. Here he shows and discusses his work.

*Contemporary Portraiture.* Produced by Finelight Videos. Dist. by Light Impressions. Three videos, 45 min. each. Dean Collins presents ideas for posing and lighting portraits of people. Studio settings are featured in one video, location settings in another. The third tape gives an overview of the field.

*Control and Command: Exposure as a Creative Force.* Produced and distributed by Media Loft, 1980. 79 slides with audio cassette, 28 min. Fundamentals of exposure, including measuring light with incident and reflected meters. The program eases the transition from automatic to manual exposure systems in cameras, and shows the creative choices possible with hand-held meters.

*To Dream with Open Eyes* and *Expanding Photographic Vision.* Produced and distributed by Media Loft, 1987. Video, 49 min. These combined programs feature famed photographer Ernst Haas exploring themes of movement and the moment, liberty and discipline, and levels of abstraction.

*David Goldblatt in Black-and-White.* Produced by Bernard Jaffa, 1988. Dist. by Wombat Films. Video, 52 min. A sensitive visual essay on what it is like to be white in South Africa. Narrated largely by the photographer (a minority person himself within the white community there), it examines how Goldblatt expresses his feelings through his photography and how he deals with the paradoxes and compromises that confront one who tries to live a normal life in a bizarre society.

*John Hoagland, Front Line Photographer.* Produced by David Helvarg, 1985. Dist. by Cinema Guild. Video, 29 min. A program that graphically illustrates the dangers photojournalists face when covering war. Hoagland was a surfer and school dropout who became a noted war photographer in El Salvador and Nicaragua before he was killed.

*Holography: Memories in Light.* Produced by Global Educational, 1985. Dist. by Arthur Mokin Productions. Film or video, 21 min. An excellent introduction to holography, showing different ways that holograms can be made and displayed. Especially valuable because these images cannot be shown on the printed page or adequately described by words alone.

*Large Format—The Professional's Choice.* Produced and distributed by Calumet Photographic. Video, 25 min. How to set up and use the view camera, with a discussion of its advantages over other cameras and formats. Includes a 48-page workbook.

*Joel Meyerowitz—Photographer.* Produced by Robert Gilberg, Dist. by Nimble Thimble Productions. Video, 57 min. Colin L. Westerbeck, Jr. introduces the photographer and his work, placing them in the larger contexts of street photography, landscapes, and portraiture in color. Photographs from *Cape Light* and *St. Louis and the Arch* are included.

*Moving Still.* Produced by WGBH/BBC, 1980. Dist. by Time-Life Video. Video, 57 min. Part of the NOVA series seen on public television, this program presents a history of photography including the use of high-speed and time-lapse images to show things too fast and too slow for the human eye to see unaided. Excellent visual examples.

*Objective Camera.* Produced for WCBS, New York, by Camera Three, 1975. Dist. by New York State Education Dept. Video, 30 min. Famed photojournalist W. Eugene Smith discusses his involvement in the Minimata industrial pollution story.

*On Assignment: The Photojournalists.* Produced and distributed by Media Loft, 1983. Video or 160 slides with audio cassettes, 43 min. A fast-paced program that shows photographers Annie Griffiths, Bruce Bisping, Skip Heine, and Peggy Walsh on actual assignments.

*The Photographer's Eye.* Produced by Bill Moyers, 1982. Dist. by PBS Video. Video, 28 min. Emmet Gowin and Gary Winogrand, two contemporary photographers with very different styles, are the subjects. The program shows that creative work is possible in both structured and unstructured environments.

*Photographer: Russell Lee.* Produced by Ann Mundy, 1987. Dist. by Ann Mundy & Associates. Video, 58 min. A program that documents the life and work of the late Farm Security Administration photographer Russell Lee, whose flash shots of life in Texas and the West formed an important facet of the FSA archive.

*Post-Visualization and the Multiple Image.* Produced and directed by Media Loft, 1983. 80 slides with audio cassette, 33 min. Jerry N. Uelsmann, famous for his photomontages and multiple images, explains his ideas of post-visualization and demonstrates his step-by-step techniques.

*The Precise Image: From Imagination to Reality.* Produced and distributed by Media Loft, 1985. Video or 126 slides with audio cassette; 36 min. (video), 43 min. (slides). New York advertising photographer Klaus Lucka shows how he produces images to his clients' exact needs.

*Galen Rowell: Mountain Light.* Produced by Eastman Kodak Company. Dist. by Light Impressions. Video, 60 min. Photographer and mountaineer Galen Rowell shows how he uses natural light to produce the unique color images for which he is noted.

*The Searching Eye.* Produced and distributed by Media Loft, 1985. Video or 80 slides with audio cassette, 24 min. Photographs and commentary by famed Magnum photojournalist Mary Ellen Mark, including scenes from a story about a women's mental hospital and *Falkland Road.* Mark's comments on the challenges of difficult, self-assigned subjects are revealing and instructive.

*Sharing the Dream: Brian Lanker Photographs Black Women Who Changed America.* Produced and distributed by Media Loft, 1989. Video, 40 min. A Pulitzer prize-winning photographer shares his experience photographing 75 notable black women. He covers everything from arranging grant funding through editing sessions with his book publisher.†

*Shedding Light on Light.* Produced and distributed by Media Loft, 1978. 80 slides with audio cassette, 18 min. Photographs by Pete Turner, Jay Maisel, Douglas Kirkland, and others from New York's Image Bank stock agency are used to demonstrate and discuss this universal topic.

---

† Additional set of 20 study slides available.

*Sight and Insight: Photographer Sam Abell's Art of Simplicity.* Produced and distributed by Media Loft, 1989. Video, 35 min. A *National Geographic* photographer who is concerned with vanishing cultures discusses his visual thinking on assignments and the value of pictures that transcend their literal meaning.†

*Ralph Steiner.* Produced by Thomas Schiff, 1983. Dist. by Images Productions. Video, 30 min. An interview with photographer Ralph Steiner, who presents his work in a witty and earthy manner. Useful for beginning film students as well as still photographers.

*The Studio.* Produced by Media West. Dist. by Light Impressions. Video, 90 min. Practical ideas and advice on how to set up and equip your own photo studio.

*The Weston Eye: Composition, Detail, and the Large Format Image.* Produced and distributed by Media Loft, 1981. 80 slides with audio cassette, 29 min. Cole Weston anchors this program featuring three generations of Weston photographs: Edward's classic black-and-white images, Cole's landscapes and details in color, and recent work by Cole's son, Kim.

*The World in the Camera.* Produced by WGBH, Boston, 1983. Dist. by King Features Entertainment. The story of George Eastman, his inventions, and the legacy he left in Eastman Kodak Company.

## SOURCES FOR NON-PRINT MATERIALS

R. L. Burrill Associate Films
817 Calero Street
Milpitas, CA 95035

Calumet Photographic
890 Supreme Drive
Bensenville, IL 60106

Center for Humanities
Communications Park
P.O. Box 1000
Mt. Kisco, NY 10549

Churchill Films
662 N. Robertson Blvd.
Los Angeles, CA 90069

Cinema Guild
1697 Broadway
New York, NY 10019

FilmAmerica
420 E. 55th Street
New York, NY 10022

Images Productions
PO Box 46691
Cincinnati, OH 45246

King Features Entertainment
235 E. 45th Street
New York, NY 10017

Light Impressions
439 Monroe Avenue
Rochester, NY 14607

Media Loft
10720 40th Avenue N.
Minneapolis, MN 55441

Arthur Mokin Productions
2900 McBride Lane
Santa Rosa, CA 95401

Ann Mundy & Associates
PO Box 5354
Austin, TX 78763

New York State Education Dept.
Media Distribution Network
Room C-7, Concourse Level
Cultural Education Center
Albany, NY 12230

Nimble Thimble Productions, Inc.
16 W. 16th Street
New York, NY 10011

PBS Video
1320 Braddock Place
Alexandria, VA 22314

Time-Life Video
PO Box 644
Paramus, NJ 07652

Wombat Films
250 W. 57th Street
New York, NY 10019

# INDEX

*Boldface numbers refer to illustrations.*